HUNDREDS OF PUBLISHERS.
THOUSANDS OF TITLES.
PLENTY OF ALTERNATIVES.

And they're all in
PREVIEWS!

Each month, this mega-catalog offers a galaxy of comics that will satisfy any reading taste! Whether you're looking for super-hero epics or intimate slice-of-life stories, *PREVIEWS* has them, all told by creators who range from industry legends to the newest, hottest talents!

Pick up this month's catalog at your favorite comic book specialty shop today. See for yourself that, when it comes to comics and related merchandise, *PREVIEWS* offers you plenty of alternatives!

To find a comic book specialty shop near you, call toll-free (888) COMIC-BOOK, or visit our web site at www.diamondcomics.com/csls!

8. *TCJ* Summer Reading List

18. Journal Datebook
by Greg Stump and staff

23. You Are Now Entering Deitchworld
Introduction and interviews conducted by Gary Groth

> **25. Gene Deitch**

> **64. Kim Deitch**

> **160. Simon Deitch**

> **177. Seth Deitch**

190. Reviews
Laika, The Best of Mutts, Little Sammy Sneeze, A Dangerous Woman, Azumanga Daioh, MW *and* Palestine: The Special Edition

182. F.M. Howarth Comic Strips
With an introduction by Jared Gardner

222. Columns
The Observer *by Donald Phelps,* Comicopia *by R.C. Harvey and* Lost in Translation *by Bill Randall*

238. Coming Comics

THE COMICS JOURNAL #292 (ISBN: 987-1-56097-938-8) Oct. 2008. Published monthly in Jan., Feb., Apr., May, July, Aug., Oct., Nov. by Fantagraphics Books, Inc., from the editorial and business offices at 7563 Lake City Way N.E., Seattle, WA 98115. *The Comics Journal* is copyright © 2008 by Fantagraphics Books, Inc. All images/photos/text © Their respective copyright holders. Unauthorized reproduction of any of its contents is prohibited by law. Periodicals postage paid at Seattle, WA, and at additional mailing offices. POSTMASTER: Please send address changes to The Comics Journal, 7563 Lake City Way N.E., Seattle, WA 98115. PRINTED IN SINGAPORE.

Cover art by Kim Deitch. [©2008 Kim Deitch] **Above:** The model sheet for Gaston LeCrayon: courtesy of Gene Deitch

COMICS COUNTRY

You'll find all your favourite comics, 'zines, books and **LOTSA** neat stuff at these well stocked, **HIGHLY** recommended specialty stores.

LEE'S COMICS
1020 N RENGSTORFF AVE.
SUITE F
MOUNTAIN VIEW, CA
94043
(650) 965-1800

2222 S EL CAMINO REAL
SAN MATEO, CA 94403
(650) 571-1489

WWW.LCOMICS.COM

SECRET HEADQUARTERS
3817 W SUNSET BLVD.
LOS ANGELES, CA 90026
323-666-2228
WWW.THESECRETHEADQUARTERS.COM

THE FANTAGRAPHICS STORE
1201 S. VALE ST.
SEATTLE WA 98108
(206) 568-0110

WWW.FANTAGRAPHICS.COM

COSMIC MONKEY
5335 NE SANDY BLVD
PORTLAND OREGON
97213

503
253
2752

WWW.COSMICMONKEYCOMICS.COM

CHICAGO COMICS
3244 N CLARK
CHICAGO, IL
60657
773-528-1983

WWW.CHICAGOCOMICS.COM

QUIMBY'S
1854 W NORTH AVE
CHICAGO, IL 60622
773-342-0910
WWW.QUIMBYS.COM

BIG BRAIN COMICS
1027 WASHINGTON AVE. S.
MINNEAPOLIS, MN 55415
612-338-4390
WWW.
BIGBRAINCOMICS
.COM

COMIX REVOLUTION

606 DAVIS ST.
EVANSTON, IL 60201
847-866-8659
WWW.
ONLINE-REVOLU
TION.COM

HIJINX COMICS
2050 LINCOLN AVE. SAN JOSE, CA 95125
408-266-1103

WWW.HIJINXCOMICS.COM

GOLDEN APPLE
7018 MELROSE AVE
LOS ANGELES, CA
90038
323-652-6047
WWW.GOLDENAPPLECOMICS.COM

COMIC RELIEF
2026 SHATTUCK AVE
BERKELEY, CA
94704-1117
510-843-5002
WWW.COMICRELIEF.NET

LAUGHING OGRE
4258 N HIGH STREET
COLUMBUS, OH 43214-3048
TEL: 614-A-MR-OGRE
WWW.THELAUGHINGOGRE.COM

THE BEGUILING
601 MARKHAM ST.
TORONTO, ON
CANADA, M6G 2L7
416-533-9168
WWW.BEGUILING.COM

STRANGE ADVENTURES COMIC BOOKSHOPS 5262 SACKVILLE ST. HALIFAX, NOVA SCOTIA CANADA B3J 1K8 PH: 902-425-2140
WWW.STRANGEADVENTURES.COM

COMICOPIA ★★★★
464 COMMONWEALTH AVE.
BOSTON, MA 02215
617-266-4266
WWW.COMICOPIA.COM

JIM HANLEY'S UNIVERSE
4 W. 33RD ST.
NEW YORK, NY
10001-3302
212-268-7088
325 NEWDORP LANE
STATEN ISLAND, NY
10306
718-351-6299
WWW.JHUNIVERSE.COM

BIG PLANET COMICS
4908 FAIRMONT AVE BETHESDA, MD 20814
301-654-6856
426 MAPLE AVE E. VIENNA, VA 22180
703-242-9412
3145 DUMBARTON AVE NW WASHINGTON, DC 20007
202-342-1961
7315 BALTIMORE AVE COLLEGE PARK, MD 20740
301-699-0498
WWW.BIGPLANETCOMICS.COM

WWW.ATOMICBOOKS.COM
ATOMIC BOOKS
1100 W. 36TH ST.
BALTIMORE, MD 21211
410-662-4444

WWW.CRIMINAL.COM
CRIMINAL RECORDS
466 MORELAND AVE NE
ATLANTA, GA 30307
404-215-9511

ALTERNATE REALITY
4800 S. MARYLAND PKWY. D
LAS VEGAS, NV 89119
WWW.ALTERNATEREALITYCOMICS.NET
702-736-3673

The Comics Journal Summer Reading List

The Journal *asked comics professionals what they're reading this summer — comics and otherwise. Due to the magazine's long lead time, all were approached with this question before the summer had even begun. Thanks to all the contributors whose literary anticipations were well organized enough for them to respond.*

— MD

JOHN ALLISON
• *Armed Madhouse* by Greg Palast
• *Norwegian Wood* by Haruki Murakami
• *Moomin: The Complete Tove Jansson Comic Strip*, Book 2 by Tove Jansson
• *Yotsuba&!* Vol. 5 by Kiyohoko Azuma
• *The Underground Man* by Mick Jackson

STEVE BISSETTE
Comics/graphic novels:
Too many to name but the new Joe Kubert *Tor*, the wind-up of the Jonathan Lethem *Omega* series and others top the stack. I'm also rereading the complete *Marvelman/Miracleman* this summer, going back to the 1950s L.P. Miller's *Marvelman* Annuals I picked up this winter from a New Zealand collector.

Books:
Just finished David Hajdu's *The Ten-Cent Plague: The Great Comic-Book Scare And How It Changed America*, which was terrific.

Now on the reading stack:
• *Charlatan: America's Most Dangerous Huckster, the Man Who Pursued Him, and the Age of Flimflam* by Pope Brock (almost completed this read, excellent book!)
• *No End In Sight: Iraq's Descent Into Chaos* by Charles H. Ferguson
• *Frost/Nixon: Behind the Scenes of the Nixon Interviews* by Sir David Frost and Bob Zelnich (I picked up and read the other two books on the Frost/Nixon interviews, and

rewatched the DVD showcasing the original 1977 broadcast of the interview)
• *The Graveyard Book* by Neil Gaiman (rereading; Neil sent me the first draft, which I'm dipping back into in June for a second go-around)
• *Julia Pastrana: The Tragic Story of the Victorian Ape Woman* by Christopher Hals Gylseth and Lars O. Toverud
• *Heart-Shaped Box* by Joe Hill (rereading; I loved Joe's short-story collection, best of its kind since Barker's original *Books Of Blood*)
• *The Fortress Of Solitude* by Jonathan Lethem
• *Monster 1959* by David Maine (top of the stack)
• *The Teapot Dome Scandal: How Big Oil Bought the Harding White House and Tried to Steal the Country* by Laton McCartney
• *The Bush Tragedy* by Jacob Weisberg

I always have at least two nonfiction film and cinema books on the reading table — too many of those to name, honestly! I read one a week. Just finished *Shocking Cinema of the Seventies* edited by Xavier Mendik, which was excellent and recommended.

JEFFREY BROWN
I'm not sure what all is even due to come out this year, really, but I know I'll be reading Mike Dawson's *Freddie & Me* ... as usual I'm sure I'll be reading 95 percent of everything put out by Top Shelf, Drawn & Quarterly, Fantagraphics, Alternative and Buenaventura Press. I am planning on catching up with a chunk of reading of some mainstreamy titles; I've read the first few volumes each of *Fables* and *100 Bullets* so I'm going to read the rest of those trades, as well as the *Madman Gargantua* book and the big first collection of *Invincible*. I'm also thinking about picking up the *Uncanny X-Men Omnibus*.

BECKY CLOONAN
I've been meaning to read *The Devil in the White City* by Erik Larson for a while now. I bought it almost a year ago and it's just been sitting on my shelf because I've just been

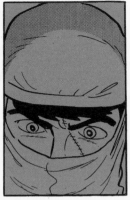
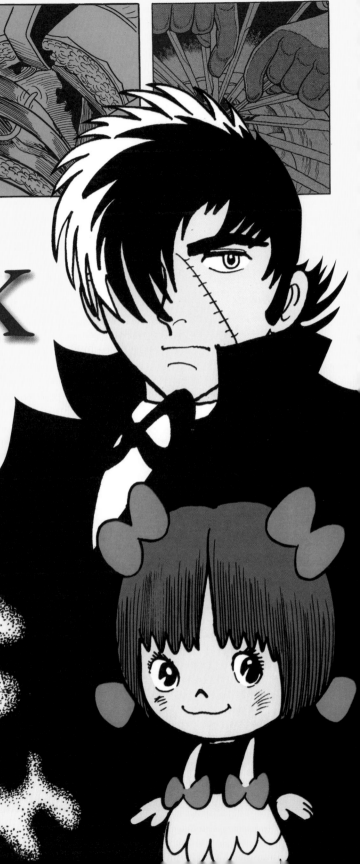

Osamu Tezuka's
BLACK JACK

Volume 1
SEPTEMBER 2008
Published Bi-Monthly
288 pages, 6 x 8 inches
High Quality
$16.95/$20.00

From the creator of
Buddha, Astro Boy and
Kimba, the White Lion comes
his most popular creation
amongst Japanese adults,
the notorious surgeon-for-hire
Black Jack.

too busy to touch it! Shame. It's on my list this summer because I'm doing so much traveling; I'll definitely need a few books.

Some other books that I've been meaning to read:
• *Howl's Moving Castle* by Diana Wynne Jones
• *The Somnambulist* by Jonathan Barnes
• *The Club Dumas* by Arturo Pérez-Reverte

SARA EDWARD-CORBETT
• *What It Is* by Lynda Barry
• New *War and Peace* translation by Richard Pevear and Larissa Volokhonsky
• *The Education of Hopey Glass* by Jaime Hernandez
• *Haunted* by Philippe Dupuy
• *The Lost* by Daniel Mendelsohn

RAY FENWICK
This list is perfect for me right now, because I am actually trying to read the following five books simultaneously.
• *Um ... Slips, Stumbles, and Verbal Blunders, and What They Mean* by Michael Erard
The weird structures and missteps that normally get edited out, talked about in detail.
• *What It Is* by Lynda Barry

This is the most inspiring comics-related book I think I've ever read, and I'm only halfway through.
• *For Whom the Bell Tolls* by Ernest Hemingway
This is the first Hemingway book I've read, and of these five books it's pulling me along the fastest.
• *IDEO Eyes Wide Open New York* by IDEO
A beautiful guide to New York that focuses on less typical and more observational experiences.
• *The Essays, A Selection* by Michel De Montaigne
I read his essay "On Friendship" and was really moved by it.

BILL GRIFFITH
• *Hubert's Freaks* by Gregory Gibson (a somewhat novelistic investigation of Hubert's Flea Circus, 1940s-1960s, the Times Square institution that spawned "Tiny Tim" and was photographed by Diane Arbus — I visited it a few times in the mid-'60s, shortly before it closed its doors).
• *A History of the Snowman* by Bob Eckstein
• Rereading "Bartleby the Scrivener" by Herman Melville

NICHOLAS GUREWITCH
This summer, I would like to read *As You Like It* by William Shakespeare, Jeff Smith's *Bone* and the *Italian Folktales* by Italo Calvino.

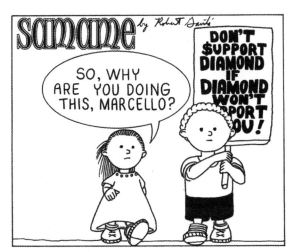

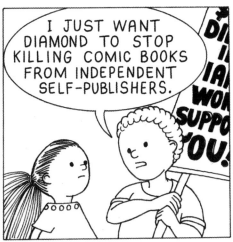

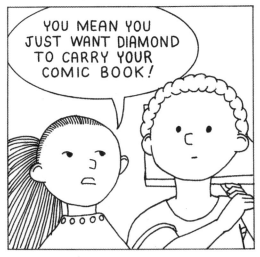

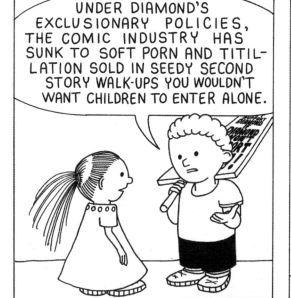

SAM HENDERSON

- *Schulz & Peanuts* by David Michaelis
- *The Portable Atheist* edited by Christopher Hitchens
- *Chuck Klosterman IV* by Chuck Klosterman
- *A Youth in Babylon* by David Friedman
- *Rapture Ready* by Daniel Radosh
- *Dark at the Roots* by Sarah Thyre
- *I Love You, Beth Cooper* by Larry Doyle
- *The Ten Cent Plague* by David Hadju
- *Little Lotta In Foodland* #11, author(s) unknown
- *Midnight Tales* # 17 edited by George R. Wildman
- *Dracula #7* by Tony Tallarico
- *Walt Disney's Comics and Stories #244* not by Carl Barks it turns out
- *Armageddon In Retrospect* by Kurt Vonnegut
- *Sex to Sexty: The Most Vulgar Magazine Ever Made* edited by Dian Hanson
- *I Am America And So Can You* by Stephen Colbert
- *How To Make Lists Solely To Impress People* by various cartoonists
- *Checking Amazon to Make Sure the Books Everyone Mentions Actually Exist* by the editors of *The Comics Journal*

TIM HENSLEY

A few books I've read recently:
- *Jackie Ormes* by Nancy Goldstein

A biography of the first female African American cartoonist. It's written by someone whose focus is more on doll collecting than cartooning. The doll angle seemed a little cutesy to me until I read that Ormes had a child with a brain tumor who died at 3 years old. The book is maybe not the best written; it repeats itself and there are too many footnotes, but it is profusely illustrated and has many scans of her cartoons. It also includes excerpts from her FBI file.
- *Testimony* by Charles Reznikoff

These are poems fashioned from court transcripts, so pretty much they are one poem after another where someone is going to be killed in a dispute or have their hands mangled in yarn, coal or train machinery. Two thumbs up.
- *Snowbird's Blood* by Joe Hensley

This is my Uncle Joe's final book about an older Vietnam vet with terminal cancer pursuing vigilante justice in Florida against swindlers of senior citizens. It reads like airport fiction, probably wouldn't have read it if I wasn't a blood relation. It was depressing because the main character's cancer inexplicably goes into remission at the end of the book. Why wouldn't you write that fate for your protagonist if you yourself knew you were going to die?
- One book I plan to order is *Final Series Book of World Famous Television Executive Billionaire Star Celebrity* by White Goldfish King. King is, I think, a homeless men-

BLURRED VISION 4

Karl Stevens
Woojung Ahn
Mark Sunshine
Paul O'Connell
Michael Teague
Jaoquin de la Puente and Josh Bayer
Koren Shadmi
Stem
Gary Sullivan
D.Dominick Lombardi
Doug Harvey
Kevin Mutch
Iain Laurie
Icecreamlandia
Toc Fetch
Andrei Molotiu
Roland Brener
Quintin Gonzalez
Ethan Persoff
K. Thor Jensen
Tobias Tak
Matt Madden
Henrik Rehr

BLURRED BOOKS

NEW YORK CITY

tally ill man who has written a number of books and self-published them. This new book is the third in a trilogy of mostly impenetrable monomania.
• As far as summer comics that I'm aware are forthcoming, seems like I'm most looking forward to the new format *Love & Rockets* and *Red Colored Elegy*.

BEN KATCHOR
I'm reading *Laura Warholic* by Alexander Theroux. I'm also reading *The Crowd Sounds Happy* by Nichola Dawidoff.

JEFF LEMIRE
• *The Scar* — China Mieville
• *The Border Trilogy* — Cormac McCarthy
• *Final Crisis* — Grant Morrison
• *Showcase Presents The Phantom Stranger* Vol.1-2 — Various
• *Little Things* — Jeffrey Brown
• *Man of Rock: The Joe Kubert Biography* — Bill Schelly

JASON LITTLE
These are variously finished, still being read, or sitting patiently on my bedside table:
• *Tesla: Man out of Time* by Margaret Cheney
Uneven writing, but the compelling subject carries the book anyway.

THE BOY WHO MADE SILENCE

A richly imagined new series from award-winning artist Joshua Hagler

"One of the best comic book reading experiences I've had in a long time."
DAVID MACK

"Just take one look at this book and it is obvious why it won a Xeric Grant."
BROKEN FRONTIER

"A bleak and oddly frightening place...An absolutely gorgeous book..."
CBR

"A moody and impressionistic story...Hagler finds his true voice."
SAM KIETH

"Hagler has the proper focus on telling the story...subtle, understated work. A very impressive start."
X-AXIS

"...one of the most interesting and beautiful comics you could ever hope to read."
COMICS VILLAGE

in Previews under AAM/Markosia | www.5minedfields.com
www.myspace.com/theboywhomadesilence | www.markosia.com

• *Robinson Crusoe* by Daniel Defoe
Holy smokes, this was written in 1719! Is it possible that our language has changed so little since then?
• *Forty Years With Mr. Oswald* by Russell Johnson
This guy's name should be a household word. He sure draws a mean hardware store.
• *Foucault's Pendulum* by Umberto Eco
All research and little character. Great if you are into research-porn.
• *The Encyclopedia of the Renaissance*, Paul F. Grendler, ed.
I don't expect I'll read the whole six volumes, but it's great to graze randomly.
• *Cigarettes* by Harry Matthews
A major work by a member of the OuLiPo.
• *The Count of Monte Cristo* by Alexandre Dumas
I loved Orson Welles radio play of this. But it's 1,500 pages! It's next on my list.
• *Gravity's Rainbow* by Thomas Pynchon
I'll get back to this when I finish *Count of Monte Cristo*, if I haven't died of old age first.
• *The Piazza Tales* by Herman Melville
The other stuff in here isn't as good as "Bartleby the Scrivener," but it's relentlessly nautical like good old books should be.
• *New Engineering* by Yuichi Yokoyama
Incredible atmospheric conceptual-art manga.
• *The Passport* by Saul Steinberg
Relentlessly experimental. Perhaps an influence on Gary Panter?

CATHY MALKASIAN
My summer list has only two titles so far:
Indian Summer (the Secret History of the End of an Empire) by Alex Von Tunzelmann and *The Rebel* by Albert Camus.

JOSH NEUFELD
• *The Road*, Cormac McCarthy
• *Poetics*, Aristotle
• *Boulevard Of Broken Dreams*, Kim Deitch
• *Making Comics*, Scott McCloud
• *Persepolis*, Marjane Satrapi
As you can tell, I'm a little behind in my reading!

DANICA NOVGORODOFF
Already Dead by Denis Johnson, *Absurdistan*, by Gary Shteyngart, *The Bottomless Belly Button*, by Dash Shaw, *Pastoralia* by George Saunders, *Alan's War* by Emmanuel Guibert, *Oracle Bones* by Peter Hessler, *Slow Man* by J.M. Coetzee

GARY PANTER

Recently read or reading:
- *The Teachings of Don B.* - Donald Barthelme
- *40 Stories* - Donald Barthelme
- *Riddley Walker* - Russell Hoban
- *The Road* - Cormac McCarthy
- *McSweeney's 24*
- *Into the Tunnel* - Kellman and Mailin
- *As She Crawled Across the Table* - Jonathan Lethem
- *All About H Hatterr* - G. V. Desani
- *Kill All Your Darlings* - Luc Sante
- *Illuminations* - Walter Banjamin
- *Tripping* - B.H. Friedman
- *Pharmako Gnosis* - Dale Pendell
- *Beyond the Dream Syndicate* - Branden Joseph
- *That Uncertain Feeling* - Kingsley Amis

JOHN PORCELLINO

- *Cartoon America* - ed. Harry Katz
- Rereading various *Love & Rockets* (in the new collections) - Gilbert & Jaime Hernandez
- *The Replacements: All Over But the Shouting: An Oral History* - ed. Jim Walsh
- *The City in Mind* - James Howard Kunstler
- *Complete Peanuts 1957-1958* - Charles M. Schulz
- *What It Is* - Lynda Barry
- *Dogen's Extensive Record: A Translation of the Eihei Koroku* - trans. Taigen Dan Leighton & Shohaku Okumura

JAMIE S. RICH

- *The Apocalipstix* by Ray Fawkes and Cameron Stewart (Oni Press)
- *Berlin, Book Two: City of Smoke* by Jason Lutes
- *The Book of Lies* by Brad Meltzer (Grand Central)
- *Chiggers* by Hope Larson (Aladdin)
- The *Daredevil* story arc reuniting Ed Brubaker and Greg Rucka (Marvel)
- *Emiko Superstar* by Mariko Tamaki and Steve Rolston (DC/Minx)
- *Grenuord* by Francesca Ghermandi (Fantagraphics)
- *Madame Xanadu* by Matt Wagner and Amy Reeder Hadley (DC/Vertigo)
- *Monster* Vol. 16 by Naoki Urasawa (Viz)
- *Patsy Walker: Hellcat* Kathryn Immonen and David Lafuente (Marvel)

FRANK STACK

- *Benito Cereno* by Herman Melville
In a Pacific seaport, an American sea captain comes the aid of a mysterious ship carrying a cargo of 300 slaves.

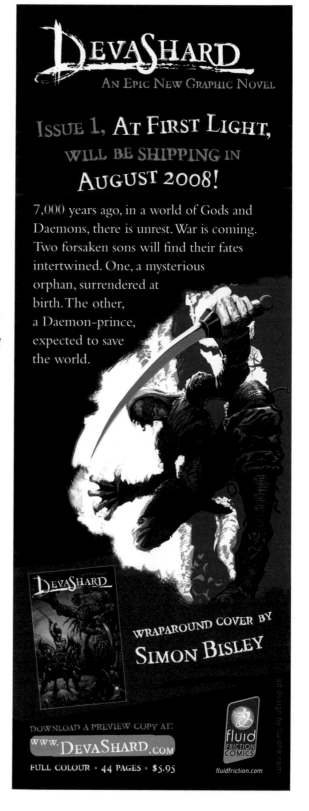

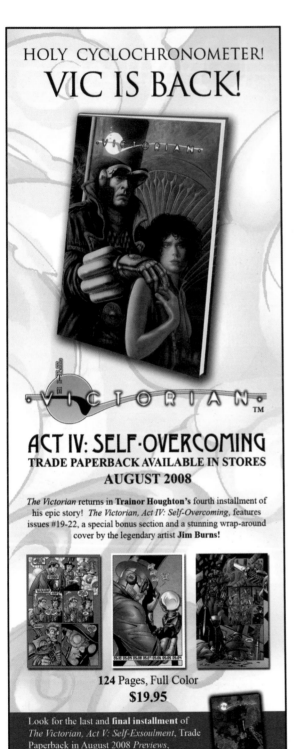
• *White Jacket* by Herman Melville
Autobiographical account of Melville's last voyage as a sailor, in 1843 on the largest warship in the U.S. fleet, including the author's own near-fatal plunge into the sea from the main topmast.

• *Redburn* by Herman Melville
Fictionalized first-person story of Melville's first voyage as a teenage seaman, from New York to Liverpool, with a very strange one-night visit to London.

• *The Third Policeman* by Flann O'Brien
Surreal comic novel, the second by Brian O'Nolan, writing under a pseudonym. First-person narrative of a murderer who forgets his own name.

• *Gasoline Alley* Vol. 2 by Frank King
Masterful early comic strip with young Uncle Walt as a single parent caring for the infant Skeezix. A loving and persuasive epic of the interrelationships of an entire neighborhood.

• *Complete Dick Tracy* Vol. 3 1935-36 and Vol. 4 1937-38 by Chester Gould
Four years of Tracy's adventures concluding with "The Blank," the man with no face. Gould was probably the greatest master in newspaper continuities of the irresistible cliffhanger. "How is Tracy (or the villain for that matter) going to get out of THIS one?"

• *Fun Home* by Alison Bechdel
Much well-deserved praise for this story of Alison's early years and relations, especially with her troubled but talented father who committed suicide (maybe) shortly after she revealed her homosexuality to the family. Wonderful incorporation of her introduction to literature and the effect of reading on her attitude toward life.

• *The Shiniest Jewel* by Marian Henley (in manuscript)
This book, also about the author/artists relations with her father, her own late marriage and long process of adopting a child, from Russia.

• *Mr Glencannon* by Guy Gilpatric
Comic stories from the 1930s centering around the chief engineer of a tramp steamer.

• *Uncle Dynamite* by P.G. Wodehouse
Another wonderfully plotted comic novel featuring the handsome and genteel but infuriating Lord Ickenham.

SETH TOBOCMAN
What I just read: Naomi Klein's *The Shock Doctrine*. And of course, the second hardcover collection of *The Rabbi's Cat*.

DYLAN WILLIAMS
My books are mostly just a plan:
• *Michelangelo Antonioni: The Architecture of Vision* edited by Marg Cottino-Jones

- *Michelangelo Antonioni Interviews* edited by Bert Cardullo
- *Satyajit Ray Interviews* edited by Bert Cadullo
- *The Remarkable Michael Reeves* by John B. Murray
- *Negative Spaces: Manny Farber on the Movies*
- *The Philosophy of Friedrich Nietzsche* by H.L. Mencken
- *The Dice Man* by Luke Rinehart
- *The Business Man* by Thomas M. Disch
- *Quatermass* by Nigel Kneale
- *Otto Rahn & the Quest for the Holy Grail* by Nigel Graddon
- *Sinister Forces* Book 1 *The Nine* by Peter Levenda
- *The City of the Discreet* by Pio Baroja
- *Personality* by Rabindranath Tagore
- *The Need for Roots* by Simone Weil
- *Ax* by Ernie Colón
- *The Medusa Chain* by Ernie Colón
- *Dororo* by Osamu Tezuka
- *Means of Evil* by Ruth Rendell
- *Most Outrageous* by Bob Levin
- *Wobblies!* edited by Paul Buhle and Nicole Schulman
- *Welcome to the Dahl House* by Ken Dahl
- *BFF* by Nate Beaty
- *Sci-Fi & Fantasy Modeller* #9 edited by Mike Reccia
- *Lapham's Quarterly* #2: *About Money* edited by Lewis Lapham

GENE YANG

This is just what I *hope* to be reading this summer, right? I never get through my intended summer reading list.

Comics:
- *Three Shadows* by Cyril Pedrosa
- *The Essex County Trilogy* by Jeff Lemire
- *What It Is* by Lynda Barry
- *Slow Storm* by Danica Novgorodoff
- *Amulet* by Kazu Kibuishi
- *Hamlet* adapted by Neil Babra
- *North World* by Lars Brown
- *Dororo* by Osamu Tezuka
- *Black Panther* Vol. 1 by Jack Kirby
- *The Best of American Splendor* by Harvey Pekar
- *The Blue Lotus* by Hergé
- Whatever volumes of Brian K. Vaughn's *Runaways* I can find in my local library's teen section
- Whatever new work Jason Shiga, Lark Pien, or Jesse Hamm bring to Comic-Con

Books with no pictures:
- *Stop Me If You've Heard This One Before* by David Yoo
- *The Kite Runner* by Khaled Hosseini
- *The Power and the Glory* by Graham Greene
- *Modern Physics, Ancient Faith* by Stephen Barr ∎

Apr. 18, 2008 – June 3, 2008
by Greg Stump & staff

Complaint over cartoon launches police investigation in Canada

April 18: A cartoon by Bruce MacKinnon that ran in the Halifax *Chronicle Herald* has led police in the region to investigate whether the paper is guilty of a hate crime. MacKinnon's cartoon depicts a woman wearing a burqa and holding a sign that says she wants "millions" to "put towards my husband's next training camp." According to the *Chronicle Herald*, MacKinnon was depicting a Nova Scotia woman who told reporters that she wanted millions of dollars in compensation for the arrest of her husband in an anti-terrorism raid. A local Muslim group, the Centre for Islamic Development, felt that the cartoon was linking Muslims to terrorism, rather than commenting on an individual. As a result, a complaint was lodged and an investigation is being conducted to see whether MacKinnon committed a hate crime under the Criminal Code of Canada for "intimidating, harming or terrifying" an entire group.

Poe Comics exhibited in Virginia museum

April 24: Comic books and graphic novels inspired by Poe and his works are on display until October 31 at the Edgar Allan Poe Museum (www.poemuseum.org) in Richmond, Va., in an exhibition curated by Richmond artist Chris Semtner.

— M. Thomas Inge (contributor of many of the comics on display)

Retailer critically wounded in robbery

April 25: David Pirkola, the owner of Apparitions Comics and Books, was shot in April during a robbery at his store in Grand Rapids, Mich. Pirkola was critically wounded and remained in intensive care for several days after being shot in the chest, reportedly by a group of three men who have since been arrested by local police. He was slated to return home from the hospital in June, but his lack of health insurance has left him with medical bills that place an extra burden on his recovery and rehabilitation. Anyone wishing to donate to a fund that his been set up in his behalf can do so through ifanboy.com; Pirkola's progress is tracked online at davidpirkola.blogspot.com.

Hazel's Ted Key Dies at 95

May 3: Cartoonist Ted Key died May 3, 2008, at his home in Tredyffrin Township just outside Philadelphia, Penn. His health had been failing since he was diagnosed with bladder cancer in 2006, and he had suffered a stroke in September 2007. In his 95 years, Key had parlayed his cartoonist's skills and instincts into an impressive array of creative accomplishments in a variety of entertainment media.

He was born August 25, 1912, in Fresno, Calif., son of Latvian immigrant Simon Keyser, who shortened his name to Key during World War II. After graduating in 1933, Ted Key trekked to cartooning Mecca, New York City, and freelanced cartoons to magazines, soon appearing in *Ladies' Home Journal, Good Housekeeping, McCall's, Cosmopolitan, TV Guide, Mademoiselle, Collier's, Look, Better Homes and Gardens, Judge* (where he was associate editor in 1937) and *The New Yorker*. And he sometimes wrote for radio. In the late 1950s, Mark Evanier reports at newsfromme.com, Key worked with TV animation producer Jay Ward, creating Mr. Peabody, a time-traveling professor who was a dog, and his little boy sidekick, Sherman, featured on *Rocky and His Friends*. But Key is likely to be remembered most often as the creator of Hazel, the Marine drill sergeant of a housemaid who dominated a panel cartoon in *Saturday Evening Post*. Oddly, in Key's initial notion, the maid was incompetent and timid and wholly submissive, and in the early cartoons sold to other magazines, he depicted her as a thin, round-

shouldered and bleary-eyed woman. But Key found that the humorous possibilities in a bumbling, self-effacing maid were quickly exhausted, so he gradually evolved the character into the domineering Hazel of matronly mein, who would prove a font of material for comedy. This new creation began appearing in the *Post* Feb. 13, 1943, where, in the kitchen, turning away from a steaming pot on the stove, she addresses the man of the house: "One more thing," she says, glaring at him, "do I tell you how to sell insurance?"

Key was signed to a fiendishly restrictive contract, giving the *Post* exclusive possession of Hazel and prohibiting the character's use for endorsing commercial products. Key produced *Hazel* every week for the next 24 years, finally gaining full possession of the feature only when the *Post* ceased publication in February 1969. Whereupon, Key immediately sold the cartoon into syndication with King Features, where it has remained, stolidly, ever since. These days, King is distributing *Hazel* cartoons Key drew before he retired in 1993, according to *The New York Times*.

Despite the conditions of servitude the magazine imposed, Key was granted book and movie rights, and he almost certainly enjoyed revenue from the 1961-69 television sitcom adaptation (with Shirley Booth playing Hazel), which earned two Emmys.

— R.C. Harvey

NCS urges opposition to Orphaned Works bill

May 12: The National Cartoonists Society has issued a statement encouraging its members to voice their opposition to a new bill working its way through Congress that some worry could jeopardize the rights of artists. The Orphaned Works Act of 2008, scheduled to come before the Senate in September, would allow the Copyright Office to license rights to publish images, when no copyright has been recorded and the publisher has been unable to track down the copyright owner. It would also call for the establishment of a searchable image database. Authors, artists and photographers are not currently required to file with the Copyright Office to retain their ownership rights — they just have to prove they created the work if challenged — and that would not change under the proposed law. However, the law would place a greater burden on creators to assure that they can be reasonably tracked down. Although creators of "orphaned works" would still be entitled to "reasonable" compensation if they turn up after publication, it would be too late for them to have any control over how their work is used and in what context.

The Comics Journal
http://www.tcj.com

Publisher: Fantagraphics Books

Editor in Chief: Gary Groth

Managing Editor: Michael Dean

Art Director: Adam Grano

Scanmaster: Paul Baresh

Assistant Editor: Kristy Valenti

Online Editor: Dirk Deppey

Interns: Eric Buckler, Suzy Chen, Michael Jewell, Alexa Koenings, Benjamin Neusius, Sam Schultz

Columnists:
Bart Beaty, Tom Crippen, R. Fiore, Steven Grant, R.C. Harvey, Rich Kreiner, John Lent, Tim O'Neil, Donald Phelps, Bill Randall, Kenneth Smith

Contributing Writers:
Simon Abrams, Jack Baney, Noah Berlatsky, Bill Blackbeard, Robert Boyd, Christopher Brayshaw, Ian Brill, Gabriel Carras, Michael Catron, Gregory Cwiklik, Alan David Doane, Austin English, Ron Evry, Craig Fischer, Jared Gardner, Paul Gravett, David Groenewegen, Charles Hatfield, Jeet Heer, John F. Kelly, Megan Kelso, Tim Kreider, Chris Lanier, Bob Levin, Ana Merino, Chris Mautner, Ng Suat Tong, Jim Ottaviani, Leonard Rifas, Trina Robbins, Larry Rodman, Robert Sandiford, Seth, Bill Sherman, Whit Spurgeon, Frank Stack, Greg Stump, Matthew Surridge, Rob Vollmar, Dylan Williams, Kristian Williams, Kent Worcester

Proofreader: Rusty McGuffin

Transcriptionists: Carol Gnojewski, Kristy Valenti

Advertising: Matt Silvie

Publicity: Eric Reynolds

Circulation: Jason T. Miles

"Like a child, we get hungry and restless and wicked and wild."
— Plants and Animals

For advertising information, e-mail Matt Silvie: silvie @fantagraphics.com.

Contributions: *The Comics Journal* is always interested in receiving contributions — news and feature articles, essays, photos, cartoons and reviews. We're especially interested in taking on news correspondents and photographers in the United States and abroad. While we can't print everything we receive, we give all contributions careful consideration, and we try to reply to submissions within six weeks. Internet inquiries are preferred, but those without online access are asked to send a self-addressed stamped envelope and address all contributions and requests for Writers' and/or Editorial Guidelines to: Managing Editor, The Comics Journal, 7563 Lake City Way N.E., Seattle, WA 98115.

The Comics Journal *welcomes all comments and criticism. Send letters to Blood & Thunder, 7563 Lake City Way N.E., Seattle, WA 98115. E-Mail: tcjnews@tcj.com*

From the point of view of the NCS, the bill "will undermine key elements of your copyright protection," the organization stated in its release voicing opposition to the bill, adding that while "there are likely to be some modifications … nothing under serious consideration makes this legislation remotely acceptable."

While some artists have joined the NCS in expressing concerns about the bill, defenders have noted that, while the notion of "qualified searches" and "reasonable compensation" leave much to interpretation, the bill does not actually transfer ownership of the copyright (and as long as creators have a byline or credit that appears alongside their work, users should not be able to claim ignorance of authorship). The bill may actually be to the advantage of some creators, since the searchable database will make it easier for them to be found by publishers interested in using their work. Some creators, however, fear that the proposed law would encourage the production of catalogs full of stock "orphaned" images and works that can be safely used without compensation to creators. With access to material that is free for the taking (minus fees to the stockpilers), critics of the bill say it will discourage publishers from using more expensive copyrighted images or commissioning new material. Supporters of the bill include libraries, historians, researchers and scholars, who say it will allow for the use of images that are currently unpublishable because their origins are undetermined.

The profusion of images on the Internet has brought the issue to the fore and is especially worrisome to photographers. Despite the NCS's strong statement and the panic that has been sweeping through the cartooning community, however, it's unlikely that cartoonists and comics creators would be much affected by the bill, since comic books, cartoons and comic strips tend to have a clear copyright trail, and a searchable image database maintained by the Copyright Office would only make the trail clearer.

Will Elder dies at 86

May 14: Will Elder, the masterful and unbridled cartoonist whose work in *Mad* and elsewhere had an influence that reached far beyond the comics field, died on May 14 due to complications from Parkinson's disease. He was 86. Elder may be best remembered for his work with Harvey Kurtzman in *Mad* magazine, but the pair also collaborated for decades on *Little Annie Fanny* for *Playboy*, in addition to pieces for Kurtzman's post-*Mad* efforts like *Help!*, *Humbug*, and *Trump*. The cartoonists first met during their teenage years as members of the first class to graduate from Manhattan's High School of Music and

Art. A native of the Bronx, Elder had already met in that neighborhood another one of his future *Mad* colleagues, Al Jaffee, when they both attended the same junior high school. Elder's artistic talents were honed in part from sitting on the sidelines while his peers played sports. The unathletic youth, relegated to keeping score, found that his chalk drawings and caricatures afforded him a level of respect that he could not attain on the ball field.

By his high school years, Elder had acquired a well-deserved reputation as a prankster of the highest order. He routinely constructed elaborate hoaxes that often seemed designed to provoke a very real sense of terror and shock in those unfortunate enough to stumble into Elder's world. In one episode, Elder and a friend dumped a mound of ground beef, dressed up in little boy's clothing, onto some train tracks and began shouting that their friend had fallen into the path of the train. Another time, Elder dusted his face with white and donned a noose to surprise his classmates when they entered the room he was in. "Harvey was often in the audience watching me do my schtick in the cafeteria before I even knew him," Elder said in an interview for madmumblings.com. "believe we had a natural affinity because we were both iconoclastic." Elder added that he and Kurtzman were "alter egos" who shared an affection for each other's sense of humor and attraction to "dismantling conventions."

After graduation, Elder studied at the National Academy of Design before he was drafted to serve in the Army during WWII. Upon his return, he began looking for freelance illustration work and soon set up a studio with Kurtzman and another artist, Charles Stern. Elder illustrated some comics for the EC line, published by William Gaines, including work for titles like *Weird Fantasy*, *Frontline Combat* and *Two-Fisted Tales*. In 1952, Gaines and Kurtzman assembled the staff for the first issue of *Mad*, a group that included Elder and several other artists and writers whose work helped define the style and voice of an enterprise that revolutionized American humor and satire. Although Elder's first contribution to *Mad* — "Ganefs!," in the debut issue — was a solo piece, he began collaborating with Kurtzman, starting with the second issue. Features like "Melvin Mole" (about a prisoner who tunnels his way out of jail with a nose hair) and parodies like "Mickey Rodent" and "Starchie" quickly established Elder as a singular talent whose panels often included so much extra background detail and embedded gags that one might consider him a co-author of the comics rather than just an illustrator.

Elder followed his childhood friend out the door in 1956 when conflicts over control of the magazine led

Kurtzman to break from Gaines and *Mad* (though the pair eventually returned to do work for *Mad* in the mid-'80s). Out of the post-*Mad* era, one of the most noteworthy Elder/Kurtzman collaborations was *Help!*'s "Goodman Beaver Goes Playboy," in which the naive titular character encounters a group of delinquent and hedonistic teens bearing an uncanny resemblance to Archie and his gang from Riverdale High. A lawsuit filed and won by Archie Comics transferred the copyright away from the artists and to the company, although it eventually slipped back into the Public Domain when the publisher failed to renew it.

While some of Kurtzman's endeavors were short-lived — the Hefner-backed *Trump* lasted just two issues — he and Elder created regular installments of *Little Annie Fanny* that Elder and Kurtzman created for *Playboy* from 1962 to 1988. Elder agreed with those who considered the character of Annie to be essentially a female (and big-chested) version of Goodman Beaver, an innocent navigating a depraved world. The racy episodes were often several pages long and drawn in a detailed, painterly style that required an elaborate process. Because *Playboy* editor Hugh Hefner took such a hands-on approach to shepherding the feature through each issue, Elder and and Kurtzman often traveled to Playboy's Chicago headquarters to complete the strips. When the deadline pressures got too heavy, the pair brought in outside assistance in the form of comics all-stars like Jaffee, Jack Davis, Frank Frazetta and others — a scenario made possible by the generous wages Hefner paid his illustrators and cartoonists.

Elder was inducted into the Comic Book Hall of Fame in 2003 and his work was collected in several volumes by publishers like Dark Horse, Kitchen Sink and Fantagraphics. A compilation of *Humbug* is due out from Fantagraphics in 2008. Elder's wife, Jean, whom he married in 1948, died in 2005. He is survived by his daughter Nancy, his son Martin, his brother Irving, and two grandchildren.

An in-depth interview with Elder that appeared in 2003 in *TCJ* #254 is posted on *The Comics Journal* website at tcj.com.

Fantagraphics goes exclusive with Diamond

May 15: Fantagraphics, the leading alternative publisher that also puts out *The Comics Journal*, has signed a contract with Diamond for exclusive distribution in the North American Direct Market. Diamond is the lone option for any comics store to obtain comics from the largest publishers in the U.S. and Canada. Fantagraphics stayed independent while publishers like DC, Image and eventually Dark Horse went exclusive with Diamond, but ultimately it ended up with *de facto* exclusive Diamond distribution as other distributors fell by the wayside. Diamond bought out its last major rival, Capital City, in 1996, and after a failed attempt to distribute itself, Marvel too signed an exclusive contract in 1997. As of 2008, even tiny holdouts like FM International had gone by the wayside.

Under the terms of the exclusive agreement between Fantagraphics and Diamond, the alternative-focused distributors Bud Plant and Last Gasp will be grandfathered in as the remaining outlets for FBI material in the Direct Market.

Comics Retailer Rory Root dies

May 19: Rory Root, the Bay Area retailer who owned and operated one of the country's top comics stores, died on May 19 after falling into a coma during surgery from a ruptured hernia. Root was 50 years old. His career in the retail industry began in the 1980s, when Root dropped out of the University of California at Berkeley to manage a Bay area gaming store. Root later became an employee at the Berkeley comics store owned by Direct Market pioneer Robert Beerbohm, an experience that helped provide a foundation for the opening of Comics Relief in the spring of 1987 with business partner Michael Patchen.

Over the course of the next decade, the shop blossomed into what many described as the ideal comics store: an inviting space that accommodated both hardcore fans and curious newcomers, stocked with a wide range of material that spanned many different genres, countries and eras, and staffed by helpful and knowledgeable employees. Root was a passionate reader who made a point of filling his shelves with material that interested him, rather than just focusing on the highest-selling comics; in doing so he created a store that was ahead if its in time. Numerous cartoonists in the Bay Area scene (and beyond) found Root to be a tireless advocate for their work, in addition to being an articulate voice in behalf of literary and well-crafted comics. And many upcoming artists sold far more copies of their self-published efforts through his store than in other outlets, as Root gave minicomics prominent shelf space and often paid creators outright for their wares rather than merely carrying such low-profit items on consignment.

Root's shop was and is considered to be one of the best comics stores in the country, a perspective made clear in 1993 when Comics Relief was one of the first recipients of the Will Eisner Spirit of Retailing Award. Root also regularly hosted signings and other events at his store and

was a regular and distinctive sight on the convention circuit — usually clad in black, wearing a wide-brimmed hat, carrying a thermos full of coffee and often in the thick of a conversation whether he was touring the floor, selling books or taking a cigarette break.

While it was no secret that Root had experienced health problems in recent years, the news of his death came as a shock to those in the industry who had grown accustomed to his gregarious, enthusiastic presence. The flood of tributes and remembrances that were posted online after the news of his death provided strong testimony to just how much Root was liked and respected for his work and friendship. Comics Relief, located since 2005 on Shattuck Avenue in Berkeley, will remain open for business, reportedly under the stewardship of the store's manager, Todd Martinez. Root is survived by his mother, two brothers and a sister.

Redeye's Mel Casson dies
May 21: Mel Casson, the illustrator and cartoonist who spent several years working on the strip feature *Redeye*, died on May 21 at the age of 88. Casson was born in Boston and studied at the Art Students League in New York. Service in WWII and Korea interrupted his career, which saw him contributing work to magazines like *Esquire* and the *Saturday Evening Post* and working on features like *Mixed Singles*, *Jeff Crockett* and *It's Me Dilly* for newspapers. Casson began working as the artist on *Redeye* in 1990 and took over the feature entirely following the death of writer Bill Yates.

Cartoonists lose posts in Florida and Massachusetts; Telnaes leaves print syndication
May 21: Two editorial cartoonists have been laid off from their staff positions at daily newspapers in Florida and Massachusetts. Jake Fuller, the cartoonist for the *The Gainesville Sun*, and Dave Granlund, who drew cartoons for the *MetroWest Daily News* in Framington, Mass. The latter artist had been with the paper for more than three decades, while Fuller had been working with the *Sun* for about 15 years. They join the growing ranks of cartoonists displaced by layoffs and buyouts in the news industry as daily papers attempt to deal with declining circulation. *Editor & Publisher* placed the number of full-time, staff editorial cartoonists at around 85, down from 200 in the 1980s.

In another development in the field, cartoonist Ann Telnaes, a former Pulitzer winner, will no longer create cartoons for syndication in print as she instead focuses on her animation work for *The Washington Post*'s website. *E&P* reported that the artist is not abandoning print

entirely, as she will continue to draw on a freelance basis for publications like the *Guardian* in addition to her weekly contributions to *Women's eNews*. Many editorial cartoonists these days are working as both animators and illustrators as papers seek ways to drive up their online readerships.

Jaffee wins Reuben
May 24: Al Jaffee, the longtime *Mad* great best known for features like the recurring "fold-in" that appears on the inside back cover of the magazine, won the top prize at this year's Reuben awards. See R.C. Harvey's *Comicopia* column in this issue for a full report.

Creators Syndicate buys Copley News Service
May 29: Creators Syndicate has purchased Copley News Service, another distributor of comics and other content to newspapers, in a move that will likely lead to layoffs of some or even most of the employees who worked at CNS. A report in *E&P* stated that the Copley employees had been offered buyouts and that some of them would be making the transition to the new entity known as Creators News Service. Among those likely to stay on is the editor and CNS Vice-President Glenda Winters; *E&P* stated that she would be remaining in a consultant role with an emphasis on working with the cartoonists in the Copley stable. Cartoonists distributed by Copley include Michael Ramirez, Steve Breen and Scott Stantis.

Cartoons cited in attack on Danish Embassy in Pakistan
June 2: A suicide bomber drove a car into the Danish Embassy in Islamabad, Pakistan, killing six people and causing significant damage to structures in the neighborhood. In the days following the attack, an message was posted online attributing the action to the terrorist group al-Qaida in response to the publication and re-publication of the infamous *Jyllands-Posten* cartoons that depicted Muhammad. The images continue to spark controversy around the world, with some groups urging a boycott of Danish products, and others staging protests.

Tokypop splits in two
June 3: Tokyopop, one of the largest publishers of English-language manga, announced in June that it would be splitting into two companies and cutting back the number of titles it releases by about 50 percent. A report from ICv2.com stated that 39 staffers would be laid off in the transition from one entity in two (one for print publications and another for film and digital properties). ∎

COMICS REVUE

Manuscript Press, PO Box 336, Mountain Home TN 37684 f.norwood@att.net www.io.com/~norwoodr

[] Please send a sample copy of Comics Revue : $9
[] Please send 12 issues of Comics Revue : $45 ($80 outside the US, sent airmail)
[] Please send 25 issues of Comics Revue : $90 ($160 outside the US, sent airmail)
[] Please send Buz Sawyer -- Sultry's Tiger : $ 30 ($35 outside the US, sent airmail)
[] Please send Flash Gordon -- Star Over Atlantis: $30 ($35 outside the US, sent airmail)

[] Please send Prince Valiant -- An American Epic Vol 1 [], 2 [], 3 []: $150 each ($180 outside the US sent airmail)
[] Please send Hal Foster's last Prince Valiant page, full page size print, $19 each ($24 outside the US)
[] Please send 2 Modesty Blaise: *The Double Agent* and *The Galley Slaves* : $ 20 ($29 outside US)

Your name _____
Your address _____
City/State/Zip _____

Full color Russ Manning Tarzan in every issue.
Full color Casey Ruggles by Warren Tufts in every issue.

We accept paypal! Go to www.paypal.com and
make payment to f.norwood@att.net. Or pay by
credit card at our web page: www.io.com/~norwoodr

You Are No
DEITCH

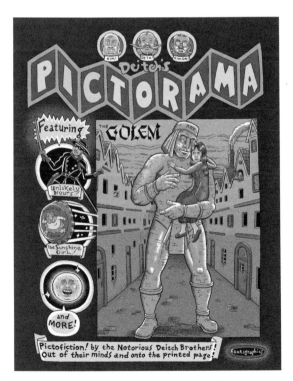

Cover to *Deitch's Pictorama*, published by Fantagraphics Books (publisher of the *Journal*), which includes work from Kim, Seth and Simon, with an introduction by Gene. Art by Kim Deitch [© 2008 Kim Deitch]

Last year, I had lunch in New York with Gene Deitch and two of his sons — Kim and Simon. The dynamic I witnessed among father and sons was, not to put too fine a point on it, fascinating and complicated.

Kim Deitch has been drawing comics for 40 years, and he's done his best work in the last 10 of those 40 years. The same cannot be said about the careers of most cartoonists, or of many artists generally. There is often a slackening of creative powers after so many years of hard-at-it work, but Kim seems to just be hitting his stride. In the event, I thought it was a propitious time to interview him, but since we'd already published an interview with him, I thought we should give it a twist, and watching Kim and Simon interact with their father over lunch crystallized the idea: Interview two generations of four creative members of the same family. I didn't realize that the interviews taken together would have the additional, serendipitous virtue of reading like a Kim Deitch story; clearly, I didn't know what I'd gotten myself into.

Gene Deitch was born in 1924 in Chicago. His ambition, from an early age, was to be an animator or a comic-strip artist; by 1955, he was both. He started working at UPA (United Productions of America), founded by the animation pioneer John Hubley, which became known for its graphically sophisticated, stylistically modernist approach to animation. His comic strip, *Terr'ble Thompson*, lasted a mere six months from October 1955 to April

w Entering
WORLD

1946. He went on to work at Jam Handy in Detroit, which Deitch has described as "virtually an adjunct to mighty General Motors" and produced largely industrial films before he became Creative Art Director at UPA in New York. In 1960, he divorced his wife, said goodbye to his three children and moved to Prague, where he had taken a job at an animation studio called Rembrandt Films and, incidentally, fallen in love with the woman to whom he is still married.

Kim, the eldest of the Deitch children, born in 1946, grew up watching his dad draw his comic strip and visiting the animation studios his dad worked at. He began drawing comics for *The East Village Other* in 1967 and was generally sucked into the underground comix movement, first in New York, then in San Francisco. He was not a prodigy; drawing did not come easily to him. He worked hard at it, fueled by his passion for telling stories, and gradually mastered the form. The books he's written and drawn over the last decade — *Boulevard of Broken Dreams*, *Shadowland* and *Alias the Cat* — represent his best work, paradigmatic Deitch with generational stories and a kaleidoscopic perspective of his characters.

Simon was, evidently, something of a prodigy in terms of drawing, but his focus was less prodigious than his skill; he was peripherally involved in underground comics, wrote and drew a handful of stories, but didn't stick to it as his bother Kim did. Recently, he's enjoyed a bit of a flowering, his drawing appearing regularly in the excellent fanzine *Mineshaft* and collaborating with his other brother Seth in the brand-spanking-new book, *Deitch's Pictorama*.

Seth Kallen Deitch was considerably younger than both his brothers and didn't get to truly know them — or his dad — until he was older. Although he drew and painted, he didn't have a gift for cartooning and did not create comics. His creative outlet between 1983 and 1991 was a fanzine he published called *Get Stupid*, in which he published a variety of prose and comics. He truly felt his calling to be a writer in the early '90s and has since written several novels and short stories, two of which can be read in *Deitch's Pictorama*, illustrated by Kim.

I did not realize, when I began this, just how long and productive their careers have been. (Seth and Simon's erratic creative output is made up for by the sheer tumult of their life stories.) Kim is truly the been-there, done-that guy, seemingly at the center of the underground movement. In fact, there is so much to Kim that we couldn't fit it all in here; if you want to read an explication of his creative process from idea to finished work, among many other things, go to our website at tcj.com where you can access 20,000 more words. You won't be disappointed. But before you do that, enjoy the following 120,000 words of Gene, Kim, Seth and Simon.

— Gary Groth

FEBRUARY 1949 35c

the record changer

jazz news

bebop

The Gene Deitch Interview
Conducted by Gary Groth

GARY GROTH:
You were born in Chicago, but you were raised in Hollywood.

GENE DEITCH:
Mostly in Hollywood, yes: Venice, Hollywood, Los Angeles, West Hollywood and Van Nuys. We jumped all over the place. People were always moving in those days.

I think you moved to the L.A. area [from Chicago] at the age of 4?
That's probably about right. I went to the Eugene Fields grammar school. It was still old times, with horse-drawn vegetable wagons, organ grinders with monkeys: the whole period-movie schtick. We went back to Chicago exactly when they were having the World's Fair which was called "A Century of Progress"; I remember it was one of the big things in my life when my family took me to that fair.

You would have been 9 years old.
I think it was 1934, when I was 10 years old. For family reasons I don't recall, we left Hollywood at that time and drove all the way to Chicago. I remember the long cross-country journey by car. We didn't stay there more than a couple of years, and then we went back to L.A. and then I lived there straight until 1949, when I moved to Detroit.

May I ask what your parents did?
My mother was a rich girl. My grandfather had a large knitting mill company in Chicago and they had a fleet of trucks, I was just looking through some old photographs and they were one of the early companies that had gasoline trucks, up through the middle-'20s. And he's one of the people who lost everything in 1929. But my mother was raised pretty much as a rich girl. She wasn't used to doing any kind of work except helping out with my grandfather's company store, just sort of fiddling around.

My father was basically a salesman. He was very handsome; looked like Cesar Romero, and was an elegant dresser. When I was born they still had money but by 1929 everybody lost everything. My father was a traveling salesman and did whatever he could get. He ended up doing well with his own insurance agency in San Francisco. He had an office on Sutter Street. But in my early days it was, of course in the Depression, exactly the time I was raised. Things were pretty crummy then for us.

Do you know why your family moved to the L.A.

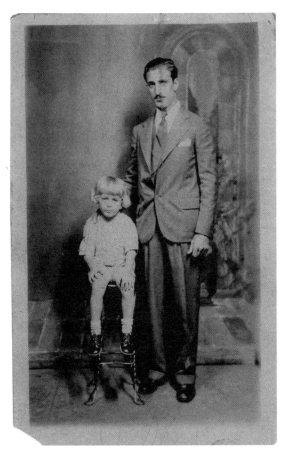

Gene Deitch and his father: courtesy of Gene Deitch.

area?
I think it was always in the search of work. I don't think we had any relatives there. My mother was one of four children and the other three were brothers, so she had three brothers, and they weren't doing too badly. When we went to California, we lived in the house of one of the older brothers, and he had a ladies' dress shop on Hollywood Boulevard, so he managed to do pretty well. But we were always living with somebody else. There wasn't really enough money in my immediate family to have our own place.

I know as a kid you read comic strips and that *Popeye* and *Mickey Mouse* were among your favorites.
Yeah. I was interested in drawing comics almost in the beginning. I don't know if you know this — the most famous story about me my mother told me that is supposed to be absolutely true: when I was a baby, still in Chicago, barely able to stand up in the baby bed at that age, my mother came into my room and sniffed a ter-

rible smell and she saw that I had dipped my left hand in to my diaper and with the material thus procured, I was drawing on the wall with it, with my left hand. My mother told me that at that moment she found I was left-handed and an artist! That was the very beginning of my artistic career.

As I grew up, I developed really early not only an interest in drawing but all kinds of technical gadgets and I got into the idea of putting out newspapers. I discovered something called a hectograph. You're in the printing business, so you must know about some of the early technologies for reproducing. You could go to a stationary store and you bought a can of this hectograph gelatin and you heat it in the oven and pour it out, let's say into a pie pan. Do you know what I'm talking about?

Yeah, wasn't that a precursor to ditto?

It was really a precursor of ditto! This gelatin, when it set, you wet it with a sponge and then you laid a sheet of paper on top of it upon which you had drawn with what was called an indelible pencil; you remember indelible pencils?

Sure.

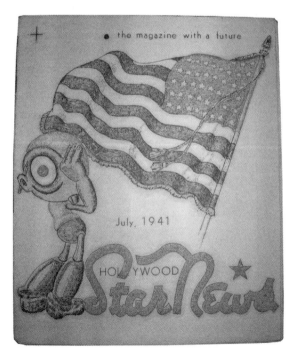

A sample of Gene Deitch's childhood newspaper: courtesy of Gene Deitch. [©2008 Gene Deitch]

It would turn purple if you put them on your tongue or something wet. With an indelible pencil you could draw on there, and later there was indelible carbon paper and indelible typewriter ribbons, and I was able to gradually put this all together. I was 8 years old. We were still in Hollywood then. We hadn't gone back to Chicago. It was 1932, and we lived in an apartment house in Hollywood called the Somerset Arms Apartments on a street called Cheremoya.

It was a big apartment house, and I got the idea that I was going to make the apartment-house newspaper. My dad helped me with the typing and I drew the pictures and all with an indelible pencil. And when you got that all onto the sheet of paper, you used a sponge to wet the surface of the gelatin, you smoothed the paper on top of it, let it sit for one minute, peeled it off, and then very quickly lay onto it one sheet of paper after another and you'd get the printed image. It gradually sank in to the gelatin, so by the time you had 50 copies it was then almost too faint to read. That was the first reproduction technology that I was able to do. I was very proud of the fact that I made this newspaper, then I would go through the halls of this apartment house and slip my little newspaper under the doors. It was called *The Somerset Scandals* — that was my father's idea to give it that name, because the name of the apartment house was the Somerset Arms Apartment. That newspaper started me on that career, and during my whole boyhood, I was putting out newspapers.

I saw *King Kong* at the neighborhood Marcal movie theater during that time, in its initial run. Scared the hell out of me, but of course, had a great influence. We stayed at the Somerset Arms until I was 13 and my parents were divorced.

When I outgrew the hectograph, I learned how to use a mimeograph, which was much more complex, and gradually I got together with another kid, Louis Desser, and we produced an actual, monthly magazine which went up to my age of 16. We called it *The Hollywood Star News*. We printed all of the press releases that were sent out to newspapers, which no real newspaper would bother to print, but we printed everything. You know about mimeographs?

Oh, absolutely. That would have been a technological step up from hectograph.

Oh, it was a big technological step. Especially when we learned how to do multicolor stuff… This kid and I (Louis Desser later became a section editor of the *Los Angeles Times*), because we actually made money with the newspaper, we were able to buy a mimeograph made by

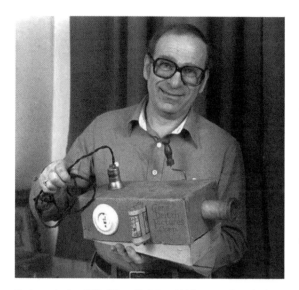

Photograph circa 1979 of Gene Deitch and his homemade projector: courtesy of Gene Deitch.

the A.B. Dick company, which was the main company which produced mimeographs, and that one had registering pins. That was a fantastic upgrade for us. With registering pins we were able, with a lot of careful figuring, to actually make images that looked like full color.

Gene, where did your interest in publishing a newspaper or in newspapers in general come from?

Naturally, I was looking at the newspapers every day, even as a kid reading the comics, and that was something I wanted to do. That was my original ambition, to be a comic-strip artist, and also a magazine writer, and it kept with me all the time until I finally was able to do it.

But at the same time, I was interested in the cartoon movies, of course. I was starting to see the cartoon movies as a small kid, and I was yearning every year for Christmas to be able to get a 16mm projector, which was too expensive for my parents to buy for me. So I made a projector out of a shoe box. This was not a completely unknown thing, I think I read about it in *Popular Mechanics Magazine* or something, but what I did was I took a shoe box, cut a hole in the top in which to insert a light bulb, put an ordinary cosmetic mirror in the back of the shoebox, and then a toilet paper tube you stuck in the front and a magnifying glass glued on to the front of that, and then with careful grooves in the side and using what was called onion-skin paper, you could slide this paper through and actually project it onto the wall. I would hang one of my mother's bed sheets on the wall, use that as a screen, and I

was able to make cartoon slides. That became even more fascinating to me than the newspaper idea because movie cartoons during my childhood were really coming into their own in the '30s. *Mickey Mouse* and all the great cartoons were actually being produced then.

With this makeshift projector you weren't able to make animated cartoons?

No, because getting a real 16mm projector, which I think cost something like $8.95 then, even a hand-crank projector was still much too expensive for my parents. So when my mother took me downtown once, I saw a projector — and I'm looking at it right now because I managed to get it again. It's a green, baked-enamel projector; it has two lenses on the front. By moving through it a wide strip of paper with two position drawings drawn on the top and bottom areas of this strip of paper, and by turning the crank, it alternately opened and closed the upper and lower lens. I don't know if you ever saw this kind of a projector?

No.

It had a decal on the side of it and it had a picture of Rudyard Kipling's *Kim* on it. You probably already know the end of the story. When we had our first son, I named him after this toy projector. This was my "Rosebud."

Is that right?

It's absolutely true. I have this projector right here and I'm looking at it now in my home-theater room in our apartment. I was talking about this projector for years and wondering whatever happened to it, and one of my friends actually had this projector and he sent it to me. Whether it's the exact one I had when I was a kid, I don't

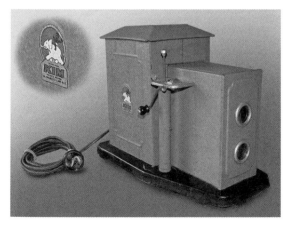

The eponymous projector: courtesy of Gene Deitch.

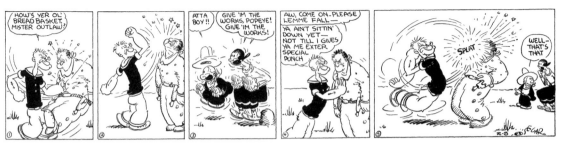

Segar's Feb. 4, 1931 *Popeye* strip. [©2007 King Features, Inc.]

know, but it's exactly the same. This was really something that meant a tremendous amount to me. I was able to do two-position animation with it. You could draw a character with his legs apart and his legs together and as you turned this crank when it opened the upper and lower lenses it would give a simplified animation effect. Later, I did get a 16mm projector and of course it just went on from that.

My whole life has been a series of upgraded technical gadgets. Right now I have a big 24-inch iMac computer. I had the first tape machine that came on the market after the war and before that I had a disc recorder. My life is really just split between technology and art. That's why I got into what I'm doing. Animation and filmmaking is just about equal parts technology and art, along with the storytelling.

What animated cartoons were you watching in the '30s?

When I first got the little 16mm projector, you could buy little short film loops at the five-and-dime and drugstores and places like that. I think it was a short bit from Mickey Mouse's "Steamboat Willie," the earliest Mickey Mouse cartoon, was I think the first one I got. Of course, I loved *Popeye* from the very beginning. You've been putting them out yourself, Gary. Those were among my favorites — I still love to look through all the stories. I was following the daily and Sunday *Popeye* comic strips in *The Los Angeles Examiner*, which was a Hearst newspaper and that had the King Features comics. I was following *Popeye* all the time. Not really from the very beginning, but almost.

I understand that, with the encouragement of an art teacher at Venice Junior High School, you made your first animated cartoon at age 13.

Yeah, this guy was named Sterret. Venice Junior High School was really a great place. It was just like a plain concrete-type building, but what made it stand out was that it had a statue of naked Myrna Loy in front of the

school, and this guy — I think his name was Sterret — was the sculptor that made that statue. She was a student there. Sterret used her as a model.

That sounds like a great junior high school!

[Laughs.] It really was a great junior high school. Those were my best school years.

Myrna Loy went to that high school?

Yeah. Her original name was Myrna Williams. She went to that high school and she was definitely the model for this statue. I'm told that it's still there. I think it's actually Venice High School, the junior high school and high school all in one. But I only went there during the junior-high-school years. I went to L.A. High when we moved back to the middle of the city. But that was in Venice, Calif., and it was really an interesting place. There was this really great art class and one day some people from the Disney Studios came and they presumably had the idea of developing talent. They gave us some basic equipment, punched paper and pegs, and gave us a little course in the basics of how to make an animated cartoon. One girl and myself were chosen to be the creators of two cartoons. And naturally the girl made something with lots of flowers and butterflies and I created a character named Pol Parrot. My story was Pol Parrot going to the Moon. So it had to be, naturally, something technical and science fiction. And the big joke in my cartoon was the parrot got in the rocket ship and zoomed up to the moon and when he got to the moon there was a sign there that said "Los Angeles City Limits." *[Groth laughs.]* And that was my first really great film joke.

Anticipating urban sprawl.

Exactly. Even in those days, I'm talking now about the mid-'30s, it was a big joke about how big Los Angeles was and the Los Angeles city limits were far away. So the Disney people then came and they took this artwork and they produced a little film and they brought it back and it

was projected in the school auditorium and this girl and I were stars for a day.

During your teen years, it sounds like you had a creatively vital childhood and upbringing.

I was pretty much encouraged by my mother. My father thought I was completely wasting time. His interests were business. He had no artistic pretensions or interests whatever. It's amazing about how this came out. My mother's side of the family were Delsons. The Delson family, according to everything I ever heard in my childhood, were all full of geniuses, so I was told. "There were poets and singers and musicians and writers and professors, but the Deitch side basically came from a line of horse thieves." *[Groth laughs.]* That was pretty much the propaganda I got, finally leading up to the fact that my parents got divorced when I was 13 years old. My mother definitely did encourage me in art, because I did have the ability to draw. I was never discouraged in that, even though it seemed like an almost impossible career to get into.

I always tell people now who I don't know how to get started, I say that in everyone's life, at one time or another, a door opens, but you have to be ready to walk into it. So I spent all my time drawing, I had lots of samples and when the door did open for me, just by the merest chance, I was able to convince the person that was going to hire me that I could do it, and that's it. Once you get in, then you can prove yourself and become successful at it; then, of course, there's no stopping you. It's always just getting through that first door.

You had no siblings?

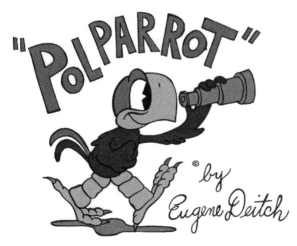

Courtesy of Gene Deitch.

I'm the oldest of three sons. My middle brother was Jim and my younger brother, Donald. My middle brother, Jim, is dead. He, unfortunately, became a lifelong smoker and also drinker and he died of lung cancer. Terrible tragedy. My younger brother has had many illnesses, but he's still OK. I'm not only the eldest, but the luckiest one, obviously. I'm going to be 84 in August and knock on wood, I'm still basically OK, as far as I know. And if I'm not OK, I don't want to know about it. I'm working every day, I'm still making things. I just delivered two new films.

Were you close to your brothers when you were growing up?

Yes. My middle brother Jim and I were only three years apart and we were quite close, all the way until the time he died. We had very similar interests. He became a writer and became a newspaper editor. He was the editor of the *Las Vegas Sun* and became quite a big journalist in Las Vegas and eventually had quite a few businesses there. We were communicating in those days by telefax — that was before e-mail — almost every day, and we had projects together. We had a lot of stuff in common. My younger brother Donald, though, was seven years younger than Jim, so he was pretty much the baby. Jim and I mainly spent our childhood torturing him. He's also quite creative but he went in to the real-estate business. He had pretensions of being a writer. He did a lot of interesting things in his time.

You made your first animated cartoon at the age of 13. What did you do subsequent to that. What was your creative activity like?

By the time I graduated, of course, the war had come. And when I graduated from Los Angeles High School in the summer of '42, we were right in the war. What was happening then, because the war was on and we were getting close to graduation, different recruiters would come to the school to offer job opportunities, because in those days with the war on and the war plants going, there was no problem about getting a job; it was only a question of the right kind of job. Some people came from Frank Wiggins Art School and said there was a great opportunity to do industrial drawing or parts catalog drawing in the aircraft factories. You had to learn perspective, how to draw ellipses, how to render mechanical parts. So I took this course, and it was a great way to also keep out of the Army for a while.

So I went to work at North American Aviation and went into the Parts Catalog Department. I became really very good at this and it stood me in great stead, because

1938 Box Brownie shots of 14-year-old Gene Deitch, taken by his brother Jim: courtesy of Gene Deitch.

not only did I know how to draw cartoons and figures and things, but learning the technology of how to draw mechanical parts, how to render metal so it looked like metal and how to do stippling.

So you acquired an invaluable technical skill doing all this?

Exactly. All of these things come together when you get into filmmaking because it is, as I said before, 50 percent technology. So, in this work, I got a feeling for technology and a great love of doing this and being able to draw in perspective and do faithful rendering of objects and so on. I use many of those skills doing layouts for my films.

How long did you work for them?

I worked for North American Aviation until I was drafted. In 1943, I was actually drafted. So it was only about a year. It was very enjoyable. But out of that, I met my first wife. When I mentioned before that I was checking out blueprints, she was the girl in charge of the blueprint department. And how things came together — very quickly, without going into a whole romantic story — in those days you had gasoline tickets. In order to buy gasoline, you had to have a sticker on the windshield of your car. An "A" sticker gave you a right to buy more gallons of gasoline. In order to get this, you had to take at least one person to work. You had what they called carpools. So when I met this girl, she became my carpool. And that's how that happened.

The old carpool ploy.

Exactly. And then I was drafted, and by that time, Kim was conceived. He was born in 1944, May 21st, one day before I was discharged from the Army.

You were drafted in '43?

'43, right, and already a child was on the way, so it was a pretty desperate situation.

Did you get married before…?

Yeah. I was in a terrible place. It was called Muskogee, Okla. In those days, it was Jim Crow country and it was really terrible.

They have a huge military base there, right?

Yeah, and the name of the base was Camp Gruber *[laughter]*. What could be worse than being in a place called Camp Gruber in Muskogee, Okla.? One day I saw on a bulletin board that there were some tests being made for the Air Force. In those days it was the Army Air Corp. I took the test and I managed to pass. I was one of the few people that passed all the psycho-motor tests and whatever else they threw at us, and I was then transferred to Washington State, not so far from where you are. I went to Washington State University in Pullman, Wash., and that was my first experience with snow that I could re-

HYDRAULIC BRAKE CONTROL VALVE — VICKERS

One of Gene Deitch's parts catalog drawings, circa 1942: courtesy of Gene Deitch.

member. That was really very interesting. There I became an air cadet, and I was going to be trained to be either a bombardier or a pilot or a navigator. Those were the three things you could get. That was my one and only university training. So I was there going to Washington State University and that was a great boon. I learned a lot. One of the great things about Washington State University in those days was that they had, and I discovered it almost by accident, a tremendous newspaper archive way down in some cellar. They had bound copies of all major American newspapers. Every minute I could get away, I was down there turning these books, page after page of the Sundays and the daily comic strips, going all the way back to the beginning of the 20th century. Going back to the original *Katzenjammer Kids* and everything. That's where I really further developed and intensified my interest in comic strips. I followed the comic strips looking at the original yellowed newspapers. I can never forget the fantastic smell — You know how old newspapers smell? Huge bound books. With that was I was able to follow the development of comic strips. I saw comic strips such as *Blondie* from the very first day and followed them all the way through. That was really great.

It sounds like all of this is happening in a very short time but there was so much going on. What happened there, after just six months, and before I even got close to an airplane, in early 1944, they marched us all out, all the students in this university, on to the field and they read a notice to us that the whole program was being dissolved, that they had more pilots and navigators then they needed. In 1944, even by that time, they already saw the war winding down. So that was a very desperate, terrible shock and terrible disappointment and I was going to be sent back to the infantry. I guess by luck or whatever, being in the snow and winter of Washington state, I caught pneumonia and I was in the university hospital with pneumonia. Whereas everybody else was sent back to the infantry, I got a discharge. It was a miracle. I got back to Marie's bedside when Kim was one day old.

So I found myself out of the Army in 1944 while the war was still on and there were no other men around, and in those days all you had to do was just stand on the street corner and look dumb, and somebody would hire you. So I had the golden opportunity there of being able to get into jobs as a commercial artist. I had no contacts whatever. With my new wife, Marie, we went to the Los Angeles telephone book, and I made a little file card for every place that was listed as an art agency. I took my hand-drawn samples — I had nothing yet published — and I went to downtown L.A. and went from one address to another, of

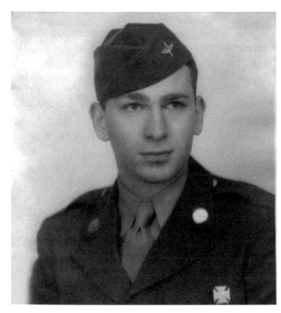

Gene Deitch as an air cadet, circa 1944: courtesy of Gene Deitch.

There I learned another technology, which was print. So I learned, working with Jim Cantwell, direct mail. They use a lot of direct mail, advertising their shows. This was before television; just radio. Frank Sinatra had a weekly show, as did Jack Benny. I was able to go in and watch these shows. The main thing I learned was typography and cutting and pasting. I was able to learn all these different things and it was exactly at that time that I started drawing the Cat cartoons.

Did your wife share your passion for the arts?

She was not an artist, but she did share my passion for jazz. That was one of the things that brought us together and kept us together for a long time. We collected jazz records together.

I understand you were a jazz fan since the age of 15.

Yeah. That was when I was still living with my mother, of course. Jazz, at that time, meant to me Benny Goodman. I hadn't gotten very much beyond the swing bands. I always had some kind of a record player, however primitive. I would play my records really loudly, and my mother was convinced that I was deaf. But that was the way you did it. At maximum volume, attempting to emulate the sound of a big band, but of course with a primitive

course always getting refused. Even though they needed people, I was just too young and had no experience.

I was really very glum and when I was walking back to where we lived down Sunset Boulevard. I looked up and saw the brand new CBS Radio building, which was, at that time, one of the most advanced architectural buildings in Hollywood. CBS always had a great graphic tradition, and I said, "My God, there's the place to work." I had no contact, no previous telephone calls, nothing, but I had learned from my other experiences how to get into places. Of course, you never ask anybody anything. You just look straight ahead and walk like you belong there. So I took this same ploy and I walked into this radio-station building. In those days, Jack Benny was broadcasting from there. I walked in there and immediately went in to the elevator to get out of the lobby as fast as possible. Once I got up on the upper floor I asked someone where the art department was and I had my folder under my arm so they pointed it out to me. There was a man named James Cantwell, a really nice guy, who was the art director of this Hollywood headquarters of CBS Radio. I showed him my stuff and he hired me, just like that, asking me only one question: "Are you married?" When he heard that I was not only married, but also had a kid, that was all he needed to know, assuming that I would thus be responsible and not be a person who would konk out on him after being trained. That was really big luck and a crucial step for me.

"Gad, Darling! We two could make such beautiful improvised ensemble together!"

A Cat cartoon from the February 1948 issue of *The Record Changer.*
[©2003 Gene Deitch]

record player with much distortion!

Going backward from Benny Goodman I discovered Bob Crosby and his "Bobcats" (pseudo-Dixieland), and I finally stumbled into the Jazzman Record Shop and met Marili Morden and Nesuhi Ertegun, who were big factotums of jazz music, and they said, "No, that's not Real Jazz," and Marili brought out a King Oliver record. I started to learn all about the snobbism of jazz collectors, and naturally being a cartoonist and liking funny stuff, I picked up a copy of the *Record Changer* magazine in this Jazzman Record shop and I saw that this was a pretty dry-looking magazine with nothing but classified ads for buying, selling and trading records, and I thought, "what this magazine needs is some funny cartoons."

So I made this character and sent some cartoons to the editor. His name was Gordon Gullickson. He came up with the name The Cat, after the first couple of issues he said that was going to be the name of the character, so that was fine with me.

And I assume that was derived from a "cool cat"?

Yeah, it was an expression that Louie Armstrong used a lot.

So you started contributing drawings to *The Record Changer*?

Yeah, and that was what got me back in to the animation. Collecting jazz records was a real endeavor in those days, because you could barely buy jazz records in a normal record shop. So buying and selling and trading records, and finding them in attics and junk piles, or in Black neighborhoods was the way you accumulated real jazz records. Most of the historic jazz records that are now reissued on CDs, lots of them came from these obscure sources.

So I sent in my cartoons, and because most of the people who were in animation and the arts were exactly the kind of people who were jazz record collectors, it turned out that practically all the leading, core guys at the UPA studio in Hollywood were readers of *The Record Changer*.

Bill Bernal was a screenwriter at that time and he was working on a project for UPA Studios. He placed a record ad. When I knocked on his door and I said, "I'd like to get that Jellyroll Morton record from you," he said, "Are you the same Gene Deitch that draws the cartoons in *The Record Changer*? I know some guys who are actually looking for you." To make a long story short, the person I was assigned to assist, when I got the temporary job at UPA, was Bill Hurtz, who was the production designer at UPA. He happened to also be the president of the Cartoonist

"That's mighty kind of you, young man, to offer to clean out my attic!"

From the October 1947 issue of *The Record Changer*. [©2003 Gene Deitch]

Union! Through his pull, he managed to get an exception for me, and I was able to get into the union, and thus went from temporary to full-time employee at UPA, and that was the beginning of my animation career.

It was in June 1946. You can see how things were happening to me very quickly.

Let me skip back a little bit. You acquired an awful lot of technical skill, you learned typography and graphic design at CBS. How were you developing your drawing, who was influencing you, and how did you reach the level of drawing you did when you started doing the *Record Changer* material?

I think William Steig was the first real inspiration for me of wild and crazy caricature. William Steig, who was the creator of Shrek and did all those cartoons for *The New Yorker* for years, [but] in his spare time he did real wild and crazy abstract figures. He put out a book that was called *Persistent Faces*. A book by William Steig that was full of extreme caricatured faces. If you look at them, you will really see what got me inspired into the kind of abstract drawings that I was doing for *The Record Changer*. Then Steinberg. Many, many people were influenced by Steinberg and I was one of them. Then, of course, I came under the influence immediately of people like John Hubley, who was the main creative director of UPA.

How about Jim Flora?

How could I forget him? Jim Flora was even earlier. Jim Flora was working also for CBS at the time I was. He was doing those monthly little bulletins about Columbia Records Releases. I must not skip over him. I was basically

first influenced by Jim Flora, because I was going into record stores, and discovered his stuff. And then, when I got the job at CBS, there I was, actually working at the same company that he was contributing to. He was doing all LP album covers for Columbia Records before it was called CBS Records. He was my great influence and of course we later became great friends. I made quite a few films with his work. For Weston Woods I made "Leopold, The See-Through Crumb Picker," which I adapted from his book, and for Terrytoons I did "The Fabulous Fireworks Family." We did quite a few projects together. We became very close friends. It was another devastating death for me. Jim Flora was truly a great guy. He was spectacular. A most original, unique artist. He was definitely my primary influence. My first *Record Changer* cover, if you look at the very first one, the crazy profile on the December 1945 cover, that was pure imitation Jim Flora, and there was much else, but no one, certainly not I, who could come anywhere close to his amazing inventiveness.

Naturally, I moved away from the attempt. I kept his influences and I still use a lot of his design elements whenever I have a chance. What I'm doing now, adapting children's picture books, I have to follow the style of each book that I'm doing, so my artwork now is all over the

Deitch's first cover for *The Record Changer*. [©2003 Gene Deitch]

lot. I sort of pride myself that I don't have a "Gene Deitch style." I'm able to adapt myself to anybody's style.

You're a chameleon.

That's part of doing film work.

It seems like your influences were all over the place. One of your early *Record Changer* covers was an homage to Salvador Dali, for instance.

Yeah. That was fun. That was when I was just basically doing that "Who am I going to do this week?" I even imitated Braque. There's one towards the end that's right out of the Braque-Picasso type of cubism. I was following all the graphic designers. At one time or another, I was trying the elements of all of them. There was a Steinberg cover.

Were you familiar with UPA?

No, I had never heard of it at all. Actually, it was a brand-new studio. I'm talking about 1946. When I came into UPA it was exactly at the moment that Dave Hilberman and Zach Schwartz were going out. UPA was a political hotbed. It's a great romantic tradition, but not everything about it was great. There were definitely inside battles going on. For reasons which I didn't really understand at the time, Dave and Zach left the studio and Steve Bosustow took over. Steve Bosustow later got all the credit for UPA, but he was never one of the creative people there. He was an in-betweener or an assistant animator at Disney and mainly he was a political leftist. He was one of the people who was marching in front of the Disney Studio in the 1941 strike. He also had some money and was able to help in financing the studio at the beginning and he became the president of the studio and eventually got the credit.

The real creative leader of UPA was John Hubley and people like Phil Eastman in writing, and even Chuck Jones. He did one of the early films for them, and Art Babbitt. All the best animators came over, and more or less moonlighted at UPA, helping to develop the basic concept that UPA had. Many people in those days wrote articles about UPA, saying they invented "limited animation." That was a lot of baloney because limited animation was simply because there was limited money! What UPA did invent was the idea that the whole world of graphic art could be animated. That's what made the studio unique. They didn't have a house style. Every kind of art, they thought, could be adapted and made into an animated film. I think UPA was definitely the first studio, certainly in America, to do it.

My understanding is that John Hubley took you under his wing.

Yeah, I immediately became his protégé. They said amazing things to me as a young, naïve guy. They said, "Gene, we're going to make you into the first true UPA director." Well they said that because all of them came from Disney or they came from Warner Brothers. Robert "Bobe" Cannon came from Warners, Chuck Jones was from Warners, and Art Babbitt was from Disney. So were Hubley and Hurtz. So they were all trying to break away from that. They saw me as a piece of moldable clay. The other studios would have rejected me because I didn't have that experience but, by a miracle, I fit exactly into what UPA was looking for: someone who had no experience in another animation studio and who was not going to be wedded to any particular style. They really said that they were going to make me the first "pure UPA" director and it sounded like a lot of BS to me at the time. It turned out to be true. I was the first American animation director who had only UPA training.

How big an operation was UPA at the time?

When I came in there were 12 of us. That's all. We were in the Otto K. Oleson Building in Hollywood. Otto K. Oleson was the supplier of the big Kleig lights for the premiers. That building was basically his. On the very top floor, the roof as a matter of fact, was divided up into offices, but the hallways were unroofed — open to the sky. So when we were up there and it rained, we had to put our coats on and bundle our animation drawings under our coats and dash from one room to next to keep the drawings from getting wet. So it was really a pauper operation.

You worked on the roof?

Yeah. It was a top floor. It wasn't exactly a roof. It was a bunch of offices, but the hallways were open to the sky.

It had no ceiling?

Yeah, no ceiling. So when it rained, as I said, we had to dash from one room to another to keep the drawings from getting wet. Gradually, when we made a couple of films and started to make a splash, and we got the Columbia release, then there was enough money, that at least could be borrowed, to build a real studio. That's when UPA then moved out to Burbank. That's where the studio really prospered.

I understand that a guy by the name of Bill Hurtz also taught you a lot.

As I said, I was sort of the creative godson of Hubley. I looked up to him as a creative god. He was the creative chief of the whole studio and was working mainly on stories and trying to develop big projects. But I was put directly with Bill Hurtz as Bill Hurtz' assistant, to learn the technology of what they called "Production Design," which every other studio called "layout." But, after all, a company that called itself "United Productions of America," and was only 12 guys working in a roofless place, you can see that they were very big on trying to create their own terminology.

From Bill Hurtz I learned all the nuts and bolts of animation. He told me everything there was to know about pan bars, peg holes, field guides, how to construct scenes so that they would flow together technically. All the craft things that are necessary to construct an animated film I learned from Bill Hurtz.

Then, of course, he became a great friend and he's the one who got me into the union, and I eventually became a full-fledged production designer. By 1949, I was Bobe Cannon's designer, up until the time I got the offer to go to Detroit for Jam Handy, which is part of another long story. Hey, this is an expensive telephone call for you!

Well, I hope you're worth it.

[Laughs.] Jam Handy was a big step for me. That's where I directed my first film. What happened was that I'd gotten practically to the ceiling of what I could do at UPA Hollywood. I was surrounded by giants. By people like Hubley and Hurtz and Bobe Cannon, people like that. My chances of becoming a director at UPA then were pretty distant, although they kept telling me that I was going to be one, and I should hang in there.

One day in 1949, I got a message from a company called the Jam Handy Organization. I remembered Jam Handy from the educational films that they would send to schools. Even when I was in Venice Junior High School, we would often be called into the auditorium where they would project a film that maybe showed how automobiles were made or God knows what, all these kind of technical things, and they always said Jam Handy at the end of them and I thought "Jam Handy" was a pretty funny name. I couldn't imagine what that meant. But later, I got an offer from them. It turned out there really was a man named Jamison Handy, who had this big film company in Detroit, Mich., basically connected with General Motors, doing all the documentary, sales-promotion films for Chevrolet cars every year, etc., and they had an animation department. The animation department was really backward and primitive and they were doing early Max

Fleischer-style "rubber hose" animation. You know what that means?

Yeah; where the people's limbs are like rubber hoses?

At UPA we made fun of that all the time. So this guy, Bill Murray, who just went out of my life, I found he became a film director for the Jam Handy Organization (JHO). And they always needed to have animation sequences in their films, even if it had to be something like a cross section of a Chevrolet motor with the pistons going up and down or whatever, or sometimes little parables that they would insert into these sales films. The animation being made at the Jam Handy studio was really terrible, and Bill Murray remembered me from my working with him at Lockheed. He told the JHO people about me and that they should get me. He built me all the way up, you know, that I was a great Hollywood animator. In fact, I was still just barely a layout man, I was not an animator or anything like that.

So, suddenly I got a letter saying that they were sending one of their cameramen out to interview me because Bill Murray had told them that I was really somebody great that they should hire. And I had nothing to show except a reel of UPA cartoons. I was not the creator of those cartoons. I was an assistant layout man on all of them and in many cases not even credited. But that was all I had to show and, even though I carefully pointed this out, they wouldn't listen to it. They thought the cartoons were great and they agreed to hire me on a trial basis and pay my train fare to Detroit. It was another one of the great key moments of my career.

When they got me there, there was a circle of all the bigwigs of Jam Handy sitting in like a horseshoe of chairs. They put me in the middle, and they started to interview me. They started right off by saying, "Well Gene, we understand from Bill Murray that you're really a great animator."

And I said the words that nobody looking for a job should ever utter. I said, "But I'm not an animator."

And the whole place went ice cold. Suddenly, I realized that I had made the world's worst possible faux pas. I could see going through their minds, "What? He's not an animator? We paid this guy's train fare across the United States to come here?!"

So then I had to really go in to this great back-pedaling. I said, "This is really a question of terminology. I'm an animation filmmaker and we all call ourselves animators, and blah blah blah …" and so, naturally, the very first job they gave me to do was to animate a TV commercial with figures.

I had never animated anything in my life. Really. Only flip books in my math books or something. I was doing layouts and scene planning, but I had never actually animated professionally. Nothing I animated, aside from my parrot going to the moon when I was 13 years old. But I had been spending a lot of time going in the editing room and looking at the stuff on the Movieola, and trying to analyze how animation was done. I definitely knew how it was done from a theoretical viewpoint. It's just that I had never done it. So I animated this commercial and they thought it was the greatest thing they ever saw! That was the number-one test. One of the big tests of my career. And they hired me.

One thing I didn't quite understand is why you would move from UPA to what seems like a second-rate company like the Jam Handy organization.

I had reached as high as I was going to get at UPA for a long time. To be an animation director in those days, you had to be working for 20 years as an animator, as a layout man and so on. I went to Hub and said, "Look I got this offer, but I love being at UPA and I'm really reluctant to go to such a cornball place." I didn't want to go to Detroit at all and JHO really was an absolute crass commercial

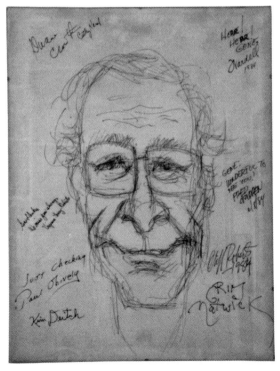

1984 drawing of Gene Deitch by the UPA staff: courtesy of Gene Deitch.

company. But Hub said, "Take it. Go there and spread your own wings and we'll see what will happen."

So what happened was, in short, I became the head of the animation department and, two years later, Steve Bosustow flew to Detroit and hired me to head the planned UPA-New York studio. So Jam Handy turned out to be a proper move. I did find myself in charge of an animation department, I was thrust into it. I was creating stories and creating films from the ground up; doing story creation much more advanced than I would ever have been able to do at UPA.

When you moved to Detroit, you moved lock, stock and barrel, right?

Yeah. Once I got that commercial done, the animation, they hired me. Then they moved my whole family there and they found me a house to live in, everything. They treated me great.

Jam Handy turned out to be a really fascinating place to work. It was the essence of the American Dream, capitalism kind of thing. Jamison Handy and all the leaders were Christian Scientists. They all had kind of a do-gooder attitude. This was 500 people. This was a really big studio, mainly doing lots of live-action films, and also putting on some of the early industrial fairs. Like presenting the new model of the Chevrolet and it would be like a piece of show business, as they still do now. Jam Handy was one of the creators of this kind of thing. Big product launches. They had a lot of divisions there and animation was just one part of it. They did some of the first stop-motion animation commercials. The marching Lucky Strike cigarettes were created at Jam Handy by an old duffer named Goodman.

Was the reason they were located in Detroit because they had auto manufacturers as clients?

It was because it was practically a branch of General Motors. Jamison Handy had top-level connections with General Motors and that was his bread and butter.

It must have been a culture shock to move from L.A. to Detroit.

It was. It was really a hellhole. But on the other hand a lot of great things happened to me. First of all, I became a director. And Detroit is where I did the recordings with John Lee Hooker, which 50 years later turned out to be such a big thing, an important thing to have done.

Did you have your second son by then?

Yes. Simon was born in California. He was dragged kicking and screaming to Detroit. Simon was a difficult kid. That's another story.

What year was Simon born?

'47, I guess. Ask him.

I will.

I know it was May 12th, his birthday, and I think it was 1947.

And when you moved to Detroit, Kim would have been 5?

Yeah.

One of the great things about working at Jam Handy, (you asked my why in the world I would want to go to Detroit and so on), it was just something that happened, and it gave me a chance to spread my wings as a director. Also, as somebody who was born in Chicago and raised in Hollywood and California in a certain kind of atmosphere, to be suddenly subjected to Middle America was interesting with all the typical Middle American values.

Jam Handy was a very paternalistic organization. Moral values were emphasized, and there were all kinds of posters and slogans all over the walls. Over everybody's desk was a little framed list that had your name and duties. Mine said "Gene Deitch" and it says "Answers To:," "Is Responsible For:," and "His Job is to do this and this and this." I immediately thought this was a great thing: In case you ever came to work absolutely drunk one day and didn't know what the hell you were doing there, all you had to do was look at that frame! *[Laughs.]*

Or if you forgot your own name. *[Laughs.]*

Everything was going great for me, and then suddenly I got a telephone call from Steve Bosustow, president of UPA, that they had decided to open a studio in New York and they had heard of my success at Jam Handy, and he came to Detroit and offered me to lead this new group in New York. Somebody had once told me, "Don't go to New York unless you've got a contract and a good job, because you can end up washing dishes at a take-out food place or something." So I was sent to New York finally in style. It was my ambition, ever since I had read about the New York World's Fair in 1939, to someday go to New York. And it now was really the right way. They got me an apartment, they arranged everything, they moved us. Don't forget that I had two kids at that time. They moved us and all our furniture and everything else and got us a really nice apartment in Hastings-on-Hudson, up the river from Manhattan. If you know that village, it's a

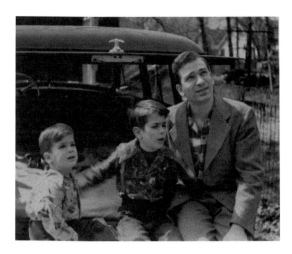
Left to right: Simon, Kim and Gene in Detroit: courtesy of Gene Deitch.

wonderful place. So that's how I got to New York.

Your mission at UPA in New York was, I think, to do television commercials, right?

Yeah. The idea was that UPA had made all this prestige in Hollywood, but no money. They were constantly just barely making the payroll every week because it was a big operation: they were doing these Columbia Pictures shorts. So now suddenly TV commercials began to be a real business and they wanted to get in on it almost at the ground floor. Our job was really to support the Hollywood studio. All the money we were making had to be sent to Hollywood, and we ourselves had to lock ourselves into the office every week, waiting for the checks to come in from them so we could pay our people in New York. Even though we were doing really well, they were siphoning off all the money.

Nevertheless, that also pushed my career way up. We had managed to make a splash, winning big clients and lots of prizes. By 1954, the Museum of Modern Art had a month-long show of our TV commercials, the very first television commercials ever shown at the Museum of Modern Art. We were then riding really high.

Gene, how big a crew did you have in New York?

It grew very fast. I have a photograph of the original staff we took on the day or second day we all arrived. But very quickly, and especially after Abe left, the staff grew, and people like Chris Ishii, Fred Crippen, Duane Crowther, Bard Wiggenhorn, Jack Goodford, Lu Guanier came in, I was able to bring in Cliff Roberts from Detroit, and many other great guys came in, even Richard Wil-

liams for a while. There were a lot of people, including the most glorious girl ever created: Edna Jacobs. Whenever she walked through the whole studio, because the inking and painting department was up at the back, she had to walk past the whole studio to go to the john and, during those walks, all work stopped. She's still living. She's a nice white-haired lady by now, but she was really a boom-boom girl.

You refer to her in your book as the studio sex object.

Exactly.

Were you happy doing TV commercials?

Yeah. We had success and we were doing stuff at a high quality. After all, we did the first TV commercials with Saul Steinberg. We brought in avant-garde musicians. John Cage did a score for us and Carlos Surinach, a great Spanish composer. We did the openings for the CBS *Omnibus* show, which was one of the high-class TV shows in the '50s, hosted by Alistair Cooke.

So you were able to find creative fulfillment doing this?

Oh yes. I won the Art Director's Gold Medal twice and lots of other honors, and was called upon to make speeches. We got the Museum of Modern Art show. So I had plenty of prestige, and I was very happy and of course, that led to my being chosen to take over Terrytoons. But the first reason I left UPA New York was because John Hubley came and hired me away.

Before you get into that, tell me a little about what working with Steinberg was like on a Jell-O Instant Pudding commercial.

It was very exciting. Going to his apartment was one of the really great happenings and thrills. He collected pendulum clocks and rocking chairs, which were all over the place. Right at the time I was there, he was drawing these series of drawings in which he had somehow discovered he could put his fingerprint on the inkpad and put the fingerprint on paper and then draw a bird or something around it. He was really very forthcoming. I never register peoples' age, but he didn't seem to be very old. He might have been 50 or something: in his 40s or 50s. He wore round glasses and he was really very nice. He was getting paid to do a TV commercial. He made the key drawings, which we then adapted as close as we could to his style. That was, of course, a great happening.

Steinberg was easy to collaborate with?

Yeah. Absolutely no problem. Unfortunately it was only one project — Jell-O Instant Pudding.

The UPA approach seemed to owe something to Steinberg.

Sure. Steinberg was one of the main influences, definitely.

My understanding is that John Hubley was forced out of UPA in 1954.

Yeah. Earlier than that, I think. There again, there was an animosity between he and Steve. Steve had just worked himself up to be the chief and was not willing to tolerate anyone that was any kind of a threat to him, and because Hubley was the obvious central creative genius at UPA, the creative director of the studio. He was invaluable and irreplaceable and yet, Steve was willing to sacrifice him to the McCarthyists.

You wrote that Steve Bosustow "fed him to the Red-baiting wolves." What did you mean by that?

The word came from Columbia Pictures that anybody who was on the McCarthy shitlist had to go. Otherwise they would have lost the Columbia release, which was the key to survival of UPA. Ethics at that time was really thin on the ground. Some people did sacrifice their careers. Many great writers in Hollywood were out and many great actors. All kinds of people were blacklisted and couldn't be on television.

Earlier than 1954 Hubley had established his own studio, Storyboard, inc., and had opened a New York branch. In 1954, possibly to get revenge on Steve, I guess, he hired me away from UPA New York. There were multiple factors here working. Hubley was my guru, he was my god in animation-film creativity. To me, every word he spoke was gold. I was on my knees to him.

Hub knew that one way he could get revenge against

Steve was to hire me away from UPA, and that's what he did. It was an offer I couldn't refuse, even though it was a big mistake. Hub hired me away from UPA and then really didn't let me do anything. Hub was perpetually flying back and forth between his Hollywood and New York office. When he came to New York, he came to me and saw what I was doing and said, "Hmmm. Pretty good. Let me take a look at it. I'll take it with me and I'll bring it back." And he would take it with him to the coast and I'd never see it again. He would redo whatever I did. I couldn't really do much for him.

Fortunately, I got another offer from Robert Lawrence to become creative director. He had a big studio and was going to make me the creative chief of his animation department, where I could at last do something. No sooner had I got there when the CBS scouts found me and hired me to go to Terrytoons.

So in the Spring of '56, you went to work for Terrytoons.

I was only just a few weeks with Robert Laurence when suddenly comes in the offer I couldn't refuse. I'd gotten several offers I couldn't refuse, but this was the main one: to become the creative chief of Terrytoons, even though I knew that Terrytoons was the world's worst animation studio. I saw this as the ultimate challenge.

You were excited about working at Terrytoons because there was so much room for improvement?

Yeah. They were the bottom. They did nothing but hack work. Everything they did was a knockoff of something else. *[Contemptuously]*: The only thing they ever had that became a hit was Mighty Mouse, if you like that. *[Groth laughs.]* That was their number-one success. They had Gandy Goose and Dinky Duck … all were just imitations of something else. What they did have was the Twentieth Century Fox release of 18 Cinemascope

From the Feb. 16, 1956 *Terr'ble Thompson* strip. [©2006 Gene Deitch]

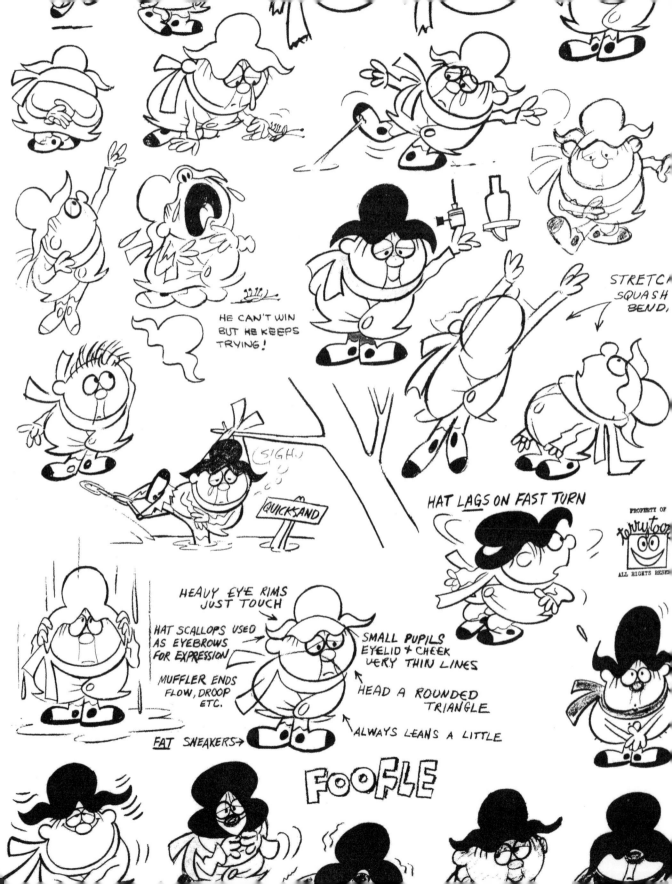

HE CAN'T WIN
BUT HE KEEPS
TRYING!

STRETCH
SQUASH
BEND,

HAT LAGS ON FAST TURN

(SIGH)

QUICKSAND

HEAVY EYE RIMS
JUST TOUCH

HAT SCALLOPS USED
AS EYEBROWS
FOR EXPRESSION

SMALL PUPILS
EYELID & CHEEK
VERY THIN LINES

MUFFLER ENDS
FLOW, DROOP
ETC.

HEAD A ROUNDED
TRIANGLE

FAT SNEAKERS→

ALWAYS LEANS A LITTLE

FOOFLE

cartoons a year: that was the key opportunity to me. I said, "My God, just imagine the 18 Cinemascope-shaped screens a year to run barefoot through." Being backed by the CBS organization.

I came in with an absolute promise that I was going to be supported. The man who recruited me was named Newt Schwinn, who actually came from the bicycle family. He was one of the star salesmen for CBS Television. He came to our weekly Terrytoons staff meetings, and he was my protector. Everything was going really great as long as he was there, but then suddenly he got a big job somewhere else and left. I was then at the mercy of Bill Weiss.

I first turned the job down as soon as they took me out there to meet Bill Weiss. I said, "Who is he? No one mentioned him before!"

And they said, "Don't pay any attention to him. He's only the manager."

I said, "If he's the manager, I want to have a contract."

And they said, "Nobody at CBS had a contract." That's what they told me. "No executives at CBS have contracts." So I was a CBS executive and I didn't have a contract. I learned later that Bill Weiss *did* have a contract. And the reason he had a contract — he was the only one who had a contract — was because that was a condition of the sale.

The greatest swindler of all was Paul Terry. Paul Terry had promised key staff members a piece of the company when he retired. He sold out to CBS surreptitiously. People in the studio read about it in the newspapers. He never mentioned it to anyone. During the gangster days of the film business when they were lowering cans of film out the windows to keep the bankers or police from confiscating their negatives, Bill Weiss was somebody who actually perjured himself in court to keep Terry from being imprisoned. Therefore, Terry owed Bill Weiss. He had promised Bill Weiss 10 percent of the studio if he sold. Of course, CBS wasn't going to go for that. What Terry was able to get out of CBS was a five-year contract of tenure for Bill Weiss. Putting all those things together, I was dead in the water before I even got there. But I did have a glorious two years that made my career, really.

You brought a number of very young artists into Terrytoons, who established successful careers subsequently. You brought in Jules Feiffer. Tell me how you met him and what his involvement was.

Jules had come to me when I was at UPA, looking for a job, but he was not at all anybody you could use to make TV commercials. He was a really interesting cartoonist. I was working in UPA when I got my contract from United Features Syndicate to make the *Terr'ble Thompson* comic strip, so I hired Jules to be my first assistant. I think in [my] book there's an example of how he was going to draw Terr'ble Thompson. It was fine, perhaps better than what I could do, but it wasn't what I wanted for that strip. So I actually was not able to use him, and I really felt terrible about it. He was living in Greenwich Village on a mattress on the floor in a closet. He had no money at all. When I got to CBS, then it hit me: now I could use Jules and bring him in to the story department, because that's what he was superb at. He was a fantastic writer. So that worked. That's how it happened.

How did you know he was a good writer? Did he bring in samples?

Yeah. He hadn't yet done the *Village Voice* cartoon, but he had brought me some things that he had done: some stories and also comic strips. He was trying to create a comic strip himself. I can't remember specifically, but you could definitely see that he was a fantastic talent.

Why did you not like the work he did on *Terr'ble Thompson*?

Well, I guess I had my own idea about how I wanted it to be drawn and I think in retrospect people look at *Terr'ble Thompson* now and think it was very advanced design for the time. It was also more commercial and possible to get away with than what he was doing, I thought. I hired Ruby Davidson to be my TT assistant. He closely followed my style; good or bad, the strip was my personal expression.

More recently, you adapted Jules Feiffer's *Bark George* into an animated short, didn't you?

Yes, that's the new series: *Bark George* and *I Lost My Bear* were two additional films we did together.

I understand that you had a bit of a falling out with Jules over one of those.

Well, he fell out with me. And he fell out with me for a reason which is really hard to understand. It was when we did *I Lost My Bear*, which was adapted from his first children's book. He had written the story for his daughter, Halley, when she was about 7 years old. She was very little. Now she's a grown-up. On a visit to Weston Woods, the present producer, Paul Gagne, said "We found two books by Jules Feiffer we'd really like to do, but we can't

get past his agent. The agent really wants big money for the film rights, and it's beyond our budget for a children's film." He said, "You know Jules, so maybe you can talk him into it."

Well, of course we were old buddies, so when Zdenka and I were in New York, we phoned him, went to his apartment and got a great welcome. I explained to him the situation with Weston Woods, and he said, "Don't worry about my agent, we'll make a deal."

So that was great. Because of my 45-year personal friendship with Jules, Weston Woods was able to do these two films. We first did *Bark, George*, which he loved. All went well. And then we got to *I Lost My Bear*, and he said, "My daughter has to do the narration." But by that time, she was a late teenager, she had a woman's voice. It seemed to be really impossible. So I said, "Jules, it's not going to work, because the character in this film is 6 or 7 years old."

So I went to the American school here in Prague, and interviewed a bunch of kids, and I found a little girl who really had a great voice, and I recorded her as a test and sent it to him for approval. But just my doing that made Jules completely furious. For my treachery, he never wanted to speak to me again!

I later found out, too late, there's a program that had been developed called ProTools in which it is possible to raise pitch without speeding up or slowing down. We did end up having to use Halley — and she turned out to be a terrific actress. And we used ProTools, which raised the pitch of her voice to a 7-year-old without any of that speeded-up effect, and it was great! I was amazed at this magical computer wizardry.

However, it was too late. Jules had already slammed the iron door on me because I had the temerity to try somebody else. And he said, "I never want to speak to you again in my life." It was a terrible blow to me. So those are the ways that things happen, it's just a personal thing.

You also hired Ralph Bakshi. He must have been a kid at the time.

I didn't actually hire Ralph. He was hired as a cel painter, probably the lowest level of production work. Ralph was a feisty young kid and he would often be drifting away from his work, following me around the studio and eavesdropping on the meetings I was having with the animators and story guys, trying to soak up whatever he could. He was really hungry for getting ahead. I didn't pay all that much attention to him. I didn't actually hire him. I hired animators and story people, writers, musicians, designers; the creative personnel. I didn't hire in-betweeners and I didn't hire inkers and painters.

Did Bakshi stand out in any way?

Only in his intense interest. I never saw anything he created, because he was just a cel painter. That's all. He never did any creative work when I was there but when I left he suddenly bloomed. He was an eager beaver. Well, so was I in my still-younger days.

You adapted Bob Blechman's *The Juggler of Our Lady*.

That was one of my great adventures. I really loved that book. I found it by chance, and got in touch with him. He knew very well the standard of Terrytoons and hadn't yet seen what we were doing or hadn't really known me at that time. It took me a full year of talking to him on the telephone every night to talk him into letting us do this. I thought his style would be really ideal to sell the CinemaScope screen in an absolutely new way. I thought, what could be funnier than having this tremendous wide screen and these tiny, squiggly little drawings? Everybody else, especially Bill Weiss, thought I was completely out of my mind. That this would never go. Of course, it was a great story. I had ideas about how to do it, and I had the idea of getting Boris Karloff to narrate it. I was always interested in casting people against type. Even later, when I had the first chance to do *The Hobbit* here in Prague, my idea was to hire Stan Laurel to do the voice. I knew Boris Karloff was a British gentleman. He was not a monster in any way. He was a very refined, highly sophisticated, intelligent, cultured guy, and a fine actor. I thought, here's a chance to use Boris Karloff in a way that nobody else has ever used him. And that worked, I think. His voice helped make that film, along with Bob Blechman's drawings, and Phil Scheib's music.

Can you tell me how long that film was?

It was a typical movie short. About seven, eight minutes. Not much longer than that. Movie cartoons were really limited in length. It was always certainly well under a reel. A standard 35mm reel of film is 12 minutes.

And these would be shown before films in theaters.

Oh yeah. These were movie cartoons. Twentieth Century Fox release. That was certainly, at that time, the most far-out extraordinary movie cartoon ever. People were used to looking at Bugs Bunny and Tom and Jerry. Nobody had ever seen anything like Blechman! And it was basically a failure. Twentieth Century Fox always audience-tested our cartoons, and I was being beaten over the head all the time because what they would do was

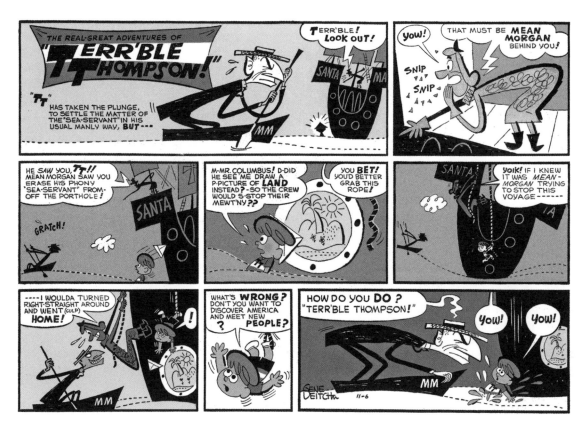

The Nov. 6, 1955 *Terr'ble Thompson* Sunday strip. [©2006 Gene Deitch]

have screenings and bring in people off the street who had to press little buttons, you know, "yes/no," as the film unreeled. And my films always got really rotten ratings. People would go in there expecting to see madcap cartoons, and when I was trying to do something more sophisticated it really bombed. I made the history books, but it would be a while.

Once you talked Bob Blechman into allowing you to adapt *The Juggler of Our Lady*, was he involved in the production?

One of the ways that I was able to do it was that a friend of his who had worked with me at UPA and was now on my staff at Terrytoons, was Al Kouzel, I said, "You know Al Kouzel. He's an honorable and sensitive guy. We're not going to turn your characters into Mighty Mouse or Dinky Duck or anything like that. You know if I put Al Kouzel on it as the animation director, it's going to be your images that are going to get on the screen." That's what I had to keep drumming into him every night: that we guaranteed him that it was going to look exactly like

his work and that he was welcome to come to the studio any time he wants and follow the progress along. Of course, Al Kouzel was also a really high-class artist. He later did the layouts for *Munro* for me. He was perfect at adapting anybody's style. And I think, if you look at "Juggler of Our Lady," it really looks like Bob Blechman drew it himself.

In 1955, of course, you started *Terr'ble Thompson*. Was it always your ambition to have a comic strip of your own?

Yeah, that was one of my ambitions — from reading *The Herald Express* and *The Examiner* in Los Angeles, following the *Popeye* strip. *Popeye* was always my example. I'm talking of course about the Segar *Popeye*. His storytelling, to me was the example of what I wanted to do in a comic strip sometime: in other words, a comic adventure that had fun with language. The fact that he invented the word "Jeep" and "Goon" and had characters like that, and Wimpy's "I'll be happy to pay you Tuesday for a hamburger today," and "I yam what I yam." All these great

phrases. Everything about the *Popeye* strip and the way it was drawn was what I wanted to do.

And, of course, I think *Terr'ble Thompson* has a lot of that in it. The whole idea of using twisted language, trying to create funny words and everything, was all inspired by Segar. Not that I ever got close to it, but that was my goal. That's why it started as an adventure strip with a continuous story, which nowadays would not be possible.

Because animation is such a collaborative medium and because the comic strip is a much more intimate medium, did you find a great satisfaction doing the comic strip?

I loved doing it, because it was personal: exactly what you just indicated. This was something I wrote and drew myself. I did bring in an assistant simply because technically I couldn't get it out unless somebody would help me with lettering and doing some inking in the background. I basically wrote it and penciled it and I inked the characters. I only let my assistant do the lettering, but I set the lettering style, and he inked some of the background and helped clean up things and so on. And he took all the money, incidentally. In order to have an assistant at all I had to give him all the money I got from United Features because I was working full-time at UPA. My idea was somehow to get this up to the point where I could quit animation and do the strip. One of the greatest creative losses of my life was that I had to give up the strip. But it was simply tremendous pressure for my then-wife.

You were working full time and doing the strip at the same time.

That's why I had to have help. I was working night and day. I worked full-time at UPA and then I came home at night and worked till midnight on the strips and I worked on the weekends. I wasn't paying attention to my kids.

Simon and his rope-cat: provided by both Kim and Gene Deitch.

I was a rotten daddy. I had convinced myself that I was doing this for their future and if I could make it go, we would buy ourselves a motor home, we would travel all over the United States and I would mail in my strip from wherever we would be, completely overlooking the fact that the kids would have to go to school. But look, this was a passion. That's all.

This is a good time to talk about your being a father. Kim would have been about 11 years old at this point.

Kim was old enough that he was hanging around me all the time I was drawing *Terr'ble Thompson*. He was really fascinated with it, and he came with me very often to the studio at Terrytoons and I think his whole Fontaine Fables schtick came directly out of Terrytoons. He spent a lot of time at the studio. He got to know many of the animators. I didn't realize it myself at the time, but he was absorbing a hell of a lot. Kim was really that kind of a guy. And later, when he visited here in Prague, he acted all the time like he was bored shitless. He didn't seem to be seeing anything. But later, he sent me a copy of his diary, his memoirs of this trip to Prague, and he saw everything. He never showed it. Kim is really very closed and doesn't tell you everything about himself. Kim, when he was a little kid, when he was able to write a few words, he made a paper sign that said "Peace," and he would march around the house with this flag.

It said "Peace?"

"Peace," yeah. He was absolutely a nonviolent kid, whereas Simon was exactly the opposite. Simon was a firecracker; an uncontrollable kid who would throw tantrums and would get so furious sometimes he would actually run in to a wall and bang his head on the wall. We were of course very modern parents, and we wanted to bring up these kids in the best possible way and introduce them to art and culture. We didn't buy them any mechanical toys. What we bought our kids were unmarked wooden blocks so that they could be creative with them in their own way. Most kids would take wooden blocks and make a little house out of them. These were big blocks, actually bigger than bricks. You could really build a little fort or a house or a tower. But Simon would take these bricks and he would lay them out on the basement floor of our house in Terrytown in the form of a dinosaur skeleton. Who do you know who would take wooden bricks and use them in that way? To make a *picture*?

I was going down to the garage. We had bought a clothesline rope that Marie had wanted to rig up in some

way in the basement. I couldn't find the clothesline rope, so I went outside and asked the kids if they were playing skip rope or something. Simon had taken that rope and cut it into little lengths and he arranged the rope on a stone to look like a cat. Simon had natural graphic talent. Whereas I could have beaten his brains out or something, I ran for my camera and took a photo of it, and it's one of my treasures. Simon I think probably is a greater artist than Kim, a greater creative graphic artist and natural-born artist: can draw much better than Kim, even today. Even Kim says so. But he has his flaws and he cannot succeed. He just seemed to aim for trouble.

As a kid he was a bit of a hellion?

An absolute hellion. And some of his friends were the worst sort: the kind who taught him to steal, who taught him to smoke, who taught him everything negative and self-destructive.

But you think he was more naturally gifted than Kim?

Definitely. We saw that he had this talent. Marie was big on psychiatry, and we had sent him to a psychiatrist, weekly sessions. We knew he was a troubled kid and tried every way to help him. We took him to the Museum of Modern Art, which at that time was having Saturday morning art opportunities for kids. They taught how to make things out of colored paper and scraps of cloth and scraps of material and so on: artsy-craftsy kind of things. Simon was really wonderful at it. He made great images and constructions.

But nothing seemed to overcome the fact that he was somehow just on fire inside and seemed to gravitate to the worst kinds of company. He got in to every trouble in the world. Simon is a guy, when he was grown up, that I visited in jail in New York. One of the worst things, I guess, for Marie when I left was leaving her to have to cope with Simon. It was just constant trouble. Sometimes he would just set the couch on fire with his cigarette: all kinds of weird things, make horrible messes. He was a problem kid, and a wasted talent.

Whereas Kim never really learned how to draw in an academic way. Today you wouldn't want to spoil him, of course. Let's face it, Kim is a naïvist. Nothing wrong with that, and Kim is an incredible storyteller, detailist and decorative artist. He's somebody who makes the absolute maximum out of a minimum amount of academic art ability. Kim cannot draw realistically at all.

Even though he says he tries.

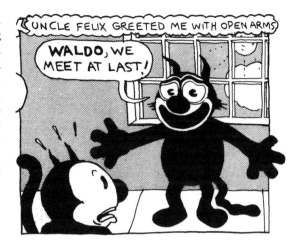

From Kim Deitch's "Déjà vu" in *The Gothic Blimp Works #3* (the dedication to the story's reprint in *All Waldo Comics* reads, "To Simon Deitch, the smartest kid on the block"). [©1992 Kim Deitch]

He tries I have a painting by him, it's one of the best things he ever did. It's right above my working place in my little studio and it's called "Great Holy Ned on a Mountainside." He tries, definitely. That's the thing about Kim. He exceeds himself.

I asked Kim once how he came to his unique style and he said he came to it by trying to draw realistically.

[Laughs.] He doesn't know anatomy, but God love him, don't change him now. He has created his own way and his own style and it's perfect. Every single page of his comics is just so full of work. He does all this ruling and shading and I said, "what kind of gadget do you have to make all these lines in the background?" and he said, "I just draw them." *[Laughs.]* He does. He doesn't use any Ben Day screens or anything like that. He just draws everything.

And none of the decorative quality of his work impedes the storytelling.

It certainly doesn't impede it. It helps it. He is so good at it that he creates this fantastic atmosphere. His style evokes the naive animation cartoons of the late 1920s and early 1930s, perfectly. And those guys didn't know how to draw, either. *[Laughs.]* That's when they did the rubber-hose animation: Felix the Cat and whatever. He has his own Felix the Cat: Waldo.

He's able to create this highly stylized but completely believable world.

Exactly. And nobody in his right mind would want to change him. He is such a great observer and storyteller. And I kid him all the time, I said, if you want to believe in channeling or something occult, I said, "Kim, I don't know how it's possible, but you are recreating *my childhood!*" I'm a child of the 1930s. I lived and grew up in the era that he draws and that he now knows better than I remember, because he's done such incredible research. I said, "How come you're so interested in the 1930s? That was a hellish time, that was The Depression. We were starving. Nobody thought anything was so great in the 1930s in America." But he said, "Dad, those were the peak years of American culture."

And in that way he was right. That's when the WPA was created. That's when the best painters were painting Post Office murals and great art and great music was being created; Jazz was being created and developed. It was great but, after all, in those days we were basically hungry. Yet, to him, these were the ideal years. It's one of the things that brings us together. Kim and I have a really great rapport together. I really like Kim and we communicate very well.

But Kim was not the son you thought would succeed at art.

Well, I wouldn't exactly say that, because I knew he had this intense interest. He tried to be an animator. One of the great things I managed to get from Terrytoons was Paul Terry's original animation crane, which was being thrown out in the junkyard at that time and I salvaged it and brought it home and set it up in our basement and I bought a 16mm camera that you could shoot frame-by-frame. And Kim and Tony Eastman, who was his close friend then, were going to make animated cartoons in our basement using this old, original Paul Terry animation stand. But the fact was that Tony was so much better at animating than Kim, that Kim became disillusioned. He saw that that wasn't what he was going to be able to do. That he wasn't really good enough as an animator and being able to draw well, whereas Tony was a natural-born animator. But Kim was so interested in cartooning that he then began to just do his own thing in his own way. I didn't think that what he was doing was so great until he basically became mature and was living in Greenwich Village and started to do things for *The Village Voice* and so on.

The East Village Other, yeah.

Then the real element of his work began to come out right away. Yet I thought it was awfully crude. The story-

telling part of it, of course, developed somewhat later. But he just wanted to do it. That's what makes any of us do what we're doing, right?

That's right. Let me quote something Kim said about you. He said, "My father seemed to go out of his way to convince me that I didn't have the right talent to draw, I would never make it as an artist." He goes on to say, "There's an orthodox way of drawing where you're supposed to draw with your arm and not just your hand …"

Right. He told me that he could never do that. I guess I might have said that to him at one point or another because the things he was talking about wanting to do I just knew he wasn't going to be able to do. By some miracle, he found a niche that he could make a living at. But it really is a miracle. I knew the commercial-art world and I knew you had to be able to do all kinds of things and I didn't think Kim could be good enough to do it. I don't know if I sounded that discouraging to him as that quote sounds. Whether I really said that or not, I can't deny it, but I definitely did feel and probably tried to, I hope, gently indicate to him that, as far as being able to be a classic commercial artist, he didn't really have the right stuff and I thought he was going to be much better as a writer.

That's what he says. He said that both you and your wife encouraged him to become a writer.

Exactly, because that's what he seemed to really have the knack at. I don't think his cartoons would have made it if it wasn't for the combination of the writing, the fantasy and the incredible imagination and the magic that he was able to bring with his ideas. Ideas are everything. You can get away with a lot if you've got the right ideas. That's what made it for Kim. I had worked in art studios and art departments and I knew what you had to do, and I knew he just was not going to be able to get a job. For example, one of my very first jobs getting out of the Army was for a real third-rate advertising agency called the Tullis Company, run by a guy named Howard Tullis. His main client was something called Franilla Ice Cream. I had to draw 24 sheet posters of ice cream in a dish and learned how to draw and paint ice cream that really looked like ice cream, and it's not easy. Drawing ice cream was the most difficult thing I ever did.

But I was personally very good at object drawing. In my younger days, I would sit a shoe on the table and draw it. I would draw a can opener to learn how to make it look shiny, and I learned how to do lighting and shading.

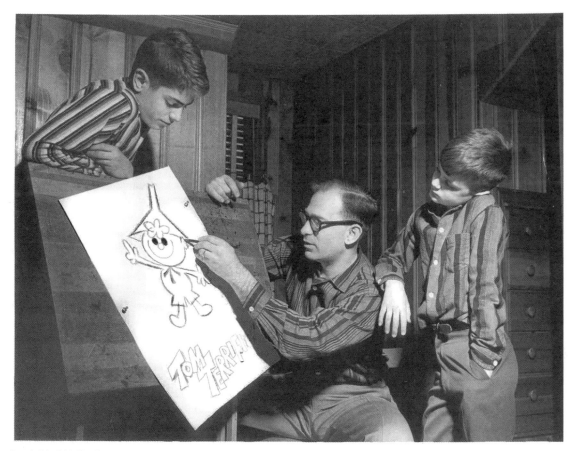

From left to right: Kim, Gene and Simon: courtesy of Gene Deitch.

I could do realistic drawing. I could do portrait drawing. And I knew that Kim was never going to be able to do that. On the other hand, I certainly don't have the fantasy that he has. I wish I did. So everybody has their own thing and by a great miracle Kim found what he could do. He just managed to luck into it, or fall into the right area, the right scene, at the right time when this whole new approach to comics was being created. Now, of course, graphic novels … Look what's happened with *Persepolis*. Here you've got a film that should have won the Oscar, and I have to tell you, and I swear to you, I voted for it, because I thought it was really important for that film to win the Oscar.

What won instead?

What won was *Ratatouille*. A great film.

That was a great film.

But look, that's a hundred-million-dollar production by a company that wins every single year. But what is the Oscar for? I was writing all my fellow members that I knew in the Academy, saying, "Look, the Oscar is to reward somebody who is bringing something absolutely new and fresh to the medium, and here are just a couple of people making an ultra-low-budget animation that is telling a story that nobody has ever done in a feature-length animation film for movie theaters. And *Persepolis* really is fantastic! Nevertheless, they did nominate it. And nevertheless, as you well know, graphic novels are now in. You're in on it!

Riding the wave to riches, yes.

Well, let me read you something else Kim said. He was talking about the time when you were working at UPA full time and drawing *Terr'ble Thompson*. He said, "That's probably when he and I became closest," referring to you, "because, while he was home moonlighting, doing this comic strip, I was hanging around

with him. I used to love to hang around, watch him draw, and talk to him, and he encouraged it. So that was probably a big thing in my development toward becoming a comic-strip artist."

We talked about that before and it is absolutely true. Not only did he get something from me, but I got something from him and from Simon. The way they spoke and the kind of twisted words that they used were really inspirations for me, too. True, he was watching me all the time I was drawing the comic strip and I was always telling him about all the technical problems and how I had to arrange the panels. You know how it was in those days: you had to arrange the panels for different newspaper setups. You had to go for a half-page, third-page, quarter-page, tabloid and make it all work. It's true that Kim was definitely picking up all of this. Even when I left, we corresponded a lot, and that was always the big subject. So I'm really glad to hear that.

In a way, you must have been the dream dad for a kid who was interested in cartoons.

Sure, if you wanted to be a cartoonist and your dad's a cartoonist, naturally that's great. My father was a vacuum-cleaner salesman or a ladies'-hat salesman or a hosiery salesman or electric-fan salesman. He was doing nothing that interested me whatever, and he thought I was on the road to ruin. Only my mother encouraged me as an artist.

And indeed you were on the road to ruin.

Uh-huh!

Obviously, your enthusiasm and interest in comics was infectious because all of your kids became interested in comics.

They all picked up one degree or another of it. Seth, who does not really draw, became really a good writer. And I'm sorry he hasn't yet made it, because I think his stuff is great. I love his stories. I have great admiration for Seth. His stories show real craftsmanship, and he has done a tremendous amount of research. He's very knowledgeable. He's created his own world. I keep thinking that, sooner or later, he's going to have to be discovered. I hope so.

Well, we're working on that, too. One of the things Kim said about you was that you did not like comic books. In fact, you considered them trash and you discouraged him from reading them.

Yeah. They *were* trash. *[Laughs.]* And I still think so. A lot of the stuff they brought home I really didn't like. Perhaps in retrospect, I would change my mind about a lot of it. I was raised in a much more innocent era. A lot of stuff Fantagraphics puts out I don't like. But you have a lot of great stuff, too. Everybody has different strokes.

You were particularly opposed to Basil Wolverton's work.

Yeah. I just don't really like gratuitous ugliness. His whole reputation was based on that. Look, we're in this kind of a culture now. We have rap music and rock music and art of all kinds that is gratuitously ugly and I'm still a romanticist. I love the music of the '30s, '40s and '50s. I like music that has melodies. I like traditional jazz.

You really had very refined taste in cartooning, wouldn't you say?

I admire craftsmanship. Even though I could never do it, I really admired Milton Caniff. His work was so fabulous. And Foster's *Prince Valiant*. Beautiful work. And the Alex Raymond *Flash Gordon* strips and the really beautifully drawn strips. And the Cliff Sterritt *Polly and Her Pals* on another area. Fantastic graphic work. And, of course, *Krazy Kat* to me it was high art. All of this was really high art. Lots of high art in the comic strips, starting with Winsor McCay. I admire craftsmanship and I am a craftsman in my work, I think.

And you tried to communicate these high standards to your kids.

Yes. Simon was fascinated with dinosaurs from a tiny age, before it was a big thing. And he loves the most grotesque kind of monsters and he loves to create monster

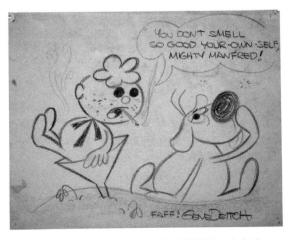

A *Tom Terrific* gag: courtesy of Gene Deitch. [©2008 Gene Deitch]

make-up. Kim's stuff is not ugly but, as I say, he is a fascinating naïvist and a decorative artist.

There's a primitive quality to Kim's work.

He's a primitive as far as art, but he's highly sophisticated in the way he uses this. He uses his talent to the maximum and works hard. You admire Kim because he puts tremendous work in to every page.

Kim said that you "recognized that Simon had a lot of talent and encouraged him to some extent, but Simon was more of a delinquent than I was."

He was definitely a delinquent. That's the term they used to use in the '50s. "Juvenile Delinquent."

He also said, "Simon had a lot of input in *Tom Terrific*. He actually created a few of the characters for *Tom Terrific*."

He had a lot of input because of the way he spoke. Simon had his own particular, unusual language. Every time he'd say something I would write it down. For example, in *Terr'ble Thompson*, the idea of calling the sea serpent a "sea servant." Straight Simon. Because that's the way he pronounced it. Not that he was trying to be funny. He just mispronounced everything, but in hilarious ways. He would say things like "it's upside-wrong-down." Look at *Terr'ble Thompson*, you'll find it in there. Kim, of course, was older, but Simon was the great language influence. Not everything in the strip is from him, but he created the pattern. And from his pattern I made up lots of similar kinds of crazy words. But he was the inspiration.

So you didn't actually let Simon work on *Tom Terrific*?

Oh, no. He was too young. *Tom Terrific* and *Terr'ble Thompson* were two different things, but similar. *Tom Terrific* also used expressions. Like "wowie boom," also came from Simon. God knows why he said that, but he got excited and he said, "Wowie Boom!" Those kinds of things definitely got into the strip. But he was too young to do it. Simon wasn't the guy who would be drawing something like *Tom Terrific* or *Ter'ible Thompson*. Simon tried to be a realistic artist. He liked to draw as realistically as possible. Although he didn't study enough to be really good at it, as he could have been, he definitely is a far better draftsman, as far as the craft of drawing, than Kim is.

Would you say that your interest in art was the lynchpin of your relationship with your kids?

I'm really gratified with my kids, as far as that's concerned. Even though, how much influence could I have

had on them? I did leave while a lot of them were still at an early age. I know that I had some influence on them. Of course, they followed my work and I kept in touch with them and they saw the films I was making, etc. But I wasn't with them as much, personally, as I should have been. But I'm very pleased to have three kids who have such terrific talent, and at least one of them is recognized. The only thing waiting for Kim that needs to be done is a feature movie. And I don't understand yet why somebody hasn't picked up the Fontaine Fables saga to make a feature animation out of. That's something you can work on, Gary.

Yes, right, right. I'll get on that. *[Laughs.]* I'll tell you, as one of Kim's publishers, Kim is a hard sell. And I don't know why that is. I think it might be his highly stylized approach.

It's hard to get used to the style, I guess. But what drawing of cartoon characters is worse than *The Simpsons*? *[Groth laughs.]* I'm not kidding. *The Simpsons*' drawing is truly schlock stuff, but it's the most popular, biggest success of anything ever in history; the most successful television show of all time. It's pointless for me to criticize something so tremendously successful. But why? It's the *ideas, the stories, the truth* that's in it! The drawing is really grammar-school level, but it's original. But Kim is not as bad as *The Simpsons*' drawing, by no means. Maybe it's not as immediately accessible. You've got to be with his story. Just like, somehow, Groening was able to put across his stuff because he got some television breaks in the early days and he was able to run with it.

This is one thing Kim has not been able to do. He hasn't gotten that kind of a break. His fan-base isn't broad enough.

You have to be willing to enter into Kim's world.

Absolutely. But I think the story, the characters, are so crazy and so bizarre that it seems to me it definitely fits into our time, even though it's supposed to be the '30s. Everything he does is in the timeframe of the '30s, yet it relates naturally.

And once you're in that world, it's compelling.

Exactly. And I'm always amazed how he's managed to find things that I've forgotten, because he reads all the books and looks at all the old pictures and has watched all the old movies.

Did your kids go with you to the UPA studios?

Kim did, but that was earlier and Simon would have

been too small. Kim definitely visited us. In those days when I first befriended Allen Swift and Allen Swift was doing the Popeye show on television, Allen invited Kim and Tony [Eastman] to come on the show and show a clip of their animation. So Kim and Tony's first stuff on television was on Allen Swift's Popeye show. Allen Swift played a sea captain of some kind — Captain Allen Swift is what he called himself — and he showed Popeye cartoons and did a certain amount of patter in between.

Did you help Kim with his animation projects?

Only because I made it possible for him: I got the camera, I got the stand and had it set up in the basement, bought a stop-motion camera and showed them how to do it, but then I had to let them do their thing. I didn't want to show off how clever Daddy is. When they asked me, I told them what the principles were: the principles of how to make animation. How to do timing and space character action, but I let them do it.

You said you didn't spend enough time with your kids, but it sounds like you spent a lot of time with them.

I tried to. The time we're talking about is after I gave up the strip. When I got the job at Terrytoons, that was the absolute death-knell of the strip, too, besides the birth of Seth. Poor Seth. I don't want to keep telling him this, but it was the fact that Marie got pregnant with Seth that absolutely made it impossible for me to continue the strip, because it required too much domestic time. I realized it was all over.

So Seth killed *Terr'ble Thompson*.

Yeah, but he was well worth it. He was the most charming and lovable of all my kids.

Your next port-of-call was Gene Deitch Associates.

Well, people had been after me almost all the time who wanted to set me up in a studio and I had all kinds of different offers. There was nothing much else left for me to do after leaving Terrytoons except to go into my own studio. By that time I had all the reputation I needed, all the connections I needed and people offering me work, so it started out really well. I had gotten a consulting position with the Cunningham and Walsh advertising agency, which gave me a really nice annual income, and they had to develop animation characters for their Folgers Coffee account. As soon as I was developing that, the next thing I was trying to convince them is, now that I've developed the idea, let me do it. So that led to my opening up my own studio and that was my first big account that gave

Great Thoughts of Western Man #8

Deitch on Aesthetics

"I know what sells."

◐ | Gene Deitch Associates, Inc.
◼ | △ | 43 West 61 New York CIrcle 7-1970

for Great Thoughts in Animation

This spread: Jules Feiffer illustrations for Gene Deitch's company.

the studio a basic income.

Of course, I had people who wanted to back me but it turned out I didn't need it and so therefore I didn't have to give away any stock. And I had Jules Feiffer, of course, who came over from Terrytoons and he made a very elaborate series of promotional drawings for me, which turned out to be a really big hit. We sent them out once a week to all the advertising agencies, and they told me they had put them all on their bulletin boards, and so we really got off to a good start with it. That was the time we were doing well, when this unknown person, William L. Snyder, walked in to my office and gradually pulled me into the idea of going with him to Prague and that, again, changed my life. That studio hardly was really off the ground before I basically had to abandon it.

Great Thoughts of Western Man #1

Deitch on the Acquisitive Society

"I own my own Hi Fi
I own my own tape recorder
I own my own sports car
I own my own animation studio
I need work."

Gene Deitch Associates, Inc.
43 West 61 New York CIrcle 7-1970

for Great Thoughts in Animation

This would have been around '59, correct?

That was 1959 when he came, yes.

Now, William L. Snyder was quite a character.

He was really quite a character. He was a guy whom you would have so many mixed feelings about, because Bill Snyder was really a fascinating man but, on the other hand, he was totally impossible to deal with. He had so much charm that you could hardly resist him. And certainly women couldn't resist him. Zdenka loves him today in her memory, because he was a guy who really made it with women. But, on the other hand, he gave me lots of trouble. So I do have these mixed feelings about him because he brought me here [to Prague], he introduced me to Zdenka, he changed my life. So it's impossible for me to say I hate him by any means, but he did give me an awful lot of trouble.

Nevertheless, he is a key figure in my life and of course

I became also involved with his children. His daughter, Dana, who suffers from multiple sclerosis, writes a weekly column about her life fighting this disease. And his son, Adam Snyder, who *looks* like him but has a completely different personality, turned out to be really a good close friend and we've had many projects together.

He [Bill Snyder] struck me as a lovable rogue.

Yes. He's a lovable rogue. I think that's Bill Snyder, all right.

Now briefly, he cajoled you into going to his animation studio in Prague for what was going to be a short stint, correct?

Yes. When I finally agreed to go, I said, "I've got to have a contract in black and white that says I don't have to stay more than 10 days."

What was the specific project you were going to be doing over there?

What he wanted me to do was to help him correct some films that he had in work here with Zdenka. The reason I accepted was because he also agreed, that if I would come, he would back the production of "Munro" and one other project that I had created with my best friend in New York, Allen Swift, called "Samson Scrap and Delilah."

Jules Feiffer was working for me and he had created the storyboard [for "Munro"]. It was on my studio office wall, and was almost getting brown with decay waiting for somebody to come in and back it. So of course, when Snyder said that he would finance "Munro," that was the offer I couldn't refuse.

"Munro" had been published as a comic.

As a book. It was one story in a book which was called *Passionella and Other Stories*. That was the first thing that Jules had been able to get published. So he was working on that story, sort of moonlighting, when he was on my staff at Terrytoons, but he managed to do it off-hours so it didn't fall into the clutches of Terrytoons. Eventually, Jules made the storyboard himself and then Al Kouzel made the production layouts. I was really very close to being able to get this into production. All I needed was the money. Getting to the storyboard part didn't cost very much.

Visually, the animated cartoon hones very much to Jules' cartooning.

Oh, yeah. Of course, the one thing that I was trained

in at UPA is following whatever graphic style was right for each story. If we adapted a children's book, we wanted to make it look exactly like the book. And I'm doing that 'til this very day. That's the basis of my work. I've learned how to recreate anybody's drawing style. I keep telling people there's no such thing any more as a Gene Deitch style. You saw it in *Terr'ble Thompson* and *The Cat*, but nowadays, very, very rarely do I ever get a chance to make a film in my own style because what I'm paid to do 99 percent of the time is to adapt a children's picture-book.

Now Gene, let me ask you a question about that. That seems like a serious trade-off.

It is.

You can get some satisfaction by imitating some else's ...

I do. Not many animators feel that way. Everybody wants to do their own thing and I do from time to time.

If I have a chance I do. I made a film called "The Giants" which was a definite Oscar contender but wasn't correctly entered. That was my story, done my way. Occasionally I do have a chance. I've done a few films. Of course, the Nudnik character that I did for Rembrandt films, which was distributed by Paramount and also got nominated for an Oscar, was my style and my complete story and my design. Whenever I do get a chance, I go for it.

But, of course, having to make a living, I'm finding myself becoming a specialist and Weston Woods was selling me as the world's greatest adapter of children's picture books, so I've gotten into that schtick. Authors who give me the opportunity to adapt a book of theirs know that I'm going to be true to their book and that when it's on the screen it will look like they did it themselves. Look at *Where The Wild Things Are,* Maurice Sendak's most famous book: When we brought Maurice here to Prague to approve our first test, Morton Schindel, who was the creator/producer of Weston Woods, after the screening,

Gene Deitch working on the animated *Where the Wild Things Are*: courtesy of Gene Deitch.

turned to Maurice and asked him, "Can you tell which of the scenes or which of the drawings in the test were yours and which were theirs?" And Maurice very seriously said, "I'm pretty sure that's mine, but I'm not sure of the other, but I'm sure this is mine, definitely this one is mine." And, of course, none of them were. *[Groth laughs.]* So that was what really sold him on letting us make the movie. We did it 100 percent.

That's one of the things that also fixed me on Prague when I got here and got into the studio. Even though I had all these trepidations about coming to a Communist country, when I saw what these guys were doing, that they were just animators and without having any of the same experiences of Western ways of working, they're doing exactly what the UPA philosophy was, and that is adapting the work of the best designers. They also didn't have a house style, and still don't. They bring in the best designers, the best illustrators to do films. They don't have a house style. So this is something I do take pride in. I don't mind being in the background. Everybody knows that I made the picture. I made four films with Tomi Ungerer, the great Alsatian-French children's-book author-illustrator. He told me, "Look, Gene. I made the book, you make the film!" He had faith in me, and when he saw our result, he slapped his knee and he said, "My God, it looks like I did it myself." That's great satisfaction to me.

Let me ask you this, though. Is there part of you that regrets not making more pure Gene Deitch work?

Yeah. There always is, of course. As I said, my favorite personally created character was Nudnik. It did get a Paramount release. The first film was nominated for an Oscar. Nudnik could have gone on, but unfortunately theatrical cartoons died just when it was running. There's no such thing now as theatrical short cartoons. Short cartoons now are made mainly for film festivals. You have to get a grant or a financial backer, or save your money half your life, and you're lucky, you make one film and it wins a Golden Pussycat at some festival and that's it. I've been lucky that in my career of over 60 years I have never been out of work, even for a day. And one film just blends into the next. And that, of course, is important. You're trying to make a living. I've found the key to how to make what I think is creatively gratifying and also satisfy my clients. What more can I ask for?

"Munro" won the Oscar in 1961. That must have been enormously gratifying.

Of course it was. And it was a tremendous surprise because I didn't bother to go to L.A. for the ceremony.

Bill Snyder picked up the Oscar because he was the nominal producer. In those days, and still, the Oscar for a short film goes to just one person. Snyder simply entered "Munro" on his own as if he had made it, and it won. So my Oscar has his name on it. That's the truth.

In making "Munro," I believe, you used Seth's voice.

Yes. Seth was 3 years old at the time and I had an early home tape recorder at the time, as I mentioned before, and I followed him around with a microphone and I said, "Now Seth, say 'I'm only 4, I'm only 4.'"

And he said, "But Daddy, I'm only 3. I can't lie."

So I said, "I know you're only 3, but this is make-believe. Say 'I'm only 4.'" It took a lot to get him to do that, but he did say it. He could even pronounce the name "Czech-o-slo-vakia" at the age of 3. He was really an early speaker and had a charming voice. As far as I'm concerned, he made the film.

In Prague, not to put too fine a point on it, basically you fell in love.

Exactly, that's not too fine a point: almost immediately. The irony is that every week, when Snyder was coming to my GDA office on West 61st Street and was giving me all kinds of propaganda about how great it was, and I should go there and I was pushing him out the door each time, he actually said to me, because he was a great womanizer and that was one of the great thrills of being, in those days, a European traveler. You could do a lot of things your wife didn't know about. He actually told me, "Gene, there's a little girl there, an animation production manager, who you will love." So that's one of the great ironies of my life.

I said, "Bill, that's a lot of bullshit. Don't give me that." *[Groth laughs.]* But it happened, that's the amazing part.

At some point, you had to take the big leap and you had to make a decision to leave your wife and to leave your family.

Exactly. This was, of course, wrenching. I'd had a tremendous amount of conflict with my first wife. She was somewhat fearsome-tempered and very aggressive, especially when I was doing the comic strip or trying to do anything I believed in, but that affected our home life. First of all, she was not an artist herself. She was a great reader, a great intellectual, but she didn't really understand my work at all. With Zdenka, we're colleagues. We work in exactly the same studio and we're working on the same films together. Whatever conflicts we have, they are all leading towards the same goal. Marie had no real

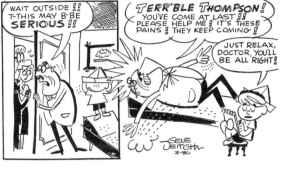

The Mar. 30, 1956 *Terr'ble Thompson* strip. [©2006 Gene Deitch]

appreciation of it. For example, the fact that I wanted to do a comic strip was something that was a threat to her, that's all. Who knows if I ever would have divorced her; I don't know. We did have three kids together, and if I had opted out of Zdenka, perhaps the marriage would have held together at least for a certain amount of time. Dunno, but the real wrenching thing was leaving my kids. I had three interesting boys. Kim was a latent genius and so was Simon and so was Seth, each in their own way, although Seth was still a baby. But, as I said, he had tremendous charisma. He remembered everyone's name. When he was 3 or 4 years old and the doorbell rang and the door opened he'd say, "Oh, hello Bill! How are you?" He remembered everybody's name. He was really fantastic. That's why he became a writer, I guess.

As someone with a son, I would think that would have to be a terrible conflicting…

It was. It was really difficult. You did see the photograph I sent of Simon laying there with that rope cat?

Yes.

That was really one of the most fascinating and revealing photographs I was ever able to take, and it shows an awful lot, right in that one shot, about the graphic feelings within him.

When you made this decision, did you sit your kids down and explain to them what was going on?

Oh yes, of course. I had to. The most difficult part was first to tell Marie. She threw a bottle at me. *[Groth laughs.]* That explains my mental instability.

I guess that sums up her point of view on your decision.

But naturally I could explain only so much. It wasn't anything I could explain at all to Seth. He was still a baby

— or really much to Simon. But to Kim, yes. And I kept very closely in touch with him. First of all, as I said, I brought the first stereo tape recorder to Prague almost immediately and I developed a sound correspondence with Kim. That was the most fun. I made funny little pseudo-dramatic tapes, 'cause I was big on sound effects and I knew how to do all this as a filmmaker. I know how to edit tape. I put in music and I put in sound effects and I made a tape in which I was supposedly an African explorer and put in all kinds of jungle noises and everything like that. I tried to keep them entertained. I sent them these tapes and Kim would then send back in his own way. Kim got from me the idea of collecting records from the 1930s. That also contributed to his schtick. So he would send me records and I would send him records and so on. So we did keep in touch. We also wrote letters. Kim had really terrible handwriting. It took him a long time to learn how to write legibly because he was mainly using drawing. But we did exchange letters and even phone calls, although that was very difficult in those days. And, don't forget, it isn't that I just came here and never appeared again. In those days, I was traveling back and forth several times a year because we had to record voices for our films in New York. So every time I went there, I had my visiting rights and I took the kids and we would do something together. And later, when Zdenka was allowed to travel, we also got together with the kids, so they would get used to my being with her. That was really difficult. Zdenka will tell you, one of the real funny things is when Seth was 7 or 8, we took him to one outing with us and he went up to Zdenka and he said, "My mother doesn't like you." *[Groth laughs.]* Kids really say exactly what's on their mind straight out. Of course, we thought that was pretty hilarious. But those are the kind of things we had to live with and it took a while.

As the boys got older we don't have any kind of problems like that. There were many embarrassments, too.

There was a demented idea I had at the beginning, that if Marie would come here and see this place and see Zdenka, then she would understand: *[laughter]* a pretty dumb idea. That was a disaster.

She went? [Incredulous.]

Yeah, she did come. But, of course, I promised her that I'd take her to Paris, and I did. She liked Prague and she did meet a couple of the people on our staff, a woman film editor I worked with, whom she liked very much and they corresponded for a while. But as far as Zdenka was concerned … But you go through really crazy things when your whole life is being torn apart. We're just happy that it all worked out. Look, Zdenka and I are getting very close to our 50th anniversary of being together. Marie definitely thought this was a fling: I would get over it and be back.

But the bottom line is that you guys just weren't getting along.

Well, obviously not. She figured if she got me to a psychiatrist, then I would see the light and be OK. That just wasn't my thing. Everybody's got something. Everybody's got their own hang-ups, but I believe that I can function.

Getting back to your animation in Prague, you basically went through a succession of commercial gigs.

Yeah. Once I fell in love with Zdenka, with Prague and with the group of people that I was working with, I was willing to take anything that Snyder could bring in, just to be able to stay here. And, of course, when we won the Oscar that opened the golden doors. The first result from winning the Oscar was that we got the *Tom and Jerry* series from MGM, so that was really big time. That was the biggest big time I ever got into. And we did the 13 *Tom and Jerry*s, then we got the offer from King Features Syndicate to do *Popeye*. I can't even remember how many *Popeye*s we did. Then *Krazy Kat*. Not necessarily the way I would have liked to have done it, however. I did everything I could to do the *Popeye*s in the Segar style, but you're up against tremendous pressure there because 99 percent of the public know Popeye from the Fleischer cartoons. So it was definitely compromised. Same thing with *Krazy Kat*. *Krazy Kat* is so poetic and there's so many conundrums in there — like, is Krazy Kat a boy or a girl? And it's difficult because Herriman always referred to Krazy Kat as he but clearly it was she. So you had to make a decision when you're making a cartoon film, so I definitely played Krazy Kat as a girl. And I tried to keep it as close as possible to the Herriman style but again, you've got a lot of writers

[©2008 Gene Deitch]

writing stories and they have to go for commercial television, so I'm not going to say that my *Krazy Kat*s were anything in the poetic level of Herriman, or the *Popeye*s were anything like Segar. Nevertheless, I did try.

But look, I was just wanting to stay here. I wanted to keep busy, so we did those things. Then when we got the Paramount release, I was able then to create my own character, which was Nudnik, a character pretty much based on my own clumsiness. He was the ultimate clumsy character and my favorite creation. I still love my Nudnik films. One did get nominated for an Oscar. I feel Nudnik surely could have been successful if the actual cartoons had maintained themselves. But it was too expensive to make for television and so we got off on to other things. There were several attempts to revive it. Adam Snyder managed to get a deal to make something called *Gene Deitch Presents the Nudnik Show* and we did a series of half-hour shows but each one of them only had one *Nudnik* in it and the half-hour show was filled out with other things. The woman who was so hot to promote it, who

Tom and Jerry art: courtesy of Gene Deitch. [©™2008 Turner Entertainment Co.]

was supposed to be a crackerjack syndicate saleswoman, told us that we were going to create "Nudnik mania" in America, "It's going to be tremendous!" she promised me. But while we were still in production with it, she was lured away to another job and the person who took over was not able to put it across. That's show business. That's the way things often work.

You did 12 *Nudnik* episodes.

Yes. Twelve or 13, I think.

I haven't seen them. Was it a slapstick?

No. It's hard to describe Nudnik. Nudnik was a guy who, if he leaned down and tied his shoelaces, he somehow got his thumbs caught in it, he couldn't stand up. He also could take a can opener and open a can of food from the top, but all the food would fall out the bottom. Anything that he did turned out wrong. There was a series of gags, all, you could say, developed from basic ideas from Laurel and Hardy and Buster Keaton. Many of my gags were more or less in that style: big mechanical gags. Once Nudnik was putting an antenna up on a roof. He got a ladder that was much too high and when he got up on the ladder, the ladder tipped over and lifted up a stone so that he's rocking back and forth on this ladder and as he moves forward, the stone flops more towards the middle and if he moves back the stone moves the other way. This is pretty much a Buster Keaton kind of a gag. I loved to create mechanical gags like that.

You did some *Tom and Jerry* cartoons, but you objected to the violence in the earlier *Tom and Jerry*s.

Yeah. I'm a UPA man and I always looked down on *Tom and Jerry*. There were definitely things in *Tom and Jerry* that I absolutely refused to do. One was using the

black woman housekeeper. This was all through the *Tom and Jerry* cartoons. You never saw her head, but you always saw this black character. That, of course, was a no-no. Naturally you do have to use violence, but I tried to do it in an intelligent way. I get fan letters today, I got one yesterday, from somebody who says he thinks my *Tom and Jerry*s are the best. But, on the other hand, if you read any book on animation made by a critic, my *Tom and Jerry*s are always badmouthed as the worst ever made. They're not as bad as the ones Chuck Jones made, I swear. *[Groth laughs.]*

Your *Tom and Jerry*s definitely had that elegant UPA design work.

I tried to make it best as I could, but I had to make it look like *Tom and Jerry*. And I had lots of different writers contributing the basic ideas, although I reworked all of the stories myself and I did all the layouts and all the poses and I really got pretty good at drawing Tom and Jerry. It was OK when it ended. That was a great learning experience, but it was not really my kind of thing.

One of the things that I think you were most proud of was *Giants*.

Yeah. *The Giants* was a film which was really a tragedy because this was a film that very likely could have won the 1968 Oscar. We made it in 1968, it was banned in Czechoslovakia but was a co-production and therefore Morton Schindel had the rights to it. But he was strictly making films for schools and he had no experience with an entertainment film and he bolloxed up the Academy entry requirements to qualify for the Oscar.

Now Mort Schindel was also a character...

Morton Schindel is a really dedicated man and working with him came about in an amazing way. When I was at my big-ass job, creative director of CBS Terrytoons, we were doing 18 Twentieth Century Fox CinemaScope cartoons a year, we were developing *Tom Terrific*. I was a big man there, I had a secretary and the secretary says, "A man named Morton Schindel called and he wants to see you." I'm busy, but he sounded sincere, she said, on the telephone. So I let him come. He came in and in his sweaty palm he had about six 16-millimeter prints. So I took the time, took him up to the projection room, projected these films. They were just 16-millimeter camera panning over the actual pages of a children's book, no animation whatever, with nice narration and nice music but really simple. So here we are, doing these big CinemaScope cartoons, Twentieth Century Fox, etc.

So all I could do was just feel sorry for this guy. I said, "You've got something really that has value, no question about it but, in the commercial world, who is going to put on these films." In order to make it sound like something, he called his films "iconographic," which simply meant that a 16-millimeter camera was panning over these illustrations and zooming in on them and dissolving from one to the other. They were really lovely stories, nicely presented, but I really felt sorry for this guy. There was absolutely nothing we could do for him.

But just as he left, I suddenly got something into my mind. We were right in the middle of producing *Tom Terrific*. We were at least six months away from completion and I was getting calls every day from the *Captain Kangaroo* office saying, "When are we going to get *Tom Terrific*?" So I said to Mort, "They're desperate for something to put on. Go there." And I called Keeshan and told them Schindel was coming. I said, "Here's something." The only place in the world I could think of where these might go would be on *The Captain Kangaroo Show*. And they actually bought all of his films that he had made at that time, which was about 12 and they were showing them every day. And when we finally got *Tom Terrific* done, they didn't take his off.

So this put Morton Schindel in business, and then, by chance, and I forget exactly how, he got the idea or he got the suggestion to try to sell his films to schools, and that led to his creation of Weston Woods and that became a tremendous success and he became the first person to successfully produce audio-visual material for schools and libraries. And Weston Woods became a really successful company. So successful that he began to get requests for real animation. His iconographic films were no longer sufficient for the schools and libraries.

And he remembered me: that I gave him his first chance, and he looked me up — and I'm still working for Weston Woods. In the meantime, Mort, about five years ago, finally sold Weston Woods to Scholastic. So, in fact, I'm working for Scholastic, Weston Woods-Scholastic now, as it's called.

You made many, many children's book adaptations for Weston Woods over the yearas.

Yes. By this time about 40 for Weston Woods.

Including books by William Steig and Crockett Johnson.

Yes, that's it. Every major book illustrator, writer you could name, we did. Sendak, as you said. Tomi Ungerer

From *The Giants*: courtesy of Gene Deitch.

Charlotte and Templeton model sheets from the *Charlotte's Web* project.

and Crockett Johnson, Dave Johnson, Tomi de Paola, Doreen Cronis, Jules Feiffer and now with Rosemary Wells, who is one of the most successful book illustrators of all time. She's published 170 books, if you can believe it. So many.

Would Mort Schindel approach the author or their agent and then cut a deal and then talk to you?

Yeah. In the beginning, the authors and the book publishers were so eager to have their books adapted as films, which they saw as great publicity, that they would give him rights for something like 50 bucks, you know? It was easy because it was a great thing to have your book made into a film at no cost to them and something that would publicize the book. And, of course, the thing was that he was able to convince them, and it was true, that we would absolutely be true to the book. So, on this basis, he was able to really become the king of this market and for a long time Weston Woods was practically the only com-

pany making films for schools and libraries in this way, and they still are the leading one. Now with the Scholastic connection, of course, more than ever, they're the most powerful distributor and producer of audio-visual materials for schools and libraries.

You were also involved in animating a version of *Charlotte's Web.*

Yeah. *Charlotte's Web*, of course, was one of the great experiences and of course a greater disappointment. I have to start right out by saying that the recent film of *Charlotte's Web* is perfect, and that's the way it should have been done at the beginning, but it wasn't possible to do that in those days. It wasn't possible. The special effects weren't that well developed.

I know that Andy White, E.B. White, would have really loved that film because it was really true to his story. But I wanted to do my very best, and the great thing in my life was meeting him and working with him. He was

a fantastic guy. Without question, one of the great writers and creators in American literature. It was a great honor for me to be working with him and we got along really greatly. We had a wonderful correspondence. We really understood each other.

But we were caught in a real typical Hollywood tiger production company. They were ruthless, absolutely ruthless people who had no respect whatever for his work. They really wanted to bastardize it. What they ultimately did, when they took the project away from me, was give it to Hanna-Barbera: and if you've seen that, that was a disaster, and I would say that that basically killed Andy White. He just didn't know what hit him.

He was a brilliant satirist and a writer, but he was absolutely naïve in the ways of the film business. And you know when he made the contract with Sagittarius Productions, these are the Darth Vaders, he insisted on only one thing: That he would have the right to approve the model of Charlotte. I mean, can you imagine? He didn't have approval of the story, he didn't have approval of the adaptation, he didn't have approval of the music, who would do the acting, who would animate it, anything. He only had the approval of this one thing. The model of what Charlotte would look like: the spider.

He was just raped. It was terrible. It got to the point where Sagittarius did not allow me to show him anything of the script we were writing or anything we were doing. It was really devastating.

It was such a great thing to be in touch with him. His wife was also a great person. He was "Mr. New Yorker" basically, in those days. He lived in Maine, you know: in Brooklin, Me. He just was completely isolated from the real world. He had a big barn and he loved working in the barn, the animals. I think he really did talk to the spiders: a fascinating man.

Throughout your time in Prague, from 1960 to today, how did you interact with your kids and what was your relationship with the three of them like?

I think I mentioned before that I did correspond, especially with Kim and then later with Simon and Seth, as they grew up. And, as I said, I went to America at least three times a year, sometimes more. I only wish I could have been physically more with them. Kim actually did come to visit Prague. He was the only one I was able to get here.

And how old would he have been, and when was that?

I think he was 17 when he came here, something like that.

Did you follow your kids' creative efforts from Prague?

Oh yes. Of course, Kim started getting his stuff published, and he was sending them to me. He always sent everything to me. I loved what he was doing from the beginning, although he had, at least up to a certain time, the really nonstarter idea that he was going to make it in the world of commercial art. Look, he makes the comic strips for the books. And that is his work. Then he'll make the same kind of drawings on order for somebody who asked him to make a special drawing for him. And it's still exactly the same thing he does in the cartoons, and that he calls his "fine art." I don't *[laughs]* laugh at him, I don't want to say anything, but —

You're saying that they're the same thing.

It's the same thing. *[Groth laughs.]* But it's just that it's for a different purpose. And so when he does that kind of thing it's "fine art," when he does the other thing, it's work. But look, still, it's him. He is a genius. I mean, he's definitely a genius that has overcome any limitations he's had. He is brilliant. And I never wanted to discourage him from that point of view, but as you quoted yourself, in normal commercial art, he couldn't make it. He found his niche and that's what he should stick to and nobody can do what *he* does now. No one can imitate *him*. Kim Deitch is a brand.

Now, you may say that it's a difficult sell, but one of these days … He's got a real great story saga. Story is what's most important. And I think Kim has that.

Now, when Kim would send you his comics, would you send him critiques? What would be your — ?

Well, sometimes, but mainly I just told him I liked them. And I did. You can ask him about that, because I don't want to say something that's not true, but I don't remember that I made any criticisms of his drawings or his stories. I recognized that they are not my kind of thing, but nevertheless they reflected my childhood, so that fascinated me.

Kim's had a very peripatetic life. He's lived all over the place, and he's moved around a lot. How did you guys stay in touch?

He's made lots of mistakes. He's got weird, crude tattoos on his body. *[Groth laughs.]* Not even the kind that they do today. He's got the kind of tattoos that someone puts on with a pen while they're drunk. *[Groth laughs.]* Yeah, Kim's had his ups and downs. He's had his drugs and everything. But he pulled himself out of it. It's amazing. And he's very athletic. He regularly exercises and

takes care of himself now. He realizes now that he's somebody, and he's got to take care of himself. [*Listens to his wife.*] He has a good wife. Zdenka comes in always with the key lines. I have a good wife, Kim has a good wife. *That's* the key to our success. [*Laughs.*]

Now, how about Simon and Seth? Did you keep in touch with all —

Simon was harder to keep in touch with. He definitely faded out of the picture at different times. Of course, he always gravitated toward the weird. Kim is weird, but weird in a rich, productive way, which Simon was never quite able to do. I think I mentioned that Simon missed his calling: He could have been one of the really great, successful makeup men and special-effects men. This is the thing that really interested him. If only he just hadn't sunk into such bad social habits. This is difficult. I don't know what I can really say about that. It's one of the real tragedies, you know?

When you have three kids, they're always completely different, you can't expect they're all going to be the same. And each one is an individual. There's something about Simon that turned out immediately from the beginning; the way they laid in their cribs was different. Kim would lie on his stomach and sleep peacefully. Simon was lying on his back and screaming [*Groth laughs*].

And there's a sense of powerlessness as a father.

Probably. I don't know why. I don't know if there's any jealousy with he and Kim. They work together sometimes, but sometimes not. There have been times when Kim says he simply cannot work with Simon any more, he's just not reliable. I think you had better get all this out of Kim. Have you done your interview with Kim yet?

I've done two of them, and I have a third one coming up.

Well, what do you think?

Reading all of your interviews is going to be a great *Rashômon*-like experience.

That is exactly it. Everybody can go through the same forest and see three different things. This is normal. I'd be very interested to hear what Kim has to say. I'm trying to be truthful as I can, but I don't want to be negative or devastating. I don't think what I'm saying is really bad. These are just facts that are difficult, yet I know that all three of my kids really, in their own way, have a genius. And I'm very proud of what they can do. And I'm just sad that Simon was not able to realize his full potential and I'm also sad that Seth hasn't been recognized.

Seth was 3 years old I think, when you went to Prague. How did your relationship with Seth develop?

That took time, because naturally, he was definitely being raised by Marie, and I was not her hero. It took awhile with Seth, until he got into puberty. At that time, I think, our relationship warmed up and developed and now I have a wonderful relationship with him. Ask him, don't ask me. I think we have a great relationship.

Now Seth didn't having the drawing skill that Simon and Kim did. He became a writer.

No. He liked to draw, I think. Seth does have a certain graphic skill, but that's not his forte. He's mainly a writer, and a very imaginative writer. And he also had a musical group. And he made rockets. He was a rocket fan: He was making amateur rockets and shooting them up at one time.

So he was a rocket scientist? [Half joking.]

Yeah. [*Groth laughs.*] He made these big amateur rockets. He had a group of people who would go into a field and shoot off rockets. He's done a lot of things.

Do you enjoy his writing?

Yes I do. He's a terrific fantasy writer. Not exactly science fiction, but he's in the Edgar Rice Burroughs tradition of fantasy. He will tell you himself his influences. He's created a parallel world. He created a world in which California breaks away from the United States and becomes an independent country, and he has a parallel history to our history. Very, very interesting, I think.

Well, this whole issue of the *Journal* is going to be Deitchworld.

Deitchworld. OK, well, that's good. [*Groth laughter.*] We all have our own worlds. *Rashômon* is the right phrase there, because all three of us have overlaps. We have lots of interests in common, but we also diverge — why not? We're different people. Kim and I are both interested in 1930s culture, we both are jazz-record collectors: Seth too. Look, I'm 84 and when I tell somebody I have a 64-year-old son, they look at me as if I'm kidding [*Groth laughs*]. Some who see us say they think we are brothers, but those are generally people whom I pay to say that. Though Kim is bearded and, when we were up on the stage together in New York, some who were near-sighted and in the back thought that Kim was older than I. The actual fact is that I am just 19 years older than Kim. And at our age, that

Gene Deitch photograph dated Feb. 28, 2008: courtesy of Gene Deitch.

doesn't seem like such a big difference. If he's 1 year old, and I'm 19 years old, that's a big difference. But if he's 64 and I'm 84 … we're both old men. *[Laughs.]*

You could be brothers, biologically speaking.

Yeah. We could be. I like Kim very much: I have a good relationship with him. Simon is very difficult to communicate with. There were issues between us, but I think that's all over and we're now fine, but he is sensitive to any perceived slight. I want to have good relations with him, and I try for that..

Is Simon prickly?

Prickly? Yes, I guess he is. He's sometimes on the defensive. He has in the past seemed to feel I was either giving up on him or against him or be bad-mouthing him or something. I really don't want to do that.

So he did not get your sweet-natured disposition.

Not like Seth, no. Seth is a sweet-natured guy. Simon is much deeper and he has inner fires. He has inner torments. He's somebody I cannot say I know well enough. He seems to be a recovering delinquent right now. He's doing good work. He's working with children. He's doing good things.

Well, some people are able to corral those demons and use them —

Yes, exactly.

— and some can't.

Well, that's it. Kim has done that. Kim has had his demons. He managed to pull himself out of it. Kim got into lots of troubles and bad angles, and he did get into drugs and so on. But he pulled out of it and look, he does have a great wife.

Gene, do you have demons?

Demons? I don't *think* so. I don't want to psychoanalyze myself: I'm a very *[laughs]* practical person. I have my faults, I have all kinds of nervous twitches, but I don't think I have any demons, No, no, Zdenka says I have no demons *[laughs].*

Just the average neuroses?

Well, I may have, but I don't think I have anything that keeps me from functioning. I sleep nights, I eat well. I have my things I'm proud of. I don't want to brag. I've never smoked a cigarette in my life: I've never taken a single puff, never had any mistresses or outside affairs. On the other hand, I tend to be nervous. I'm tapping on the table all the time, and drumming. But I keep telling people that I'm not tapping because I'm nervous, I'm tapping in rhythm. I hear rhythm all the time. I'm a great music lover, I know music, but I cannot sing, and I cannot play any musical instrument, but I can play hand drums.

Aha. Zdenka says that the demon I have is that I tend to be pessimistic. Zdenka is a world-classc optimist. No matter what I tell her. If I say, "Look, the American dollar is crashing, and we're going to be poor" *[laughs]*, Zdenka says, "It's not so bad." Zdenka will see the bright side of everything. I cannot depress her. There's no way that I can say anything to Zdenka that will depress her. *[Groth laughs.]* I do get depressed from time to time, but I don't think I ever suffer from depression, as an illness. But sometimes I do feel down. I am very sensitive to the news. I mean, I see what's happening to America with George Bush and with Iraq and Mugabe and with impossible people in the world. I get depressed with humanity. But I don't let it slow me down, I mean, I do my work. I've never been in a situation where I can't work or that I go to the studio and I can't — no matter how I'm feeling, or how down I'm feeling, I can still do my job. ∎

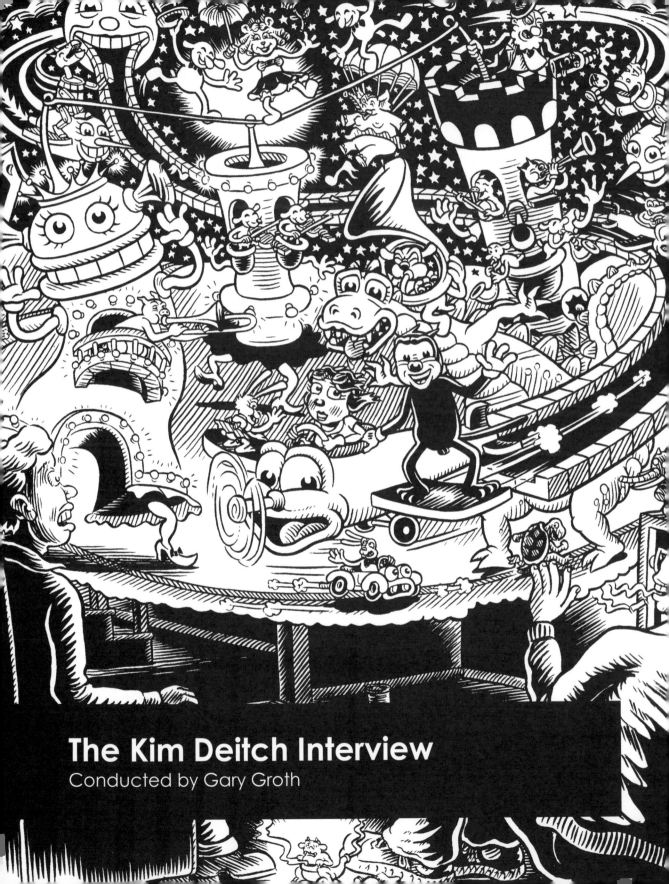

The Kim Deitch Interview

Conducted by Gary Groth

GARY GROTH:
You were born in Los Angeles in '44, and you grew up in L.A. until your dad moved to Detroit.

KIM DEITCH:
That's right. He got a job with Jam Handy.

Tell me what your boyhood was like. My understanding is that you were always drawing as a kid, but not necessarily comics.

Well, I had a great childhood. The thing that was great about childhood was having young parents. They were just full of "gosh! wow!" enthusiasm about the things they were enthusiastic about and I definitely caught it from them. They were always encouraging me about all the things that interested them. They were wild characters. Not wild in a dissipated way, just really intense in their enthusiasm. They had a jazz record party open house every Friday night of the year.

How old were you when you were able to truly experience that?

Really pretty much from the cradle. I remember having a really terrific childhood when I was a little kid in Los Angeles. They were real excited about me being there and so I felt like I was welcome.

When you say they were young, your dad was about 20 when he had you, right?

Nineteen.

And your mom must have been around the same age?

Twenty.

So it was an energized environment?

Definitely. And fun, too. There was always something going on. There were always musicians coming over to the house: always some kind of crazy novelty.

When you were a kid, did you recognize this as being different from your friends' households?

I did. Later on, in fact, it even bothered me, because, at a certain point, you start to want to be like everybody else. I definitely went through a phase of "this isn't normal," and I thought I wanted more of an "Ozzie and Harriet"-type existence, but I got over that.

Opposite: From *The Boulevard of Broken Dreams*, by Kim Deitch with Simon Deitch. [©2002 Kim Deitch]

Kim Deitch, circa 1945-'46, in Hollywood: photograph courtesy of Gene Deitch.

Did you always draw? Did you always sketch?

I always drew, but I don't think it was a foregone conclusion that I was necessarily going to be an artist. I wasn't a child prodigy. I've known a few of those, so I know the difference. I drew, I was interested in drawing, but I was never what you'd call a real natural artist. If I I'm going to categorize myself, I'm definitely in category B. You know, a writer who draws.

Did you read newspaper strips or comics when you were a kid?

I read comics. Yeah, I was definitely looking at comics even before I could read. I read a lot of comics. And I read and looked at a lot of books. My parents had a really cool library and I started devouring the books of theirs that interested me even before I could read. Some of those books were about comics. There were certain seminal books about comics that I absolutely devoured over a period of years, such as *Comics and Their Creators*, and there was another one I remember called *Cartoon Cavalcade*. I just ate those books up.

Did reading those inspire you to draw like them to get into cartooning?

Yeah. I can definitely remember copying the different characters out of *Comics and Their Creators*, for instance. The idea of doing comics was something that got planted in my head early. Once I got over the idea that I was going to be a cowboy when I grew up or maybe own a pet store, yeah, then I was really onto the idea that might be an option. I especially became that way when I was amazingly lucky enough to see my father creating a comic strip right

Gene Deitch drew this Cat cartoon for *The Record Changer* (December 1947). [©2003 Gene Deitch]

in our house. But even before that happened, my earliest memories were seeing him draw those Cat cartoons for *The Record Changer*. He started drawing those in '45. So it was going on even as I emerged into consciousness.

So you actually watched your dad draw when you were very, very young.

I did. And he was drawing all over everything. We had an old-fashioned ice box in the kitchen that he had drawn all kinds of modern-art designs on. Things like that, you know.

You moved to Detroit when you were 5 years old. Was that a culture shock to you?

It was, on a lot of different levels. First of all, the whole concept of winter was definitely a shock. I think we had some kind of snow that didn't stick once in California: but seeing snow and seeing how cold and wet it was, that was rough. In fact, I remember Detroit generally being a rather gray place. Not that I didn't have a lot of fun. Moving to Detroit, and all the moving that my old man did with our family subsequently, I think it had a bad effect on me in that every time I'd meet a bunch of kids I'd be uprooted again, and I think it contributed to my being shy after a certain point. Which I got over, but it took a while.

Your dad was working at UPA. He started working there in '46.

Or '48. Something like that. He was definitely working on the second cartoon, "Robin Hoodlum," I know that.

No, '46, and then he started working with Jam Handy in '49. Were you also as interested in animated cartoons and movies during your boyhood?

Well, I was fascinated by it, yeah. I can definitely remember the first time my father showed me a flipbook and I could see how it worked, with consecutive drawings. He had a flipbook of a rabbit chasing a bee. It just totally grabbed me. I remember getting in trouble at UPA for seeing a pile of cels and flipping them and even proudly showing my father, "Look! It's just like a flipbook!" and catching hell for it.

What was your mom like? Was she very much a participant in the creative energy?

Definitely. The way my parents met was my father was in the Army and she was an airplane-spotter in a defense plant and they were in some kind of a car pool and the reason they got together was because of their mutual interest in jazz. My father was huge on Armstrong and she liked Muggsy Spanier.

Tell me in what ways your mother influenced you.

She definitely encouraged me to get into reading books more than my father did. She was a big reader. My father was a very culturally interesting and bright guy, but he wasn't a big book reader, whereas she was.

What kinds of books are you talking about?

She read everything: lot of psychology books, all kinds of weird modern writers that I wouldn't be particularly interested in. But she encouraged me to get into it. She was a little appalled at all the comic-book reading that was going on in the house. She was also a huge science-fiction fan and there was a massive pile of science-fiction pulp magazines in our basement dating from 1939 on. They liked comics, but they liked highbrow comics. They had the *Krazy Kat* book with the introduction by e. e. cummings and they got all the *Peanuts* books and they had a subscription to *Pogo* that came to the house every month, but Superman and Captain Marvel and the horror comics, not so much.

You've said that your dad was a little obsessed with good taste and he really was appalled by some of the comics you brought home, especially EC Comics and especially work by Basil Wolverton. Can you describe what the dynamic was there? Did you actually bring comics like that into the house and they would raise hell about them?

Yeah. I think there was something about cheesy lu-

ridness that put him off. He was all over me about it, you know, "What the hell do you see in that guy? He's the worst!" I remember one time he went to school and they had all our pictures up on the wall and I had some Wolvertonesque drawing of a guy with his eyes bulging out and he really got on me for that.

So your parents really loved certain contemporary art and popular art, but they were also highbrow in a way.

Yeah, they were really into Modern Art. There were all kinds of books about Picasso and Matisse and all of that in the house, which I never really took to. I cultivated a passing appreciation for some of it, but it wasn't really what was doing it for me.

It's interesting that your dad would work in animation, which is not exactly a highbrow form.

But he was working for UPA, which was definitely a highbrow trend in animation.

From left to right: Kim, Marie and Simon Deitch, circa 1954: photograph courtesy of Kim Deitch.

Right, but *Mr. Magoo* is still not Matisse.

Even that, though, definitely has a Modern Art lick at the heart of it.

Yeah, right. But you didn't quite take to that aspect of their influences?

I couldn't really understand it that well. I didn't even like jazz music at first. I thought that just sounded like a bunch of loud, cacophonous noise. It's only over time that I cultivated a liking for it.

So what kind of music would you have listened to in the '50s?

When I was a kid, I was always trying to find the music that was for me. I'd go through different phases. Of course, we listened to all the yellow Little Golden records with Mitch Miller and little seven-inch 78s and stuff. I don't know: all kinds of goofy things, trying to find out what was good. I remember one time there was a hit on the *Hit Parade* called "The Swedish Rhapsody" by Percy Faith. For some reason, I got into that in a big way and played it over and over again. I'm sure if I heard it now, I'd wonder why. It seems like I wanted to find music that sounded beautiful. For the longest time, I felt like I didn't know what that music was and I couldn't get into it. Over time I've gotten into all kinds of music. I didn't feel like I just wanted to jump on their bandwagon and listen to what they listened to, although, the more I heard it, the more interested I became in that, as well. One place where me and my old man see eye-to-eye is Louis Armstrong; he's as great as Mozart, I guess. Although I don't know enough about Mozart to really make that claim, but I tend to think it.

I understand that Pete Seeger sang you to sleep when you were a kid.

Yeah. I've known him longer than I can remember. He was definitely a presence in the household.

Would you say your dad was a very participatory father?

Yeah, definitely. That was what was cool about him. It's not like he was that much older than us, and he was a kid at heart himself. He was still dressing up for Halloween well into his 20s and he was very easy to trip out. We'd know how to push the right buttons in him to get him to forget what he was supposed to be doing and get off on our wavelengths: A lot of times our mother would have to come in and say, "Hey, what's going on here? They've got to do this and that and the other thing."

Your brother, Simon, was born three years after you, in '47. Tell me, if you can, the dynamic between the two of you. Because you were close in age, were you close growing up?

No. Not at all. I developed an antipathy for Simon really at birth. We fought continuously. I was really not a good brother to him. I bullied him. It always seemed like, "Well, when he gets to be 6, that's a reasonable age. We'll get along then." But I'd keep upping the ante to older and older. It got really bad. We were really contentious, bitter enemies well up to nearly adulthood. It was only when we were adults that we became friends. I remember we took a mescaline trip together, I guess about 1965. Somehow, in the midst of that, we buried the hatchet. Somehow that took. After that, we were not only friends but, for years after that, I would say he was my best friend.

So it took mescaline to do that for you.

Yeah, it seemed to. I just came to the conclusion that it was the dynamic of the situation more than I really had anything against him. Although we've got issues even today. In fact, I'd say we're not really friends today, although I still am a big fan of his work.

Was the antipathy mutual?

Sure it was. I didn't give him any good reason to like me.

So where do you think your hostility toward him came from?

It was probably basic, simple-minded jealousy. When I was first growing up alone in the house, I was really fussed over. I was really treated like the golden child. Then to have him come along, I think it was nothing more or less

than plain old jealousy.

You've said that your father told you that you didn't have the talent to be a cartoonist but that he felt Simon did.

Yeah. Maybe he did.

Was that dynamic playing into it? Were you pissed off that Simon had a more natural gift?

No, I don't think that's true because I don't think I really believed that at the time. I think he does have great gift. In all honesty, of me and my two brothers, at core, I'd say Simon is the smartest of the three of us. I don't think he necessarily does enough with it, but I think he's amazingly intelligent.

Do you think your dad was right that he was more naturally gifted as an artist?

It's possible. Believe me: the guy's got a lot on the ball. As pissed off and annoyed as I was with working with him again on this book, *Deitch's Pictorama*, and as much as I was swearing up and down I'd never do it again, he sent me some stuff for a new story that is just too irresistible to me. I think I'm going to have to do it with him. The guy is wonderfully talented. Part of working with him I really enjoyed was the fact that, yeah, I've got certain things going for me and he's got certain things going for him. They're not exactly the same things. I can learn from this guy. And I've really gone out of my way to do that down through the decades. The thing that disappoints me somewhat in Simon is that he hasn't learned as much as he could have from me, but that's his business and it is what it is.

When you say you thought he was the smartest of the three of you, how do you mean that exactly? There're different kinds of intelligence, you know.

He just sometimes would really floor me out with some really good insights. He's incredibly imaginative. He's a pretty lazy guy, but when the chips are down and he's really got to get out of a situation, he's done some astonishing things. I don't know how much of this I should go into. Like he ended up divorcing his last wife: He didn't really know what was going on with her. He went to a detective and the detective told him what he could do and what he couldn't do and Simon basically said, "Off the record, if you were me and you wanted to do something that would get the result, what would you do?" And the guy told him, and Simon really got himself into gear and did some amazing detective work in rattling out that situation and it utterly astonished me. It would make a great story, too.

From left to right: Kim and Simon Deitch, circa 1949: photograph courtesy of Kim Deitch.

From "Venusian Vermin: A Miles Microft Adventure" by "Fowlton Means" (illustrated by Kim Deitch) in *Corn Fed* #1. [©1972 Kim Deitch]

So he did the detective work himself?

Yeah.

Your dad said that when he was a kid he was a real hell-raiser.

He was.

I mean he was really troubled.

He was big trouble. And he's been in and out of jams all his life. He's a problematic individual. I don't think it's my place to be telling major tales out of school. If you ask him some stuff, he'll comment on it.

Tell me what he was like as a kid growing up and how his being a difficult kid … I mean, were you pretty easygoing, or…?

I wasn't exactly a goody-goody either.

That's what I wanted to know.

Really both of us were skirting around on the edge of delinquency at various times.

Just him more so.

To the point where he's gotten himself in some fairly big jams at one time and another. I kind of wised up. Also, I think I had incredible luck. I've been in all kinds of situations that could have really screwed me up good and always luck was with me.

When you were 7, your parents moved to New York City. Your dad went back to work at UPA and then he started *Terr'ble Thompson* **in 1955. You would have been 11 years old. I understand that watching him work on** *Terr'ble Thompson* **every night was a big influence.**

It was. It was amazing.

Tell me a little about it. Every night he would come home and he would basically get to work?

Yeah, which was hell on his marriage. But it was really a golden period between me and him. When you're drawing comics, sometimes you need all your concentration. Other times, you know, busywork and whatnot and more perfunctory inking, you'd be only too happy to have a little company. So it was really this golden opportunity to get his attention and also, in the process, start learning the fundamentals of what went in to making comics. Clearly that was a seed that grew in me.

And that intrigued you at the time.

It way intrigued me. And he would even go on like, "You know, son, this thing really takes off, who knows, over the years, maybe you could be my assistant."

"Really?! You think so?!"

And in '55, you could have been reading *Mad.*

I was reading *Mad.*

Was *Mad* as big an influence on you as it was on many of the underground cartoonists?

Easily just as big as any of them. Yes. Absolutely. Positively. I loved it. You know, go to the store where they sold it over in Yonkers, we'd have it read before we got home. I just worshipped it.

Basically that's because of the kind of subversive edge to it?

Kids love satire. That's the perfect date and time for it. To me, I think it's like a good ingredient of story, but it gets old fast and has a terrible shelf-life, but when you're 11 years old, nothing seems quite so richly wonderful. Plus, the drawing and cartoon styles of *Mad* just fascinated the hell out of me.

Your dad disapproved of that, though.

No. Quite the opposite. The way *Mad* worked its way into the house was, one time my mother found that issue that said, "Hey kids! You can read this one in school because it looks so conservative!" You know, it had "Starchie" inside. I bought it and, when I was done reading it, I put it under my mattress and my mother found it and she was going, "Kim, what is this? This is terrible! I don't want you reading these kind of books." She was definitely under the spell of Wertham at that time.

Then, less than a year later, we're on vacation and me and my dad are standing at a newsstand and my mother's nearby and there's the issue with the *Alice in Wonderland* cover. Inside: "Gasoline Valley." I pick it up, start looking at it. My father's looking over my shoulder at it and we both really liked it. Talk about an issue that really was reeking with fabulous comics history. So we're both flipping the pages and "Gosh! Wow!"-ing and then my mother comes along and goes, "Kim! You're not supposed to read that book!"

And this was the only time I actually remember my father standing up to my mother. He just turned around and looked at her and said, "It's OK, Marie. This is a good book. He can read this." And after that, the ban on *Mad* was rescinded. It got better than that, too. Not long after that, Harvey Kurtzman got a hold of my old man: wanted to talk to him about doing some kind of animation thing along the lines of *Mad*. Sent him a massive pile of back issues of *Mad*, which he gave to me! I ordered a few more issues here and there from Lafayette Street. I think I just about every one but #5 before it was over.

So your dad could appreciate Kurtzman?

Yeah. He could appreciate Kurtzman. He could appreciate Elder. He definitely dug that stuff. There was a strong element of satire in the air in the '50s, too. You know, Martin and Lewis movies were into that, and Ernie Kovacs and all that stuff. He was into much of that, especially Ernie Kovacs.

Your dad, he was working at UPA while he was doing *Terr'ble Thompson*, and then in '55, he moved to Terrytoons. Did he take you to his office, to the studio?

Yeah.

What was that like?

It was always great. I was in those studios right from day one, even before UPA in the CBS Radio offices. I used to be over there all the time. Terrytoons? Absolutely fantastic! I think they'd been in that same place since 1930. There were all these old-time animators. I found in one closet, somebody had bound issues of all the *Superman*s going right back to the beginning. My father brought home the first issue of *Life* magazine that was lying around somewhere. That place was like a fabulous mausoleum. Plus, they even had tons of old 16mm prints of cartoons. I built up a massive collection of cartoons.

Did you have a home projector you could play them on?

Yep.

At some point you became a teen animator yourself, right?

I did.

Tell me how that came about.

Well, it just sort of happened. I used to make a lot of flipbooks. At one point, this friend of my father, Allen Swift, who was the host of a local *Popeye* TV show, invited me to come on that show and I brought a flipbook I'd made of Bluto dancing: not very good. Then this other kid named Tony Eastman saw me on that TV show and it turned out he was an old friend of my father's and he said, "Dad, I want to meet that kid!"

So it brought us together and we became best friends and started our own company called Eastman Deitch Cartoons. We did some pretty amazing things. I said before I wasn't a child prodigy, because I know one when I see one. Tony was a child prodigy. This guy, at 14, was animating good enough to be a pro and was totally fascinated by it. So we started doing cartoons together. Of course, I was definitely the lesser partner of that association. I made some cartoons and they were all right, but they paled in

Gene Deitch's Dec. 30, 1955 *Terr'ble Thompson* strip. [©2006 Gene Deitch]

comparison to Tony's.

So basically what I learned from that association was that I really wasn't cut out to be in animation. In retrospect, I don't think that was entirely true. I moonlight in animation every now and then. I've done storyboards. I'll do some more, probably. But I wasn't a natural artist and I sure as hell couldn't have competitively been an animator, and that's what I was really learning. Also, the real interest, the deep-down interest wasn't there. I was really more interested in other things than animation. Although it was a great ride, making cartoons with Tony for three years, I could tell it wasn't going to be my vocation.

Did you know at the time that you wanted to be a visual artist? Either a painter or an artist or a cartoonist?

I wasn't sure exactly what I wanted to be. I knew I wanted to do something creative. I think if I could have had my druthers: making movies. But the kind of movies I really liked, they weren't making those any more anyway.

And what were those?

Oh, I'd say silent movies. I was already fascinated by those.

They definitely weren't making those any more.

No, but you'd still see them on TV. If I had been 18 in 1910, wild horses couldn't have kept me away from trying to get into the movies. But it wasn't 1910, it was 1962. I wasn't sure what I was going to do. I went to art school and schlepped around for a while, but I didn't really fit in there, either. I think it's miraculous how it all did play out.

In your teen years you made some movies with Tony Eastman. I'm not sure how old you were when you made *Dial M for Monster* …

I must have been 16.

Fifteen or16. Were you good in school? Were you good academically?

No. My last year I started coming to the party, but really I was kind of a lazy kid. I had very poor work habits. Socially, I wasn't doing very well, either. Over time I got better, but really I was a misfit. Actually, part of what got me into popularity in the school was, all of a sudden, the misfit type started to be more of an "in" type. By the time I was in my senior year, CBS came and wanted to do a show about the most outstanding students in the school and I ended up being in that because they had me cast as like the rebel, you know?

Spirit of Rebellion

Your dad moved to Prague in 1960 and divorced your mother. You're quoted as saying that when he did that, there was a sense in which you said, "Now the party starts," because your dad left and maybe his influence …

Yeah. That's an appalling quote. But it is true that I really came out of my shell to a large extent. I started doing better in school, I started going out with girls.

Was it traumatizing for your dad to split at that point?

I don't feel it was consciously traumatizing, although I certainly wasn't happy about it. The weird part of it, in retrospect, to me was that it was really terrible on everybody in my family except me.

Except you?

Yeah. For some reason I was really the Teflon character in that scenario.

So it was really an emotional holocaust for everybody

From *The Boulevard of Broken Dreams*. [©2002 Kim Deitch]

else?

I feel that. My youngest brother, Seth, wasn't really old enough to feel or understand it, I don't think: Although, you can ask him that.

He would have been 4, I think.

Yeah, he was young. He might have been younger than that even. He was more like 3. It's like I was ready for it. It wasn't like I saw it coming with my parents, but I saw it coming to the extent that, among their friends, it was happening all the time. And also, the record of my family is terrible. My parents' parents, both were divorced. All my grandparents were divorced. Most of my uncles are divorced. My two brothers have both been married and divorced, Simon several times. I think I've got a good chance of breaking that record. But I didn't tie the knot till I was 56 years old.

I was going to say, you've burned through a few girlfriends.

I've burned through a few girlfriends. More to the point, I, somewhere along the line, grew up. A little later than most people, but I finally got to it. Maybe by the time I was 40, I, in some way, began to resemble an adult person emotionally. I really didn't realize how immature I was until I became more mature.

So getting back to the split, was your mother devastated and did that send repercussions through the family?

Oh, for sure. I don't think she really saw it coming: My father, in spite of the fact that he liked jazz and had a big social life, he wasn't a real debauched person and he wasn't a real partier. I severely doubt he'd been any kind of a chaser before that.

Notwithstanding his love of jazz, he was not a womanizer?

No, no, no. And if he was, boy, he sure made a best-kept secret of it. I just don't think it's so.

When he made his decision to move and to divorce your mother, did he take you aside and explain what was going on?

No. Nobody really gave me a straight story for a while, which made more tension between me and him and, to a lesser extent, my mother, but not quite so much. And I was seeing what was going on with her. She started going out with other guys. I don't know. I wish that it had worked out. Simon can tell you some stories about that.

So the only tangible effect it had on you was that you came out of your shell a bit more and became more social.

I just suddenly felt somehow freer and more liberated. What that may mean in terms of my relationship with my father, I'm not exactly sure. It's not like we don't have a good relationship now. It's not like I didn't have a great childhood while he was around.

When you were 15 or 16 were you still feeding to some extent on his creative energy? Were you still tapping in to that?

I must have been. In a way, that might have been something of problem. When I really took on animation, it became pretty glaringly clear that I really wasn't cut out for it. If I was ever going to be in animation, it would have been this weird nepotism, fourth-squeezing-of-the-grape kind of situation. And there's a lot of that that goes on in animation, too. As far as that goes, I was already working in animation. My first job ever was assistant photographer for some outfit in Midtown Manhattan called L & L Animation and I put in plenty of time on vacations working

for Gene Deitch Associates. So I was already drifting into it while he was around.

What kind of work would you have done for them?

Mostly running errands. Occasionally, opaquing cells. Nothing creative.

You said after your father left you started drifting towards becoming a beatnik. Can you explain what you meant by that?

Well, look, everybody was kind of drifting towards becoming a beatnik at that time. It was in the air. There was a spirit of rebellion, and I was on board with it. Just like any kid, I was looking for new experiences, kicks. As a kid, my idea of how to live was to try anything — anything and everything — at least once.

At that point, what were you rebelling against?

When you put it like that, maybe rebellion is the wrong word. Sure, I was feeling like, at school there're a lot of squares around here and all of that. But I wasn't feeling that negative about it. It was more like I just wanted to get out and try stuff and have a rich life experience.

That was the time of *The Man in the Gray Flannel Suit* and *The Organization Man*. People were wanting to drift into corporate environments and you were maybe rebelling against that whole mindset.

To some extent. Of course, that was looking starchier and starchier, and I was just a slob of a kid anyway, you know? A layabout, not looking to move my ass any more than I had to, which is what I had to overcome.

You probably graduated high school in '62, is that right?

Yes, I did. And it was tough sledding. But I got through and I graduated.

Didn't you say you flourished in your last year?

Yeah, I did.

Now, oddly enough, you said you were actually interested in joining the Army.

That seemed like an option, yeah.

Because you could get around and see the world. But, of course, the Army would be antithetical to the beatnik aspiration: I mean, the regimentation and …

Yeah, but deep down inside I thought maybe they could help me overcome some of these essential faults that were in me. Being too sloppy, not being organized enough, not really having a very good work ethic. I knew these were things I was going to have to overcome if I was ever going to really amount to anything.

So you were self-aware to that extent?

Yeah, I was.

That's amazing for an 18-year-old would-be beatnik.

That's one of the reasons I went to the Merchant Marine. I thought if I could just work like a regular working man, this would be a good thing for me. Set a good precedent.

Instead of going into the Army, you attended Pratt Institute.

Yeah. I drifted into Pratt Institute. I couldn't get out of elementary algebra in school. The third time I took it I cheated and got good marks for the first semester, but then I lost my nerve and flunked again. So Pratt Institute was one of the few colleges that I knew didn't care whether you had algebra and geometry. Plus, I had a buddy there, so I'd already seen the campus. It was really nothing more than that.

What did you actually study at Pratt?

Foundation art the first year and I was in graphic arts the second year. The first year, I nearly flunked out, I was such a bum. And also, all the cartooning that was in my style was really going against the grain of most of the teachers there. But my second year, I ratcheted it up. I could have easily graduated from Pratt. That wasn't going to be a problem. It's not like I was going anywhere there. I still hadn't figured out what I wanted to do or who I wanted to be, so one night when I went out drinking and I met a Norwegian seaman, and he started telling me all the fun he had traveling all over the world and how easy it was for even somebody like me if I had just a passport to do it — Oh, I was out of there.

Lord Kim

Did you just meet this guy spontaneously in a bar?

Yeah. I was just sitting there drinking in some bar and there's this loudmouthed kid. He might have been a year or two older than me. I think he was Norwegian. He spoke English well. He just laid it out for me and I said, "Man!" I finished off my sophomore year. I took a leave of absence, I didn't drop out. And in very short time I was

off on a six-month cruise to the Far East. For a 20-year-old kid, it was just the thing!

Positively Conradian.

Yeah, I was reading some Conrad while I was on the boat. One of the things that my mother did, I wrote her a letter … at that time we were very close. I actually told her I consider her to be my best friend at the time. She was so touched by that, she sent me this box of books and, cultural louts that most seaman are, it was like treasure. I read every fucking book in that bunch. Scared up a few others. That was really not the beginning of my being a big reader, but it definitely pushed it forward. I definitely read like five Conrads.

Like *The Secret Sharer* and *Typhoon*?

Those were definitely two of them. *Heart of Darkness*. I forget what else. It was one of those Readers that had a bunch of novels and stories in them.

First of all, tell me what the hell the Merchant Marines

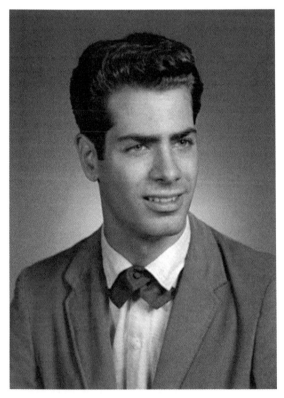

Kim Deitch's high-school graduation photograph: courtesy of Gene Deitch.

are. I've heard about them for years, but I'm not sure what the Merchant Marines really are.

It's like tramp ships that pick up cargos, deliver them places, pick up other cargos, deliver them other places and it just goes on and on like that. The American Merchant Marine, which pays very well, is bitchin' hard to get into. You have to go to seaman schools, which basically is a big scam. You're in some place in like New Orleans working as a cheap longshoreman for a while until you get a certain card that says you can get on a ship. But not so with the Norwegians. The pay is shit. I think I got like $53 a month and some overtime, and the food was lousy, but hey, a ticket to all over the world!

I was going to ask you how the hell you qualified for being on a tramp steamer.

Well, I was, like, at the bottom rung. I was like a deck boy. That's where you start. You start as a deck boy or an engine boy. I was out on deck and working and I was smart enough to mind my own business, so I didn't get in any big fights or anything. Boy, I saw more stuff like that than you could ever shake a stick at. But it was wonderful. I signed off in New York six months later. I joined the Norwegian Seaman's Union somewhere in there and I kept my dues up for a couple of years, figuring I was going to go back again. But before that happened, underground comics did.

So was the six months you spent there as interesting and romantic as you anticipated?

It was a little of everything. On the ship, hard, grueling work like you can't imagine. I guess the first two weeks, I was just down in some oil hold, scraping rust off the sides of the hold and when we'd come up, we'd be orange-colored. So that wasn't so great. None of the work was so great, but, you know, you went to Japan and Hong Kong. And women. That was great. And seamen themselves, some of them are nice guys, none of them were much to speak of in the way of culture, but another book my mother sent me that was just terrific at that time was *Japan on Five Dollars a Day* by John Wilcock, who ultimately turned out to be one of the founders of *The East Village Other*. That book was like a treasure trove. It showed me all kinds of interesting things, over and above whorehouses, that I could find in Japan. Also, it had a fantastic glossary in the back, which was a beautiful foundation to learning the language, which I built on by getting some dictionaries and practicing it on the street with people. I'd say I was in and out of Japan and a lot of different port cities for about two months.

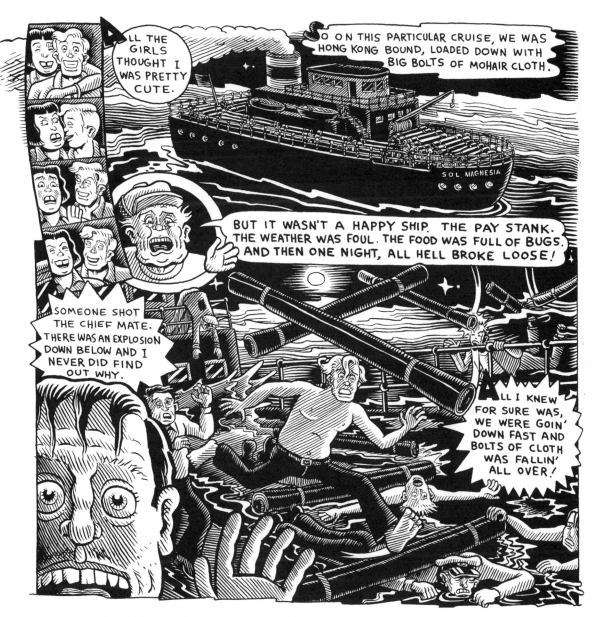

From "The Stuff of Dreams" collected in *Alias the Cat*. [©2007 Kim Deitch]

That sounds like a great experience.

It was wonderful. And it got me into a more freed-up state. When I was done there, I didn't know what I wanted to do next, but I knew I didn't want to go back to art school. After that, I just tried different working-stiff jobs, again with the idea that I had to build up my ability to learn how to work.

Tell me about your karate class.

Oh, it was a disaster. Some of the books I was reading, I'm ashamed to admit, were all the James Bond books. First one of those I read, my immediate reaction was, "Man, this is better than Mickey Spillane!" Although it was like it, strangely, too. But, you know, they're both great. But I really bought into that whole James Bond thing.

One of the things I did see a lot on the ship was some real heavy-duty fighting going on all around me. There was even an attempted murder on our ship. Interestingly,

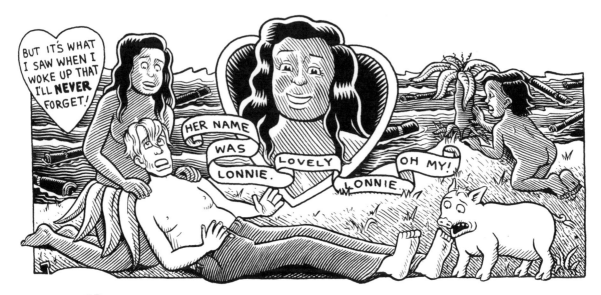

From "The Stuff of Dreams" collected in *Alias the Cat*. [©2007 Kim Deitch]

no one ever bothered me. If you didn't act like a wise-ass, no one was really out to bully you. In fact, everybody was kind of fascinated by the fact that I was American. But I thought, if I'm going to be doing this sort of thing, I've got to learn how to kick ass, because it's clearly part of the deal. So, as soon as I got out, one of the first things I did was, I went to karate school. Well, I was a disaster in karate school. All the *katas* [forms], I thought they were really beautiful. I've got a real respect for it. The teacher, some Puerto Rican guy, I really loved watching him go through all the stuff, and he was a nice fella, too. But I wasn't getting it. In fact, I was even getting hurt and I was getting to the point where I was starting to dread going to the classes, but I had already prepaid for this big course. I hung on as long as I could, but it was a dead end for me.

Plus, more than that, I realized one thing that I didn't have that was really essential is that killer instinct. I've got a major temper. I could get into fights where I almost think I could kill someone, but it's not something I'm looking to cultivate. Fighting is stupid.

You have a temper? I'm not sure I've seen that.

Well, I try not to let it show. I think it's weakness to just be flying off the handle. To have a major blowout with somebody, it might be the right thing to do one time in a hundred, but every other time it's the wrong, inept and a stupid thing to do.

During and after your short stint with karate, you worked a succession of shitty jobs. You were a stock clerk at Macy's.

Yeah. I was very good at that. I was a hard worker. I was getting that hard-work thing together. And the other stock boys hated me for it.

Then you finally became what I understand to be a psychiatric aide at New York Hospital in '65?

It was the beginning of my art career, almost the beginning of my undoing and very, very interesting. It's amazing that I haven't used more of those things I saw and experienced.

Tell me how you got that and what it was like.

I got laid off from my stock-boy job at Macy's and I got laid off working in a hardware warehouse, which really crushed me because I was *really* trying to do that job good. Then somebody just mentioned, "There's the New York Hospital over there and you could probably get a job there." So I went over and I walked into the place and when I walked in, it was just amazing. I felt liked I just walked into the year 1930, walking on these red plush rugs. You'd walk over to the wall and there would be a picture of Bobby Jones sinking that famous putt in 1930 and stuff like that. And I was enchanted: "Oh, my God! I want to work here!" So I went in for my interview and I got the job.

Right away, they put me on what was considered the worst hall in there. It was the most violent. It was the real rompin', stompin' jungle room of the place, but the worst, in my opinion, was the geriatric ward, which total-

ly smelled like shit and was utterly depressing. Death was around you. But I got in there and, it's funny, I seemed to have a good aptitude for the place. I was very good with the patients. I was always in marvelous condition, so if somebody came running up to me and socked me in the gut it wasn't a deal-breaker or anything. *[Laughter.]* I could grapple with these guys if I had to. And, better than that, I was very good at reasoning with them.

What were you actually called upon to do? What was your job?

I wore a white coat, had a little tie. I was basically supposed to get these guys through their daily programs, which included taking people over to electroshock treatment and occupational therapy. It was a high-class joint. The nuts taught me how to play bridge, so I played bridge with them. I was terrible at it.

Were you like one of those guys with the white shirts in *Cuckoo's Nest*?

Yeah. That's when I got turned against the place. There were a lot of smart people there among the patients and I got very friendly with many of them. And, at one point, one of them said, "You know, Deitch? You should read *One Flew Over the Cuckoo's Nest*. That's really the last word in books about places like this."

And I did, I read it. And it was a great book. If you want to know what that place was like, that book really tells you. We had a Big Nurse. We had all the black boys looming around. I just about thought I *was* black for a while there, you know, when I was socializing with the guys at that place. And it turned me against the place, basically.

All of a sudden, I started thinking, "This is all wrong." For one thing, it seemed like their basic cure for almost everything was electroshock therapy, and just about everybody was walking around like a zombie on Thorazine. It didn't seem very progressive. And also, the other thing that was depressing about it, the thing I learned there is that mental illness is catching. The whole place was screwy: The doctors were nuts; the kitchen staff was nuts. You're around mental illness a lot, it's going to rub off on you. I think I stayed too long.

That worried you?

Well, for one thing, I wanted to get on the night shift. That's really where my art career started. Basically, what happened to me at a certain point was that I captured an escaping nut. It's not like I went out of my way to do it, but I was walking some guy through a hall and there

was an open side door and he leaped away and ran. And what could I do? I had to catch the guy. It would have looked bad. I don't know if they would have fired me, but it wouldn't have been good. So, I went tearing out after the guy. And he's running around the side, coming out the front, just as the director of the place is walking out the door with some people. So, what does the director of the place see? He sees me ripping off my white coat, throwing it on the ground and chasing down a hill after this guy who's just run down a hill. He sees nothing for a few minutes, and then a few minutes later he sees me coming back up the hill with the guy in tow. He looks at me and goes, "Good work, Deitch." I had gone up a notch. Plus, I graduated head of my class in a nurses'-aide class they made us take. So, then they started putting me in charge, not every night, but on many nights, on the night shift of the bad hall, which included giving me the key to the drug cabinet.

So did you actually tackle this guy? How did you wrestle this guy back?

He was just a little punk kid. He didn't need any tackling. He was basically out of steam by the time he got to the bottom of the hill and I just said, "Fella, come on. Let's go." And on the way back I was saying, "Listen, this isn't personal. I'm sorry about this, but I got a job here." And I even just gave him advice about what he should do

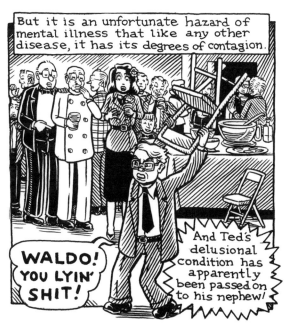

From *The Boulevard of Broken Dreams*. [©2002 Kim Deitch]

when we get back up there. In fact, after we were back in the hall, I talked with him a long time, listened to his story. If anything, I was closer to the guy after that. I'm pretty empathetic. I'm pretty good at talking to people one-on-one. I'm sure I probably could have done something in a field like that if that's what I wanted to do, although I don't think it would have been the right decision.

So you were essentially given a promotion and given the night shift.

Here I was with the key to the drug cabinet. I started fooling around with the drugs and stuff, which would basically be like big bottles of liquid tranquilizer. One time I took way too much of some drug, I think it was Compazine. Instead of tranquilizing me, it gave me this case of the heebie-jeebies that lasted for two fucking weeks. *[Groth laughs.]* The only thing that would calm me down was drinking. It wouldn't make me drunk, it would just sort of normalize me.

Why did you want the night shift in the first place?

I wanted the night shift because you don't have to do much on the night shift. All you had to do on the night shift was stay awake. You'd sit in this dormitory where all these people were sleeping and if something went wrong you had to be up and at 'em. What was interesting is: The one time when things would sometimes get crazy was when the moon was full. It's really true what they say about the full moon. At that time, there'd be a lot of acting up. You could have a rough night, but really, most of the time, not so much.

Of course, the other thing — it's depressing — was that tended to be when people in the old-age wing would drop dead. So occasionally, I'd have to help somebody lug somebody to the morgue, but most of the time was my own. All you have to do is don't fall asleep. You get caught asleep more than once and they'd sack you. But it was good for reading. So I started doing a lot of reading. Really, that's where my art career started, in 1965, on the night shift at the nuthouse. Reading. Thinking. Thinking for the first time really since I left college, or maybe in my life, "Where in the hell am I going?" I started looking down that long and lonesome road that is my life and started thinking, "What the hell am I really going to do with myself?"

And you started reading a lot of poetry.

I started reading a lot of poetry. I started reading Blake. I read that couplet of his. I'm not sure what it means, but it was that one, "To see a World in a Grain of Sand/ And

a Heaven in a Wild Flower/ Hold Infinity in the palm of your hand/ And Eternity in an hour." And for some reason that catalyzed my mind and it made me think, "You know what? I can try art again. But instead of doing what the art school says, instead of trying to do what my father's idea of being an artist is, do it on my own terms, just get it out of my own brain." And, on the strength of that, while I was still working at the nuthouse, I started painting. I started doing oil paintings in my spare time. And I kept it up. I have never really stopped, and over time, partially from the influence of my brother Simon, it morphed into comics at this magic moment when comics were about to take a quantum leap.

What were these paintings like? Where they representational?

They were vaguely representational. They were just different subject matter. I think the first one I remember painting was this guy looking all bent out of shape while some little parasitic creature was gnawing on him. I showed that to a psychiatrist a couple of years later, and he said, "This, I think, shows that you have homosexual tendencies." But I think what it meant was he wished I had homosexual tendencies. *[Groth laughs.]*

But they were sort of design-y, semi-abstract, somewhat figurative. They would have been more figurative if I knew anything about how to draw. The one thing I did get out of art school, the only real thing, is I did come away with some good sense of composition. And they just had a flair because, the fact is, without having much training or anything, they had something because I managed to start selling some.

And these were oil paintings, right?

They started out as oil, but at a certain point I started getting more mixed-media. And, at a certain point, under the influence of my brother Simon, who, unlike me, had never stopped reading comics, they started to morph into comic strips.

It was around this time when you actually got back together with your brother Simon?

Well, he was always around. We started being friendlier. He dropped out of high school and he went down to the Village and was hanging around with these pre-hippies around Washington Square Park. Even when I was working in the nuthouse, I started going down and visiting him sometimes on the weekends and just knocking about with him in his pre-hippy life. And we started spending more time together and that was around the time we had

Kim Deitch at a peace rally in 1967: photograph courtesy of Kim Deitch.

that mescaline trip. And one thing Simon started doing was showing me comic books that were coming out. He showed me *The Double Life of Private Strong*, *The Adventures of The Fly*, these interesting, pre-Marvel things. And he was like, "Look at these. This stuff is kind of like those cool Captain Marvel comics we used to read when we were kids."

That was the great tragedy of early comic-book reading. We really got hooked on *Captain Marvel* and just as we were really in full cry, it just mysteriously disappeared. That certain kind of boffo, comedy superhero thing was different from most of the other, more leaden superheroes. But anyway, I digress.

So he's showing me that. Even though I wasn't then reading comic books, through him, I was in this good position when comics started taking off again, to see it as it started to happen. He showed me the issue when *Amazing Adult Fantasy* turned into *Amazing Fantasy* and Spider-Man was born, the first issue of *The Fantastic Four* …

And Simon was very knowledgeable about all this stuff?

He was pretty knowledgeable, and he was getting more knowledgeable all the time. He started developing into a serious collector. There was some old comic shop in Brooklyn on Grand Street he used to go to all the time. I started going there with him, too. You could pick up back issues of really good Marvel comics for not much money. It's not like I thought the writing was great in these com-

ics, but it was a dynamic delivery system for dishing out words and pictures. So, that was one of the things that fired me up. Another thing, just out of nowhere that happened while at the nuthouse, one day I'm sitting there and — I guess I had run out of books to read that night — there was a copy of *Redbook* magazine lying on this table. And I picked it up and, what the hell these were doing in *Redbook*, I don't know, but …

Little Nemo.

Two pages of *Little Nemo*. Shit, man. And two beautiful ones, in full color, too. Between *Little Nemo* and Marvel Comics, I was really thinking, "Comics, man, comics."

Of course, the big issue immediately: "Yeah, but you know you can't draw," which is where Waldo came in. And I actually got to the point where, first, my paintings were looking a little more comic-y and had elements of comics … and then a few actually became comics. But since I couldn't really draw a human figure to save my life, I came up with a little black cat, basically being influenced by the old silent cartoons I used to see on TV. That's the why of Waldo at the very beginning.

I'd had a few of those samples when I was now at my better job. I was a child-care worker in this hoity-toity orphanage in Irvington, N.Y. And I was showing some of my co-workers my art and I was going, "Comics are really starting to fascinate me. The only trouble is I really can't draw that well."

And one guy was looking at them and he goes, "Well, hell, you draw as good as *Captain High*."

I said, "*Captain High*? What's that?"

And he said, "That's a strip that runs in this hippy newspaper, *The East Village Other*." And he showed me some and, yeah, I guess I could keep up with that guy. And that gave me the encouragement to quit my job, take my savings of 500 bucks, and move to the Lower East Side. I wasn't sure if I was going to pursue painting or try comics or what. I just went there and …

This "classier," post-nuthouse job you referred to was working at an orphanage in Irvington, New York, right?

Yeah, I was living in the dormitory of this glorified orphanage. Boy, that was hot livin'. This coed dorm, and all kinds of hot-looking black chicks.

And your job was to take care of 17 little girls?

Yeah.

That's unbelievable.

It was. And again, I wasn't bad at it. In a way, I was a wild card and the wrong person to be doing it, but on another level I was rather good at it. I was really good at writing the reports. I was really good at forming relationships with the kids. They'd open up to me and talk to me.

How old were the kids?

I was supposed to be the father figure. I was the only male counselor. I guess it was about 17 girls. They ranged in age from 8 to 13. They were marvelous kids; some of them were walking trouble.

How long were you there?

More than a year: It was hot place to live, this dormitory with all these great-looking black counselors. For a young fellow like me, it was good.

Did you actually hook up with some of them?

Definitely! Definitely! Which ultimately led to my first real girlfriend: She was one of those workers, who eventually got a job at *The New York Times* and moved to the city. So when I moved to the Lower East Side I kept that relationship up.

Days of Pot and Romolar

So you moved to the Lower East Side because you felt you could do at least as good a job as this guy was doing drawing *Captain High* at *The East Village Other*. I know, of course, that you eventually started working at *The East Village Other*, but tell me how that came about. Did you just go visit their offices?

It happened really fast. First week there, I painted a couple of pictures while I was thinking about it all and, at a certain point, I took my rough portfolio over to *The East Village Other*, which even included a couple of comic strips. And I showed it to this editor there named Allen Katzman, and he looked at it all and said, "This stuff isn't bad, but I think we're looking for something a little more psychedelic." Big buzzword at the time. But before I left, he introduced me to the art director, this guy named Bill Beckman, who drew *Captain High*. Well, Bill gave me a job right away, but not working for *The East Village Other*. He gave me a job dealing dope. So I start dealing dope. Basically, I wasn't making that much money at it, but I was doing well enough to keep myself in all the grass I wanted to smoke.

So I started smoking some of that grass, and while I was

doing that, I immediately pretty much came up with *Sunshine Girl* and did a few strips of that. Brought those back over to *The East Village Other*, at which point Allen Katzman looked at them. I guess it turned out that he really wasn't that in charge as I thought, because he called some other guy over, which turned out to be Walter Bower, the real head of *The East Village Other*. And he looked at them and he's just, "These are great! Will you keep doing these for us?" And I said, "Yeah! Yeah!" So that was good. Bad news was there was no pay.

But you didn't need pay. You were a dope dealer.

Yeah, but not a very good dope dealer. You're dealing to all your friends, they all want a bargain, you give them all a bargain. I wasn't doing that great. But, at a certain point, *Sunshine Girl* started to catch on a little and one of the sub-distributor guys at the place took pity on me. He started giving me 100 copies of the paper every time it came out. So I'd take those to Washington Square Park and sell them and get $15. They were easy to sell. And that was my pay for a while.

Could be a little synergy between selling the paper and dope.

Yeah. But, I was never gonna sell it like that. That's how you get busted.

I assume you're talking about exclusively grass?

Occasionally, if I had a good deal on hash, I'd do hash. Occasionally, I'd sell some LSD. But mostly grass.

Were you concerned about getting busted, or was that not really a consideration?

I didn't really give it a lot of thought. Actual, technical fact, I was already a fugitive from the Army because I had a year's deferral and I never showed up when the year was up. I wasn't really worrying about that.

Did you just say you were drafted and didn't show up?

I was drafted, I showed up, I pulled a nut act in the draft office and got a year's deferral. They really wanted bodies that year.

What year was that?

'66. So now it's '67 and there I am. My year was up. They did send me a notice and I just ignored it. I figured if they want to come down here and get me, then let them come and get me. Fuck them.

Oppostie: [©1968 The Gothic Blimp Works Ltd. Inc.]

VOL. 3, NO. 44 METROPOLITAN 15¢ OCTOBER 4, 1968

THE east village OTHER

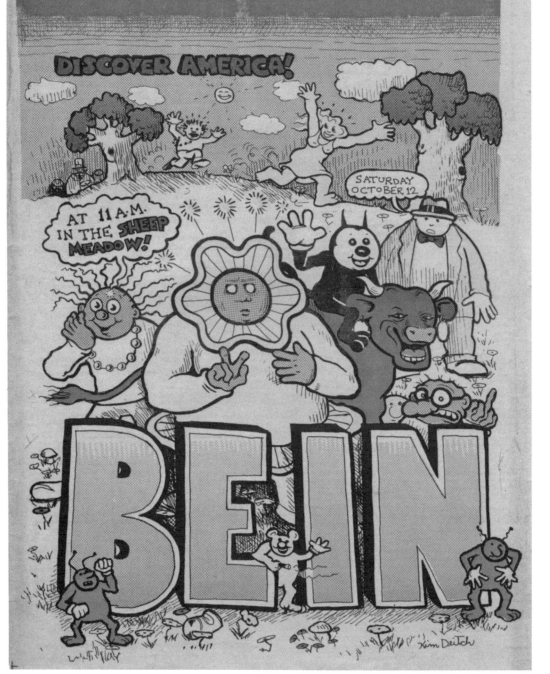

And Vietnam was going full-bore at that time.

Yeah. Believe me, I was looking in disgust at the other guys in the office when they were trying to draft me. I was saying, "You want to go in the Army?" They said no, and I said, "Well what the fuck are you going for?" I drank a bottle of Romolar. It was this weird psychedelic cough syrup. I was a glorious mess in the draft office. It's a wonder that all they did was to defer me for a year. I put on a spectacular nut act.

What did you do? Did you jump around on chairs and desks?

Well, everybody came and everybody had a suitcase. I came, I had a paper bag with a toothbrush and a pint of whisky. *[Groth laughs.]* At one point, they had some woman in a Salvation Army uniform giving us little comb sets and stuff and I'd just take mine and drop it on the floor. And I had a letter from a psychiatrist. I had several letters from psychiatrists. (I was going to a psychiatrist for a while.) And it just wasn't cutting it that year. They were really cracking down. I would have done better, but when I went originally to get classified, I was still a Republican and I still believed that the war in Vietnam was a good thing. So I was fully cooperative and got 1A. So I really could have nipped it all in the bud earlier than that. But I was going through some sort of personal metamorphosis.

You were a Republican during this period?

Yeah.

Wow.

I even subscribed to *The National Review*.

Wow. Did you vote for Barry Goldwater?

I did not vote for Barry Goldwater. It hadn't really hit me altogether and I was in the Merchant Marine that year, although I was fascinated by that campaign. The worst offense I ever committed was I voted for Nelson Rockefeller one year.

So you were a middle-of-the-road Republican?

Actually, I was thinking that the real basic conservatives were rather interesting. Like Robert Taft. I've read several books about him. You know, the real dedicated, fiscal conservative, non-crook. I thought they had some points, too. Maybe I went a little overboard. I don't know, you've got to try different things. See everybody's point of view.

Wow. That's fascinating. Well, getting back to your caper at the Army Board. So you put on a show, and they

basically gave you a year deferral. And that would have been '66?

Yeah, that was '66. And my nut act was so good that really I was nuts when I got out of there and the first thing I did was I bust up with my really good-looking black girlfriend I had at the time over nothing and then flew to Niagara Falls and was on this big drunk for a long weekend. I remember trashing the hotel room. I did a good job of my nut act.

[Laughs.] So much so, it might not have been an act for a little while.

Well, yeah.

A fine line.

A fine line. I think I was more unstable in those days anyway. And I had a drinking problem which was growing and I wasn't quite aware of how bad it was yet.

And you went to *EVO* after you got the deferral in '67??

Yeah. It was the very beginning of '67.

So Walter Bowart liked *Sunshine Girl* and commissioned you to do it for free.

Every now and then I'd come in and if his largess was really overflowing, he'd throw me $50 out of petty cash to be fair. But I had no guaranteed salary.

Is this when you got a series of jobs through Manpower Inc.?

No, that was always ongoing, all through early adulthood. Any time I was up a tree, needed a few bucks, I'd go work there. I even actually did a stint at Manpower after I had gotten into underground comics. There was one point where Art Speigelman and Bill Griffith were both pressuring me not to work for the Marvel *Comix Book* and I got so disgusted I quit doing comics for about a month and worked for Manpower.

We'll talk about that, but you were doing the strip, *Sunshine Girl*. Were you doing that every week?

No. *EVO* came out every two weeks. Later on it was weekly. Occasionally they'd do an extra, but mostly weekly.

I know what *EVO* is and I'm sure I've seen a copy or two, but can you describe it? Was it a hippy version of *Village Voice*, or what?

That's exactly right. *The East Village Other*. The name is even riffing on *The Village Voice*. And yeah, that's what it

From "Mishkin's Folly: Or, a Moon, a Fool, and a Furlough" by "Fowlton Means" *Arcade* #1, 1975. [©1975 Kim Deitch]

was. John Wilcock, one of the founders, had been working at *The Village Voice* before that. It was bombastically revolutionary, psychedelic.

So it published journalism?

Yeah, but they also had graphics and comics.

Did you work in the offices of *The East Village Other*?

Not in those days. Later on, yes.

It was around this time you also discovered yoga. Is that right?

That was in between my two stints at *The East Village Other*. At this point, I went bust at *The East Village Other* and I also started to run out of money and I ended up breaking up with my good black girlfriend and I was on the ropes. And at that time, I somehow stumbled into the Integral Yoga Institute over in West 80s here in the City. And that was an amazing experience. I got in there, and I really was all torn up and I didn't quite know what to expect. They didn't even get into the exercises at first. The first thing they had us do was start chanting these mantras. We were supposed to sing back whatever they said to us. It seemed a little ridiculous to me, except, after doing it, it was incredible. It had this instantaneously soothing effect on me.

Really, by the time I got to the yoga exercises, I was already in another zone. I wanted to quit drinking. Just going to that first session there, quitting drinking was like taking off a coat! No problem at all. Bing bang boom.

Easy as that. I got very hooked into all that. The exercises were great; the mantras were even greater. I was so messianic about it I got a lot of people I knew into it, some of whom lasted longer than me. It made me very well-adjusted all of a sudden. I started thinking really clearly.

One thing I did was, "I've run out of money, I've got to get a job. What kind of a job? Well, Post Office: Take the Civil Service test, you can walk right into a pretty good paying job." I did all these responsible things: Getting window gates for my apartment, got a proper police lock. I was very happy. The weird downside in the midst of it all, I thought, "I want to still do art so I'll go back to Pratt Institute." Went back there, started taking some night courses, took a silkscreen course, took a painting course from Jacob Lawrence. Everything was fine, except the art wasn't very good. There was something about this very happy, well-adjusted me that wasn't really firing on all eight creatively, which gradually started to dawn on me.

I still used to go over to *The East Village Other* office because I made up a bunch of *Sunshine Girl* buttons at one time. They sold really good. I was on my second batch. They gave me a free ad in the back of *EVO*, so I'd go back every couple of weeks and there was a mail place for me and I'd pick up my envelopes with quarters and whatnot for *Sunshine Girl* buttons. Well, one day I walked in there, and this guy waylaid me: "You're Kim Deitch, right?"

I said, "Yeah."

He says, "I'm Joel Fabricant and I'm running the paper now. I heard about you. We've got to get the quality up in this thing." He was right. The quality had really gone into

From Kim's "The Sunshine Girl" in *Deitch's Pictorama*. [©2008 Kim Deitch]

with me." He sat me down in an office and said, "Have a cigarette."

I said, "Nah, I don't smoke."

He started rattling on about how he "wants to get some quality back in the paper." He said, "I don't even read the thing, myself, but it's a good business proposition, blah blah blah …" I'm thinking, "What the fuck?" Plus, I'm this perfectly happy, well-adjusted guy now. He offers me a cigarette about three times. At one point he goes, "Listen, this is a good deal. Hey! Somebody get Spain. Spain! Spain! You come in here!" Of course, I knew Spain. And he says, "Spain, sit down." And he said "Spain, don't I pay you $40 a week?"

He said, "Yeah, man. You do."

He said, "It's a good job, right?"

"Oh yeah, man. It's good."

Joel looked at me and said, "This could be you, too!" Basically, I was leery of it. He said, "Have you got any comic strips right now? We'll put something in right away." And that led, ultimately, to my working for *The East Village Other* again under the Joel Fabricant regime.

And Fabricant knew you based only on the Sunshine Girl strip?

Uh, yeah. And I guess other illustrations and stuff I'd done. He kept noticing me coming in and getting all these quarters out of my box all the time. I'm not exactly sure what cued him, but he did. And, with some trepidation and leeriness, I started working for them again. And in no time at all, I was back to drinking.

But now that I've told you what a creep Joel Fabricant is, this is the other side of the coin. It turns out that, OK, he didn't read the paper. And I took him to task about that. I said, "Jesus Christ, Joel. You've got to at least read the thing if you're gonna work here." And after that, he maybe didn't read it all but he always made a point of reading my stuff. And occasionally he'd give me a criticism like, "You know what, Kim? I read your strip last week and I didn't understand it at all." Well, when he said something like that I took it very seriously.

The thing about Joel was, OK, he was a real roughneck and kind of obnoxious, but he really took care of us. And I've been around a lot of rough-edged people before, so that didn't really put me off as much as it might have put off somebody else. And what I gradually understood about Joel is, in his own crazy roughneck way, he was really an honorable kind of guy. Anytime he'd ever make you a promise, you could count on it.

So he was straight?

the toilet. I'd noticed that. What happened was Walter Bowart, this big jivey hippy type, pulled the coup of the century. He married this chick named Peggy Hitchcock-Melon who was Andrew Melon's granddaughter. Andrew Melon was this patrician guy who was Secretary of the Treasury in the Harding and Hoover administrations. Had so much money that she had money coming out of her ears. And Walter Bowart married this. I was reading his obituary. They say the going-away party was something else. There were butlers holding up trays of joints and stuff. But I was on the outs at the time and did not go to this party.

So the new guy, Joel Fabricant, who had been there before, he had been the accountant. He was this roughneck, racist, Republican, vulgar, loud-mouthed guy. He looked and sounded like Broderick Crawford. He had this offensive, overbearing way. He said, "Come with me. Come

In that respect, he was. I really grew to love the guy and, as far as I'm concerned, more than any other single person in my career, he is the one who really gave me my first big break. Basically, once I got in the groove of the new *EVO*, I was getting $40 a week, I had to draw a strip every week and be there on paste-up night. If it was my turn, I'd have to go to the printer to wherever they printed it at that time and make sure that they did it good. But also one of the big ad buyers was Steve Paul, owner of "The Scene" which was this fairly decent nightclub down in Midtown. It had all the best rock 'n' roll acts. We could go in there and drink all we wanted for free. That was one fringe benefit. And the other fringe benefit was at New York Central Art, we could charge all the art supplies we wanted for free.

They sound like two pretty good fringe benefits.

You said it. It really was a solid deal. Suddenly, there I was. I was earnin' while I was learnin'. In all honesty, I don't think I was really fit for the job. I was in the right place at the right time. I think there's plenty of people who could have done much better with it than me. But I did the best I could with it. I never for a minute was unaware of just what a wonderful opportunity I'd fallen into.

Where did Fabricant come from?

I guess he had something to do with accounting, even during the Bowart era. He'd come from money, was apparently disowned by his parents for something or other. He was a little sinister. I'd heard, and I believe it, he turned down a good-paying accounting job with the mob. And he was rough. Many's the time when I was in *The East Village Other* office, if somebody came in and was talking a lot of shit with him, I'd see him kick that person's ass right where he stood.

You mean just punch them out?

Yeah. But I never saw him do it to somebody who didn't have it coming. I'll give you the other side of that, too. At a certain point, and Simon will verify this, I think I'd already left for the coast and Simon came in and he was badly strung out on heroin and had been making himself to be a general pest in *The East Village Other* office. At some point, Joel saw him loitering in there and he just walked up and said, "You!" Grabbed him by the scruff of the neck and hauled him out of the room, marched him down the stairs and just grandly threw him out. But what nobody saw at the other end of that was before he let Simon go, he stuffed $20 in his pocket. That was the sort of guy Joel was.

Was he a middle-aged guy?

No. He seemed like a much older guy, but he was like 28 to my 24. But when you're young it's a big difference. He didn't live very long.

Oh, no?

Sadly. I think he was just too much for this world and ultimately, the world was too much for him. What I'd heard, and it breaks my heart, I still get a pang when I think about this: I'd seen him a few times after *EVO* ended but at some point he died of an overdose of heroin: him and his girlfriend at the time. I've never gotten over it. Last time I saw him I remember he was so glad to see me. I was with Tony Eastman and a bunch of his fraternity pals, and they were in a hurry to go to some stupid thing and I left sooner than I wanted to and I remember seeing Joel look sad and disappointed and I never saw him again. It still haunts me.

When would that have been?

That would have been like '72. And he prided the time

[©1969 The East Village Other Inc.]

we'd been together. When I went over to his house, he had a picture of mine hanging up in the office. He had a Spain original up. Spain loved him as much as I did, too. The guy that never could quite key him right was Crumb. And I tried to explain him to Crumb. Crumb's been wonderfully nice to a lot of people, including me, but he couldn't see Joel. He just saw the big bully and all the obvious, superficial things.

How Joel ended up leaving *EVO* had to do with Crumb. I wasn't there, but I heard about it. Joel had everybody out in the front room and he was giving a bullying talk about something or other, and in the midst of it Crumb walked up to him and shoved a pie in his face. Joel immediately exploded, and I think he must have looked at Crumb like, "Should I kick his ass? No, he's a wimp. I can't kick his ass." It really shattered him and apparently, less than a week later, he quit *The East Village Other.*

Holy shit. He sounds like the kind of guy Crumb would take an immediate dislike to?

I think he probably just saw him as another asshole. Crumb has his own pet assholes, too. I guess that's what it amounts to. We all have our pet jerks that we cherish as opposed to the ones that we despise. But I can't really call Joel a jerk. He was a rough character, but he was never boring and [he was] a straight, square-shooting son of a bitch. I've still got the contract that he wrote for me when he put me in charge of the *Gothic Blimp Works.*

It's funny how you can establish a bond with somebody whose values are in many ways the opposite of yours.

Yeah, but he had the right stuff where it counted. Plus, he wasn't boring. He was vastly entertaining, even when you didn't agree with him. I could tell you more whacked stories about him, but they wouldn't accomplish my purpose because I don't want people to think ill of him. I want people to understand that he was, in his odd way, a wonderful man.

You once said his favorite expression was, "Never trust a nigger."

Well, yeah. I wasn't going to bring that up. It's true. Not that he didn't have blacks working for him! And they had an OK relationship, the ones that worked for him week in and week out.

So was he being ironic when he said that?

No, I think he was genuinely racist on some levels.

It sounds like it took some courage on Crumb's part to throw a pie in his face.

Crumb has courage. He characterizes himself as a wimp, but I don't really think that's true. It's just something he says. He's one of the best men I ever met.

Speaking of Crumb, a number of cartoonists contributed to *EVO*. Crumb was one of them, Spain, Spiegelman, Trina [Robbins]. What was the environment like? Did they all come in and just drop stuff off? Did you guys hang out?

Yeah. Some people came in and dropped stuff off, but when I was working for Joel, I was now considered a member of the staff. So, if we weren't really working, you could use it as your clubhouse. But me and Spain were

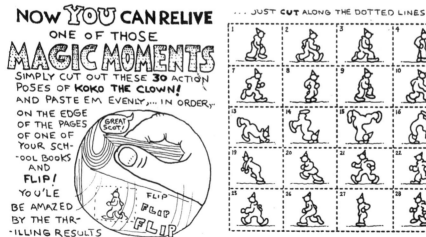
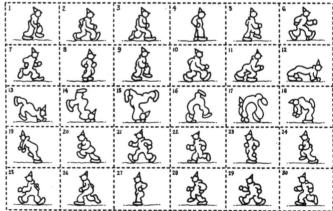

From *The East Village Other* (EVO) Vol. 4 #24 (May 4, 1969). [©1969 The East Village Other Inc.]

expected to be there Wednesday night and not leave until the paper was put to bed.

At some point, you and Spain became roommates.

Yeah. That was in '68. I had another roommate over in this place I had next to Tompkins Square Park on E. Eighth Street between B and C, and he, following my earlier whim, didn't get into the Merchant Marine, but he got a job as a steward on some ship and so he was traveling around the world like that. So, at one point while he was off on one of his long trips, Spain came over and he said, "Why don't you let me move in here?" And so I did.

Now, this was a pretty rough neighborhood.

It was rough, yeah. I used to carry a gun. One day, when I was coming back into the building, I got followed by a couple of muggers. They didn't even say, "Give me your money," just one of them started poking his fucking toadstabber knife at my belly, which is how they do it. They do their own version of good cop, bad cop. The other guy said, "Hey man! Don't hurt him, don't hurt him! I don't want him to hurt you, man!" Well, I knew how things worked in this neighborhood and I knew that whatever level of crime you were being victimized at, once they succeeded, they always come back. So, a lot of people came and went out of this apartment and at some point somebody left a five-shot, .32 caliber revolver in the apartment. And I really hadn't even thought about it much. I knew where it was. But as soon as that happened to me, I grabbed that thing off the kitchen shelf and put it in my pocket.

And I was right, man. Two or three days later, I was walking back up the hall steps and I hear "thump, thump, thump, thump" coming again. Shit, I was paralyzed. I didn't think, like, "Oh, I'm going to pull my gun at them." Fuck, no. I thought, "Can I get back to my apartment fast enough to get in there?" And so I got there, but the key had been messed with so many times that by the time he came up, I'm still just shaking with my hand trying to get the door open. So, at that moment, I reached into my pocket, hand shaking, and I pull out the gun.

Then an amazing thing happened. This guy, pow, disappeared like some character in a Tex Avery cartoon. I was like, "Whoa." Plus, no more trouble because failure is the same way. It's not like they think you're a mighty, mighty man, but they're not looking to take any more risks than they have to, either. Why go after the guy who's got a gun in his pocket when you can go after the chump next door who doesn't?

From "The Cult of the Clown" by "Fowlton Means" in *Cord Fed* #1. [©1972 Kim Deitch]

So there may be some truth to the assertion that guns prevent crime.

I successfully defended myself with it on two occasions: that one and another one that happened later on. Both times I was trying to not use it. The second time, some fucking black just started coming on to me in the street with a bunch of shitty talk. I even said to him, "Listen man, I don't provoke you."

And he's just coming on, "Yeah man, I like that jacket you got. I think you ought to give that jacket to me."

I said, "No, I don't want to give you my jacket." And all the time, I'm walking backwards up the apartment steps and he's coming right after me because I'm thinking, get off the street and we'll see what we can do about this. I wasn't going to flash a gun on the street. That's nuts. So, as soon as we go in through the building's front door and we're in the alcove where the mail slots were, I pulled my gun out of my jeans pocket and with a lot of swagger this time and said, "OK, man." Boom! He was gone. That's the fun of guns, man. Just watching them absolutely disappear. And I saw that guy on the street about a week

later. I gave him the evil eye and he looked at me and just kept on walking.

Spain said that the cylinder in the gun was wobbly and he wasn't even sure it would shoot. Did you ever shoot this gun?

I was told this about it. I was told that it had a really high upkick. It definitely fired, but if you were going to really shoot at something, you had to compensate for the fact that it was going to push your hand way up high when the gun went off. The pull on the trigger was really hard. It would have been really hard to accidentally fire a shot, which was a good thing. But, thank heaven, I never *had* to fire it.

Did you ever practice with it?

Never. Interestingly enough, I knew how to use a revolver. How I learned how to use a revolver, hilariously, was in the Post Office. That thing about going postal, well, to some extent they must bring it on themselves, because, at a certain point, they sent me and some of my co-workers off to gun school. They taught us with bullets that had a powder charge with a wax bullet, and I wasn't even particularly good at it. The idea was that once a week, I'd have to strap on a gun and guard the Post Office. So, I'd walk around for an hour …

This is a different gun, I assume.

Yeah, this is their gun.

The postal gun, right.

Yeah. The one you'd use to shoot up everyone when you go postal.

So you and Spain were roommates. Now, Spain strikes me as being somewhat different than you in the sense that he might be more confrontational in a situation like that. An urban situation.

I suppose he could be. It's not like I ever saw him being great with confrontation. One of the interesting things about Spain is he has a very placid temperament. One of his virtues is, I've seen him in situations where all hell is breaking loose and everyone is running around, freaking out, and Spain will be sitting in the middle of it doing some good piece of artwork. The only person I ever saw him really mess up was Simon. He kicked Simon's ass a couple of times because Simon was wising off too much. In fact, one time, it was really funny, Simon will be interested to hear this if I haven't told him already. He was just giving Spain too much shit, and Spain slapped him

His hand wobbled badly when he pulled the gun out.

From "Two Jews from Yonkers" in *Weirdo* #11 (1984). [©1984 Kim Deitch]

around pretty hard, I guess. Spain told me later on that he hurt his hand so much doing it that he couldn't draw for a few days. *[Groth laughs.]* But that he wouldn't tell Simon. He didn't want to give him the satisfaction of knowing that. Believe me, it was smart. Simon never would have let him hear the end of that.

People don't realize that if you actually hit somebody with your hand, you can hurt your hand.

That's right. In karate they show you the right way to punch.

So I'm trying to get a sense of the milieu. As cartoonists, did you all hang out? Did you get together with Crumb and get to know him a little?

Yeah. The way I met Crumb was one day I was doing my weekly strip for *EVO* in the apartment and Spain came walking in with him. And then Crumb stayed with us for a few days after that. He had the Xeroxes from *Zap* #0 that hadn't come out. It was fabulous to see. Plus, it was the first time I ever saw his fabulous sketchbooks.

That must have been pretty inspirational. Or intimidating.

Way inspirational. I love Crumb. Believe me, I really love Crumb. I feel I'm a better artist today because of his example than I would have been otherwise. I mean, my first reaction to Crumb was, I was totally intimidated by him. That was one of the reasons I went scurrying to the Post Office. One day I came in and I asked Walter Bowart if I could have a whole half-page. All the pages were all

strung up on a clothes wire like they always were on paste-up night, and he pointed to a Crumb strip which he got out of *Yarrowsticks*, which is a paper Crumb's stuff was appearing in. He said, "Listen, you give me stuff like this, I'll give you a whole page." And that was like, whoa, how can I compete with that?

That really was one of the things that cowed me out of comics briefly. It's funny because I stopped doing comics when I was working for the Post Office, but I never stopped reading those Crumb strips, and I was loving them. But at a certain point I snapped out of it and realized, OK, maybe I can never be as good as Crumb, but I can be a lot better than I am right now. That's the covenant that I made with myself: to get going to the next level with this.

Tell me what he was like at the time?

He was in the first flush of early success. It was really fascinating. He said, "I had this guy from *Life* magazine following me around, but I shook him off." That's what was wild about it. He was enjoying great success, but he seemed to have this unbelievable integrity about it. He seemed to have his head really screwed on straight about what it was all about and what it wasn't all about and just making a big flash in the pan definitely was not what it was all about to him. He'd already told The Rolling Stones to go get fucked. He turned down The Beatles for something. He just wasn't going there.

On the other hand, he was wonderfully encouraging to us. If he didn't like something I was doing, he'd tell me he didn't like it and show my why, but he extended himself tremendously. And it's not just with me, but I've seen him do it again and again with all kinds of people. He was amazingly accessible if you were a worthy enough person and weren't some kind of asshole on the make. He was a little loopy with broads, but he explained that to me by the fact that I don't think he'd ever been laid until he was 20 years old. Because he was famous, he was getting popular and, admittedly, girls had gone to his head.

When you say "loopy," what do you mean?

He'd do any crazy thing. There was some ad running in *The East Village Other* for some book of his that was out at the time, it might have been *Head Comix*, and it was just a straight-ahead ad. Crumb said, "Wait a minute. Let me have that thing," and he added all these new cartoons to the picture and a character saying, "Yeah! And he fucks good, too, girls!"

Joel was really pissed off that he did that. "That's got to run again, and you keep your hands off it this time!" He

was just an enigma in that way. Not that it really bothered me or anything. He'd get grabby enough with your girl, but on the other hand, if you got grabby with his girl, he was OK with that.

At some point in 1968, you met Trina [Robbins] and then you guys eventually took a trip to San Francisco. But before then, did you meet other artists who were working at *EVO*?

Yeah. Somewhere along the line I met Art Spiegelman. He wasn't working for *EVO*, but he occasionally did something. Yeah, I met plenty of artists working for *EVO* whom you might have heard of and some you've probably never heard of.

Tell me about Spiegelman. Do you remember how you met him?

Vividly. I remember it like it was yesterday. Me and Spain were walking down the street and he knew Art and he introduced me. And I was happy to meet him, too, because I'd seen his work in Wally Wood's magazine, *Witzend*. And I shook hands with him and the first thing Art said to me, more or less, was, "You know? I really liked your early *Sunshine Girl* strips, but you've really been slacking off lately."

[Laughs.] Hasn't changed a bit.

Which definitely was off-putting. Except, in retrospect, I think he was right.

Hasn't changed a bit. [Laughter.]

He's the same person. He's older and wiser, but …

I mean, still sharp in terms of looking at the work and assessing it.

Definitely. You've got to be able to take it, but if you can, it's a good thing, because you can learn something if you're smart.

So did you get to know him?

I got to know him, but I didn't really like him. I didn't like him for a long time.

Is that just because he was so critical?

In those days I just felt he was an effete candy-ass of a guy. He was too cute for me. Trina was absolutely enchanted by him, so, consequently, I saw enough of him. It's funny, though, not the moment when I got to like Art, but the defining moment when I opened my mind enough to think that such a thing was conceivable was about a year

and a half later in San Francisco. Art had just broken up with his girlfriend and he'd come to stay with us in a little bungalow me and Trina were renting. He was unloading his stuff and I was feeling like, "Oh, great." So he's taking out this and that and one thing he took out was an old movie magazine from 1932. It had Constance Bennett on the cover, and Trina went, "Oooo, that's cool!"

And Art looked at her and said, "You like that, Trina?" She said, "Yeah!"

He said, "I'll tell you what, Trina. I'll give it to you on one condition. While I'm here I don't want to hear one God-damned word about Women's Liberation."

*[Groth laughs.]*And I thought, "Whoa. There's more to this boy than I give him credit for." It wasn't like we were going to be bosom buddies — that came later — but, you know …

Trina Robbins and Fatherhood

I guess up to that point you'd heard an earful about Women's Liberation, huh?

I'd had a bellyful of it. Me and Trina were fighting like dogs by that time. We had a kid, too. It got to be a pretty rotten situation. I'm not saying it was all her fault, either. I was very immature at the time. We had plenty of good times, too, but it was definitely a stormy relationship as it went along, and really all we're talking about is two-and-a-half years, but when you're younger it seems like a much longer time.

You can pack a lot of storminess in two-and-a-half years.

Oh yeah. You said it.

Let me go back to New York. You met Trina in 1968, and obviously became boyfriend/girlfriend at some point.

Yeah. She was somewhat older than me and had really been around. It was like a fascinating step up in the hierarchy of hippydom at the time, meeting and going with her. She knew all kinds of people. And really, the early part of our relationship was great, plus she was a cool chick in a lot of ways. That definitely needs to be said. You can say this about her and that about her, but Trina was never boring. She hates me to this day, and that's too bad. I wish that wasn't so. I mean, we've got a kid, you know … That's why I'm not looking to take a bunch of cheap shots here just for the fat yuck.

But you obviously fell for her.

I did. She was a fascinating older woman. I learned a lot from her, even just how to be better in bed. As fundamental as that.

So, how did you guys meet? Did you meet at *EVO*?

I'd seen her come in a few times and I sort of knew who she was. One day I was out walking with this guy named Baby Jerry, and he saw her and called her over and introduced me and she said she'd really been liking some of my recent work. So I invited her back over to the place along with some other people and one thing led to another and, after a while, we were an item.

What did you think of her art? She was a clothes designer, as well as an artist.

To me, that was always the really brilliant thing about Trina. I sometimes wonder why she didn't stick with that more. She was a positive genius at making clothes. She made commissioned clothes for just about all the big stars. She turned down Sonny and Cher. She did stuff for Bob Dylan and you name it.

About 14 years ago when I was going with Flo Steinberg, one day we were sitting around and she said, "I want to show you something." And she ran into her closet and she pulled out this hippy dress that Trina had made for her back in around 1969. She'd maybe worn it once but had just kept it as an artifact. And it was fabulous. I looked at that and I thought, damn, that should be in the Smithsonian Institute. I told Flo, "Don't ever let anything happen to that because that really is a fantastic artifact."

What did you think of her drawing and her comics?

Well, different things. One thing, I thought she had amazingly good facility. Goddamn, she was great at drawing girls and clothes. Sometimes I'd get her to draw something for me in my strips along those lines. But I also felt why she'd never really get anywhere in comics was she was trying to be too much of a Renaissance woman. Trying to do too many things and not really giving comics the time she would need to give them to really excel in doing them. She wouldn't put in the same kind of hours that me and a lot of my fellow cartoonists would do, and then she'd get pissed off when she wasn't getting the same success. But she wasn't putting in the same effort. Plus, while she had a certain facility in drawing, storytelling was less her forte. But I think she could have gone somewhere big in it if she'd ever been willing to make the right kind of commitment to it. I'm sure she's got a real high IQ. And she's very nimble-witted; really fast on the uptake. I don't think she's a real deep thinker, but … she's something else.

You two were living on Mott Street. The famous Mott Street.

Yeah. I was living in that really cheesy place. The place where I had the gun and then we got flushed out and we were living in Walter Bowart's old pad, which was where anybody who was between homes lived when you worked for *The East Village Other*. And at one point she said, "I'm going to San Francisco for a while and when I get back, I expect you to have a better apartment." So I did the best I could. I got this crummy joint over on Mott Street, which she immediately made me tear the linoleum off of when she got back, and paint.

But then she got us a much nicer place, because Trina's really smart about wheeling and dealing and bargaining and stuff like that. I used to sick her on people who owed me money. She had her points, no mistake; a gifted person.

So, at some point, sometime in '69, you and Trina drove cross-country to San Francisco.

Yeah. First what happened was we had one of our big dust-ups and she said, "I can't take you any more. I'm going to San Francisco for a while, just to get away from you," and somehow I talked her into taking me along on this "let's get away from Kim trip," which was my first exposure to San Francisco, which was like, "Whoa!" I was enfabulated by it, really. I did several strips for different people while I was there and just said, "This is it! Got to go there." I came back, tied up the loose ends of what was going on in New York and then we did. We rode across the country with Gilbert Shelton and his girlfriend of the moment. That was at the end of '69.

How long were you in San Francisco the first time?

When we just were checking it out, about two-and-a-half weeks.

And you stayed at Crumb's place. I understand Dana, Crumb's first wife, allowed you to stay there.

Yes. Very nice of her, too. She hardly knew us.

Tell me how you got around. How did you start meeting people? I know you visited Rick Griffin.

Oh, there was nothing to it. I visited Griffin, went over to the San Francisco Comics book store. Already a bunch of people I knew were around. There was nothing to it. People were coming over to Crumb's house, too. There was no problem in meeting people. It was great. I met [Gary] Arlington and [Don] Donahue and [S. Clay] Wilson for the first time.

Wilson must have been pretty wild at the time.

Well, he was a beer drinker, and I was comfortable with that, because I was a beer drinker, too, and not that many people were. But, you know, he was an abrasive person. Simon got to be really good pals with him. Me and Wilson never really hit it off. The big problem I had with him ultimately was at a certain point Crumb invited me to be in *Zap* and Wilson put the kibosh on that. I could have withstood one nay vote, as Moscoso said no to just about anything.

Did Wilson just not like your work?

Basically, he told me at one point later on when we were drinking, "You know, it just reminds me too much of myself in some way." I know from Simon he respected me as a writer, but I don't know. Maybe he just didn't want to let me in on a good thing.

But Crumb wanted you in?

Crumb invited me. That was one of the greatest moments of my life. I'll never forget it. I was at this Rip-Off Press party and somebody doped some wine with LSD, so I was really flying and grooving at the party. I was very sensitive to everything that was happening. I was staring at the door at the very moment Crumb walked in. It was funny, all of a sudden you could hear everybody was more quiet because Crumb was there. And then he looked around and he saw me and he went stomping over to me and he said, "Hey! I was over at Arlington's and I saw that strip you just did for San Francisco Comic Books. It was great! I want you to do something for *Zap*!" Real loud like that. That was one of the greatest moments of my life. I couldn't believe it. Such public adulation from my hero of heroes. It almost doesn't matter what happened after that because that was just such a high high.

I saw Wilson at a con here in New York recently — and he was that way … how you are when you've been drinking all night and you wake up and you're still drunk but you're more nimble and articulate. And it was actually a good time to be talking to Wilson because he was very expansive and vocal. Somebody just put out a book of the history of his work. I was sitting next to him at the table and I just let him guide me through his career and really it was quite a treat. I was very entertained. He's charming and entertaining and a very gifted artist, too. I think he's seen better days as an artist, but …

But a visionary in his way.

Yeah. I like it. That book he was showing me, I wouldn't mind having a copy.

That was his art book?

It was the history of S. Clay Wilson. Somebody just put it out. It's a little rough around the edges.

You also met Rory Hayes.

Yes I did.

And he must have been a little younger than you.

A lot younger. Actually, chronologically, compared to people we know now, not so much. But he was 19 to my 25.

Which is a lot at that time.

Yeah. And still a virgin, too. He was famously still a virgin. Very likable guy. Very sweet. Got to know him quite well. A really good kid. A little spaced out. Simon used to call him Hazy Hayes. Simon's got this story, it's going to be a little about the comic-book store. It's definitely going to have to have at least a little bit of Rory in it. Actually, it's a cooler story than that, though. I'll show it to you when you get here. This could be a killer. I read that book, *Men Of Tomorrow*, and basically the focus is on Siegel and Shuster, the creators of Superman. Jesus, there's a story about Simon and Jerry Siegel and if this guy knew that story it would be in this book.

Your brother and Jerry Siegel?

Yeah. This story is so hilarious. Basically, I'll give it to you in a nutshell and I'll show you some of the art he's been working on for it when you get here. Simon's working for the San Francisco Comic Book store. At one point, Jerry Siegel gets in touch with Gary Arlington. He's on seedy days and he basically tells Gary that he really would like to get in on the underground thing. He wanted to know if maybe Gary could come and see him in L.A. And Gary doesn't like to go anywhere. He's a very sedentary guy. Simon's working there, so basically Gary talks Simon into going to L.A. to see Jerry Siegel. Not just going to L.A., but going to L.A. *as* Gary Arlington. "Listen. It'll be OK. You can be me." It's like something out of Laurel and Hardy.

And so Simon went to L.A. as Gary Arlington to meet Jerry Siegel, who was going to show him material that he thought would be great underground comics. And actually, Simon's longer-range plan was that he'd team him up with me. So I was actually *quite* interested. I didn't exactly know what to think, but it was fabulous, potential folklore on the hoof. What a setup!

This has all the makings of a screwball comedy.

Yeah. That's what we're going to make: a screwball

comedy out of it. So Simon went there, met Jerry Siegel. The encounter was very interesting. Nothing came of it, because Jerry Sigel's scripts were so lame, corny and scatological that there's no way. But I think this could be a hot story. It's a great way to show off the adventures of Simon Deitch and also utilizing Gary Arlington as a character. I think Gary Arlington had not gotten nearly enough credit for being a seminal, prime mover in the midst of all this.

I'll have to ask Simon about the Jerry Siegel story, too. I think you also met Roger Brand. What was going on with him and what was he like?

What can I say about Roger Brand? He was like our comics university. I learned so much from that guy. He's another enigma, though; such a mysterious character. He just kind of wiped himself off the face of the Earth.

He was like the University of Comics for you?

Well, yeah. This you'll be able to relate to. Roger, among other things, was Gil Kane's assistant. We all know what a great raconteur of comics lore Gil Kane was. So, Roger was sitting next to him day in, day out. Well, I got it all secondhand. All that knowledge that Roger really soaked up from Gil Kane, me and Simon got it from Roger.

When we first met him, he was another one who seemed like too much of a rooty-tooty dude. I met him at the same convention that I met [Wally] Wood at and other guys like that. Roger was hanging around. And it got to the point where I thought, look at this guy. Couldn't we shake him off? Well, we couldn't shake him off. So we ended up in some hotel room with him and a bunch of other people. We're smoking some dope and we're drinking beer. Roger popped a beer and he took a slug of it and he said, "You know, this marijuana's OK, but when all is said and done, there's nothing like a good old beer." Me and Simon kind of looked across at each other and nodded, and from that moment on, Roger was in with us.

That's great. *[Laughs.]*

I know. It's true, too. So we got comfortable with Roger and then he had this great collection. He collected comics the way the pros collected comics in those days, which was: It doesn't matter if it's a Golden Age book in near-mint condition. You rip out the good Kirby story, or you rip out the good Matt Baker story, or you rip out the good Jack Cole story. I got a lot of leftovers from that, from people who followed the Roger Brand approach to collecting. I've still got some of his collection, stuff he gave to me. Lots of pasted-up Eisner stuff where even two comic books were trashed, and various other things like that.

From "Déjà Vu" which ran in *Gothic Blimp Works* #3-6. [©1969 The Gothic Blimp Works Ltd. Inc.]

And he knew all about it. He could look at a *Spirit* section and tell you who penciled it and this and that. (For instance, John Spranger penciled *most* of the 1946 *Spirit* jobs — Roger said.) It was unbelievable.

Plus, he was just a really great guy except for the fact that he was really messed up. When he was like a slick dude, basically what that was all about was he was in more of the up side of his speed-freak cycle. Speed is hell on your nerves and usually the way you come down is with drinking and usually at some point the drinking takes over. That's the way Roger went until he was really one of the worst incredible bums you ever saw. I still liked him.

Close to the end, when I knew he wasn't going to live much longer, I lured him over when my girlfriend was out of town to a Thanksgiving dinner so that I could get him to do an interview with Bruce Duncan, because I knew he wasn't going to be available much longer. Unfortunately, even at that point, he was so crumbly mentally

that it wasn't even a particularly good interview. There was a period where Art Spiegelman had some kind of a comics class in San Francisco and he was inviting different people on different weeks to come and be special guests. So when I arrived to be a special guest, Roger was also there, because basically what happened was when Roger was a special guest, he went over so good that he just basically became a permanent part of the class: just contributing to everything that Art was talking about.

What year would that have been?
Probably the early '70s. I met Roger in '68. I'd seen him in good times and bad times.

And it was just drugs and booze that did him in?
Yeah. Spectacularly. I was at a party and Gil Kane came up to me and cornered me and he said he wanted to know what happened to Roger.

That was at my party, right?

Yes, it was at your party. Basically, I said, "Did you ever read *Sister Carrie* by Theodore Dreiser?"

He said, "Yes." That impressed me.

And I said, "Well, you know that guy in there? The spectacular downfall of the guy in that book?" That's what Roger seemed like to me. It was so relentless. It wasn't exactly a death wish, although he certainly knew that's what was going to happen to him. I don't know. He just pissed it all away. He had a good wife and everything. He just killed himself on drink. I think he might have been exactly 40 when he died. I heard about it. Him and some guy were watching *Saturday Night Live* and Roger was laughing at the show and then Roger went in to the other room to take a leak and the guy heard the toilet just continue running, running, running, which he thought was odd because when you were done you were supposed to jiggle it a little bit and it would stop running and Roger hadn't jiggled the toilet [handle]. He went back in there and Roger was just crumpled on the floor with his eyes open, dead. That was the end of Roger Brand.

I never knew him, but Gil often spoke effusively about him.

A fine guy. Spectacular character defects, but just a wonderful guy. And a God-damned education of a kind. You couldn't find a better one, especially if you liked to drink beer and have a good time, too. He was the whole package.

Now, I guess you got so jazzed up in San Francisco that you started drawing some strips out there.

Yeah.

Did that invigorate your interest in comics and cartooning?

Yeah. What was happening to me in New York was I'd gotten to be a bad speed freak. So I was starting to crumble behind that. But riding out with Gilbert Shelton, I kicked speed on the weeklong ride out there. And a couple of days there I really felt renewed and reborn. Although that town, too, is wilder than shit and pretty soon I was taking speed again. But it was different. It was like you'd be at these drinking parties and you'd be so drunk you couldn't move and you'd take some speed so that you could drink some more; a little different. I mean, San Francisco was way too rich for my blood. I had a whole other new set of problems. But I had a brief flurry of artistic rebirth before it all caught up with me again.

OK, but when you got back from San Francisco to New York after your first short stint, my understanding is that at some point Joel Fabricant started *Gothic Blimp Works*.

What happened was that Joel and Vaughn Bodé put this thing together. In early meetings about it, when Crumb was still around, I remember us — Crumb, Spain and Vaughn Bodé and me — all talking, and Crumb and Spain were definitely saying, "Look, do a comic book. Do a comic book. That's the future." Well, they disappeared and I was off doing other stuff, and somehow Vaughn Bodé prevailed with this tabloid format. He got a couple of issues out. I was one of his assistants on those. Basically what happened to Vaughn is he couldn't take the hippy life. It caught up with him bad. I remember, towards the end, he just said, "I just can't take it around here any more." It wasn't him that said I'm taking over the *Blimp*, either. I just said goodbye and good luck and all that. So there was the *Blimp* and Spain had already left for San Francisco. So Joel just looked around and said, "It's you."

And I said, "No it isn't!"

He said, "You come with me. Let's smoke a joint." So we smoked a joint and he made a proposition to me. Basically I could be making $100 a week. I'd still have to do my *EVO* job and then … actually it was $90 a week. He was going to give me $50 over and above my 40 a week. And I didn't really want to do it. One of the reasons I didn't want to do it was, officially, this guy, Peter Legieri, who was also part of the *EVO* old guard, still had something to say about things, somehow was given the title of the publisher of *The Gothic Blimp*. And I didn't hate Legieri or anything, but the idea of having to answer to him, it just struck me as a big pain in the ass. So I said, "I don't know. Working for Legieri, I don't like it."

So Joel said, "Legieri doesn't have to see it until the paper's printed." OK, that's pretty good. And he basically wrote out all these particulars on a piece of paper. It wasn't a real contract, but he put it in writing. And I've still got it, too. And I did it. By that time I was taking a lot of speed and I was really crumbling. What started happening was I started missing my *EVO* deadline a lot. So I wasn't really making $90 a week. Maybe I made $90 a week here and a week there. I was mostly making $50 instead of $40 editing the *Blimp*, which wasn't rocket science. You just had to have a different page on each page of this tabloid thing.

Well, you had to commission the work and coordinate it all.

Yeah. And I did OK, but I wasn't great at it.

Didn't Bhob Stewart edit the *Blimp* for a few issues?

Good question. Yes. I'm glad you brought that up. So what happened was Vaughn had brought him in. He'd been doing pages of the strip. I guess Vaughn left it to Bhob Stewart. But Joel didn't know who the fuck Bhob Stewart was. OK, his name went on, but it was the same thing with "Legieri doesn't have to see it till it's printed." As far as Joel was concerned, he'd given it to me. And I think it did say Bhob Stewart for a couple of issues. And he might have brought over a page or two of somebody's. But Bhob Stewart seemed to be going through some sort of emotional breakdown himself at the time. He had personal problems going on. I think I could have found a way to work with him if it really seemed like that's what I was wrangled into doing, but I saw a guy — I mean, I'm a fine one to talk, I was in pretty crunchy-bunchy shape myself, but at least I had my methedrine. Bhob seemed to be hanging to the rafters.

He should have had your methedrine.

Except that stuff's no good. It catches up with you. Tears you down for all it builds you up. Nobody over the age of 28 has any business messing with it.

So Bhob edited a couple issues.

He didn't edit it really at all. He brought over a few things. After Vaughn Bodé left, I put those issues together. Bhob might have brought over a page or two of something.

Oh, I see. That clarifies things. Who were the contributors when you edited it?

Whoever I could get my hands on. All kinds of people. Trina was on hand, so she was in. There was another girl cartoonist named Willie Mendez who I knew. I liked her work. I immediately started using her stuff.

Was Bill Griffith in it?

Bill? Definitely. Bill was around. Bill and me, we went back to Pratt Institute.

Really?

Yeah. I'd known him since '62. I met Bill at Pratt. He kind of looked down on me at the time because I was a roughneck character and he was on the Dean's List. And then the second year in he flunked himself out and went to Paris, don't you know. And I didn't see Bill again until 1965. I was on line at the Brooklyn Academy of Music for a Rolling Stones show and the guy standing in front of me was Bill Griffith! And we stood and talked for a while and then I didn't see him again until he showed up at the front door in 2nd Avenue when I was starting the *Blimp* looking for work. I'd seen the stuff he'd been doing in *Screw*. I didn't think it was him, the same Bill Griffith, 'cause it was so scruffy. But eventually, I figured out it was. And of course, as soon as he came looking for work, I did my best to get him in *EVO*, too. I had Jay Lynch. Crumb occasionally kicked in with something. An occasional page from Wilson. I got a cover from Robert Williams at one point. You know, I could have had a page by Bill Everett, but I was too stupid to take it.

Whoa.

Yeah. Isn't that dumb?

Yeah.

But I was reaching out. I got Bernie Wrightson in there. I got Mike Kaluta in there. I met Bill Everett at one of Phil Seuling's comic cons. What a sweet guy. And *so* talented. He was so encouraging. He had that AA religion when I met him. Sort of Christ-like. And he showed me something I could have used in *Gothic Blimp*, which was this nude couple in an embrace under a waterfall. It was so corny, but I should have used it. Maybe I'd like it now. I don't know.

People like that came around. There was one guy, I don't know what his name was, who came around, and all his samples were '50s horror stuff from comics. He was a total hack. But I was fascinated that such a person was in my presence. I really couldn't use him. I did hook him up with Dean Lattimer, who wrote stuff at *The East Village Other,* and I think they did some work together.

Dean Lattimer wrote *Dick and Pat* with you.

Yeah. And Bhob Stewart inked it. Bob kept hanging around going, "When are you going to let me ink something of yours?"

And it's like, "I don't need anybody to ink anything." Finally, one week, I got this inspiration to do this really dirty strip about Pat Nixon and Dick Nixon. I came up with the plot, I told Lattimer what the plot was and I said, "You think you could work this up? It's so dirty they'll never use it, though." So then when Bhob Stewart said, "When you gonna let me ink something?" I said, "OK! I got just the page for you!" It was this fucking *Dick and Pat.* It ran in something. It might have been *Kiss*, it might have been *The East Village Other;* I'm not sure. But I don't need to see it again, that's a fact.

From *The East Village Other* Vol. 3 #44 (Oct. 4, 1968). [©1968 The East Village Other Inc.]

I thought *Dick and Pat* ran in *The East Village Other*.

If you say so, it's probably true. If it did, it probably ran along with whatever actual real strip I was doing that week.

I'm a little surprised that you got Kaluta and Wrightson in there, because it doesn't seem as if they would've traveled in the same circles as you. How'd you hook up with them?

I met Wrightson in a convention. I shook hands with him and I said, "Hey, I like your work."

And he said, "Well, I like *Uncle Ed.*"

The Indian Rubber Man.

Yeah. He's a nice guy. It's not like I got to be real friends with him or anything, but when I asked him to do a strip, he not only did it, but he gave me the original. It was a one-page horror story. Maybe a little more beyond the pale than that. Then his buddy Kaluta came by and wanted to do some stuff. I got to know him a little bit better. They seemed like nice guys, but they were on some other level than me. I didn't know too many above-ground people. Occasionally, me and Trina went to some parties that Roy Thomas put on, but I always felt a little out of place at them.

That would have to be a little surreal. You said you got to know Kaluta a bit. What was your take on him?

Seemed like a nice, earnest young man. I see him now and he's sort of garrulous. He gives off the impression of a person who drinks a lot. I really don't know if that's true or not. But at the time he was very earnest. They were all involved in something called The Studio.

I think that came a little bit later, but yeah.

It must have been around because I met that other guy, Jeff Jones, one time when I came looking for either Bernie or Mike. He seemed much more snooty and standoffish

and a lot less like he wanted to talk to me.

You mentioned *Uncle Ed*; you started a strip called *Uncle Ed, the Indian Rubber Man*, which I've never seen, for *EVO*.

It's not like you're missing a lot. I used to go get a lot of old magazines over at some place called Wiser's Book Store here in town. One of them had an ad in it for some Michelin auto products from about 1920. There's this guy in this rubber suit. He sort of looked like Franklin Roosevelt in a rubber suit. I didn't know they were still using him, which it turns out they are, and I used him a few times. First, I just used him as this innocuous guy bouncing around, but, at one point, they were looking for stuff that was a little more edgy, and somehow he got a dick and, you know, I started doing basically this sex strip about this guy in this bouncy rubber suit going around and raping women.

That was the premise?

It seemed to be the basic premise. Sometimes he did good things, but it was always something sexual … and it might not have gotten that far. There was one week where it really took off. One week I came home. Simon was still living with my mother in White Plains and I said, "Simon, Crumb's in town. There's going to be a big comics issue of *EVO*. I got to have something good. You've got to help me." So we worked up this *Uncle Ed* strip. It ends up when this little Campbell's Kid-type girl rips Uncle Ed's dick off his rubber suit. And Simon came up with this marvelous title for it, "Shake It, But Don't Break It." I knew we had a hit with that one.

And finally I'd really reached Joel. He saw *Uncle Ed* and he liked it. So he started encouraging me. He said, "*Gothic Blimp* #5 is going to have Uncle Ed on the cover!"

So I said, "Oh, OK. Number #5 is going to have Uncle Ed on the cover." Whatever I could do for my benefactor.

You really didn't like editing.

No. When I left town, all these people hated me. It's fine when you use your friends and they like it and you pay them, but then all these other people have brought you stuff and you didn't use it, you know. That's how I met Justin Green. The first time I met him, I can't believe it. I bounced several things of his. I went back and looked at them later and thought, "What was wrong with me?"

You rejected his work?

I rejected some of his work at first. I guess it comes down to Justin's an acquired taste and I hadn't quite acquired it yet. I bounced a few things of Bill Griffith's, too. That's what editors do. But I don't like that. It's a bad feeling. It's not what I'm looking for. The only books I want to edit are the books with me. My relationship with my two brothers has gone down several notches since *Deitch's Pictorama* began. It's unpleasant.

It can be treacherous.

[©1969 The Gothic Blimp Works Ltd. Inc.]

It doesn't feel good to be dicking people around, which is sometimes what an editor is forced to do.

Did you meet Justin in '68 at *EVO*, too?

More or less. It might have been '69. Basically, the way I met Justin is one day I was sitting around just goofing off at *EVO,* and the phone rang and it was Justin Green and he was all in a lather because he'd sent some stuff to *EVO* and they lost his work. And I immediately go, "Whoa! They lost your work! Goddamn it!" So I put the word out. This went on for several days, and we finally found the work. Then he says, "What do you think?"

And I said, "Nah. I don't think I can use it." So, that was my first encounter with him. I don't even remember whether that was justifiable or not, but I know there were several that came later that Mad Peck ultimately used ,and seeing them, I couldn't understand why I hadn't used them. They were perfectly good Justin Green pages.

Did you move to San Francisco when you were editing *Gothic Blimp* and then stopped editing it because you moved?

Yeah. I went and checked out what was going on in San Francisco and decided this is for me and I wanted to go there. Then I came back and I figured I got to play the game out. I'm editing this mag and I'll begin to wind things up so I could leave. So that's what I did and there was about six months where I wound things up.

And I thought *Gothic Blimp* was finished when I left, but it turns out that they did put out one final issue. I was really pissed off about it, too, because I'd been running a serial by George Metzger and I think we even had the last episode and they didn't use it.

Metzger wasn't living in New York, was he?

No, he wasn't. I hadn't even met him yet. I believe Metzger was somebody that Bhob Stewart brought in, as a matter of fact. But I liked it. If I didn't get it right away, I read an interview with Will Eisner where he called Metzger's stuff brilliant so I took another look at this guy. And I think there was something intriguing about Metzger's stuff. It had this interesting Japanese influence. You know what he was? He was the king of the fanzine artists.

Yeah. Right. He had an avant-garde strip in *Graphic Story Magazine, Master Time* and *Mobius Tripp.*

So he was a crossover from the fanzine world. But I was happy to have him. I ran into George recently, too. He came through town for some anime convention.

Really?

Yeah. There's old George Metzger sitting right in this room here.

Do you know what he's been doing for the last 30 or 40 years?

This and that. He had a story. It's touching and sad. He was married to some woman who died of cancer. He's had his ups and downs. It's not like he's really doing much artistically, which is too bad. I thought he would go farther than he did. He was on to something. I think he was just too easygoing or something. That's like my brother, Seth. He's a brilliant guy, but he's too easygoing to ever really get anywhere. Maybe I'm wrong. I'm highly impressed by his talent.

My understanding is you were drinking more and taking speed and decided to move to San Francisco. Is any of that related?

I was drinking and taking speed when I made that decision. Everybody who was serious about comics was going to San Francisco at that time. We all went looking for that comic-book El Dorado and we found it.

So you and Trina and Gilbert Shelton and his girlfriend drove across country. What was that like?

That was a little tense because Gilbert and his girlfriend had definitely agreed to break up once they got to the other side. There was a lot of tension. It was an interesting trip, though. I remember, it was coming to the end of the '60s, and me and Trina were talking about "what was all this coming to?" And she was saying, "I think the great thing that's really going to stand out about all this is LSD."

And I was going, "Aw, you're crazy. It's fun to take LSD and all, but you're vastly overrating it." And it must have been about two days later that, over the radio, it's starting to come out about Manson and the Manson Family. It was the death knell of all of that, and the proof in the pudding that more than just great holy activities took place on LSD. So that always stayed with me.

Had you known Gilbert Shelton earlier?

He blew into town at some point and I had this place over on Ninth Street with Trina over on Second Avenue. I called him up when I was editing the *Blimp* and I asked him if he'd be in it. And he basically said he didn't have time and that was it. But then he showed up at my doorstep and, what's more, he needed a place to stay. So it was, "Come in, come in and stay, you know …" so yeah,

he did a cover and some other stuff. It was great. Gilbert brought a lot of excitement with him. One of those things that happened almost immediately after that was he invited Harvey Kurtzman to come over to *The East Village Other* and we all did this big jam with Crumb, Gilbert and all kinds of people.

Was that the first time you met Kurtzman?

Yeah. I only met him twice. That was the first time and a week later, maybe less, he invited us, along with Roger Brand, always the great conduit, to his home in Mount Vernon. So we spent a pleasant evening with him there.

What was your impression of Harvey?

Totally great. Totally wonderful, great guy. And very funny, too. I think what he was doing at that time was a *Little Annie Fanny* that was going to have to do with the underground press, and so he was researching the underground press by agreeing to be at *EVO* with us doing that strip. Basically, Gilbert wrote a two-page poem thing. I wrote the part for me, but other than that, it was all Gilbert. And Crumb was in town. So it was great.

Man, what a social whirlwind.

Yeah. It was great times. And that's the thing: I knew it right then. Some people, they're going through stuff, and they come back later and say, "I didn't really appreciate it." I appreciated it. I really knew that I was going through hot times. The only regret I had was that I wasn't more up to it than I was. Because, you know, I hadn't really found my groove yet.

The best was yet to come.

Yeah, it was. And amazing that it came because I wasn't exactly on anybody's "Most Likely to Succeed" list. *[Groth laughs.]* I was infantile. I was unbelievably immature, though I had no idea of it at the time.

So, you traveled across country. Did that go smoothly?

Well, there was some tension because Gilbert and his girlfriend, Noel, were always bickering with each other. That was a little surprising because Gilbert is always on stage. He's a very gentlemanly guy. To see him any less than that way is a little disconcerting. It was great, though. We stopped in Cleveland overnight, and I met Frank Stack. I forget what else. We stopped a few places along the way.

It must have taken you, what, a week to get there?

Yeah, and we smoked dope the whole time. We smoked

so much dope at the time, it wasn't like we were royally stoned. We just had a buzz going all the way.

And you drove stoned?

I don't drive at all. Gilbert and his girl were doing all the driving. Me and Trina were paying for half the gas.

Where did you live when you arrived in San Francisco?

Well, it was murder finding a place right in San Francisco and somewhere in there, a friend of Trina's put us onto several places in Marin County.

Marin County?

That's right, they had beautiful hills in Marin County. But you know I didn't drive. I came to be part of the scene.

I know your relationship with Trina ended in 1970.

Essentially, although we had some kind of a sex life going on for another year. You know we had a kid together and I was taking the kid on weekends. It even seemed like for a while we might have gotten back together, but then I met another girl.

When was Casey born?

Casey was born on, I think, June 2, 1970.

Same birth date as my kid.

Is that right? Wow.

And by that point your relationship was deteriorating?

It was deteriorating. We broke up at the end of the year.

What were you doing in terms of drawing comics? You had not yet drawn *Corn Fed* #1.

I was just drawing pages for everybody's books. I did five pages for Gary Arlington's *San Francisco Comic Book*. I think I was working on another five pages for *San Francisco Comic Book* when Jackson invited me to do a story for *Up From the Deep* and I did 13 pages. Then, no sooner had I finished that than Gilbert invited me to do something for *H-Bomb Funnies*. So I did nine pages for Gilbert. And it was like that. I kept meaning to do my own book, but instead I just kept doing pages in other people's books, which was OK. I knew I eventually wanted to do a book. 'Cause at some point Bob Rita said he'd do a book of mine. It was just a matter of doing it. I finally had to get out to Oregon and get away from it all. That's when I finally got the chance to do a whole book.

What was your impression of Jackson?

Very personable, and he was so complimentary about my work. I even knew that before I met him. I guess I'd done the *Hydrogen Bomb* one first 'cause he came into the San Francisco Comic Book Store and read that *Hydrogen Bomb* story. I wasn't there but Simon was there and Simon said he'd read it and he said, "That is one of the greatest comic-book stories I've ever read." *[Groth laughs.]* So I was very flattered and encouraged when he invited me to do a job for him.

Did you feel that at this point you were beginning to find your voice as a cartoonist? Were you trying to figure out what subject matter you were —

Yeah. And it was tough. I'd have these bad slumps 'cause there's a lot I hadn't figured out about it. The groove I'd

Kim Deitch and his daughter Casey Robbins in 1970: photograph courtesy of Kim Deitch.

worked out for myself, well, there were several things involved in it: One thing, a lingering aspect of my straight-job days, I was still on the night shift. Doing comics, I'd generally work all night, Trina was pretty social, and the best way I could really get a lot done was sleeping as much as I could during the day. And the other thing is — this is pathetic but — in those days I felt I couldn't do comics unless I was stoned. In a way, it helped me do the comics; in another way, to rely on a crutch like that you're gonna run out of gas with that kind of approach. Nowadays, if I'm smoking dope and I'm in the middle of something, maybe I'll work stoned for a day or two until I'm not smoking dope again, but really it's not a good idea. But see, what it is with me is, I seem to have a more interesting response to weed than some people. There are times when I smoke it that I can really feel a whole other part of my brain opening up and I can actually hear my brain talking to me. You know, from smoking pot, and it'll say some worthwhile things and I'll take some notes. But that doesn't happen on command. It usually happens when I least expect it, and less and less, the older I get. I've found there are better ways to get in touch with the inside of your head. Less wear and tear. Nowadays if I'm smoking dope, I'm smoking dope to relax and chill out, and I keep it pretty segregated out of my day-to-day life for the most part.

I haven't actually seen more than a handful of pages, but the strips you did for *EVO* struck me as being almost stereotypical '60s hippy trips.

Yeah, it's student work; I was earning while I was learning. I got better later, and that's the good news.

How do you think your work evolved from the *EVO* stuff to the work you started doing in San Francisco, in an entirely different milieu?

I definitely said, "Comic books, that's the future." I mean I was already doing some comic-book stories, even before I left New York 'cause I'd made some contacts out there. I'd done a four-page story for Spain's *Insect Fear* already. I even used a comic-book format for something called *Doc Destiny* that ran in *EVO* but it ended up in an early issue of *Bijou Funnies*, too. So I was already shifting over.

You did *Hector Perez, the Boy Vivisectionist*.

Yeah, but actually, that was one of the ones I drew while I was visiting San Francisco. I drew half of that while I was still in San Francisco, and then finished it when I got back to New York. And that was very popular. That one got picked up all over the place. Not that it was so hot or

anything. Like I say they were more aimless in those days. I was still more or less making them up as I went along: I hadn't really learned how to plot things out.

And how to truly craft a story.

Yeah I mean, I'm only figuring that out fully now. I'm doing a real novel now. It's gonna be loaded with pictures, but I just figure it's time. I don't know if that's what I'll do from this point on, perhaps not, but I think I've got to at least do it once. I got a hundred pages already, and a pile of art. I'll show it to you. I think it's pretty good.

The underground scene was a small community, you had X number of publishers and you had all the artists hanging around and —

It was cool. It was a small community, but what was really cool about San Francisco was we were popular in the town. There was always a party for us. You know what it seemed like? It wasn't like you were all the way to being a star, but it sort of seemed like you were in a well-liked minor-league ball team.

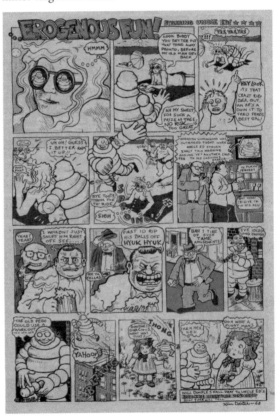

From *EVO* Vol. 3 #43 (Oct. 4, 1968. [©1968 The East Village Other Inc.]

You were mini-celebrities?

Yeah, there was always a party: there was always a door open for us guys. And that was fun, plenty of girls too. So you know.

What more could you want, really?

In a way, yeah. I mean I knew I was still missing the boat on some essential level.

You mean some essential creative level?

Yeah, I knew in my heart of hearts I wasn't living right, too.

Because of your lifestyle?

Well, it wasn't healthy, physically.

But you were young.

I was young, but a lot of these people we're talking about, they're not here any more. I think I made a lot of really stupid mistakes when I was younger. I don't regret 'em because I have this dumb luck that saved the day and I didn't seem to do any permanent physical damage to myself. But it could have easily gone the other way and it sure did go the other way with plenty of people I knew. Not just Roger [Brand], but this other guy we looked up to, Jim [Osborne]. Goddamn! Fucking guy ended up drinking himself to death. And I was the big drunk when we were hanging out, that's another one I just can't get over.

Did you like his work a lot?

A lot. Yeah, and I liked him a lot as well.

You became fairly close to him?

Yeah, him and his wife. They were really good people. I had many a good evening going over and hanging out with those two, Jim and Margaret. I looked up to the guy. He'd drink wine, but he didn't drink to excess that I could notice. And I sure didn't see that coming with him. I thought his work was tremendous. I thought this guy was definitely going places. He was definitely a big influence on me and Simon. I just can't accept what happened to him.

And his death was related to drinking?

Yeah, he drank himself right into a hole in the ground. I can't accept it.

Was your brother Simon out there?

He appeared at some point. What happened was he was already going down a bad path when he left [New York], he was badly strung out on heroin, which happens to him periodically. I left and, at a certain point, Simon just showed up, and at that time, I'm living in a little bungalow with a fence out front with Trina, and a baby on the way. Of course, he came to me, and of course, I took him in. If it was just me, that's probably where he would have ended up living, but Trina, she says, "Look, a day, two days, three, get him out of here." And she was right. What happened was Gary [Arlington] took a shine to him, cause he's nothing if not interesting, and he said, "OK, you can sleep in here, and work the cash register." He eventually ended up living around the corner on Valencia Street in Don Donahue's print shop, where Osborne ended up living too when he broke up with his wife. Beautiful wife. That was his first mistake right there.

So you had Casey in June of 1970; what was being a father like while working in underground comics? Were you making a living, such as it was, doing underground comics?

I was making a living, 'cause Trina was so smart and such a good finagler. Basically, this is the premise we came out on: We met Crumb, and he said to us, "$40 a week, humph, I predict you guys come out to San Francisco, you'll be making a hundred dollars a week!" and we said "No, no." The more important thing he said was, "And anyways, what's the difference? California's the welfare state. I'm on welfare, you can be on welfare, too." *[Groth laughs.]*

So Trina heard that part, and she said, "OK." And she was pregnant too, perfect for welfare. When we got out there she went into the Welfare office, she's a good talker, and she got us everything the law allowed and maybe a little more. We were sitting pretty. So yeah, I was making a living with underground comics 'cause everything I got was mad money, 'cause we had all the basics between Welfare and food stamps covered, baby, covered. Believe me, staying with Trina, I didn't never have to worry about money, it's just that she was driving me crazy. Trina owns her own building now in San Francisco.

Holy shit.

That'll be all Casey's one day. Trina knows how to get along in the world. That just comes to her natural-like.

Wow, that building in San Francisco's gotta be worth millions of dollars.

Yes it does. It's not a posh building, but nor is it a dump.

A building's a building, especially in San Francisco.

She'll just be listening to somebody at the right moment and make the right move.

So your standard of living must have dropped like a rock when you split up.

I guess it did. The year that we were officially split up was kind of a bum year. Gary Arlington took me in. I had to share the rent at his place over on Albion Street. Me and Gary were roomies. And that was a dead year: I was drinking too much, I was getting laid a lot. But so what? You know? God, I hardly did any work that year to speak of, I mean none that seemed good. It really seemed like, for a while there, I was going down the toilet. But at a certain point I met this new girl, you know.

Is that Sally Cruikshank?

Yeah, and she basically said, "Look, my sister is living in Portland, Ore. I wouldn't mind spending some time with her; maybe we should relocate up there for a while."

So, I said, "Yeah, OK." It got me away from some of the problems I was having in town at the time with my ex-wife and kid and all that. So I went there, and that's where I finally got it together to do a whole comic. It's weird in Portland. First of all, the living was cheap; it was a real stumblebum place. There's this aura of ineptitude about Portland, although the people are very nice. But it seemed like all the jobs that I'd done in San Francisco were still being reprinted; I was getting a heap of royalties that year. Plus, with paying next to nothing for where I was living, I could have gone on a long time in Portland. I certainly had no trouble supporting myself while I did *Corn Fed Comics*.

Underground publishers actually paid you?

Yeah. Well, there really was a boom. Here's the thing, in those days, any underground comic generally speaking printed a 20,000 print run. And just about anything was good for three printings. So you know just about anything was 60,000.

I sure miss those days.

Yeah. The bottom fell out about '72. Then Bill Griffith, another man with horse sense, got us together and we formed an ad-hoc emergency publishing company called The Cartoonist Co-op Press. We managed to publish 10,000 [copies] each of our comics.

Let me skip back for a second and ask you, how you took to fatherhood?

Not well. *[Groth laughs.]* Which is weird, 'cause it was my big idea. I'll tell you the story. Here's what happened, essentially, when I met Trina. We got along and there's a certain point where suddenly we're in bed, and it looks like we really like each other. She then drops the bomb on me, "Yeah but you know, I got a boyfriend and I'm three months pregnant."

And I said, "Gee, that's too bad."

And then she comes back to me a few days later and she's, "Big news, big news! I went to Paul Krassner and he told me where to get an abortion and I got an abortion and now I'm all yours!"

So I thought, "Oh that's OK, yes, it's OK." But here's what happened: It was eating at me. It was eating at me that a baby died because of me, and it was eating at me so much I thought, "Gotta put the baby back, gotta put the baby back." So it was my idea to have a kid.

I see.

She was even hesitant about it at first. I mean, it wasn't that hard to talk her into it because she'd been pregnant before. And so, because of me, badgering her, that is how we ended up having a kid. It's funny, too — after we broke up, my father was asking me, "How did you and Trina get together and have a kid and what was that all about?" And I couldn't tell him, because I just blanked all that out. It was a couple of years before I could even remember all that. But that's what it was.

So I'm basically answering your question, so you'd think I must be interested in being a father. But once she was pregnant, I started getting pissy about it. And what really brought it on was she wanted to do it as a natural childbirth, and she started making me go to these Lamaze natural childbirth classes. I was hating that. And I was a real shit about it, too. I'd like to think that maybe I'd stretch a point and just go along with it, you know? It's a big thing making a new kid, a new human being — and the fact that I was such a royal shit about it. You know, I don't think that speaks well of me. But that's the way it was, and really, by the time we were done with all of that and I was there seeing the kid getting born, I'd had a bellyful of it.

And then all of a sudden, there we were with a kid! And at that point, I was malcontent, plus Trina had gotten into all this shrill women's liberation stuff. It got to the point where it seemed like we couldn't have a fight where I'd storm out of the house that I wouldn't come back and her support group'd be in the living room. *[Groth laughs.]* And I'm not defending myself here. I'm parading before you some basically immature behavior of mine. But that's what went down.

And certainly, I've got a lot to answer for in all of this. I'm trying to be a better person now. I'm trying to be a more decent person. I've had the usual number of girlfriends, and I think I've had some darn good ones that I've run through. I'm lucky that I've grown up a little, and now I've got a good one and I'm gonna try and hold onto her and treat her right. 'Cause I've sure done more than my share of treating them wrong.

So fatherhood was not for you.

No, I behaved poorly. I sort of got to like the kid, but even then when we broke up, taking the kid on the weekends, I was really pissy about that, too. A better man than me could have somehow made that work better than I was making it work. That whole chapter in my life doesn't say a lot for me. Like I say, I hope I've learned from my mistakes.

Were you just so interested in other things that you couldn't take the time?

Casey and Trina Robbins in 1972: photograph taken by Patrick Rosenkrantz.

Yeah, self-absorbed. Wanting to have my own fun and do my own thing: a selfish person.

When you have a kid you have to rein that in.

You should, yeah. I made a royal mess of it, and that's a fact. And I'm sorry for it. I did what I thought I had to do at the time, and maybe it was what I had to do, but it didn't make me a very nice person.

When you moved to Portland in '71, you moved away from your daughter?

Yes I did.

Was that a hard decision to make?

No, it seemed like it was an easy decision to make. I liked the kid, but it's not like I felt any tremendous bond to her. Maybe if me and Trina had been getting along better, it would have been different. But she was so gone on the kid that it just made me that much more resentful about the whole situation, even though it was a situation of my own making. I'm telling you, I've done a lot of growing up since then. But because of it all, there's another living person in the world and that's, I think, a good thing. We're all still here. I'm sure she thinks I'm some kind of a shithead, and to some extent, maybe she's right.

You're talking about your daughter or Trina?

I was talking about my daughter, but it will serve well for either one. *[Groth laughs.]* I have some limited relationship with my daughter. You know, whenever she gets in touch with me and wants to know this or that, I do my best to oblige her. I don't know her very well; she lives in that building Trina owns.

I was gonna say it has to be a very different relationship than if you had grown up with her, if she had grown up with you.

I hardly saw her when she was growing up. Basically, the person who engineered my getting to know her again when she'd reached adulthood was Leslie Cabarga. At a certain point, Trina decided to haul me into the child-support court. And basically, I said, "What if I get together a pile of money for you?" She basically said that if I could get some dough together for her and also promise to stay away from the kid, she'd go away. I had this eight-page Crumb story, "Lenore Goldberg and Her All Girl Commandos," so I sold that.

The original art?

You know, I heard that fucking thing recently went for

40 grand? That could put the kid through college. I didn't get 40 grand for it, but what I got for it I gave to Trina, and I told her I'd stay away from the kid, and that's what I did. Though I actually did catch a glimpse of the kid every now and then.

Why did Trina want you to stay away from your daughter? Did she consider you that toxic a presence?

Because I'd been so unreasonable. I took care of the kid on weekends for the year of '71, but then I went away to Portland and did a comic book, and when I came back again, I said I wasn't gonna do that any more. Even my father got into it; he said, "Look Kim, come on, come on, you gotta take care of the kid for a weekend. What's so hard about that?"

But I just said, "I'm not doing it." I put my foot down and that's where it stayed. And that's when she served me with papers. That's when I did what I did. That's what happened.

She proposed it and you accepted it?

I guess I first brought it up, but she's the one who said, "And you'll stay away from the kid."

I said, "OK." It was all a big mistake, but that's what I did, not that I didn't feel regret about it, 'cause I did.

And later on when Casey was about 18, Leslie Carbaga then moved in with Trina. I was living in L.A. in the early '80s and, one day, he called me up and said, "You know, Kim, I wanna apologize to you. You know, I think you got a bad deal in all of this. How would you like to be able to have some kind of relationship with your daughter again?"

And I said, "Yeah, I would like that." So he arranged for some kind of get together in Philadelphia I think it was, around 1989 or 1990 and that's when I officially met my daughter again.

And you hadn't seen her in many many years?

Hadn't seen her in many years, I've seen her maybe once or twice since then. Every now and then she'll e-mail me about something. When she had a kid, she told me about it. I think she thinks I'm interesting, and every now and then she gets the bee in her bonnet and wants to talk to me about something.

That's got to be a very tricky relationship.

Yeah. So I don't even know exactly what kind of a person she really is.

That's got to be a little painful.

It is a little painful, but I've gotten over it to a point.

But I bet it's still painful.

Yes.

When you met Sally Cruikshank I guess you guys got along and became boyfriend/girlfriend, and you moved to Portland with her.

Yes.

Now I know she became an animator, but was she an animator at the time?

Already was. I met her at a party where they were showing a couple of her cartoons. She showed some cartoon she called *Ducky* that just used the entire side of this old Ben Selvin record of *Ain't We Got Fun?*, the song that Bosco is always singing in the old Looney Tunes. I was so impressed, not only with the cartoon, but also the song *Ain't We Got Fun?* It just resonated: the whole thing resonated with me. One thing led to another, she'd actually been going with Osborne for a while and Osborne unloaded her on me 'cause she was getting too serious with him and he was looking to get back together with his wife, which he did briefly.

So he broke up with her?

Well, he was cheating on her with Sally. You know he was starting to go to the dogs although I didn't realize it yet.

So you moved to Portland because it was quieter and gave you some respite from the hurly burly of San Francisco?

I had a bad creative year in '71. Some of it you could blame on my own personal disorganization *[Groth laughs]*. But I really needed to get away from San Francisco for a while because I felt that I was overdue to do a solo comic book, so that seemed to be the ticket.

The year was '70, which was a very good year. It was a rejuvenating year for me, I was really flush with the excitement of being in San Francisco and being among all those people.

Then you decided to do your own solo book.

Right. Bob Rita had told me that he'd do a book with me and I said, "Oh gosh yeah, the time has come."

Corn Fed

Tell me what your conception of *Corn Fed* #1 was and how you went about conceiving an entire solo comic.

From "Madam Fatal Pursues the Cryonic Kidnappers" in *Cord Fed* #1.
[©1972 Kim Deitch]

I'll tell you frankly there was no high concept there, really. *[Groth laughs.]* The next batch of stories I did, they were all gonna go in my own book is what it was, and at that point I was still making 'em up pretty much as I went along.

I guess the first one I did in that book is called "Venusian Vermin," which was the second Miles Microft story. I think by that time I was planning up to the extent that I decided, "Well, you better bloody well know what kind of a climax you've got"; I would prepare to that extent. I was pretty much winging it; *Corn Fed* #2 was one long story, I made that one up as I went along, one page followed the next. I look back on that now and think, "that's treacherous." *[Groth laughs.]* Ya know, it's great if it's working, spontaneity is worth something. But I think spontaneity is better to be occurring in the sketchbook stage when you're working things up.

There was one point along late in '70 where I started making one up for some book of Roger Brand's and you know I hit page four and I knew I had a stinker on my hands, and that's a bad feeling.

I assume certainly in the last 20 years or so you do not use that technique.

No. When I'm writing I'm also doing all kinds of sketchbook work at the same time and trying things out, working it out. I have a pretty intricate system worked out, and I can really show you that much more clearly when you here.

I had a guy come over here one time, a few years ago, I was showing him how I worked, he was looking at it all and he was going, "Yeah man, yeah man, but where's the spontaneity? Where's the spontaneity?" to which I just pulled out some of my sketchbook sheets and I said, "Here's the spontaneity." That's where the trial and error and all of that goes. I just said, look, you know if you're taking the story aspect of it seriously you gotta approach it with a plan. It s not like novel writers make it up as they go along… Well, there was Charles Dickens. His first draft was his last draft every time till he dropped dead in the middle of one and nobody still knows how the mystery of Edward Drood came out.

In a way, spontaneity seems like a young man's game; as you get older I think you wanna know what you're doing.

That's the thing. You can have some flashy luck with stuff, but in the end you gotta figure out something that's gonna work for you day in day out, week in week out. So that you get that flow that you can more or less count on. And also you wanna be running interference on the conduits of your inspiration so that you don't end up with dry spells, which used to be a big plague for me. (Knock on wood.)

Who is Fowlton Means?

OK, that's a perfect example of spontaneity. *[Groth laughs.]* I sat down to do a story, "The Brindlesteen Apparition," and I was on page one and I had no real plan, I think I had a few sketches with an idea of what the climax was and I started to write the byline. Instead of writing "Kim Deitch" I wrote "by Fowlton Means." Where that was coming from essentially was Spain; back in the *EVO* days he used use a *nom de plume* for writing called "Algernon Backwash" and I was very envious of it so I was unabashedly imitating Spain with a colorful *non de plume*.

Another example of spontaneity on that story (that being the first Miles Microft story) was that I didn't really know there was going to be a character named Miles Microft in it until he showed up on page three. Which is fine and it worked that time.

You used Fowlton Means many times.

Yeah eventually he became a character even. At a certain point when I was in Portland doing *Corn Fed* #1, on

From "Venusian Vermin" in *Corn Fed* #1. [©1972 Kim Deitch]

the inside front cover I have little bios of me and Fowlton Means. My girlfriend Sally's sister was going with this guy named Jerry Hawkins and I thought he'd make a good Fowlton Means. So I got two pictures, a picture of me and Fowlton Means too; of course the picture of Fowlton Means was a picture of this guy Jerry Hawkins.

The story "Cult of the Clown" was more overtly political than most of your stuff; it was distinctively anti-capitalist and you even quote Mao.

Yeah. I would say it was more like anti-political in that it was a send up of the strident jivey "right on brothers and sisters" stuff that was going on at that time. A mix of that and also, I'm kind of embarrassed to say it, but I was a big fan of *All in the Family* at the time. *[Groth laughs.]* I was trying to get a little bit of that sitcom feeling into it as well.

Tell me how long *Corn Fed* took you and how you worked on it in Portland?

Seemed like I was there seven-nine months, and that's how long it took. I came back to San Francisco with what I thought was a finished comic book, but then of course I learned a real basic, fundamental rule about printing, which is comic books come in increments of eight [pages] and I had what I called a 32 page comic book, but it really needed four more pages. Which was shocking to me 'cause I'd come back like "Woo, it's all done, it's all done, now I'm gonna chill awhile."

Fortunately Justin Green was able to lay some amphet-

amine cartwheels on me and I ponied up real fast with another four-page story.

[Laughs.] I see. You were able to earn a living in Portland because of royalties from the comics you did previously?

Yeah, and the living was cheap, it was just incredibly cheap to live in Portland, plus it seemed like every time I'd turn around I'd get another royalty check from some job I did in '70 back in San Francisco.

Those were the days.

Those were the days.

Was working on *Corn Fed* an adrenaline-fueled experience? Were you really charged to do this?

I was charged. I remember it as a good time. In a way, going to the ineptitude of the Portland scene it started to get me off of my habitual use of marijuana while working because the marijuana was so bad in Portland *[Groth laughs]*, it wasn't working that well. So I started to emerge from that crutch.

Your work habits improved due to the poor quality of the marijuana.

Yeah. Portland I remember as being a really good-natured place, but there seemed to be this aura of ineptitude about it as well. Great junk stores, though.

So you did *Corn Fed* #1, and moved back to San Francisco?

No, I had everything but the four pages that I needed, so that there wouldn't be four blank pages at the end of the book. So I did 32 pages with front-and-back covers and came back with that.

I understand, of course, there was some drama about the publication of *Corn Fed* #1 where your brother wanted to publish it. And you said you "… got involved with him about publishing it, but we got into a big falling out over it and became mortal enemies briefly."

Yeah, that is an interesting story. What happened was, while I was in Portland I actually got a letter from Don Donahue saying he'd like to publish it, which I was definitely open to. I liked Don Donahue: he was a very interesting guy. But then I also heard from Simon. "I don't care what anybody says to you, you should let me publish it."

'Cause what had happened was that Simon was at the San Francisco Comic Book Store, behind the counter, and

I guess Crumb came in one day, and he was on his way over to Donahue with the second issue of *Mr. Natural* and Simon understood how comics were printed, and he basically thought, well what's so hard about publishing a comic book? Ya know, you go have the guts printed one place, you go over to Cal Litho [Cal Litho —a color printer who printed most of the underground comic-book covers], you have the cover done, you go to a binder who puts it together and you arrange for somebody to distribute it. You could do the whole damn thing on the phone for crying out loud *[Groth laughs]*. So when Crumb was there, he goes, "Hey Crumb, I was thinking: Why don't you let me publish *Mr. Natural* #2?" and Crumb, who at the time liked Simon, although that is no longer is true, went for it. So Simon started publishing *Mr. Natural* #2. Well remember I told you just about anything went through three editions and sold 60,000? Well, *Mr. Natural* #2 was like printing money in your basement.

If you'll pardon the expression, when I came back to town, Simon was "Nigger Rich" and talked me into publishing my book. He said, "What do you want, Kim? I will give you a $1,000 advance," which sounds like bullshit now, but you know, really, a $500 advance wasn't so unusual in those days. I thought that sounds OK. So there's Simon and he's on a roll but he's also gotten so cocky. You know, I remember him talking to somebody who came over to see him while I was with him and he's describing the comic business as a sweet racket *[Groth laughs]*. A sweet racket? I am busting my ass all the time; it doesn't exactly seem like a "sweet racket" and just generally he's getting more and more hard to take. I was getting a sense that I wasn't gonna be in very good hands here, and already he's having trouble with Crumb because he's not keeping any books, everything is fine until at one point Crumb wanted him to send him some large amount of money because he wanted to bail a friend of his out somewhere else, and Simon didn't have it. It was starting to unravel but even before that point I lost confidence in Simon and plus I was just getting to the point where I couldn't stand to be around him.

One night at dinner when I was over with Simon and his wife, with me and Sally, we just had a big massive blowout, and I am sitting home after this and basically I'm going, oh shit, what am I gonna do now 'cause I already told Donahue forget it, I am doing it with Simon. I was doing the book with Simon; now to go crawling back to another publisher didn't seem so hot.

Then Sally says, "What's the matter with you? Simon Deitch could publish it. *You* publish it. *You* have the guts printed. *You* call Cal Litho and have the cover printed.

You call the bindery and have it put together!"

Of course, she was right, I didn't really have the money but it was easy enough for me to… Alfred Bergdoll had already been collecting my work and I managed to borrow some money from him, which I paid back, and that's what I did.

In fact, you know who published it? Terry Zwigoff. He was this jack-of-all-trades, master of none, 'til he finally found himself as a right good movie director and at that particular phase of things he was part owner of a printing company called Honeywell and Todd. It was named after the company that Margie's father on a TV sitcom called *My Little Margie* used to work for. Very obscure reference. They offered me a cheap quote and so I said OK, give me 30,000. Seemed smart at the time.

Man, those were the days.

Yeah, final phase I went to the Print Mint, they were willing to take 10,000, I went to Ron Turner, he took 10,000. I got rid of a thousand or so with Denis Kitchen,

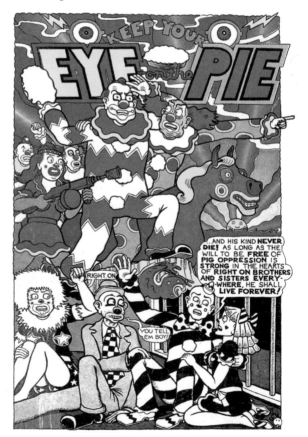

Corn Fed #1's back cover. [©1972 Kim Deitch]

so I was already in the black, although it has to be said I've got four or five thousand of 'em sitting in my warehouse space, over in Harlem, now.

Still?

Because by the time *Corn Fed* #2 came along the whole bottom fell out of it. There never was a reprint of *Corn Fed* #1. By the time *Corn Fed* #2 came out, I couldn't find a publisher. Most people couldn't find a publisher. Basically Bill Griffith saved the day by proposing something which I jumped on eagerly [which] was to form our own publishing ad hoc concern briefly just to bail out our various projects.

So you published *Corn Fed* #1, and distributed it.

I had it distributed. And here's what I discovered: Yes, it's true that it isn't that tough to publish something, but it's also true that it takes a certain amount of time and work nonetheless. And to be drawing the work and publishing it too — it's a bit overwhelming.

But you must have made more money by doing that then just by letting a publisher publish it.

I guess I did. It was a profitable venture in spite of the fact I got all those comics left over. Now I sell those for $10 apiece.

I was gonna say you're sitting on a gold mine.

They will probably still bury a bunch of 'em with me. [*Groth laughs.*]

That was actually published in '72. *Corn Fed* #3 was published in '73; in that 12-month period the bottom fell out?

Pretty much, yes, it happened in late '72. There was a major reversal, a lot of it had to do with the head-shop distribution deteriorating.

Is that when the court ruling came down?

There may have been some other things like that that were in play as well.

There was a federal court ruling that put head shops in jeopardy.

Maybe that was the catalyst of what threw the head shop thing out.

Within that year, in that year's time it really sunk the market.

Comic business, it's been pretty much like what I saw

From "Venusian Vermin" in *Corn Fed* #1. [©1972 Kim Deitch]

in the animation business growing up with my father, a boom-and-bust situation. But one interesting thing about it and one thing that gives me courage is that I've done some of my best work during bust periods. Like right now we seem to be in a boom, this is the longest boom I've ever seen. But ya know if it goes bust again, pray to God it doesn't, I'm prepared for that.

The next major step was the Cartoonist Co-op Press, which would be '73, and you had finished *Corn Fed* #2 at that point?

Yeah, I'd finished it. It was just sitting on a shelf in a closet. I knew it would get published eventually. Every now and then in a bust period I've had a story that didn't get published right away, but thank the good lord everything eventually sees print.

Can you back up for a second and give me a description of the publishing landscape? The main publishers were Last Gasp, Rip-Off and Print Mint.

Yeah, and then there was something else called Company and Sons that was looming around.

Did they each have their own distinctive personality or idiosyncrasies?

Ron Turner was the green guy. He started out with an ecology comic. Later he called himself Baba Ron Turner and had the trappings to some extent of a mystic holy man *[Groth laughs]*. Bob Rita was a crude scrapping guy, probably been in jail for getting in brawls, time and time again. Which is why I got along with him so well, I was one day standing around at his place describing how Joel Fabricant was really a crude person, but that I liked him, and I think that resonated with Bob 'cause he was going, "Yeah I'm crude, too." *[Groth laughs.]* It didn't seem a nanosecond before he offered me a job, so I worked for Bob for a while.

He was a big Hawaiian guy. Good guy, too, really nice, really good-hearted. He was a little rough-edged, and, tragically, he got way too involved in cocaine, which I think eventually wore him out and led him to an early demise.

And his wife Peggy played a part in the company right?

Yeah, she was nice. I hope she's still around and doing well. They were OK, Bob and Peggy, I've worked for worse people than them. They were good people and I liked them.

Rip-off was a co-op owned by cartoonists.

Right, Rip-Off was a co-op, so they used to call it the Texas Mafia, they were all Austin Texas refugees. They were best known for the great parties they threw. They would usually be two-keggers and like I mentioned before, sometimes there would be LSD and stuff too, you could see a lot of rock-and-roll stars there. I remember seeing Mike Bloomfield there on various occasions. It was a good place to go and get good and drunk with your compatriots. And they were all pretty likeable, Texans in general seem to be, at least they export well, let me put it that way.

What was Company and Sons?

Company and Sons was a place that was run by a guy named John Bagley. They published the very first edition of *Young Lust*. Where I first heard of them was when Bill Griffith went shopping around and decided he could get the best deal with them. Bagley was a good guy, he was fun to hang with and drink with, but he didn't seem like he was a really good businessman. I honestly don't know exactly what became of him.

And then I think Kitchen might have been operating under the Krupp Comics banner.

Right, there was Denis over in Milwaukee, who I met through Jay Lynch around '72. I worked with everyone of those people at one time or another.

Was there a reason to go with one over the other or was it just a coin toss?

No, it depended on the climate of the moment, I really liked them all to some extent or other. I can't really say there was a clear-cut schmuck among 'em. They all had their pros and cons. I could deal with them.

Print Mint was the clear standout, but then Bob … I think the cocaine started catching up with him. After a while, Last Gasp started absorbing more and more of their good titles, including *Zap*, and Bob resented it. Ron was playing a cooler hand. Ron is probably the only one of those people who is still operating.

But none of these guys were hardcore business types?

No, not at all; Bill Griffith was a better businessman than any one of them *[Groth laughs]*, which isn't to say Bill isn't a good business man; he is.

So in '73, it was Bill who came up with the idea of putting together the Cartoonist Co-op Press?

Yes.

Tell me how that unfolded.

I always had some sort of social connections with Bill, and at some point he proposed it, and it looked good to me. He basically got Justin [Green]'s brother Keith to do the distribution, and to Keiths credit, he got rid of 10,000 of each of our books.

From "The Cult of the Clown" in *Cord Fed* #1. [©1972 Kim Deitch]

The Co-op Press included Bill, Jay Lynch, Jerry Lane and Justin Green's brother Keith.

Willy Murphy published *Nard 'n' Pat* comics for Jay Lynch. I think there was one of those pocket sex books that ended up getting published with it, too, the one called *Felch*.

Tell me, how was this set up? Who was in charge? What was the structure like?

No one was really in charge, but Bill Griffith was the clear visionary leader of the situation. It was never meant to be: "Now we have our own company." It wasn't like movie stars starting United Artists. It was meant to be, and was, an ad-hoc move to keep our stuff in print during a tough period. And that's what it did, we got together and did these books and shared the labor.

Did you guys have meetings where you all got together and hammered all this stuff out?

Yeah. I don't know exactly how formal they were, but,

Jay Lynch's *Nard n' Pat* Vol. 1 #1 was published by Cartoonists' Co-Op Press. [©1974 Jay Lynch]

you know, we got together and discussed who's gonna do the work and all. It fell to me, I remember doing a real nice Cartoonist Co-op Press ad that ran in something. We all worked a little on each other's stuff when problems arose. We were really doing everything, we all stripped our books, and boy I was sweating that. It was funny, 'cause I thought, "Holy shit, man, I just hope I got the pages in the right order," but weirdly, the guy who got the pages in the wrong order was Bill. There was a horrendous four days where we were all standing around on the cement floors of the Rip-Off press tearing this one disorganized sheet out of *Tales of the Toad* #2, and putting in the new one, for 10,000 books. Man, that took way longer than I ever imagined. *[Groth laughs.]* I put a good day's work in on it, working right next to Bill all day. Art [Spiegelman] came over for a few hours, which was pure charity, 'cause he wasn't really involved. Then Bill even hired a few other people, paid 'em $3 an hour to finish the job. "You paid 'em $3 an hour?" *[Groth laughs.]* Seemed like a lot of money at the time.

I am sure it was. By "stripping" the book, do you mean actually cutting the negatives and putting them onto the large goldenrod sheets?

Yeah …

Because that's an antediluvian …

Yeah, but a key thing, and Don Donahue showed us how to do it — I think we did it in Don's printing shop — we did it more economically than just somebody who blew into town could have done it, 'cause we had all the contacts and connections. People did us favors. There was a nice community feeling at the time.

In *Corn Fed* #2, "Miles Microft's Last Case" seems to me like an important story because it's a long and elaborate story, with a lot of elements in it, including an appearance by Jesus, and it seems to presage where you're going, which is these long complex storylines.

True, interestingly enough it presaged where I'm going lately philosophically in the work I am doing now. I'm back to Jesus again in the thing I'm doing now, which you'll see when you get here. And also, I think it reinforced a theme that comes into a lot of my work, which is things supernatural in this world are, more likely than not, science we haven't caught up with yet.

It seems like your preoccupation with the occult or the supernatural appeared pretty early on. "Born Again" in *Insect Fear* in 1973, "Bayou Blues" in 1973. A lot

of that early work included supernatural elements. Where did that come from?

All right, I'll tell you. First of all, it's not like I'm a real mystic, psychic, occult person; I'm not really. I just told you what I thought about it in one sentence. Also on the other hand it's good material, colorful material. "Miles Microft" — where a lot of that came from was: Trina belonged to something called The Occult Book of the Month Club, so these things are coming in. One of the books that floated into the house was a biography of Peter Hurkos, who really was more or less a psychic detective, worked on various police cases. There was this fascinating description in there where he was talking about how he hated to drive by graveyards because he could hear all these wailing voices coming at him. I don't know whether it's true or not, but I was like, "Great stuff, great stuff," so for a guy who really isn't involved in psychic phenomena to any real extent, I've probably read more about it than most. In dry periods, I just go to the library, take out a foot of books on that stuff and just pore through them, see where I can find an angle that might work into a good story.

How much of that do you believe?

Maybe little or none.

So, where does its importance lie with you?

Good story fodder, colorful. Also it's interesting to speculate about what we don't know about. I've got various ideas of what might be going on in the world, but I'm not presumptuous enough to say that I know such things are so without having any real evidence, and reading enough about 'em, I think I've satisfied myself that the evidence isn't as strong as the people who are really into it would like to believe it is.

One of the members of the Co-op always struck me as odd-man-out: Jerry Lane. I remember liking his comic *Middle Class Fantasies* but thinking that it wasn't very underground-ish at the time, if you know what I mean. What was he like, and what did you make of his work?

Damn! You know, I doubt if I met him more than twice. I liked his work OK. Basically, where Jerry Lane came from was: There was another guy named Charlie Dallas, he was like Wilson-y, really over-the-top, gory, eerie stuff; really sweet guy though, a friend. But Bill [Griffith] really, really despised his work to such an extent that he was basically heading off Charlie Dallas by coming up with a substitute, and that substitute was Jerry Lane.

Of course, then eventually I came up with some needy

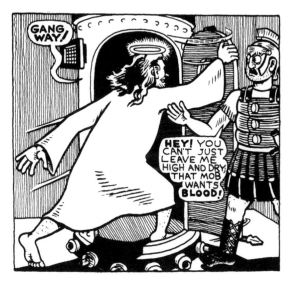

From "Miles Microft's Last Case" in *Cord Fed* #2. [©1973 Kim Deitch]

people at a certain point, which is these guys named Bruce Simon and Barry Siegel, two young guys in Berkeley, who basically had a book and their entry-level plan was to find some relatively established underground cartoonist to front the book, so they hired me to do a double-page cover and a four-page story for something called *Lean Years*, which, again, I don't think really would have fit Bill's criteria at the time. But I just had my way with that one.

Bill had very strong opinions about …

Yeah, he has very strong opinions about things, many of which I don't share. I like Bill. He's a friend. He's just more into controlling things at a certain level. I can remember *Young Lust* #3, whichever one was in full color. At some point we're all sitting at some table in the middle of Bill's apartment cutting Zipatone color separations, and Spain was over there, and you know Spain likes to use large dots for special effect, and as far as I am concerned, let it be, let large-dot zipatone be for Spain if he wants to use it [*Groth laughs*]. But Bill was so finicky about it, he really got into Spain's face. "I don't want to see this large dot in the book." I can't understand it, even if I didn't particularly care for the effect, c'mon, gimme a break.

That's funny. Correct me if I'm wrong, but it seems like Bill probably would have been a lot more dogmatic than you about matters of taste.

Yeah, I think so. He would sometimes like to discuss philosophical aspects of comics that quite frankly bored me [*Groth laughs*]. I was not interested. I mean, maybe

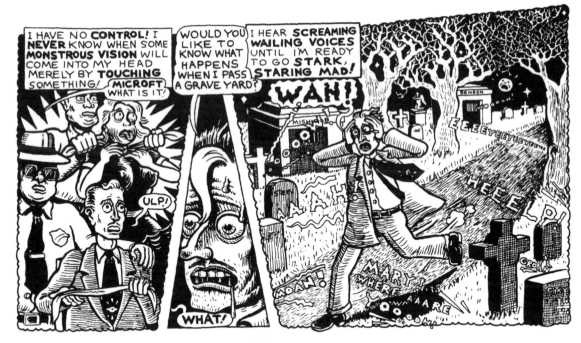

From "Miles Microft's Last Case" in *Cord Fed* #2. [©1973 Kim Deitch]

I'd be more interested now, but at the time, I just felt like this is the kind of talk that kills creativity; you start taking it apart at this level and pretty soon it's all gonna dissolve in your hands.

You were much more intuitive about the creative process. I gather.

Yeah, I'm just more of a loose cannon than Bill, and more at that time perhaps than I am now.

Comix Book and Arcade

It's interesting to look back and see how you guys bounced off of each other. That segues nicely into *Arcade*, because, of course, Bill and Art [Spiegelman] started that, I think '74. Also in '74, *Comix Book* came out. I'm not sure which one came out first. That created a bit of a political brouhaha.

Yes, it did.

***Comix Book* was published by Marvel, and edited by Denis Kitchen. *Arcade* of course was a much purer, underground effort published by Print Mint, and edited by Art and Bill.**

And they had Crumb in their pocket, too, so they had a pretty good combination there.

And of course *Arcade* was extraordinarily good book; I think you were in every issue of *Arcade*.

All but one. At the time, I felt, and I think this was incorrect of me, but I remember feeling at the time that *Arcade* was just a little too rooty-tooty and high-falutin'. But I also think that I had my nose out of joint about that, because, looking back on it now, I think it was a right fine magazine.

It really was. Now, Art and Bill were probably part of the high-falutin' underground faction.

They were pretty high-falutin', and they were also like Damon and Pythias in those days *[Groth laughs]*. That wasn't even the first venture. First they came around trying to get me into something called *Banana Oil*, which never really got off the ground.

What was that?

It was gonna be another magazine along the lines of *Arcade*.

So they were very ambitious.

They were very ambitious. I looked upon their ambition with something of a jaundiced eye at the time, but, again, I think I sometimes cop attitudes that aren't necessarily correct.

They obviously both liked your work, correct?

They both liked my work. They got me into the *Arcade* fold.

And I really think you did some of your best stuff for *Arcade*.

It was actually a good period for me. I think of some of the issues I had with them were stupid. I did a certain amount of production work that they wanted me to do — ads and stuff. I had one disagreement with them that I stand by, but then we got through that.

Which was what?

They were getting into a real hissy fit with Denis Kitchen and *Comix Book*. They basically held a meeting. They called us all over one evening; they were just basically going, "Listen, we gotta do something about these people. We got a good thing over here, and we want you people to start boycotting *Comix Book*," and they had Crumb in their pocket there. He's standing there, and he's just nodding his head at everything they're saying. And I just looked at that and I thought, "What the fuck is this kind of bullshit?" *[Groth laughs.]* At the meeting they said, "Well, Kim, what about you?" and I said, "I don't know." Basically, I thought, a lot of things had happened to me in this business, but nobody had ever told me who *not* to work for and I didn't like it. I just decided, "Fuck this shit, I am just gonna stop doing these comics altogether." I actually spent some time working at Manpower for a while.

It demoralized you or offended you that much?

Yeah, it did, I just felt, it's starting to seem like real business or something, ya know? And it also seemed like a culmination of Bill's various control-freak moves that had been going on at one time or another. I guess finally how I resolved it was I compromised with them, 'cause I thought it was cool working for Marvel Comics. I mean,

Christ, I cut my teeth on those things. They were a big influence to get me into this in the first place. There's plenty wrong with Marvel Comics, but there's plenty right about them, too. Plus they were offering twice as much as *Arcade* was. There were copyright issues, and I suppose it was correct to address that, but I think they modified that a little bit down the road. Anyway, the compromise I reached was that I would stop doing any new work for 'em, but I would continue to give 'em reprint stuff. I was getting tired of working for Manpower. It was interesting to do for a couple of weeks, but it was kind of a dickheaded move really.

I assume that Bill and Art's argument was that Marvel was coming in and trying to co-opt the underground ethos.

Yeah, they had some good points, there was just something about it that left a bad taste in my mouth. Anyway, I missed being in an issue, but then I made a big comeback with about a 16-page story after that.

What artists were at that meeting that they called?

Just about everybody who was anybody. Certainly, just about everybody who was in *Arcade* that was local.

Was there general agreement, except for yourself?

Yeah, there was general agreement. I was definitely the odd man out in that; maybe there was somebody else who thought like me, but I can't remember right now. I was there with Sally, and that was the person I was mostly talking about it with.

What'd she think?

She basically was going along with what I was saying. I don't know if she really cared that much one way or the other, but she didn't see anything drastically wrong with it. I mean even years later, Art came to me and said, "I re-

From "Where Are They Now?" in *Arcade* Vol.1 #2 (Summer 1975): story, "Fowlton Means" in collaboration with "Opal Dendrite."
[©1975 The Print Mint, Inc.]

ally admired you when you went out and started working for Manpower that time." I don't think that necessarily meant he thought it was right.

"You did a strip called "Cabbage Fiend" in *Comix Book*, which I could not find having been published previously. Was that a new strip?

Yeah, that was new. There were just a couple, at least two others besides. It wasn't like I did a raft of work for them. I would have done a little more except for what went down. And then it abruptly ended, too. But think about it: The first issue of *Comix Book* I was in, had a new story in there by Basil Wolverton. I just thought, "Geez, I'm in the same book with Basil Wolverton." I think it might have been his last go-'round, too.

And Marvel paid well.

It seemed well at the time; it seems like nothing now, but they were paying $100 a page.

And working with them went smoothly.

Yeah, pretty much, pretty much.

And how was working with Bill and Art on *Arcade*?

It was OK. Occasionally, Bill would get in my face in odd ways *[Groth laughs.]*, like when I had a vaguely ventriloquist story about AJEEB, the automatic chess player, and he didn't want me to run it in that particular issue because he had a ventriloquist story, which I agreed to. That worked out 'cause then I went and did another story and still used AJEEB down the road. To even be talking about that seems a little stupid. Basically, they were good to work for.

"Cabbage Fiend" was, as far as I can tell, an anti-vegetarian tract, which I thought was pretty funny.

It was just goofing on it. It's not such a hot strip; I think the strip lived because there's one panel with all these dancing cabbages. It's a very funny drawing. It's a throwaway.

One of your favorite motifs — the loveable rogue — starts to congeal in *Arcade*. You have a series called *Famous Frauds*.

Not much of a series; just two. I should have at least had one more. I guess I couldn't think of another one. I found both of those in the same book, which was a collection of some really interesting, old, nonfiction *New Yorker* stories.

This is something you are attracted to. There's something quintessentially American about it.

Sure. The Great Oz, you know?

What do you think attracts you to that?

Ohhhh, just the color of it. The Americana of it. It just works well in stories. Everybody loves to read about crime and skullduggery.

Tell me a little bit about *Apple Pie*, which was a magazine.

I could be wrong, but I think this guy might have been a refugee from the *National Lampoon*. And I can't remember his name, but he'd start calling me up and pressing me for a story. While walking around, I discovered a slaughterhouse maybe 10 miles away from where I lived; I actually got busted there. I was there researching that story about the pigs. One day while we were living in Berkeley, a car with all these squealing pigs went riding by. I didn't even see it myself, Sally saw it and was appalled and we both felt chagrined and stopped eating pork for a while.

Right, "Genocide" was a pro-pig tract.

Yeah, you read about pigs and they're really just as companionable and affable as dogs, and as easy to train, and the idea of what we do to those poor critters is criminal. I mean, I eat a little pork now and then, but I don't like to, 'cause I think it's terrible. I think it's terrible to kill any animals for meat, really.

But you are not a vegetarian, are you?

I'm like a *de facto* vegetarian. Pam is a fish-eating vegetarian. So there isn't much in the way of meat, outside of fish, that comes through this house. If I'm out by myself, I might get a burger and fries, although I'm really not supposed to any more. Something kind of terrible about it. At the core, I think it's a bad thing. Maybe someday we'll grow up to that fact better as a group. I don't know. Maybe I'm wrong, too; I'm not sure about it. But personally, my own sympathies are with the animals.

On a global-economic level it costs a lot more to raise cows and pigs then it does to grow vegetables.

That's right. The first person who pointed that out to me was Bill Griffith. And that's a good point, too.

It was during this period when you created some of your recurring characters. Correct me if I'm wrong, but the earliest appearance of Miles Microft I could find was 1973.

No, *Up From the Deep*, Jackson's book. "The Brendel-

From "Cabbage Fiend" in *Comix Book* #2. [©1974 Magazine Management Co., Inc.]

steins Apparition," drawn late in '70, probably appeared in early '71.

Why does he have a midget wife *[laughs]*?

Well, everything comes from something, you know. I remember reading *On the Road* by Jack Kerouac while I was in Portland, Ore. Just one long diatribe. At some point he started talking about some sexy midget girl, and it was just before I did the story "The Venusian Vermin," which was the second Miles Microft story.

This was also the period in which you created Nate Mishkin.

That came from real life. I haven't used too many of my nuthouse experiences, but that definitely came from something I saw in the nuthouse. The interesting thing in the nuthouse is they got a drunk floor, and the interesting thing about the drunks is nobody shapes up faster than the drunks *[Groth laughs]*, but nobody looks worse when they're comin' in. Occasionally I'd be working overtime in the drunk ward, and most of those people seem OK. Really, what are they even doing here? And there was one guy, maybe he wasn't a doctor, some professional guy who really was a particularly exemplary guy, and when you're doing well, you can fake it out sometimes. But the one day when I'm coming in on my usual floor on the night shift, they're bringing this guy in from his furlough, just so shit-faced fucked up, just a tragedy to see. That was definitely the root inspiration for that story. Of course, talking to Waldo, that wasn't in it. That part of it came from inside of my own foolish head.

And obviously influenced by your experience with your dad's animation involvement.

Yeah, that reoccurring black-cat thing goes right back to the point where when I first was doing comics and I didn't feel like I could finesse the drawing of a human figure, and so I used this black cat that eventually became Waldo. Eventually, he picked up all these other trappings. At some point, the crackpot piece of information that he's the reincarnation of Judas Iscariot came into the picture, and that he's not really a cat at all, but a demon in a benign state.

Another landmark strip during this period was "Beyond the Pale." Which also tends to presage some of the things you would do much more elaborately later on. That was published in *High Times*.

High Times, yeah, 'cause it started out they were gonna do a tabloid called *The National Weed* and I actually started "Beyond the Pale" in big tabloid strips for them in *The National Weed* that just had one issue. So I scrapped that version of it and recast it in a *High Times* story 'cause I had been doing little ones all along. I was riffing on all kinds of influences on that one, one of them being the Cardiff Giant hoax of 1869. That was sort of a fun story.

You can see where you're finding your voice and your focus in the work of this period.

I'm getting the drawing skills together so that I'm able to tell more interesting, quasi-realistic type stories, which is what I was hoping to be able to do all along.

Things are coming together, yes. Now, from '74 to the end of the of '70s, what was your life like? Were you still living in San Francisco during that period?

I was living in Berkeley by that time. At a certain point I decided, San Francisco's too rich for my blood, it's just too much of a partying town for a guy with such a weakness for partying. So I decided I wanna live near San Francisco, but not be in San Francisco, and my girlfriend, Sally, while I was making some kind of a cross-country

From "Famous Frauds: The Great Ajeeb" in *Arcade* Vol. 1 #5 (Spring 1976). [©1976 The Print Mint, Inc.]

trip, found a really nice apartment there, right across from the UC campus. Until now, the longest time I ever spent in one place, was the apartment we lived in for 10 years in Berkeley. Berkeley is really a swell little town. And the Bay Area is really swell, because you got three cities all hugged up to each other and a good transportation system to go to and from them.

In some ways, they were very good years; it was the majority of the years I was living with Sally Cruikshank. They were very hand-to-mouth years, because the comic business was lean, it was always going from paycheck to paycheck, and also, ultimately, I think I was starting to stagnate there, but it only came to me bit by bit. It all blew up in my face in 1982, which seemed like a disaster at the time, but it actually was the best thing that could have ever happened to me.

Sally Cruikshank was also an artist and an animator. Did your creativity feed off each other? Was there a creative back and forth in your relationship?

Absolutely. Sally is a really, really smart person, and I think the real heart and soul of our relationship was our creative aspirations. We took a lot of writing classes together, and I worked on her cartoons, and she definitely had big input on my strips. Occasionally, you'll see a strip that's signed by Kim Deitch and Opal Dendrite — well, that was like the *non de plume* she used when she was actively collaborating with me. Yeah, Sally, what a smart person. Brilliant, Brilliant.

And you were with her quite a long time?

Eleven years.

Hollywoodland

At some point you hooked up with a guy named Brian Yuzna. And I think you wanted to serve as a screenwriter.

That's what happened, yeah. He showed up at my doorstep and, boy, the timing couldn't have been better. That was part of the hand-to-mouth thing. I was living in Berkeley, and I was really wondering how the hell I was gonna pay the rent that month. Brian showed up, and basically said, "Look, (he was based in North Carolina), we made a feature, I think we must've made just about every mistake in the book, and now I wanna do one right."

Brian subsequently become a very successful movie producer, probably directed a few of them, too. But at the time he was basically a developer in North Carolina, and he was very good at making money. He'd build a bunch of houses and make a profit, and then get out of that. Christmas time he'd buy like 5,000 Christmas trees, sell them, make his profit. Always making money, always making money. Good-looking guy, looked like Mr. Slick himself, an interesting guy, pretty bright, and we had our ups and downs personally, but it was an interesting experience working with him. Anyway he gave me $1,000 up front, which seemed like the windfall of the century, to work up a story concept for him. I did and he didn't like that one,

but then he kept coming back.

He just tracked you down because he liked your underground work? He literally just knocked on your door?

Pretty literally; I guess I called first, but it was all pretty sudden. And it went on for a while, and it ultimately ended up with me being the art director for something called Art Boro Films in North Carolina where I spent about a year, after I broke up with Sally. I essentially followed him to Hollywood when he moved to Hollywood to do *Re-animator*, which is where I ended up doing *Hollywoodland*.

He was a Hollywood guy who was based in North Carolina?

He had been raised mostly in South America by his father, who was some kind of a contractor over there and he was based in North Carolina. He'd formed a company called Art Boro films, but that was his fun business; he was making money in real business while doing that. He made a whole feature called, I think, *Self-Portrait in Brain*, and he was the star. I think, ultimately, it was distributed in India and that's about it *[Groth laughs]*. He said he made every mistake in the book, and I've seen it — yeah, he made every mistake in the book — but he finished the film. He's made a bunch of films. I think he's based in Spain now making horror movies. In retrospect, it was a great experience working for him. And a good change of pace, and it got me out of my … stagnation was starting to set in with me.

Now throughout this period, you were an old-movie nut; you loved especially the silent films and movies up until 1935 right?

Yeah, I'm still a huge fan of mostly American silent films, mostly dramas, but then I also love Westerns, I liked them even all the way into the Roy Rogers era, and the Randolph Scott era. To me, they are the heart of the movies; that's where the real movies started. Somehow I think they had that essential gosh-wow wonderfulness, longer than maybe regular movies did.

He gave you 1,000 bucks to start developing screenplays.

Yeah. I moved to North Carolina and basically we were developing one of those compilation features, like *The Twilight Zone*, based on three of my stories.

One of those stories was "Genocide"?

One of those stories was "Genocide." I was in Los Angeles when he got in touch with me. I was in Los Angeles

'cause I'd gone to Los Angeles to research the possibility of doing what ultimately became *Hollywoodland*. When I was being introduced around, I met some directors. One of the directors I met turned out to be Paul Bartel, who turned around and co-opted me to do a comic book of *Eating Raoul*, so I was sitting there doing that comic in six weeks. Basically, I turned Carol Lay's apartment into a comic-book shop. It's the only time I ever really worked in that kind of a shop system, and we got that book out. When I was just finishing that job up, Brian Yuzna had been trying to get in touch with me back in Berkeley 'cause he'd pulled together $50,000 which he said he wanted to use to make a feature out of "Born Again," the story about the guy who goes to the electric chair and is reincarnated as a potato. He was even willing to make the deal with me that we could both direct it together. Actually Paul Bartel even said, "Do it! Really, there's nothing to directing. Only thing you've got to remember is to have plenty of coverage for everything, so that the film editor can have something to put it together with," and he thought I was nuts for declining to direct it with Brian, but I don't know if that was a good decision or not. What happened instead of that movie getting made is: once I was down in North Carolina and I'd storyboarded "Born Again," he started thinking, well, lets enlarge the project. *The Twilight Zone* had come out, which Sally Cruikshank had worked on. Pretty soon we were doing a compilation feature, and all kinds of things happened; the one thing that didn't happen was the *movie [Groth laughs]*, except that I was on a salary for the better part of the year, and I banked $100 a week for the better part of the year, so I built myself up a good stake of money, which is basically what financed *Hollywoodland* a year later.

He got a hold of you in L.A. after he had previously gotten a hold of you in Berkeley?

He didn't quite get a hold of me in L.A. I still had an apartment in Berkeley when I'd been in L.A. for an extended period putting together this *Eating Raoul* comic. I was at loose ends, so it seemed like he wanted me to come to North Carolina. He offered me some kind of cash amount to storyboard the thing. I guess I finished doing that instead of returning to Berkeley. I kept re-subletting my apartment. I went to live with Simon while waiting for Brian to call me back to North Carolina, which took longer than I thought it would. But then when he eventually called me back, I was living there for the better part of the year, which was a fascinating experience, working on that book. All kinds of interesting things happened to me there. One thing is I ended up joining AA and finally

quitting drinking, which was pretty key and important toward re-invigorating myself along healthier lines.

When you went to L.A. to research *Hollywoodland* initially, you were being shown around and introduced to people: How did you go about doing the research, and who was introducing you to people like Paul Bartel?

The guy who introduced me to Paul Bartel was a young lawyer named Marc von Arx, who was a big comic-book fan. I knew a few people in the business. Going to L.A. spiraled out of San Diego Comic-Con that I attended in '82. I had known [Leonardo Dicaprio's father] George Dicaprio before, but I got to know him better there. I met Carol Lay. I got to know Matt Groening. I was really enjoying the social scene in Los Angeles, so that when I went to visit L.A. after the San Diego con, it was like the con had never stopped. And I was still having a good time with these people, and it was easy enough to make contacts.

And George Dicaprio distributed underground comics at that time.

Yes he did, at that point he was Ron Turner's L.A. distributor. Los Angeles is sort of interesting in that you know a lot of people who know a lot of people in the movies all over the place. It's really not that hard to get into the swim of meeting people, and it's even very easy to think you're really doing great, because unlike New York where everybody's kind of taciturn and nasty, in L.A. you can literally be "yes-ed" to death. *[Groth laughs.]* everybody's great and nice and "loves you, loves you" and, you know, "the deal's gonna happen anytime."

That's a good contrast; in New York you're "no-ed" to death.

In New York at least you know where you stand; people are "putzes," but you know where you stand. In Los Angeles you can be lulled into thinking everything's going great before you realize that everything is built of bullshit.

Right. So you were introduced to Paul Bartel.

Marc von Arx said, "I know a director," and so we went over and met him. It was weird, too, because at first me and Bartel did not get along. When we got there, basically, what he said was, "Well, you're just in time, I'm going over to Disney to take a look at a new Matt Dillon film, you guys should come along." And so we came along, went to see the movie, it was *Tex*, and Paul thought it was a good movie. I thought it was a lousy movie — it was how it was going with him, we were clashing. But then

this weird thing happened: We were riding along through Burbank and he pointed to some piece of land and he said, "You see over there?" He'd been pointing out different sites. "That's where the old UPA cartoon studio used to be." *[Groth laughs.]*

And I said, "Holy cow, my old man used to work there." And then Paul got this really queer expression on his face, just looking at me. And I didn't quite know what was going through his head. I knew he was gay, so I immediately said, "Oh, I mean my father." *[Groth laughs.]*

"Yeah yeah yeah, I know what you mean," he said. "I didn't place it before, your last name. You know, I idolized your father," and he said, "I used to be a gopher at the UPA in New York working for him." And all of a sudden, his whole manner changed towards me, he started being really friendly to me, and he said, "Listen, I'd really like it if you would come over and see me in the near future, I'd like to talk with you about something."

So then a few days pass. In the meantime, I'm thinking about Paul Bartel working for my old man. Finally he picks me up, to drive me over to his place to talk to me about what I do not know yet. I'm chatting with him and I said, "You know, Paul, I've been thinking. I've got a funny feeling me and you have met before, and if you would just answer one question for me, I'll know whether or not I'm right for sure."

He said, "Yeah go ahead, ask."

So I said, "Did you once, when you were a young man, appear on a TV quiz show called *The $64,000 Challenge*, and did you miss the first question?"

He said "Yes." Yup, I got it. 'Cause I remembered this young rich kid who lived in Long Island. We even went over to some rich-kid Long Island party one weekend — that was him! So then, even more fascinating 'cause I actually have a vivid memory of this guy when he was 19 years old, and actually we became good friends. Basically what he wanted me to do was a comic version of his new movie, *Eating Raoul*, and that was a little touchy, too, because he showed it to me and I hated it.

Really?

And so that was tough going, because he's going, "How you liking it, how you liking it?" and I'm having to lie through my teeth 'cause really I'm thinking, "Well, this probably is a good deal and all." It just seemed so crass to me. Actually, later on, I'd come to appreciate him, I think he was a good actor in movies, and actually some of the Corman movies he directed were quite good.

***Eating Raoul* was an affable black comedy with a dry,**

From the eponymous story in *Alias the Cat*. [©2007 Kim Deitch]

understated wit to it. What did you not like about that?

Ah, it just seemed crass, and not that funny to me. I looked it up in the Leonard Maltin book, four stars, you know *[Groth laughs],* but everybody can't agree on everything. I'm balanced, I've liked other movies of his and I liked him, it was good to get to know and make friends with the guy. He was a very cultured character and was fun to be around.

So, you did the comic to coincide with the opening of the film?

Yeah.

Did Bartel publish the comic?

Basically he did. Since George Dicaprio was Ron Turner's Los Angeles distributor, we got a deal together for Ron Turner to distribute it and I got the shop set up in Carol Lay's apartment, with Carol Lay being my right-hand man so we could get the damn thing out in five or six weeks. I couldn't have done it without Carol. And another side effect of that is that was the beginning of my long friendship with Carol Lay, which continues to this day.

Carol helped draw it?

She more than helped draw it, she wrested the laying out of it away from me, and that was a very interesting experience, because basically she taught me the method of laying out that I still use now, which is your layouts are so tight that's where all your drawing appears, you fight all your drawing battles right on the layout sheet. I still use those, but now I call 'em breakdowns.

Can you go into that in a little more detail? She helped you work out how to compose panels within the page?

How to make good layouts that can then be efficiently turned into good pages, tracing them off on a lightboard. It made sense for me to be listening to her 'cause this was a new situation where you had to get a book out on the quick and we had to use a lot of different people working on the same pages trading pages all over the place at the same time. It was all new territory for me; ultimately it was a good learning experience.

How was her process of visual composition different from what you'd been doing?

She would make these proper layouts that basically had

From *Eating Raoul*: adapted by Kim Deitch from a screenplay by Paul Bartel and Dick Blackburn. [©1982 Mercury Films Dist., Inc.]

all the real drawing right on them, that you would then take and trace off onto a piece of Bristol board through a lightboard and turn into your finished pages.

And how were you doing it previously?

I would do layout breakdowns and then I would redraw it on a piece of Bristol board from my breakdown. One of the main things that happens doing that, if you're not really careful, is when you're copying your layout, the drawing tends to stiffen up, and if you get a drawing right with the right verve already, the best thing you can do to keep it is to trace the sucker. I basically use the same system today, except I've come up with a subsequent modification for myself, which is: instead of tracing the layout itself, I generally trace a Xerox of the layout about 50 percent so that my original is bigger and I have more room to move around when I finally get to the inking.

So Carol's system was not only more efficient, but did it improve the quality of the compositions as well?

I guess it did, sure. Tracing is a smart thing to be doing, because you tend to preserve whatever is spontaneously good about your sketch-drawing. Carol had done a lot more work in above-ground comics. She'd already been working for DC and whatnot. I think she even inked something by Kirby somewhere along the line. So she had a lot of good meat-and-potatoes knowledge, plus Carol *really* knows how to draw.

She's a brilliant designer too in terms of the page as a complete unit.

Yeah, yeah, she's amazing. I learned a lot from Carol and she's just a great person in general.

I think she might have done some film work, storyboarding, by then, as well.

She's done a ton of it. She's conceptualized big sequences of movies that in a weird way she's almost ghost-directed. Carol's biggest problem is that she's such a good artist and she's so efficient that she gets co-opted a lot. Everybody wants a piece of her.

I remember when that came out and thinking that it was odd for an underground cartoonist to do an adaptation of an indy movie.

It was a surprising development for me too.

That sort of thing just didn't happen.

No. I was hoping maybe it would lead to something more interesting than it ultimately did. Part of my problem, doing that comic, the six weeks I did it were maybe six of the most awful weeks of my life, but it had nothing to do with the job so much as I was in the process of breaking up with this girl Sally Cruikshank, who was also in L.A. at the time and so that was dicey and making me very unhappy.

Now why did that fall apart, if I may ask?

Ah well I'd say it was probably mostly my fault. I think in a way, I was spoiled by my relationship with Trina Robbins in that it was an open relationship, I mean we saw other people in the midst of it. Of course ultimately, that might have helped bring it to an end. So I was spoiled rotten, and when I first got together with Sally, I said, "Well, look you know you've gotta understand I'm gonna wanna see other women now and then," and of course she didn't understand. *[Groth laughs.]*

You were not naturally inclined toward monogamy?

No, I wasn't.

And that created problems.

And it created problems. It was a somewhat stormy relationship, but on balance, and I think if you even ask Sally, she'd probably say something similar, it wasn't a bad relationship. It was good while it lasted.

You did *Eating Raoul* in '82; then you moved to North Carolina.

For years I thought eventually I'm gonna get back to Berkeley, but then things just kept coming up, and in the midst of it, ultimately, the person I was subletting to signed a lease in her own name and I was out.

Were you essentially storyboarding your own stories for film adaptation in North Carolina?

Yes, that is essentially what I was doing. I was also supervising the making of props; we made an electric chair, we made a big statue of something that looked like Bob's Big Boy called Tater Boy. These stories were all stories I'd done before, but we had extended and changed them. I've got these other versions of "The Brendelsteen Apparition" and "Born Again" and storyboards for them that are much longer and more involved than the ones that originally appeared in comics.

If I understand this correctly, Simon worked with you in North Carolina?

Simon didn't work with me in North Carolina but Simon had been doing make-up and special effects work in really cheap B horror movies already and so to do the special effect of the squirming potato that this guy gets reincarnated into at the end of "Born Again," I talked Brian into subcontracting Simon to do that special effect. Which turned into a disaster, because Simon and Brian Yuzna did not get along, for the same reason that things with Simon blow up generally, 'cause he's lazy and procrastinates and you can't intimidate him about stuff like that. He'll just get more obstinate the more you lean on him, and this really made for bad juju with Simon and Brian and to some reverberating extent, with me and Brian.

What was the setup like in North Carolina; was it an office?

[Laughs.] Yeah, ultimately, I ended up living in the office and the way I did that was first I rented a shower next door from some other business. When that business went south, I joined a gym so that I could take a shower every day and I just slept on a couch for months and months. I was miserable there, too, 'cause I was really having a hard

Eating Raoul art is credited to Kim Deitch, Carol Lay, Warren Greenwood, Rich Childlaw and Shawn Kerri. [©1982 Mercury Films Dist., Inc.]

While working on *Eating Raoul*, Carol Lay taught Kim Deitch about layout designs. [©1982 Mercury Films Dist., Inc.]

time about my breakup with Sally Cruikshank, but at the same time I had a really rich and interesting experience living in North Carolina and because I had joined Alcoholics Anonymous; culturally that made it all the more rich of an experience in that I really got to know very well all kinds of interesting people in North Carolina from all walks of life. I'd really gotten to know more deeply that part of North Carolina, and also the Southern mindset to some extent, which I improved upon even more later when I lived in Virginia for about three years.

How would you describe that Southern mindset and how did that affect your work, if at all?

I like Southern people 'cause they're colorful in general. They tend to be laid back, in some cases maybe to a fault; nothing happens in a big hurry with Southerners, it seems. Although, in a way I'm making terrible stereotypes here, but you're asking me my impression. There was something imminently likeable about a lot of them,

too, and I got along with them well.

What was the social circle like? What did they do?

Well, what they call a party down in North Carolina is a pig pickin'. They got a big barbeque centered around a big, butchered pig. I went to a lot of pig pickin's, but then also, a lot of my social life centered around AA meetings at that time, which was really interesting for getting to meet people. I think there were times in those meetings that I laughed harder than I think I ever laughed in my life, 'cause one of the things that they did in these meetings was every now and then somebody would have to get up and tell their story. At some point in your development, they want you to be together enough to get up and basically hold an audience for an hour to tell your story, and some of those were just unbelievably fabulously interesting. I think that's where my incipient public-speaking ability began, which was something I hadn't really considered before, but at one point in North Carolina, in the midst of my early development, out of nowhere they pulled me out of a meeting and said, "Now you're gonna tell us something," and I held the audience for 20 minutes, talking about myself and got laughs and stuff, and that really blew my mind. I thought, "Shit, you know, I can do this!"

***[Laughs.]* That's pretty good; you were mentored by AA.**

In comics, being able to be a public speaker and being able to hold an audience is part of the job. And it's even part of the job, weirdly enough, that I actually enjoy and have thrived on.

Being a bit of a showman?

Yeah! I can get up and sing in front of people if I have to. That's a good breakthrough for me.

Really! Are you kidding?

No, I'm not kidding. "The Ship that Never Came In," I do singing in that. And also, the new story, "The Cop on the Beat, the Man on the Moon and Me," I'm definitely considering turning that into a performance art piece, which would involve a touch of singing on my part.

Maybe we should include a CD with this issue.

Yeah, well, sure. *[Laughs.]* The only reason why I'm still sitting on the fence about "The Cop on the Beat" story is, I'm not sure that that story is necessarily going to be the big hit of the comic book, in that it's all about the 1930s era, and it's not necessarily going to resonate with all that many people.

What was the name of the company?

Art Boro Films.

And you worked there, and this would've been 1983.

I was there in late '82, and it was around the fall of '83 when the whole thing fell apart.

And then you went back to L.A.

Well, I ended up going to L.A. — actually, I was traveling a lot; I was really living out of a suitcase during that period. I spent time in L.A.; I spent time in Connecticut, New York, and Virginia. Even before I ended up moving to Virginia, I was very nomadic for a few years and working on a lot of kitchen tables. I guess the survivor of that is, I still work on a flat table rather than a proper drawing board.

Did you enjoy the nomadic life?

Not especially. I mean, it was a bleak period for me, an in the wilderness period, except to say, that I think that was the period in which I really, ultimately and finally grew up, and the period where I kind of found myself.

Now, how old would you have been?

Well, I turned 40 in 1984.

So you were close to 40. Well, that's about time to grow up.

That's when I grew up, when I was about 40 years old. I was a little late, and of course it was a surprise to me that I wasn't grown up already. Some of that credit goes to AA, although ultimately, I really couldn't quite go on with everything they were putting down, but I'll always be happy to give them credit. And I'll tell you this, man, if I ever thought that I was starting to feel funny, like I was gonna slip up and go back to booze, I'd get back there quick like a bunny. Actually, at one point, when things were disintegrating between me and Simon, and he was getting strung out again towards the end of *Boulevard of Broken Dreams* and while we were doing "Southern Fried Fugitives," I actually did, for a brief period, start going to some AA meetings in White Plains. It's good to know it's always there for you. There was a lot about it — the religious aspects of it — which bugged me a little, although I was attracted to some of that, too, on another level. But, the real place where I fell out with AA was: I joined up to quit drinking, which I did, but they would be going on, "Now, let's get rid of that nasty marijuana," which I even took a few shots at, but I ultimately decided, no. marijuana isn't a *good* habit, but on the other hand, I get something out of it, and if I can learn to keep it down to a dull a roar, I'm not gonna stop using it just because AA says so. With all due respect, maybe they don't know everything.

Marijuana in moderation.

Of course, my idea of moderation is: Don't keep it in the house when you're not smoking it, 'cause, fact is, I have an addictive personality. When I let up, say, around Christmas week and start smoking it, I'm smoking it a lot, which is not a good thing, but I know enough to get rid of it when it's time to get rid of it. I have an addictive personality, but that's not completely a bad thing. That same addictive personality is what makes me so compulsive about turning out work all the time. Most habits have their good-habit side and their bad-habit side, and I have this compulsive personality. It can work against you and

From "The Mystic Shrine," originally published in *Weirdo* and collected in *Shadowland*. [©2006 Kim Deitch]

tear you down, but you can also turn it around and get addicted to good habits, too.

I was gonna say, in a way, it's almost essential to have that compulsive —

That's the thing. There were just some things AA would say, like, "Well, you're supposed to relax and take it easy, not get into high-stress situations." I think some people could definitely get blanded out and lose their edge with AA. In fact, I think I've known people who have. Not a lot of people, and I'm not mentioning any names, but you can't just blindly follow somebody. I tried to do with AA what I try to do with anything I'm being involved with and being influenced by: take things from it that I can use to formulate my own idea of the sort of program I want to have for myself, which is exactly the kind of pitch I give kids when I'm talking to them about becoming a cartoonist. I say, "Look, what I'm gonna show you, this is what I do; this is what works for me. It might not hurt for you to try to imitate it at first, but I'm not saying this is exactly how you should do it. But from that, maybe you can glean things, out of which you're gonna build your situation."

Well, it seems to me, the one thing you don't want to do is flatten yourself out merely to maintain the stability, or merely to maintain *a* stability.

Yeah! I mean, that's what I thought was happening at the Hatha Yoga Institute. Suddenly, I was feeling perfectly happy and doing rather bland, nothing artwork. You have to find a way, in the midst of it all, so that you can still get the parts of walking on the wild side that are gonna help you without getting yourself into a jam or getting yourself dead unexpectedly.

You moved to Hollywood in '84 to research *Hollywoodland*, which you had wanted to do for years, correct?

That's right. I had it in my head that I wanted to do a Los Angeles strip, and I thought that character I'd come up with, Larry Farrell, might be a good vehicle for it. That character actually came from a real person I knew, who had been a bit player in the movies but was a teller of real whoppers, but fun to talk to. And I even based the look of him off this guy.

Now, I don't know if you knew the scope of it at the time, but *Hollywoodland* became — we're going to be ostentatious about it, and why not? — your first graphic novel.

Some of it came from different screen treatments I'd

From "No Business Like Show Business," collected in *Shadowland*. [©2006 Kim Deitch]

been doing in and around that time, like the character Arlene [in *Hollywoodland*]. I'd actually developed her in a screen treatment for some exploitation horror movie called *Evil Avenue* that never happened. Also, I have some roots in Los Angeles. I mean, it's as close as a hometown to anything I've got. And also, I had a lot of people in L.A. still at that time. I was living in Park La Brea, in the same apartment complex with my Jewish grandmother and my Uncle Eli, so I was getting a lot of influence from the Jewish stuff in *Hollywoodland*, from studying my own relatives and their friends. Park La Brea was right around the corner from Fairfax Avenue, which is the big Jewish street in Los Angeles, which is a fascinating place — and also, right around the corner from the La Brea Tarpits. It was an interesting piece of landscape to set a story around.

Skipping back for just a second, you actually took screenwriting courses sometime in the early '80s?

Late '70s and early '80s. Sally and I, we took both

screenplay courses and creative writing courses.

And what prompted that? Obviously, I guess, you wanted to write screenplays, but —

Part of what prompted it was what you were talking about earlier: it looked like comics were drying up. And people were saying, "You seem to write a good yarn," so I thought, well, maybe I should try to crack into screenwriting, and Sally was feeling similar. So, we started doing that. We cranked out a lot of treatments and screenplays, both individually, and in a few cases, together.

That was good for you? You learned a lot?

Yeah, it was good for me. I definitely profited from it. I can tell you some tangible offshoots of it: "Two Jews from Yonkers," initially was written for a creative writing course. A lot of stuff, like when Brian came knocking on my door and offered me a grant, seemed like a good omen because I already had a pile of screen treatments, some of which I was already using Miles in.

I might not be alert enough to have picked up on this, but your being Jewish doesn't seem to have affected your work that much. In other words, I can't really pick out any specifically Jewish themes or —

Well, I'm not completely Jewish. I mean, I'm Jewish on my father's side, and I'm English, Irish, Scotch, French and German on my mother's side. And I can feel it, you know — being a halfbreed is a different thing. I can definitely feel the pull of both inside of me.

How Jewish was your household growing up?

Zilch. My parents were basically atheists. My father, I don't think, had any religious upbringing. My Jewish grandmother, the only religion I remember her being involved with was Christian Science at some point. But, being Jewish, as far as I'm concerned, is more of a cultural thing than a religious thing. How religious are even religious Jews, really? I even have a problem with the Jewish religion. I like Jews, and I'm fascinated by Jewish culture but not too interested in Judaism as a religion or as a cause, as in Israel. I've had fearful arguments with my Jewish relatives over that.

One funny thing is, the "Two Jews from Yonkers"— one of the Jews in there was actually Spain, right?

Well, yeah. Everything in that story is true; the only thing is, I re-jiggered the order of things, and a lot of things that happened that I credit to fictional characters based on me and Simon actually happened to me and Spain. Although, Simon really did meet the Pope just as described in that story.

Getting back to L.A. and your doing research for _Hollywoodland_: What kind of research did you think you needed to do, and what were you aiming for?

I was spending a lot of time on Fairfax Avenue. I went out of my way to try to meet and talk to people who'd actually worked in silent movies. Through Peggy DiCaprio [George's wife], I met this guy named Ralph Faulkner, who ran a fencing studio over on Western, who had actually starred in some silent movies. I got to know people in the Trouper's Club, which was one of the theatrical organizations. In terms of the Jewish stuff, where I was staying when I was writing the story — my grandmother briefly put me up — there was this other ancient Jewish woman named Lucy Finkle in the same building who rented me out a room. She was 92 years old and the widow of this guy named Harry Finkle. You could say he was a quack doctor, because he wasn't really a doctor, but he was involved in natural holistic health years and years before it became more accepted. And one of the books that I got a lot of ideas for the Issac Bauman character in _Hollywoodland_ was an unpublished manuscript by this guy, Dr. Harry Finkle. And actually subconsciously — I didn't realize it till later — the way he looks looked a lot like Lucy. I got to be good friends with her, and she was full of Hollywood stories of people she'd known down through the years. So, I just got to know her, got into her whole circle of old lady friends over at Park La Brea, and hung with my grandmother more. She'd just hold court over at the Farmer's Market on Fairfax Avenue and knew all kinds of interesting old relics, including some movie people from the silent era. One of the people she hung with regularly over there was Vilma Bánky, who was Valentino's leading lady in a couple of his films. There was another silent-movie star living in Park La Brea at the time I was living there, which was Jetta Goudal, who'd been a pretty big star. What was interesting about L.A., and what I was noticing and digging on, was that for a town that was supposed to be physically unhealthy, smoggy and also unbelievably unmindful of its own past and heritage—

[Laughs.] You had all these healthy 90-year-olds.

That's it! They were all over; now it's gotten to be more common, people in their 90s, but at that time, it seemed novel. I was meeting all kinds of people who were veterans of those old days, who were old now and who were willing to talk to me. I was, of course, thrilled to be talking to them!

From "Two Jews from Yonkers" in *Weirdo* #11 (1984). [©1984 Kim Deitch]

I was gonna say, that just had to be so great, to be immersed in that.

Well, you know, we always envied people who'd get into that position, who've gotten into that position more than me, but I'm glad. At least I got a little taste of it while there were still such people walking on the Earth with me.

Hollywoodland **is a mystery story, in a way. How did that begin to congeal based on what you were experiencing doing your research? When did that start to form as a story in your head?**

When I was living with this woman, Lucy Finkle, I just started drawing pictures and pinning them up on the wall in a certain sequential order, and little by little, it formulated into a story. Admittedly, a bit of a pot-boiler of a story, but it just grew like topsy out of pictures, really. It was the beginning of the way I work now, which is: I draw while I write, and I write while I draw. And the drawing helps me get off the dime when I get stuck on the writing, and vice versa.

Of course, it's filled with all of your trademarks: the supernatural element, melodrama and the past.

Basically, my square one when writing a story, what I'm really looking for is: If I was gonna walk into a library or a comic-book store or a bookstore and pick out a book that was really gonna float my boat, what would that be? That's the first question I ask myself when I'm writing a story: What would really turn me on? And usually, when you ask that question of yourself, you can't even answer it right away, but go to sleep on it; maybe the next morning,

you'll get a little hint, and then you build on that hint.

An actress by the name of Catherine Schreiber inspired one of the characters: Arlene — or at least her physical look.

I already had Arlene from this *Evil Avenue* treatment, but then when I was working at Art Boro Films, at a certain point, Brian put an ad in the trade paper — I guess it was *Daily Variety* — advertising for a director. A lot of people got in touch with us. We were looking at a lot of reels that people were sending that wanted the job of directing the film, and that was pretty interesting unto itself, and one guy — he must've gotten somewhere by now — a guy named Martin Kitrosser sent a 20-minute, 16-mm movie he'd shot, which was very well made, and this chick in it was pretty compelling and good. I think I mentioned that to him in our talking, and then out of the blue, Catherine Schreiber called me up and started talking to me. That's what happens: you'll put an ad in *Variety* that you're looking for somebody to work on a film; everybody starts sucking up to you. I basically told her I was working on a story with a good female character and, if it was OK with her, I'd like to base the look of that character on her, and she said, "Yeah."

So, you did all this research, and I assume you were drawing sketches and making notes.

Yeah.

And then of course it came to actually doing the strip. How did you go about selling it to the L.A. *Reader***?**

Well, one of the people that I'd met along the way was Matt Groening and he was working over there. Through Matt I met James Vowell who was the editor at that time and so at a certain point, I went over with all my drawings, and maybe I might have had a few finished strips. I showed it to him and I thought, "This'll probably work out good, and gosh, I'll probably be able to get some other papers to go with it too," but I couldn't get anybody but the L.A. *Reader*. But I said hey, I had a lot of money in the bank and here was 50 extra bucks a week coming in. It worked out.

And you did the work in L.A.?

Right in this room rented from this 92-year-old Jewish lady. And then at a certain point, ahh, she threw me out. I went over to some body else's rented room in Park La Brea.

This is your first really long story, and it's told in the form of a silent serial in a way, with each page rep-

resenting a chapter.

Yeah.

How did you go about composing the entire story? Did you map the whole thing out first — unlike what you'd done previously?

Yeah, I really had the whole thing figured out before it even ran. I think I really was thinking maybe movie project down the road. I was no longer on salary with Brian Yuzna, but I was still around him. I think I was working on some other screen concepts for him, even then although he wasn't paying me. Of course, that's how I ended up getting that little cameo part in *Re-Animator*.

Tell me a little about your working method. You actually had the story outlined, so you knew what was going to appear.

Yeah, I had it all worked out; I had readable breakdowns of the whole thing even before the first one was published.

That was substantially different than you'd ever worked before.

But it was also pretty much the harbinger of how it was gonna be after that.

Right, finally getting down to it.

That's what's happening right now. What I'm doing right now, I might conceivably serialize before I finish it. I'm not gonna do anything until I have the entire script completely worked out, but I'm making good progress, and I'm on page 112 of just the written part right now. I had a good week last week.

It's a good feeling isn't it?

It's a good feeling to have a good week, yes sir. It's a grand and glorious feeling. *[Groth laughs.]*

Second best feeling in the world.

Yeah.

So you drew *Hollywoodland*, and my understanding was, that *Raw* was going at this point and Art and Françoise were publishing the occasional one-shot book, and that Art wanted to publish *Hollywoodland* as a single book once it ran its course in the *L.A. Reader*.

Yeah, which was Art's idea. I wasn't really sure what I was going to do with it next, but at a certain point he wanted to do that, so I said, "Yeah, sure." I think I'd started doing stuff in *Raw* by then. I was supposed to be in the first issue of *Raw*, but for some reason or other it didn't happen. I think I was already doing *Raw* stuff at that time. And what happened with that, is basically he pulled the rug out from under me, because he had a kid, and the kid kinda got in the way of all of that, or so I was lead to understand. But I wasn't bitter about it. In fact I got to be very good friends with the kid.

Apparently, that's where I entered the picture.

I remember it well.

Well, tell me, because I don't remember it at all. *[Laughs.]* This makes me the perfect, objective interviewer.

I'd actually been talking to Peter Bagge about this and that, because he'd been my editor at *Weirdo*. I developed a pretty good correspondence relationship with him. Great editor, by the way. If you hadn't come to me, I would have eventually gotten in touch with you. 'Cause he was really painting a good picture of Fantagraphics as a place to do work with. So you just beat me to the punch. Although I don't know if I would have been talking to you about that

From *Hollywoodland*. [©1987 Kim Deitch]

particular project. That was very opportune, 'cause Art had essentially just pulled the plug. Although he pulled it out handsomely, I mean he gave me a $1,000 kill fee on it.

So I called you up?

Yeah.

Out of the blue?

Out in Virginia.

Was this the first time we spoke?

Absolutely.

All right, and the beginning of a beautiful friendship.

Right, and that must be, what, 20 years ago?

More than that. We published it in '87 so presumably I would have called you probably in '86. So, 22 years ago. Holy hell.

Time flies.

World of Waldo

Waldo has been a consistent character for you from '69 on.

More than '69. He goes back to '66. I hadn't named him, but there's at least one comic strip published from '66 that uses that character.

The earliest one I found, which obviously isn't the earliest one, was "Déjà Vu" from '69.

He was up and running by that time. I considered that to be a pretty ambitious project; again, that was all speed, and all color too, originally.

Waldo is not an everyman character, he's more of a …

A rich schmuck, maybe.

[Laughs.] Yeah, right. He seems to haunt you, as well as the other characters in your stories.

Yeah, I'm feeling well rid of him these days. I figure, I left him with his hot midget girlfriend and a pile of dough, and so I've done right by him.

He seemed very happy.

Give the fucker a rest for a while.

This was partly a residue of your interest and fascina-

tion with animation, and partly because you found it hard to draw the human form. *[Laughs.]*

You got it.

But you continued using him after you did indeed master drawing the human form.

Well, I have not mastered drawing the human form. I only wish I had. But I guess I'm slowly getting better. If I could really draw, I'd be dangerous *[Groth laughs]*. I do the best I can.

We'll get into that. But, obviously the character resonates with you, because you've used him very consistently from late '60s.

He pretty much writes his own stuff. That's why he's good. I said it before: I never force a story with him. Like right now, I feel like I'm done with him for a while. At some point, if a big idea occurs to me, I'll bring him back.

What does he represent to you? Obviously, the darker side of human nature is part of it.

In a way, he's like a badass alter ego. I think there's probably a certain amount of my brother Simon in the mix of that character. He's the crass side of myself, let's say.

An amoral character.

Definitely amoral: When I finally wrote his backstory in *A Shroud for Waldo*, he's the reincarnation of Judas Iscariot, so that says a lot about him right there. *[Groth laughs.]* In fact, all that stuff I showed you about Jesus Christ and recorded sound and the story I'm working on now, I was originally going to do that in a Waldo backstory revisiting Bible times, but then I got a better story. But even in those drawings, you can see the human, earlier incarnation of Waldo as Judas in the background of those drawings. Anyone who's familiar with my work will notice it, and other people, it doesn't matter.

Well, you can't get much more treacherous than being the reincarnation of Judas Iscariot.

Yeah, well, Judas, he's like an all-too-human character, really. It's not like Judas is that bad. He's a classic embodiment of certain humans with all of their weaknesses. He immediately regrets selling Jesus out when he sells him out, but it's too late. He tries to give the money back, they don't want it. It's more like a human tragedy unto itself. In fact, they just discovered this new Biblical apocrypha, this gospel of Judas, which definitely recasts him in a somewhat more sympathetic light.

From *Hollywoodland*. [©1987 Kim Deitch]

You did a story called "Blue But True" in 1971. It was a pretty wild tale that might have been influenced by hallucinogenics *[laughs]*.

I was probably smoking weed when I did it. Like, there was that Marin County shoot-out, remember that? A lot of those poses in that were definitely riffing on that: I still have the newspapers from that. I thought that was one hell of a story. A lot of Humphrey Bogart — or maybe a specific Humphrey Bogart movie, *The Big Shot* — I can't remember.

Oh yeah. *The Big Shot*.

Where he has a girlfriend and she gets killed at the end. Is that the one?

Yes, I think it is. Early Bogie, before he was Bogie.

Yeah, well some of that got into "Blue But True," as well.

But of course, it didn't have Santa.

No, it don't have Santa. I didn't just rip something off. I'm influenced, then I recycle it. At the time, I considered

that to be a high point. I still like it. It's crude. That's one of the last, I think, of one of my all-Rapidograph jobs.

The drawing is a little crude —

But it was good for me at the time. It's very clean and tight. I still thought enough of it to stick it in *All Waldo Comics*, all those years later. It seemed like it was a good defining Waldo story, as was "Déjà Vu."

They always had this quality, but at some point it really kicked into gear, and I suppose *Hollywoodland* might be the first one where you started really getting into dense plotting. But then you also did it with "Mrs. Holla and the Magic Ring."

We had a lot of the preparation, unlike earlier things. *Corn Fed* #2, which might have been my longest story up to that point, was made up as I went along. I didn't know what happened until the story was over. That was the last and longest one that I ever tried that way. *Hollywoodland* was very carefully planned out ahead of time. Before episode one was drawn, I had readable roughs, breakdowns of the whole cockamamie thing.

Was that the first story where you planned it out that carefully?

Well, let's say it's among the first. It's the first really long one that was planned out that carefully. Up to that point, my attitude was, you better have the short ones pretty tightly constructed. The long ones, well, you bloody well better have a good idea of what the climax is, at the very least, before you jump in. And in retrospect, *Hollywoodland*, in a lot of ways it's a pot-boiler of a story. I have to read it again to really pass judgment on it. But it is what it is.

It holds up.

I hope you're right. It was ambitious at the time. I had it in my mind for a long time that I wanted to do a story about Los Angeles; it's as close a thing to a hometown as I've got. It was fascinating. I was in Los Angeles when I drew it, and revisiting my early childhood among other things.

In the mid-to-late '80s, you really used Waldo. You did "Hell to Pay" in '86, which was a terrific short story.

That one wasn't too shabby. For the longest time, I had this one drawing of Waldo sitting and relaxing with a big wrecking ball blasting through the wall. I didn't know how I was going to use that, but along came "Hell to Pay."

Your art seemed to take a more sophisticated turn.

By the time I drew "Hell to Pay," that's when I was living with Erwin Bergdoll in Virginia, where I was living a strangely monastic, comic-book-boot-camp kind of existence. Really wood-shedding like I've never done before or since.

How did that affect the way you looked at your drawing?

I was working harder, so I was paying more attention to it. I was doing everything I could to get better. The main piece of everything was, I was putting in long, long hours week in and week out. And also, I was getting into really high gear with working out every day. I'd say around that time in Virginia, I was working out two hours a day — a low week would be 60 and the high weeks, many were 80-hour weeks. I was nuts. But I was coming to the party in a big, big way at that time. I was also growing up, finally,

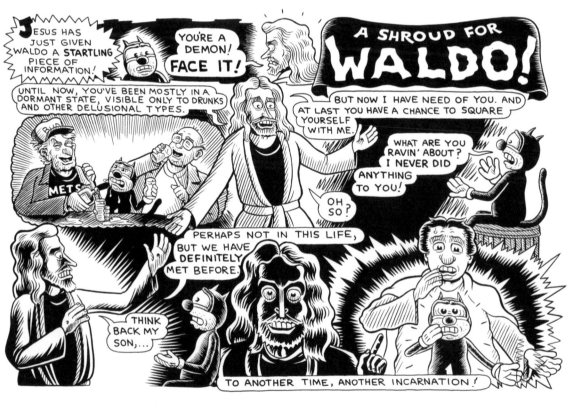

From *A Shroud for Waldo*. [©1992 Kim Deitch]

around that time. That was me in the wilderness, but in retrospect, it was the making of me.

By working out, you actually went to a gym?

In North Carolina, for a while I was at gym, but mostly, no, my big workout at that time was running six miles every day, and then do push-ups and sit-ups as well. But six miles — I can't remember — that had to take about an hour.

And that was all just part of you rejuvenating yourself?

That's where I was getting the energy. To this day, I still really hold heavily with the whole idea of keeping fit. I've been doing some teaching over at Parsons lately, and one of the big things I stress to those kids is: Get into physical fitness. It's going to be one of the four table legs that are going to hold you up. That's your machine, man. You've got to keep a clean machine.

I'm going to be fuckin' 64 in three days. *[Groth laughs.]* I'm in better shape than I have any right to deserve, really.

Well, with "Hell to Pay," you appear to have started paying more attention to texture in your drawing.

Rendering? At one point, I remember, I just started studying Crumb's work more carfully, and I started studying, for instance, specifically, the way he shades faces, realistic ones, but even his whole way of shading. I was even, just for exercise, practicing by copying Crumb figures and panels, with the accent on how the light is hitting the faces, and stuff like that.

You did "Mrs. Holla and the Magic Ring" in '88 and '89. You did that for *Weirdo*. Then you did *A Shroud for Waldo* in '89 and '90, so you must have done those one right after the other.

There was stuff in between, but I can't remember exactly what. "Mrs. Holla and the Magic Ring," I was based in Virginia, but I remember drawing a lot of that in Los Angeles, too. Even though I lived for three years in Virginia, I used to make a lot of side trips, and I was spending a lot of time in the Bay Area, L.A., and even New York. "Mrs. Holla," I definitely remember drawing a whole lot of that in Carol Lay's apartment.

You did *A Shroud for Waldo* for the *L.A. Weekly*. Can you tell me how that came about?

How it came about it was, when I took a trip to L.A., spiraling out the 1982 San Diego convention, I met Carol Lay. She told me that she had a buddy of hers who wanted to meet me, and that was Matt Groening. And I guess I

went over to the L.A. *Reader* office to meet him, so I got to know the people at the L.A. *Reader* office.

Did Matt work there? What was his involvement with the L.A. *Reader*?

He was a staff artist, although he seemed to have a little more sway than that. He might have had some editorial position as well. The strip he's doing now, he was doing then, and never really stopped doing it through all of this. So I met him, and through him I met James Vowell, the publisher at the *L.A. Weekly*, a really good guy, too. I had it in my mind I wanted to do a story about Los Angeles, and even featuring Larry Farrel. I was already working on that when I was still in Berkeley. It hadn't really gelled, but I spent a year in North Carolina, when I was on salary from Brian Yuzna, so when I finally got to L.A., I had a bunch of money. Between that and managing to talk the L.A. *Reader* into taking the strip, they gave me like $50 a week, and then I had all this money saved. That's what bankrolled *Hollwoodland*.

It's weird. I couldn't sell it to another paper, and believe me, I canvassed all over the country. I got a mailing list, I sent it to everybody. But, a continued story, nobody wants that in an independent-distributed comic strip. I was really delighted when I saw *The Shutterbug Follies* by Jason Little in the *New York Press*. I thought, "Ah! Here's somebody doing it!" And I was cutting it out and saving it. But they dropped it before he even finished the story.

That, to me, was my hope that maybe people would go along with a serialized story in an alternative comic strip, but really, that's not what's wanted. It's the same thing that goes on in regular comics: It's got to be, get in, get your fast little gag, and get out again, usually drawn in some sort of minimalistic style. And, to me, and this is just a matter of a taste [that's] totally boring and uninteresting. I don't follow any of those things. It is just probably personal taste, because I know there are some really good ones out there. My wife is really big on *Mutts*, and whenever I take the time to look at it, I can see that *Mutts* indeed is a fine strip.

But then, I've never been any good for whimsicality anyway. *Krazy Kat* is lost on me, and I know that's heresy *[Groth laughs]*. It looks nice and all, but really. We've got piles of it in the house, because Pam reads it, but every now an then, she'll show me one and I'll go, "Yeah, that is good," but mostly, I'm not interested.

You want meaty stories.

Yeah. *Krazy Kat* is just old pothead humor. That doesn't interest me.

***A Shroud for Waldo* is the origin of Waldo. It's almost impossible to summarize. It was the beginning of a trend for you, in that you started doing these really complicated, intricately woven, labyrinthine stories.**

I think that one could almost stand being revisited and drawn and plotted a little better than it is. When I tried to read it not long ago, it seemed flawed to me, although I think the basic ideas are cool: the big Waldo backstory. I did 100 percent better on that one serializing it in the papers. That time, I had two papers. That basically came out of an offer the *L.A. Weekly* made me to do a strip. Then I managed to sell it to a paper here in town as well. But it wasn't exactly a rip-roaring success. What it essentially did was it subsidized my drawing it, and ultimately it made it into book form. But it's a little jagged-y. I can't read that one without wincing a little bit now, not because of the storyline, but because it doesn't hang together as good as it could.

Again, I was traveling all over the place when I did it. I drew a lot of that in Philadelphia; I drew a lot at my mother's house in Connecticut; a bunch of it in Virginia and probably several other places that are escaping me right now. Even though I was based in Virginia, I was really still living out of a suitcase in those days, until the suitcase finally fell apart.

One of these days, if I live long enough, maybe I'll go back and try to do something with it, try to redraw it. It's sort of fun, and the backstory itself, I'm tickled by it. The fact that he's not really a cat anyway, but a demon from Hell makes a lot more sense. I got all this weird apocryphal Christianity rolling through it, too, which to me is entertaining.

Where did the idea of throwing Jesus into the mix come from?

Oh, I don't know. I like Jesus. That is great story: the story of Jesus Christ is really something else. It's got all the drama you could ever want, and human interest. So, it's also this archetypal cornerstone of Western culture and a whole lot more besides.

One thing that occurs to me about Waldo is that he's a pretty nihilistic character, but he's also completely self-satisfied.

Yeah, he's weirdly at peace with himself.

And you've done at least two stories where they end with him reveling in his own joy of life: *A Shroud for Waldo* and the shorter story that appeared in *Raw*, "Hell to Pay."

In some ways, he knows how to live, I guess *[Groth laughs]*, although I don't really like him.

Is that right?

No. What's to like? He's a schmuck. He's entertaining — but a nice guy? No. I have friends that aren't nice guys. I probably have a few friends I don't really like, too. I know that sounds contradictory, but nonetheless, it's probably true.

The characters you don't like probably make the most fascinating characters, too.

Well, that's the thing. Interesting people aren't necessarily all going to be swell guys and gals.

Your next huge book is *The Boulevard of Broken Dreams*, which appeared in …

Started in *Raw*.

OK, started in *Raw* …

… finished with you guys.

Finished with three comics that we published.

Three or four, yeah. You republished the *Raw* as a comic, and then there were three behind it.

I wasn't really aware that you collaborated with Simon on that, so I'd like to know how that broke down.

While I was still in Virginia, me and Simon were still pretty close, and I made several visits to see him. On one of the visits — it was just when VCRs were starting to get big — all he wanted to do on my visit was show me all the cartoons he'd taped off TV. Some of them good, and since we grew up with cartoons, it wasn't uninteresting.

And I guess he put my head in the frame of mind, because one evening, we were both smoking weed and being recreationally creative, because recreationally creatively, we essentially came up with the opening sequence of *The Boulevard of Broken Dreams*, which is that Winsor Newton thing. It's based on an event that both me and Simon were aware of that in 1927 in some speakeasy, Max Fleischer threw a testimonial dinner for Winsor McCay. It basically went down just like the beginning of *The Boulevard of Broken Dreams*, where Winsor McCay got up, and started to make this lofty speech about where animation has been, and where the future might take it, and he hadn't gotten too far before he looked around and realized that he was losing his audience. What Winsor McCay said [is] "Goddamnit! You guys have taken the art I've created, and turned it into shit. Bad luck to you," *[Groth laughs]*,

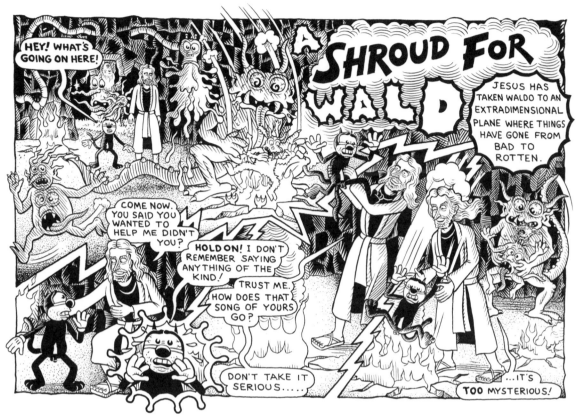

From *A Shroud for Waldo*. [©1992 Kim Deitch]

and he sat down in a huff.

I'm a little surprised I didn't keep that "bad luck to you" line, somehow it escaped when we were working it out. But we basically worked out this fictitious sequence based on that testimonial dinner. I remember Simon came up with changing Winsor McCay's name to Winsor Newton, and I remember me insisting that, when we created this delusional character, that the delusional character had to be Waldo. We worked it out, and I don't believe we had it on paper. We just worked it out talking. I don't know where it would have gone, because at that time I was working one the skein of stories that became *Shadowland*, which was what I was working on when I first met you.

I came over to Art Spiegelman's house maybe two or three days after that session with Simon. We were just sitting around talking trash. In the midst of talking trash, I started running this send-up or adaptation of the Max Fleischer/McCay testimonial dinner to Art, and while Art was listening to it, it was really surprising, I could see the expression on his face changing while telling him, and he's just looking at me, and at a certain point he goes, "Kim,

Kim. If you ever want to stop clowning around and do a story that might make you some real money. I think this might be one."

I said, "Really? You think so?" Shortly after that, I went back and I told that to Simon.

The other thing that Art had said, even before that, is that, at some point he was on a rant about something, and he said, "You know, I'd use a 40-page story in *Raw*, but it had better fucking well be one hell of a 40-page story."

So I had that in my brain, too.

[Laughs.] **A challenge.**

So then I went to Simon and I said, "Simon, I ran the thing down to Art, and he thought it really had possibilities."

Simon said, "Yeah, yeah."

So basically, what happened then is I went back to Art and I said, "Art, I'm going to take your advice. We want to do the animation story, and what's more, we want to do it in *your* magazine."

Art went, "Oh yeah, huh?" *[Groth laughs.]* Somehow I managed to talk him into it. At the end, he even gave us,

From *The Boulevard of Broken Dreams*. [©2002 Kim Deitch]

more or less, a 40-page slot. At a certain point, he gave me this choice: "Well, you can either have it one of two ways. You can either have 40 pages even, and we'll let you do a sequence of it in color, or all black and white, and we'll give you 42 pages." *[Groth laughs.]*

I definitely took the 42. So that is how the first episode of that is exactly 42 pages. I just felt that I wanted that little wiggle room to make it good. Color's nice, but it's beside the point, as far as I'm concerned, on that story.

So how did you and Simon collaborate on this? What did Simon do?

It was like the way that Ben Hecht and Charles MacArthur collaborated. Basically, I was doing most of the hands-on putting it down on paper, and Simon was talking and brainstorming with me. At some points, he designed things, I can specifically remember that that character the Sandman that was in the Fontaine Fables, that's a straight-ahead Simon Deitch design. He came up with the name Winsor Newton and he was right in there with me on it. Basically, the way I sold it to Simon was: "Look. You've been backseat-driving on stories that I've done for years." Occasionally, you can find an old *EVO* strip that's signed by both of us. I said, "Here's an opportunity for [us], why don't we make it a *real* partnership. I mean, there's the Hernandez Brothers. Why couldn't there be the Deitch Brothers? The beauty of it too is, you can enter on a fairly high tier, because here we be in *Raw* magazine. I'll tell you Simon, I've been to those signings for *Raw*, and man, those books just march out of the store like they had legs on them."

That's how I sold that idea to Simon. Of course, nothing ever runs that way. We got episode #1 done, and immediately Art decides to stop doing *Raw*. I pleaded with him. I said, "Let me edit it." Oh, no way was he gonna do that. So we did the best we could with it later and Art basically made it up to me down the road, 'cause he definitely was instrumental in helping me sell that book to Pantheon all those years later.

The crux of the book is the relationships among the animators and that seems very Kim Deitchian to me.

Here's my father's big trip about the book. "All the dysfunctionality you have among the animators," he says. "That's hogwash. I've been in that business and I can think of 'here's a guy who maybe drank himself to death, and here's a guy who didn't do so well,' but it's nothing like what you've been showing, and for you to say, 'This is like how it really was,' is bullshit."

And I thought about it, and said "Well, he's got a point. He's got a point." But a lot of it's true. Like that Jack Schick character, there's a book that influenced a lot of what went into *Boulevard of Broken Dreams* by an animator named Seamus Culhane who wrote a book, a really good book called *Talking Animals and Other People*, and he had a chapter in there on a situation that took place at Van Beuren Studios, where Burt Gillette (Schick/Gillette, get it?), who had directed "The Three Little Pigs" for Walt Disney, they imported him over to Van Beuren to upgrade the Van Beuren line, but he was basically completely insane. Ultimately, I think he ended his days in a nuthouse. So Burt Gillette became Jack Schick.

There was a girl animator named Lillian Friedman: Was she like our character, Lillian Freer? Probably not, I re-

ally didn't know that much about her, but that's where the name Lillian came from, and she was probably one of the earliest credited female animators that I know of, having worked at Max Fleisher sometime in the '30s. Lillian Friedman, she might even still be alive, but I doubt it.

They all seemed plausible.

Yeah, that's the thing. I projected a lot of the kind of really get-down raucousness of my background in underground comics onto that animation situation.

Bert Simon struck me as a stand-in for your father.

Yeah, there is a character that is absolutely based on my father.

The guy who comes in and wants to crank up the quality.

Yeah, that's it. Yeah, so a lot of that's based on my father's take on walking into Terrytoons, where he was hired to take over by CBS. That's definitely based on my old man.

Is the Winsor Newton live-action performance based on historical precedent with Winsor McCay?

Absolutely: haven't you ever heard of "Gertie the Dinosaur?"

Well, sure. I wasn't aware he did it as a live —

Absolutely: The best version of it I ever saw was the one Walt Disney put together on the old *Disneyland* show, where they got this Fleischer animator, Dick Huemer to make himself up as Winsor McCay, and do the "Gertie the Dinosaur" vaudeville act as he remembered Winsor McCay doing it back in the early teens. They might still be recycling that sequence on the Disney Channel, I don't know. I remember it vividly from my childhood. The old Disneyland show was often pretty classy and Disney did some pretty interesting episodes about the history of animation, where he actually did credit others than Walt Disney. Most notably, and admirably, wonderfully, the salute to Winsor McCay where he's doing it as the vaudeville act. The one you see on film, they re-jiggered it a little bit to make it a one-reeler.

He used to come out on the vaudeville stage: he was already a practiced vaudevillian before he ever did that. A famous early Winsor McCay act was like a chalk-talk act where he drew the seven ages of man as elucidated in *As You Like It*, the famous soliloquy, right on stage, just drawing it from baby to doddering old man, and everything in between. So he was already doing vaudeville before he even started doing animation in vaudeville; and *Little Nemo* must have been part of an early vaudeville act,

too, the Little Nemo cartoon.

I mean, yeah, McCay was an interesting renaissance man of the early 20th century. It was all killed by Hearst, who took care of him, but at a certain point decided, "I want this guy on my editorial page." Then he just became, oh I forget, Hearst's big editorial guy.

Arthur Brisbane.

Yeah, he became Arthur Brisbane's creature. He was there 20 years until he died.

Doing those elaborate drawings for his editorials.

I wonder if he ran into young Samuel Fuller at that time, who was also Arthur Brisbane's copy boy.

[Laughs.] I see another story there.

Yeah, that would make a good one. Strange encounter with Winsor McCay and Samuel Fuller, who seemed to have some cartoonist chops, himself.

Fuller did?

Yeah. There's a good documentary about him where he goes all over this stuff that I saw on one of the independent movie channels. It was quite good. He had a pretty credible cartoon of himself as Brisbane's copy boy that was really just this side of professional. And also during WWII, his little diaries are full of in-depth cartoons.

***Boulevard of Broken Dreams* was this great conflation between invention and historical fact. Now, your father, who is Bert Simon in the story, also knew an old-time animator named Ted who had a nephew named Nathan.**

That's pure bullshit. I made that story up. I asked him, "You don't mind if I take a little license for the sake of a good yarn?" That's hogwash. Although I was thinking of the animator Jim Tyer at Terrytoons, who wasn't any kind of dysfunctional but this kind of wild-ass animator. You look at old Terrytoons from before my father, and some of them are "ho hum, ho hum," and then all of a sudden there'll be this wild, cartoony action sequence animated by Tyer that's not even sticking to the model sheets. It's just wild and wonderful. When my father discovered him at Terrytoons, he just prized him, and used him every conceivable way he could think of. That guy lived long enough to do some of the animation in *Fritz the Cat*, although I've never seen *Fritz the Cat.*

So that entire preface you wrote about you and your father going to visit this guy, and the mother putting the

moves on your father and so forth, and which you said your father never remembered. That's all bullshit?

That's all bullshit. *[Groth laughs.]* I remember once being with my father at the George Eastman house in the late '50s and we were at some cocktail party. My mother wasn't along, and I remember some woman putting the moves on him, even while I stood there. I might have been thinking about that a little bit. But he was not responding.

Well, we're going to get more deeply into bullshit with *Alias the Cat*, but *Boulevard of Broken Dreams* is broken down into three chapters. The second chapter is Ted Mishkin's story, and of course, it includes your usual sanitarium, as so many of your stories do …

Yeah, well I had experience there. Not that I've ever used much of it in any really accurate way.

Waldo is very much a delusional obsession with Ted.

Yeah, I had already pioneered that with an early *Arcade* strip called *Mishkin's Folly*, which I guess is supposed to be the nephew as an older guy, delusional.

I thought Doctor Reinman narrating the story was a great touch.

His physical characteristics are based on the guy who ran New York Hospital, the one who saw me capture the escaping nut.

Is that right?

Mister Mirback, yes.

Part Three is probably the most intricate: He goes into flashbacks and flash-forwards. Then you bring the story up to date. How carefully worked out was it when you started the first story for *Raw*? Did you have the second two chapters laid out in your head?

No. Each one was carefully constructed before the work began, but I had no idea while I was working on the first section what the next section was gonna be like except maybe a general idea. I was drawing on a lot of different things. One inspiration that I got for some of the stuff in that last part was: When I was in L.A. doing *Hollywoodland*, one of the people I met was the widow of the experimental abstract animator Oskar Fischinger, and so at one point when Lillian is getting involved in all of her leftist stuff, I think she has a fling with some guy who's doing abstract animation, and it was based on Oskar Fischinger. His house was like — he'd been dead for a while — but it was almost like he was still there. All his paintings and whatnot were all around.

One of the fascinating things about your stuff is that it's all so organic. You can create these stories separately, but they all come together, because you're revisiting the same characters, and you have this *Rashômon*-like approach to the same material, where they overlap each other.

It's because I want it to be real: at least, somehow plausibly real anyway. So I'm really believing it, so people reading it are gonna really believe it. I must be doing something fairly right, because I'm astonished at how much people read of mine that I made up that people are taking for true.

Because it does have the kind of historical plausibility to it.

Some of it, yeah.

The tapestry is so dense that, not withstanding the visual stylization, there's a realism to it.

I hope so.

Maybe a psychological realism?

Yeah, something like that. It's gotta be real to me, somehow. I've gotta be really living it. The cornerstone of almost all good writing is that somehow it's got to be a plausible personal fantasy that's working for the person who's making it up.

As well as social or political realism. You even include the intimations of the blacklisting of the '50s.

Yeah, I'd heard a ton about that. I wanted the thing to have a certain dramatic ring of truth. All that Hollywood stuff — my father didn't work for Disney when the '42 strike happened, but my best friend Tony Eastman's father and mother worked there. So I'd heard many, many, many stories about the Disney strike from veteran strikers involved in the thing. That was this pivotal moment in animation, and that's how the left-wing politics of Hollywood manifested itself in the animation industry. I mean, it was manifesting itself all over the place. You read that book, *Dutch*, the Ronald Reagan biography. You know, *he* almost joined the Communist Party himself. Covered it up later on. He wanted to, but they wouldn't let him. They just didn't think he was Commie material.

There's a social texture to your work that gives it this incredible plausibility.

The social thing has been seeping in since some time [in the] '90s: *Boulevard of Broken Dreams*. The other turning point is that's probably the beginning of where

From *The Boulevard of Broken Dreams.* [©2002 Kim Deitch]

I started following the old writing saw "write what you know," whereas before I was going by the other writing saw, which I would define as "go where no man has gone before." Maybe now, what I'm doing, it's a little bit of a blend of both. The other place where "write what you know" came in higher relief is when I started doing those *Details* magazine stories that were flat-out true.

There's always been a journalistic side to your work, even going back to *Hollywoodland*, where you used a lot of research.

It got bigger after that. It's really big in *Alias the Cat*, 'cause I just came off of really being out in the world, really interviewing people. I was not only finding that interesting, but also being shocked that I was rather good at it.

Now with *Alias the Cat*, I couldn't tell where autobiographical fact ended and fiction began.

Well, fiction begins on page one. That's basically, I'd just come off of being like, roving comic-strip reporter,

telling real stories, and I really got into interviewing people, and I think what happens in *Alias the Cat* is I'm still interviewing people, except that they're not real. They're not really there. There's very little that's true in *Alias the Cat*. I mean, I researched the Furries by looking at a lot of their websites, and the historical material about the movies is true, but the rest is *fiction*. With a capital F.

So you and Pam did not go to a flea market.

Oh, we went to a flea market, sure. We went to lots of flea markets. But that's about where the truth begins and ends.

Did you start *Alias the Cat*, the first book of which was *The Stuff of Dreams* #1, after your stint on *Details*?

Good question. I think I did. Yeah, you know what happened is: One day I was doing sit-ups with the TV on and there was this Dolores del Rio movie on [*Bird of Paradise*] from 1932 with Joel McCrea where she's some South Sea island chick, who eventually gets sacrificed in some volcano — and I was just watching that, some David O. Selznick deal, and I was going "That's it! That's what I'll do for my next story. I'll steal this plot!" I didn't steal the plot, but the cornerstone was that movie.

And the other thing that entered into it was I got this really good job from *Time Out* magazine, England, where they wanted walking tours of New York. So I thought a good one will be "Walking Tour of the Flea Markets," so I did a three-page thing for *Time Out* of going through the flea markets, which Waldo was in. All the data on the flea markets was mostly true. I had such a good time on that story. I didn't want it to end. So, between the Dolores del Rio movie and doing the three-page *Time Out*, they just sort of mushed together, and that became *Stuff of Dreams* #1. Which I worked out as a complete story, having no idea that there was gonna be a #2 or #3. There's no #1 on that comic and I won the Eisner on the strength of it being a one-shot. You know, I was telling the truth at the time, but I knew that somehow I wanted to do a follow-up that was gonna be called "No Midgets in Midgetville." How I was going to get from that one to "No Midgets in Midgetville" I wasn't too sure, but while I was on tour for *Boulevard of Broken Dreams,* I started getting the idea for *Alias the Cat* as a "No Midgets in Midgetville "prequel.

Because *The Stuff of Dreams* was a stand-alone story.

It was just what it seemed to be, a one-shot comic. Except that it seemed like I had unfinished business with it all, and I came up with the book called *Alias the Cat*, which, to me, is probably my personal favorite of those

three comics, because it gave me a chance to take a bath in some of this old movie-serial stuff that I thought was very forgotten, and in a way, undeservedly forgotten, especially in terms of comics because the plotlines of those old serials from the '10s and '20s definitely influenced the next generation of comic-book artists that came along. I mean, little Jack Kirby and little Jack Cole were sitting there taking that stuff in. They had all the exotica of Golden Age comic-book stories.

I have to tell you, I thought it was funny when you reprinted the old *Alias the Cat* strips and you didn't even try to disguise the fact that you drew it. And then you describe later how you, Kim Deitch, came to be influenced by the person who did draw it, which was a brilliant kind of subterfuge.

I had to do that. I tried to disguise it —if you look at those pages, there's something significant I did, which is that all the *Alias the Cat* comic strips, I reverted to something I hadn't done in years, they're drawn entirely with Rapidograph. Everything else in the book is brush. I also tried to change the faces a little bit, but it was pathetic. It didn't work. Some of the reviews I was getting before I was done with it even pointing out that I kind of fell down on the storyline 'cause any fool can see that — and so, coming up with the idea that I was influenced by this female cartoonist Moll Barkeley was a save [to] give it a little more plausibility, but actually I was really glad. That was a save, but I came up with this interesting situation with this 104-year-old cartoonist that worked pretty good and gave me a chance to relive another fabulous part of my childhood, which is having comic books delivered to you by a bread truck once a month. Well, that's true, too.

You know, I'd never heard of that.

When I was a kid, it seemed like it happened about once month. I think it was called the Krug Bread Company. They'd come rolling though the neighborhood and, while trying to sell Mom bread products, would hand out these comics with this character called Peter Wheat; he's a little teeny-tiny guy, and his pal Beetle. It was interesting, I looked at them at the time, and my parents subscribed to *Pogo*, so I was looking at them, and I'd go, "Geez, you know, this style is an awful lot like *Pogo.*" I don't know if those Peter Wheat comics that we were getting were actually drawn by Walt Kelly, but he definitely designed them and created the concept. I believe the Peter Wheat giveaway comics were at one time way more elegant than what I remember. Because, the ones we got, they handed you a couple of sheets, which then you could cut and con-struct into an eight-page comic story; it was almost like a *Spirit*-section type thing. There was no real commercial for the bread, except maybe on the last page; they were just comic stories featuring Peter Wheat and Beetle. It'd be interesting to track down the actual history of that.

What year would that have been?

That's a good question. When me and Simon and other kids in our neighborhood were getting them, that must have been about 1954, maybe even all the way as far back as '53. I'm not so good on dates of my own childhood, but it was in there in that sort of late-early 1950s.

Because obviously *Pogo* was going at the time.

Oh, *Pogo* absolutely was going at the time, and I think that if the ones we were getting were drawn by Kelly, they were probably recycled. This style was much more like the kind of fairy-tale comic books by Kelly that you actually have reprinted in *Comics Journal*. I mean the guy could do some elegant drawings.

***Alias the Cat* was so seamless that it was hard for me to figure out what was even marginally, possibly autobiographical.**

Well, I'm really named Kim, and my wife really is named Pam. I really I did quit drinking at an AA meeting in North Carolina, but most of the rest of it's all made up.

I was gonna say, there isn't really a Ron Wiggley, is there?

The way I got the Furry thing is, there's this sex column in the *Village Voice,* mostly gay sex — I can't remember the name of it right offhand — Savage?

Dan Savage *[Savage Love]*.

Well, for two weeks in a row, he ran stuff about the Furries. There was two columns about that, and I think that it even had a few website listings there, and so I started following the Furry websites for a while. Ron Wiggley, I think I did base his physical look on one of those guys. I've got some heat from the Furries since then. *[Groth laughs.]*

In fact, there was a big brouhaha on your message board about five weeks ago, I don't know what this guy said, but he was coming to me going, "Bail me out, they don't believe me, Kim." I don't want to go into it. But I chose not to respond. I think he told people on message boards that I had made a formal apology to him and all the other Furries for the wrongs I committed to them, which is entirely not true. *[Groth laughs.]*

I think I said to this guy when he got in touch with me, "Look, if I've offended you, I'm sorry." Following up with, "You've got to admit that Ron Wiggley, if he's not entirely accurate by your reckoning, he is certainly a sympathetic character."

He was.

Yeah, I went out of my way. It wasn't like, "Ooh, the Furries are gonna get me." That's the way it was coming out, and the idea that he and Pam became friends, that was, in my mind, how it would have gone if it really was happening.

And you came around to liking him within the story.

Yeah, he was a good character, and anyway I got nothing against the Furries. Look, I think it's fascinating, these guys have essentially — I guess it's mostly guys — come up with a new sexuality, or something approaching a new sexuality. To which I say, "Oh, that's pretty wild." I don't want to be judgmental on them. More power to them. It's a weird world already. That's hardly the weirdest thing about the world.

Is it an historical fact that comic strips based on serials were running in local papers based on those same serials? Or did you make that up?

No, it is not. But, it's practically true; I point out in the story that I'd never seen it done as a comic strip, but what is absolutely true is that they generally were syndicated in newspapers as serialized stories as they were running in theaters. Like the *Perils of Pauline* was backed by Hearst, and you could read the *Perils of Pauline* every week in all of Hearst's papers. Because you could always go to the movies and see it come to life on your movie screen. In the early days of serials, that was definitely tied in as a circulation-builder for newspapers. And the other thing that's interesting about the early ones: By the time sound came in, it was pretty much relegated to something for the kiddies on Saturday; but the early ones were really meant for the whole family, and they were geared as much for women as anybody else. I mean, one of the big selling points in most of the ones in the early days is all these serial queens and it was usually a female protagonist. A big selling point was, "Look at all the gowns that Pearl White is wearing in *The Iron Claw*, $10,000 worth of gowns on her back." That was a big part of it.

***Alias the Cat* is probably your densest book, in terms of narrative.**

Yeah, maybe even too dense.

It's pretty goddamned dense. Did you write the entire story out first? How did you come to put that together?

Alias the Cat, I worked it all out as a piece. By the time I was doing *Alias the Cat*, I knew "No Midgets in Midgetville" was coming next, but exactly how it was going to

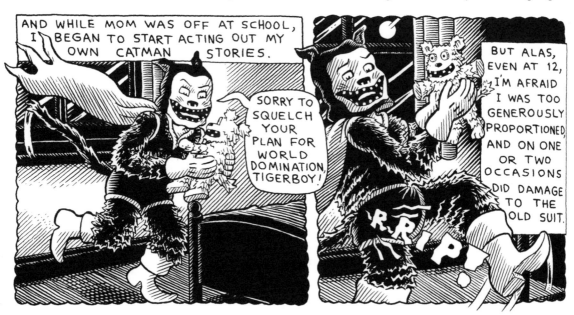

From *Alias the Cat.* [©2007 Kim Deitch]

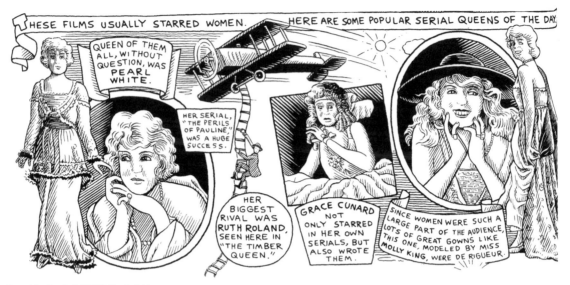

From Alias the Cat. *[©2007 Kim Deitch]*

segue I was still not quite sure. "No Midgets in Midgetville" might be the most forced of those three stories. I'm not sure. I knew I was in a mess of trouble by the time I was doing "No Midgets in Midgetville," I had a lot of things to straighten out to make it work, to make the three of them work together. It seemed to more or less happen.

I certainly think so.

I hope so.

Now, what do you mean by saying you had a lot to straighten out.

Well, for one thing, the big one was the fact that this *Alias the Cat* comic strip sure as hell looked like it was drawn by me, we're getting that straight.

Well, you handled that pretty smoothly.

And then also, the payoff where I somehow bring back the guy who tells the yarn about the Waldo dolls getting blown up carrying all these munitions cross-country, that was a good inspiration, which I certainly had no idea about until later on. That seemed to work, plus one of my reality stories where I went to Butte, Mont., came in handy because in Butte, Mont., the biggest tourist attraction was that they had the world's largest toxic-waste dump. So, all that stuff about toxic waste at the end, and staging it in Butte, that came in handy. Because that was the third of my reality stories, and the one that actually got killed before it saw publication, but I had all that good

research, so that came in handy.

When you introduced Walter Kleinschmidt in *Alias the Cat*, you knew at that point that you wanted to segue into "Midgetville"?

Yeah, that's another one. That's a part of trying to tie this all together, yes.

You had a big section in *Alias the Cat* where it was prose and illustrations rather than comics; was the reason for that dictated by necessity, which is that you had to cram a lot of narrative in there, more than you could in a comic?

That probably had something to do with it, but I was also being influenced by Phoebe Gloeckner's book which had just come out, which I'd read and liked: *Diary of a Teenage Girl* — the way she used alternating chapters of illustrated prose and comics. I really enjoyed seeing that format and presentation by her. I'd used illustrated prose before, too, but I'd never thought of throwing it into what was otherwise a comic before. I think seeing her experiment inspired me to give that a shot.

Well, it somehow works perfectly as the transcript of Marilyn Wagstaff.

I thought it worked out great, and it just gave me a chance to get a little deeper into that character's head in a way that I never could have done otherwise. I think that was what started me thinking about wanting to go further with experimenting with illustrated fiction as opposed to

comics, and trying to somehow combine those into an extension of comics, which is what I'm grappling with these days.

In *Alias the Cat*, how did Pam like how she looked in the cat costume?

Well, she must have liked it, because she designed it.

Is that right?

When I first did *Alias the Cat*, as a matter of fact, my initial idea was that this is something we could do together, and I was thinking that she would draw the *Alias the Cat* comic strips. It didn't work out, because Pam's got this high-powered job, and, basically, I knew that she couldn't keep up with me. In fact, she was downright pissed about it at first. It was around the time all of *Boulevard of Broken Dreams* was coming together — but then there was the lag time between when the book was done and I was supposed to go on tour with it, and I had time on my hands, so I just started working on *Alias the Cat*. I was pretty much working it up, and when Pam saw that, she was pissed. Because I had presented it to her as, "Here darling, this is something we can do together." So, to try to make her be less pissed at me, I asked her to design the costume. Now I never would have had the crust to put her in that scanty outfit, if I'd designed it. I would have reined it in a little bit, but I figured, "OK." *[Groth laughs.]* "I'm OK with that." I won't say "tits" in the interview.

***Alias the Cat* seems to be the comic where all of your interests and the interconnectedness of events and people and your obsession with old films all come together.**

Well, if *Alias the Cat* has anything going for it, one sign that it might be working is that I had a great time doing it. I mean, it was fun. It was hard work but satisfying. I was sorry when it was over.

I'm not sure you answered my question: Did you have the entire thing written out before you started drawing it?

Just each segment. I vaguely thought that "No Midgets in Midgetville," when I decided I was going to do a second comic, would follow *Stuff of Dreams* #1, but *Alias the Cat* just inserted itself in there, so I wrote that instead of "No Midgets in Midgetville," but then I also knew in the back of my mind: How was I going to segue from *Stuff of Dreams* #1 to "No Midgets in Midgetville"; I guess I subconsciously knew there had to be something in between. But each section, each comic book was completely worked out before I started drawing any finished work. I had complete readable breakdowns of the entire story of each one of those, but I didn't have readable roughs for all three of them.

Now what does a breakdown look like? Is it entirely writing?

It's what I call a readable rough. There's pictures, there's panels, there's writing. You can read it, but it's pretty rough. I showed you some.

They're not that rough.

Well then, the layouts are really tight.

In "No Midgets in Midgetville," it all comes together, then it culminates with Waldo again, and the scene that struck me most forcefully is when Waldo gives you a lecture about your priorities.

Wake up and smell the coffee.

"You have to stop obsessing about all this stuff."

Yeah, that was funny. I was entertained while I was doing that. I like his girlfriend, too. I don't know if I want to use her forever. At first I was going to do a story about how they were old souls, and both of them go back to Bible times and do a story like that, and probably would've eventually if I hadn't come up with a better Bible story that I'm working on.

It seemed, in this really weird way, they were perfect for each other.

That's that the thing. I really feel like I've done right by them. I left him with a nice squeeze and all that money. If he fucks up now, it ain't no fault of mine. It even brought out something like a second-cousin to his better nature. It gave me a chance to even wax a little bit touching or almost serious with Waldo for a second: That was fun.

And then, at the very end of the story, there's a little meditation about your own philosophy of how art interacts with life, and how you can recreate a more idyllic world in comics, which I'm not sure I entirely buy, given …

I'm not sure I do, either. You know, I had to finish it, and that's what I came up with.

***[Laughs.]* Now is that something you'd like to believe?**

Look, I think that the cornerstone of a lot of good yarns and stories is that they are manifestations of daydreams and personal fantasies, and I think that's really kind of key.

All these serials that you invoke in the *Alias the Cat* story are about as far removed from life as you can get.

Yeah, it's escapist entertainment.

But your work is not. The two worlds collide.

Yeah, they collide, but the people who make this escapist entertainment, they have lives. What they're doing is they're re-jiggering life to make it more appealing to themselves. Some of it's like that. One thing you can be doing with stories is making an interesting escape from grim reality. The trouble with a lot of contemporary stuff is it's just too damn realistic. A lot of stuff, I'll look at and I'll go "shit man, I get enough of that in real life." I like to go somewhere else in my recreational time. I think everything's too much "get down gritty," and now we've lost all the fun in literature and entertainment by how jaded we've become. I guess that came about from going through two world wars and atomic bombs and all that. People just aren't as lighthearted as they used to be.

But, paradoxically, the heart and soul of your work is the grim reality behind all that magic-making.

Yeah, yeah, that's true. It's good to have it grounded in some kind of reality just to resonate off, even if you are trying to get away from it in some way. I think part of the trouble with a lot of art is the idea that it can represent a good time just isn't as out front as it once was. I'm definitely not looking to do art like everybody else does, and I'm definitely trying to break ground. It just seems to me like we've lost something in entertainment media over the years that I'd like to see somehow recaptured. You could even say it has to do with corny stuff. Everybody hates corny stuff, because it's just hammered into the ground so far, but there was a time when that stuff was a good seasoning to a story. It could be a gain, if handled adroitly. We were talking about Frank Borzage before. I mean, there's a guy whose stuff wasn't really realistic, but it worked. There's ways to do it; you just have to make sure you're making it good. I don't know, I think part of the trouble with a lot of art is that it's all just resonating off of other art and there's been a trend towards more and more downbeat. You know, as time goes by, a lot of the "gosh-wow" wonder of it has gotten lost in the shuffle.

Your own work alternates between the two, from the grim realities of difficult and complicated and messy relationships to Waldo singing "Life is just a bowl of cherries so live and laugh. Aha!"

Yeah, well that was written in the middle of the worst Depression this country ever had. I think that was a re-sponse to it. And he sings "money, money, money, money," the Donald Trump theme song, too.

On Death Row

***[Laughs.]* Talk about grim. You started doing your journalistic pieces for *Details* in the late '90s, before you did *Alias the Cat*. Tell me how that came about.**

Details had got in touch with me earlier, and I pitched some stuff to them that went absolutely nowhere. But then, Art [Spiegelman] got this job which was basically to assign reality stories to different cartoonists, and he had a list he was working down. He tried some of them against type, like he sent Ben Katchor to a surfing contest in Honolulu, and the whole gag of that strip was the weather was bad and Ben missed the contest altogether. But, by the time he got to me, I knew he was coming, so Carol Lay I think had done one and she even gave me a couple of her cast-off ideas.

So when Art came to me and said "Look, you know what I'm doing, and I'd like to get you in on this," I immediately came back with, "Well, I got a few ideas for you. There's a clown college in Sarasota, Fla., and I hear they're having their commencement exercises, or doing their final exams, and I can cover that. That oughta be fun." He pitched that to the guy at *Details*, and then he said "No, no, no Kim, they don't want anything as frothy as that; they want something with a little more edge."

So that killed that, so my second idea was, "I'll do something about the new theme-park-oriented Las Vegas." Basically, I was pitching things and they were being pitched right back to me. Finally he said, "Look, Kim, I'll tell you what I'm gonna do. I was saving this for Dan Clowes, but he's got a lot on his plate right now. How would you like to go to San Quentin and interview Charles Manson?"

And I'm saying right back to him — and I was a little shocked at myself — I was going "Well, Art, I'll tell ya, I'd do it, but there's just two things I got against it: A) it's been done; we all were fascinated by Manson interviews 25 years ago, but it's old stuff now, and B) quite frankly, I don't think I could be in the same room with that guy." Then I'm thinking, my mind is coming back at me like "What the fuck are you doing, asshole?!" you know, "This is a good-paying job, Mr. Smartass!"

So then, thinking on my feet, I just heard it coming out of my own mouth, I said "Look, Art, I've got a better idea, how does this sound? What if *Details* just sends me somewhere out into the middle of the country and I cover an execution of an ordinary criminal?"

And Art said, "You'd do that? Because I've gotta tell you, I wouldn't do that. I'm against the death penalty, and I just wouldn't do that."

And I said, "Yeah, I'd do it."

And he said, "Hold that thought." Boy, I don't think 15 minutes went by, and the phone rang again and he said, "OK, Kim, you get to see somebody die." But then I found out it was all on me to find an execution and get myself invited to it. But that wasn't anywhere near as tough as I thought it would be. As long as you had some kind of press credential, and I was representing a high-circulation magazine. I tried one state earlier where they said, "Well, OK, yeah, I guess you can go to the thing, and you could also maybe go to the clemency hearing the day before, but you can't interview him." I just wasn't feeling it.

So I said, let me try another one. I guess Virginia was second on my list. I called up the public-relations guy at the Virginia penal system and said, "I'm from *Details* magazine, blah blah blah, I'd like to do an illustrated story" — I didn't say it was comics — "about the death penalty. I was wondering if I could attend an execution."

And he said "Well, I guess so, we've got two coming up in October, which one should I pencil you in for?"

[*Laughs.*] Like ordering take-out.

Yeah, so I took the later one so it would give me some time to prepare, and in the midst of preparing for it, I started researching the case, and it turned out to be really interesting, and the whole thing just worked so good. I expanded it from just attending the execution to a lengthy death-house interview, then after the execution lengthy death-house interviews with all of his pals, and then, going to the funeral, going back to the scene of the crime, interviewing relatives of the victims. It was just amazing. I just had the most incredible beginner's luck, plus I found that I had a certain amount of aptitude for talking to, and interviewing people. I just had that right kind of patience. I'm still friends with one of the relatives of the guy who was executed, all these years later. Because that's basically how I opened this thing up: I made friends with everybody. Well, some of those people who were related to the murder victims didn't really warm up to me, but I even got in front of their faces and got statements out of them. It was like, when I started doing it, I suddenly felt like, "Shit. I missed my calling. I'm good at this."

I was really living the roving reporter role. Even to the point of obnoxiousness. I was really getting into that "get the story, get the story," thing. You know, like crazy. I really was ready to go way out of my way to get this aspect of it and that aspect of it: It was like a demon inside of me. It was just taking over and, now we're gonna do this, now we're gonna do that, you know. Bing bang boom. My mother even cautioned me about it. She was saying "Look. Don't get too involved in this, you're gonna end up doing all these death-house stories, and that's not healthy."

And she was right about that 'cause, boy, after the guy was executed and I went over and was talking to his pals, they all had a story they wanted to tell me. Yeah, I guess I could have gone on doing death-row comics forever, if I got some magazines to bankroll me. That's of course, a big "if." But there were weird repercussions from that for years to come.

Really? Like what?

There was this one guy on death row who kept haranguing me about it, and he even sent a nasty letter to Pam before they finally snuffed him. The guy I did, he was generally sorry for what he did. He was really at peace with himself, almost to a spooky level. When Ted Bundy got executed, they had those tapes of him the day before, the guy practically shitting in his pants, but this guy was nothing like that. He was really serene, and he was my best lead to everything else that I did in the story. Also, why it worked so well dealing with his mother and his aunt who came there to visit him the day he got executed. He told me what hotel they were staying at. I changed my motel accommodations to the same one they were at, I'm knocking on the door and I've got my Polaroid camera and my little tape recorder and I'm saying, "Well, I've been in to see Ronald, and I'd sure like to get you in on this story." Well imagine how you think they would respond to me: That's just how they responded to me. They were looking at me like I was dogshit. And who could blame them?

How did you actually present yourself to them?

Just like I was saying: I said "I'd like to come in and interview you for a while, and maybe take a picture and do a little tape," and I remember the guy's mother — this is the day before his execution — she looked at my little tape recorder in my hand and she said, "Nobody's sticking that thing in *my* face." But how it played out was kind of amazing. I was being really aggressive. So they finally said, "OK, you wanna come in and talk with us awhile, that's OK, but no pictures, no tape recorder." Well, I agreed to that and I went in.

It wasn't looking good at all. It was looking downright bad. They had the World Series on, basically because it was third game of the series, and this guy told me the day before, "Yeah, I'm a Yankees fan, and I'm looking forward to

today's game, 'cause I know I won't see the end of the series, but I know if the Yankees take this game today, they're gonna *win*." And so, they had the series game on, too.

So I'm sitting there really uncomfortable, the World Series is on and everybody's giving me the big freeze, and I'm pretty much thinking, "Well, how am I gonna get outta here?" when the phone rings, and who's on the phone? It's *him*. And I could tell that, because when mother picked up the phone, she went like "*Hi!*" with this really forced gaiety. I didn't have to ask myself who it was, I knew who it was. But this is what happened. So there, she's talking awhile, and I guess at some point she sort of looks over at me and says, "Yeah, he's here," but then the expression on her face changes and she looks at me and says, "He wants to talk to you." And so, I took the phone and basically, what he did was he said goodbye to me.

But that legitimized you in their eyes.

By the time I handed the phone back to one of his nieces, who was in the room, it had all changed, and they basically said, "Well, look, OK. We see that this is Ronald's wish, and I guess we can cooperate with you, but you have to understand this isn't a good time." They lived in Mount Vernon, N.Y., it turned out. They said, "If you want to come and visit us in Mount Vernon 10 days or so from now, we can talk to you then."

And I wanted to, because one of the tips Ronald put me on was that, the way they make the executions go easier is on the day of the execution, you get what's called a "contact visit," which means that they take the shackles off, and you can spend a couple of hours with your close relatives, and maybe take some goodbye photos. You must have seen those. They do that for everybody's execution now, and he said "I'm gonna get my contact visitor day after tomorrow on the day that they do it, and maybe you can get them to lend the to you for your article."

And I said, "Yeah, maybe I can."

Jesus.

By the time I visited them in Mount Vernon, 10 to 12 days after that, I was tight with them. I really liked them, too. I remember I felt a little trepidation when I called them, but some little girl answered the phone, and I asked to speak to Ronald's aunt, and I could hear her as she handed the phone and she goes "It's Kim!" They were really glad to see me.

And then when I went over there and did the interview with them and talked them into letting me get these death-house Polaroids to use in the article, it was really kinda sad, because when I was all done and got everything I needed, Ronald's mother said, "Well, I guess we're not gonna see you any more, right, Kim?"

And I, bullshit artist, said "Oh no, I'm sure we'll see each other again," but I knew in my gut she was absolutely right.

I mean, actually, I still keep in touch with one of his aunts in Virginia, who was really helpful for me, opened up a lot of doors for me, got me to this wake they held where I got great interviews. What I basically got that really sold this thing was I got an interview with Ronald's ex-wife who was basically the cause of it all. And again, I was at this thing and she didn't want to talk to me, but as she saw me circulating through the party, getting all these different people to talk to me, by the time it was over, somebody went up to me and said, "She wants to talk to you." I just felt like, what have I been doing sitting in my ivory tower, making up these stupid stories all my life? I was born to be out in the world getting real stories. By the time I was done with that I was ready to rumba. But, a lot of it was beginner's luck.

Also, things were changing rapidly at *Details* magazine while all of this was gong on. By the time the story was ready to run, the editor in chief of *Details*, under whose reign I was doing this story, got canned. But then, the new guy that came on — *Details* raided *Maxim*, which was a more successful type of magazine like *Details,* and got the *Maxim* editor— he liked the death-row story, and said he'd definitely be open to more stories from me, with the proviso that now they have to be more bubblegum stories, actually more like what I was pitching before, but maybe a little sexier.

So, I came up with one of those. I don't know what I would have done, but then right after the death penalty one had been turned in and I knew it was going to run, and there was a new editor, I was riding around in a car with my wife and my father-in-law, and we were talking about how there was a big computer virus called the Melissa Virus, and basically it was a big story. It was a nine-days wonder, but it was a big story at the time. The interesting human-interest nugget about the story that stood out was when the guy who did this virus was captured, he told the authorities that the reason he named it the Melissa Virus was that he named it after a stripper that he knew in Fort Lauderdale where he had gone bankrupt several years earlier. So we're riding along, and then my father-in-law, who at the time was a news cameraman for ABC who had been following with great interest my death-penalty adventures, said "Hey, you know, that'd be a good story for that *Details* thing you're doing. Why don't you ask them if they'd send you to Fort Lauderdale

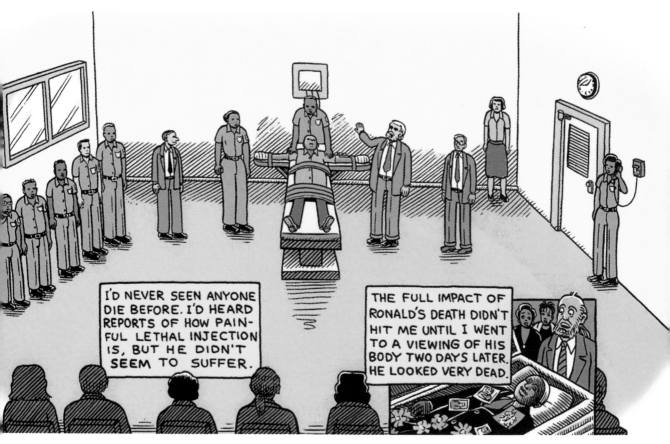

From "Ready to Die" in *Details* (May 1999). [©1999 Kim Deitch]

to track down that stripper named Melissa."

You know, when he said that, my heart sank, and the reason my heart sank was I knew in my guts that if I pitched that idea to *Details*, they were gonna go for it. And they sure as hell did. I was in Fort Lauderdale before I could turn around. Before I was done with that, they had green-lighted this other story about these artist hookers who had just taken a lease out on the world's, or at least America's, longest continuously running whorehouse in Butte, Mont., that they wanted to turn into a museum about the history of prostitution. I ran into that dame while I was looking for strippers named Melissa, and she had a stripper named Melissa that she referred me to, but then she told me about that story, so I had the green light on that even before I was done with the Melissa Virus story. I mean, I was in Butte, Mont., before the ink was dry on the Melissa Virus story. I was going great guns. It was all starting to hit the wall, though, because by this time, the highly successful *Maxim* guy was not recreating his success at *Maxim* at *Details*. He was just about out

the door by the time I was done with the Butte, Mont., story, which didn't really turn into the jazzy, glitzy story I thought it would.

Though being in Butte, Mont., was a fabulous experience, and I came back with what I thought was a really beautiful human-interest story about the good people of Butte, Montana. When I say good people, that's true, because I really had a strong feeling of liking for just about everybody I met there. I mean, it was a very depressed town. A lot of people are still living off the land, but there was a lot of good can-do spirit in a depressed sort of way, and I was very impressed with the people I was meeting. And what I did, when the story wasn't really panning out that well, I called Art and said, "This big event I'm doing, it's not really happening, but Butte is fascinating," and he went along with me turning it into a human-interest story about Butte.

But the *Maxim*, now *Details* editor, he wasn't interested in any sweet little stories at that time; he was practically gone. Actually, they had turned around and wanted me to

trash my sweet Butte, Mont., story and just talk about the irony of how Butte's really this run-down, poverty-stricken place, and it was making me sick. So much so, that I actually breathed a sigh of relief when they finally killed the thing off, and I was out of the roving-reporter business, except it's reasserted itself a little from time to time, but I wouldn't mind doing it again for the right story.

I have two questions: When you were interviewing the family of the person on death row, what were you really trying to get out of them? What was the main focus of your interviewing them?

The facts. What they were really feeling. I didn't really know, but whatever the story was, I wanted it.

What was the line of your questioning like?

Just how were they feeling about it. The one thing that was interesting to me, see, it's like there really was a fascinating camaraderie among the death-row inmates. They even referred to themselves as death-row soldiers, and all of that bizarre *esprit de corps* fascinated me. I wanted more details about that. I wanted to know who they were and how they lived. I made friends with them, and that wasn't completely bullshit, because I really did like them. They

seemed like good people. Ronald went bad — and also, how did Ronald go bad — he was likeable! I liked him. By the time I'm sitting there watching him die, I didn't feel very good. I was jumping all over the place, standing on my chair trying to draw it all, and that was pretty obnoxious, but I didn't like that he was dying. I suppose in a way it was just as bad as Truman Capote, reportedly besotted with joy when Smith and Hickock were hanged in the *In Cold Blood* story, and that made me feel shameful, but I liked him, and I liked them, and I realized in a large way that I was exploiting them, but I was trying to be as fair about it as I could.

When I had the story, in fact, the last page where I go and visit them and they talk about it all, they wanted to cut that page out. They said, "Look, this is pretty good just right here; let's just scrap that."

I said, "Art, I had tears in my eyes when I was laying that page out."

Then he went to the other extreme like "OK, OK, let's talk about the tears in your eyes." I had a lot of trouble with both him and the publisher at the end. I thought I had the ending just right, with the mother saying the last line, and I told the publisher, Caruso, I did that for a purpose: I wanted her to have the last word.

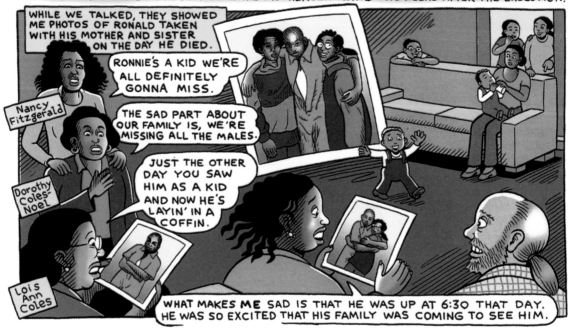

From "Ready to Die" in *Details* (May 1999). [©1999 Kim Deitch]

And he looked at me and said, "Yes, Kim, but I want *you* to have the last word." And I wrote some big sanctimonious thing, but fortunately, they somehow came to see it my way before that happened, and it did end the way I wanted it to end; more of this beginner's luck, I think.

Did you go into that story with a political position on capital punishment?

Well, my position on capital punishment is, I'm not against capital punishment. I don't love capital punishment. God, I'd be against it if it was me pulling the switch. I'm not sure I thought that any of the people I actually talked to and interviewed rated being executed. I think in a way that ideally, the way for capital punishment to be would be more like what I hear they have in communist China. Which is, you're sentenced to death — like for instance, the widow of Mao Zedong, I think she's alive today, but she was sentenced to death — but then the sentence isn't carried out. I'd think a way to do it would be: Charles Manson, kill him. But, other cases, sentence somebody to death, but have it be a provisional sentence that, if they could show by exemplary behavior that they're rehabilitating themselves, that maybe the sentence wouldn't be carried out. But that probably isn't really practical.

It might not be, because all you're saying is you kill the really bad guys, and don't kill the less bad guys, but the obstacle is that no one, especially the state, is prescient enough to know that in every case.

Yeah, well look, there's some guys, serial killers and stuff, I almost question whether they should even come to trial, but that's not, I think, the vast majority of poor schmucks that are on death row. And of course, if my wife was murdered, I'd probably have a completely different attitude about it. I'd probably get a gun and try to finish the guy off myself.

Your political position didn't really seem to play much of a part in how you saw the whole story.

Well, I'm not against capital punishment, but I'm not madly for it either. Like, this guy, Ronald Fitzgerald, I think he shouldn't have been executed. He probably could have lived, but he was so relentlessly ashamed of what he'd done. He said to me, "it's the only way out for me."

The other three guys I interviewed, I don't know if I would have gone along with their getting it or not. One of them, his lawyer said he couldn't talk about his case. I don't really know what he did. They were more like typical stereotypes, one of them had the big hairdo like you

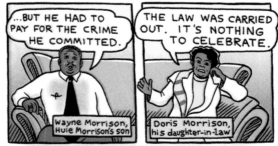

...BUT HE HAD TO PAY FOR THE CRIME HE COMMITTED.

Wayne Morrison, Huie Morrison's son

THE LAW WAS CARRIED OUT. IT'S NOTHING TO CELEBRATE.

Doris Morrison, his daughter-in-law

HUIE MORRISON'S FUNERAL WAS ATTENDED BY NEARLY ONE THOUSAND MOURNERS.

From "Ready to Die" in *Details* (May 1999). [©1999 Kim Deitch]

see so many of them have in the movies, and one guy was this smart, slick guy who swore he didn't do it, and you're looking at him, and I don't know if it's true that he didn't do it, but my guts were saying he did it. He was the one that was kinda getting sinister on me and Pam, and making weird phone calls after the fact. The other thing was, at one point about a year later, I thought, "I'll get on the website and see how those guys are doing," and they were all dead. One of 'em, the really sinister one, I'd read an account of his death, he managed to get DNA tests just before the end, but the DNA tests I think just reinforced that it was probably him, but the other two guys, one of those guys was a lot closer to his own execution than I'd realized. In Virginia, they don't mess around. They got it down to a science. Guys fuck up, they get the death sentence, and they don't last too long. It's kinda sick, I don't know. It's tricky business. The thing is, you can say all this and all of that, but then there's one fact that stands out. You get some slimeball murderer, and you execute him. Well, that's one slimeball who isn't gonna kill anybody any more. So, to that extent, it's a deterrent.

Yeah, that's the best argument. But if you lock them up forever, they're not going to kill anyone either.

People don't get locked up forever that much. There're too many people in jail. It's tricky business. I don't think it's great. I could probably be talked into being against the death penalty, but I'm not quite against the death penalty. You know, when I was talking to one of the aunts of Ronald after the execution, and she was going on about how horrible, this death penalty, it's just awful. I mentioned something about Charles Manson, and I said, "Well, you know that guy should have been executed."

I think that she said, "Oh yeah, he should have been executed, no mistake." So, you know.

There are obvious cases, but the tough call is always the ambiguous cases.

I don't think it should be done as much as it's done, that's for sure.

My second question was, it's got to be incredibly daunting to fly to a different city and try to find a stripper named Melissa. How do you even go about doing that?

Oh man, that thing was so much hard work, it's just like I was on it every day. I went to all the agencies, made different deals to publicize the agency if they would give me access to different strippers.

Stripper agencies?

My best interview is with a guy who runs one of those agencies. I figured, strippers want publicity, their managers want publicity. If you go out to try to find the Melissa that this guy named his virus after, chances are, you'll find more than one, and you'll get an interesting, fun *Roshô-mon*-type effect. And that's exactly what I got. I got more than I even used. He said, "Oh, yeah. That's the one." "I'm the one." That story, since it's about a virus that nobody can remember, on that level it has a very short shelf life. But actually, I thought some of the interviews I got were priceless.

I even use some of those when I talk at shows: the porn star Jasmine St. Claire, who allegedly stripped as Melissa and definitely said she was the one. Her interview about how she felt about the guys who pay her to see her strip was really telling: so telling that, when she told it to me, I looked at her and I said, "You don't mind if I use this stuff?"

She said, "No, no. Go ahead." Which really confused me: You go on Jasmine St. Claire's website, and she's talking about the warm feelings she has for the guys who come to her shows. She's telling me something quite different *[Groth laughs]* to my face, and telling me I can use it.

[Laughs.] Just didn't give a shit.

I don't know what. She was interesting. She was really smart, too: she spoke three languages; she's a business graduate at Columbia University. She was *smart*. But I didn't like her. The only person I really liked in that whole story was this guy Marty Foyer who was a manager of a lot of these chicks, but really was a cool guy and I had a really good time with him. And he really came through with some good material to finish off the story with, which may or may not have been completely true, but it had the ring of truth and it worked in the story.

But you didn't actually expect to find her?

Duh. I didn't care, really. They wanted a puff piece. I think it's better than it could have been, because there's a lot of good human-interest in it. It's not quite anthologize-able, but, like I say, I do use a few pages of it when I do my personal appearances. It seems to work. I do a personal appearance where I do the road to the book *Alias the Cat*. Along the way, I show a little bit of the death-penalty story, and I show a little bit of that Melissa Virus story. Tell a lot of the stories I've been telling you for the last 20 minutes.

Nickelodeon

You and Simon started doing "Southern Fried Fugitives" for *Nickelodeon Magazine* in '94. This was another collaboration, or it started out as a collaboration, between you and Simon. Can you tell me how that started?

The way that went down was, me and Simon were finishing *The Boulevard of Broken Dreams* at the time. Actually, what it really amounted to at that point: *I* was finishing *The Boulevard of Broken Dreams*, because Simon was getting really seriously strung out on dope again. So, at a certain point, Anne Bernstein at Nickelodeon approached me. She said she would pay me a certain amount of money to pitch three stories for a new magazine that Nickelodeon was starting, called *Nickelodeon Magazine*. I came up with a couple of things that I thought were pretty good.

I needed a third one, and I wasn't sure what we were going to do. I was going out with Flo Steinberg at the time and I'd been away for the weekend and I came back, and it was getting to be zero hour to send Nickelodeon a package of ideas; we needed that third one. So, I sat down at my desk and me and Simon are talking it over and, while we're talking, I loaded up some grass in a pipe and I start smoking it. *[Groth laughs]*. And we're talking, and the grass hits my brain.

"What do you got?"

And I said, "Here it is, listen to this," and took another drag, let it out, and I go, "OK. It's Frankenstein's castle. He's got the Frankenstein monster body all tied down. There's a big lightning bolt ready to hit the monster and bring him to life, just as soon as the thunderstorm — which is going on — hits high peak. And he's waiting around for it to happen. It seems to be taking its own sweet time, so he goes out to do something. In the meantime, the lightning starts up, and the big lightning bolt that's going to electrify the Frankenstein monster, *hits* and it goes through, except that he hasn't got it quite aimed at

the body, and instead of hitting the body, it hits his lunch, which is a box of southern fried chicken. *[Groth laughs.]* So the chicken parts are brought to life."

And Simon's going, "What are you talking about? You crazy?"

And I'm going, "No! No! It's great! It's great! We'll call it —" and I took another drag *[inhales deeply]*, held it a second, let it out *[exhales]* — *Southern Fried Fugitives!*

Pretty loopy. Finally I was starting to get Simon on board, but I've got other stuff I got to do — I'm finishing *Boulevard* — and so I said, "Look, why don't you flesh this out, while I work on these pages."

For all of his doped-up decrepitude *[Groth laughs]*, he really got into it. He breathed life into my crackpot idea in a way I don't think I ever could have as well. He gave the pieces all names, like the breast piece was called "Chester" and the wing was called "Wingnut," like that, drew up model sheets of these characters. It was really quite appealing, more than I was expecting. I was thinking that *Southern Fried Fugitives* was just to be this one that was in there to fill up the package and they'd pick one of the other two, but *Nickelodeon* looked at it, and they liked *Southern Fried Fugitives*, and they gave me the green light on it. All of sudden, oh brother, now we got a strip, we gotta do it. So, then I said to Simon, "Look. I got to finish this book that *we're* supposed to be collaborating on here; *you* do the fucking thing." So he started working up the opening episode. I was amazed that it looked as good as it did, because, boy, Simon … he did a good job, but he never does anything in a big hurry: and stoned on heroin … multiply that by some other number. So when I was inking that, a lot of that I was inking on thin air. I don't think we ever made a deadline for the *Fugitives* once while I was doing that strip with Simon. And that's the bad news.

But the strange, bizarre good news is that, those strips had something, and they went over great. I don't think it's that much of a stretch to say that it seemed like it was the hit of the magazine. Kids loved it. They would have canned our asses otherwise, because we never got it in in time, we were holding things up *every* time, which I felt personally mortified about, because I'm Dudley Do-Right when it comes to deadlines. I feel like it's an offense to *myself* to be late with a deadline, never mind the customer. But it was a huge hit.

Simon originally penciled and wrote it, right?

Yeah. We had collaborated together, and usually, it's the way I've described it. But this was this one time it was not like that. OK, I came up with the initial idea, but really,

those are Simon's strips. If there's anybody who deserves the credit for it being the success it was, it's Simon and not me. Except that Simon was an incredible basket case while this was going on, and something had to give, and it eventually did, and Simon got scooped up and sent to Mount Kisco Corrections, which is, interestingly enough, the same place where Ronald Fitzgerald, that executed guy, had done time, before he went to Virginia and got in his big trouble.

Small world.

Yeah. I even think I mentioned that to Ronald when I was interviewing him, that, "Oh yeah, my brother did time there, too." But you know, it's funny, when you were talking to him, he was great to talk to, as long as it was about him; if you got off the subject, he didn't have that much time to be hearing about you. *[Groth laughs.]* He smiled wanly when I mentioned that about Simon.

So you inked Simon?

I inked Simon. In some cases, I inked where there weren't even lines yet, but it's really Simon's baby, and some of those early ones are great. He hadn't hit his stride with #1, but when they reprinted #1 a few months ago, I was really shocked at how nice it looked. It had got nicer than that. To the point where, suddenly, I think the last one Simon turned in, they bounced, because he was in pretty bad condition by then. And then he wasn't there. I don't know if they knew the full details of why Simon wasn't there at that time or not, but I think they had an

A panel from a solo Kim Deitch "Southern Fried Fugitives" that ran in the September 1998 issue of *Nickelodeon Magazine*. [©1998 Viacom International, Inc.]

inkling at the very least. It was problematic. They weren't sure if I was up to continuing it, either. One of the last things Simon told me before he went away, he said, *[imitates Simon]*: "I'll tell you something. You'll never do it. You won't be able to work with them. You go through the old mill of half-a-dozen and more people every time. I just know you, and you couldn't do that."

And I think that's part of why I did it. *[Groth laughs.]* "Oh, I can't, huh?" Although, I think it's fair to say, I kept it going and I must have done three times as many of them as Simon ever did, ultimately. But I can't judge them. Maybe some of them are OK. But I don't think they're as good as the ones Simon did. He really had the flair for that thing.

Did Simon deal with the bureaucracy at Nickelodeon, or did you?

He mostly dealt with it. I remember us both being at some meetings together. In a way, I was fronting it. But I think they knew what was happening. I soon discovered the people at Nick were pretty smart. I grew to like them and enjoyed working with them.

From the April 2001 issue of *Nickelodeon Magazine*. [©2001 Viacom International, Inc.]

Originally, you signed it "Kim and Simon Deitch," and then you started signing it "Deitch Brothers," and then started signing it solo. What did that transition actually mean?

It didn't mean what it seemed to mean, because I was definitely cosigning them after Simon was gone for a good long while, maybe at least a year. I don't know why I was doing that, I just did it. But at certain point, I was starting to get involved in it. It seemed like, "Well, this is absurd."

Simon got out. He didn't come back to doing it. Our relationship had really deteriorated when he went to jail, and I don't think I saw much of Simon for a good long while, even after he got out of jail. Only recently did he discover that I did all these *Fugitives* without him. He knew I did some, but I don't think that he had any idea that I did it for three years by myself.

[Laughs.] Right. Now, Simon was busted for drugs?

Yeah. You talk to him about that. I don't know how much he's comfortable with or not. That's just something you've got to figure out with him. I'll be interested to see what he has to say about that. *[Groth laughs.]* It's part of the story.

Deitch's Pictorama

I want to talk to you about the forthcoming *Pictorama*. How did you and your brothers come together on all this?

What happened was Simon's out of jail, and I'm not seeing much of him, but after a while, he starts drawing again. He starts sending me the art, and I'm liking it. And at a certain point, he starts drawing these pictures for a story that ended up being "The Golem" that really seemed pretty good. My mother was first telling me about it. She was going, "You know, listen, he could probably sell this thing."

And I looked at it and I go, "Yeah, you know, he could go over to DC or I could go over for him and pitch this thing for a real comic book." Then I'm thinking, "Yeaaaah, he could do that … or maybe something else." I swore I'd never work with Simon again.

But the way I decided I'd wiggle out of it was, the other thing that's happening, is that my brother Seth was really coming to the party with fiction writing. It took a little while. For a while, he was heavily influenced by Edgar Rice Burroughs, and wrote Burroughs-inspired novels that really — I don't know — I didn't think they were so hot, but at a certain point, he turned the corner. I even

took an initial jump and illustrated a really good one called "A Face in the Echoes" that was in Chris Ware's third *Ragtime Ephemeralist*.

So, we'd already broken the ice for working together, and it just suddenly hit me: "Well, Jesus, maybe we should try doing a book together. It won't be like I'm working with Simon, because he'll be doing his thing, I'll be doing my thing." And in fact, like with "The Golem": pictures first, the idea was, just run some of Simon's better pencil drawings. He'd started running stuff in *Mineshaft*, and was really a hit with his stuff over there. I broached the subject to Seth, too. Seth seemed to be the most ambivalent about it, not really that keen to get on board. Finally, he gave me a story that I'd already read called "Unlikely Hours," but it was a *good* story, and I thought, OK, I could be with Seth: I could illustrate "Unlikely Hours." I didn't really feel like he was *that* interested. But then Simon was started to go, "Geez. I wonder if I could get Seth to write the storyline for these 'Golem' drawings."

And I thought, "Yeah. That would be great, if they could pull that off, but that's not going to happen. If it did happen, would it be good?"

Well, Seth wrote something, but he wrote a damn novella. That was the immediate bad news to me. OK, look, Jesus Christ. Except that the good news was: I love it! And, I wouldn't cut a word out of it.

Seth actually wound up writing "The Golem" based on Simon's drawings.

Yeah. Simon had a few illustrations: It would have to be filled out with more. But Seth wrote a really superior story. I'll tell you, I was flabbergasted. It seemed like a sign to me. So I went to Kim [Thompson] and said, "Look, Kim, I know this isn't what you agreed to, but Seth wrote a really good story for this 'Golem' thing. It would mean a longer book. What do you think?"

And he said, "Well, OK. Let's see what happens."

Now we're talking about maybe a modest book with a spine. So time marches on. What happened then was, I decided, "'Golem' will be our cover story and our big feature, and I'll do something, and then I'll illustrate a story by Seth. It'll be a nice little book." Then, Simon lets a whole year go by without doing squat on "The Golem." No more new illustrations. In a way, I think he got co-opted by *Mineshaft*, not that it was exactly their fault. But suddenly he had this great outlet for his work. In fact, if I'd known he was going to hit nice with *Mineshaft*, none of this might have happened, because I would have figured, "Well, OK, he's got his nice outlet, let it go at that."

But by this time, I'm committed to something, and I feel like I'm on the verge of really embarrassing myself here. One day I'm sitting in bed with Pam, and start pissing and moaning about all of this, and I thought, "I got to cover my butt here," and so I decided that what I'll do is I'll come up with a second lead feature, just in case Simon completely poops out. That's how I ended up with what ends up being the longest story in the book, "The Sunshine Girl." But I'm glad it happened that way, because I love that story, and in a way it was one of the most satisfying stories I've written so far. But that's how it happened. The book just evolved in that way. So I figured, "OK, this way, if Simon fucks up on 'The Golem,' we're still going to have a book." Then Simon more or less came through on "The Golem," so we got a big book.

I thought "The Golem" is at least as long as "The Sunshine Girl."

The text probably is, although Simon ultimately didn't do as many illustrations as I would have liked, and ultimately, even some of those got cut out, because he had some illustrations that he'd done before Seth wrote the text that no longer worked after Seth wrote the text. They were a little uneven. I don't know what Simon's going to think of the final selection.

Basically, I let Kim [Thompson] and Adam [Grano, *Pictorama*'s graphic designer] have their way with it. I figured I had dumped a bear in their laps with that thing. I'm lucky that they went along with me. I didn't feel like I was in a commanding position with them. What they've got now, I'm not sure how many illos are there. At least 20, I don't know, I haven't counted them. I've been more concerned lately about: Are they going to be dark enough? I pulled Adam and Kim about eight different ways to the point of obnoxiousness, to try to make them stand out, because they're pencil, and that's problematic. But it looks like they did a pretty … I mean, they did wonders with the text. The book looks fine to me, I'm just a *liiittle* worried about if those "Golem" pictures are going to stand out enough. But I might be overreacting.

I think they will. Based on what I've seen.

It's my job to be the troubleshooter here. I wouldn't be doing my job if I wasn't haranguing you about it.

Seth tells me that he had to convince you to illustrate "Unlikely Hours." You weren't keen on it at the beginning.

No, I always meant to do a full illustration job on "Unlikely Hours." It seemed like a good one to experiment on, because I'd read the story at least two years earlier and I thought it was definitely one of Seth's better stories, and

[©2008 Simon Deitch]

the more I read it, the more I liked it. No, I definitely went out of my way to go to town on that one.

The two stories you wrote, "The Sunshine Girl" and "The Cop on the Beat, the Man on the Moon and Me," were complete solo efforts. Why did you choose to do them for this book and this format rather than as comics?

I don't know. "The Cop on the Beat" I always saw as an illustrated text story. I pretty much came up with it for what became known as *Deitch's Pictorama*. The second one, I'd had that plot kicking around for a while in a more lighthearted version that I was pitching as a kids' book. The plot came to me as total inspiration one Sunday morning, but I changed it around and it got this, more Hardy Boys/ Nancy Drew flavor to it. *[Groth laughs.]* That's what had happened. See, I had it kicking around as a kids'-book story called "The Girl in the Moon." And then, when I was sitting in bed that day, pissing and moaning I could be in trouble on this book if I didn't come up with another feature, it just suddenly hit me. It just came to me, while I was talking to Pam. "I got it. I'll take that story, only instead of "The Girl in the Moon," I'll call it "The Sunshine Girl." The Girl in the Moon Miller High Life beer cap, which was what that story was centered around, I'll make it be a bottle cap that I drew for some psychedelic entrepreneur in the late '60s, and one thing led to another.

Also, a lot of juvenile fiction I'd been reading kicked in

on me. Also, just my own childhood: When I was a kid, when I lived in Hastings-on-Hudson where the story takes place, there was this old ship permanently docked about a mile out in the Hudson River that was colloquially known as the *Buccaneer*. It was something that we kids rhapsodized over. I was too little at the time to actually swim out and board the thing, although I'm sure a lot of older kids did. I mean, that sounds like a really improbable part of the story, but that part is completely true. Even the name of the characters, "The Whaleys," when I was a little kid in Hastings-on-Hudson I was friends with these two, a brother and sister who had the last name of Whaley. One of them was named Gar. The other one was a little girl named Meredith. I changed her name to Eleanor. They're not really who those people were.

I was going to say that the whole device of having it told by Eleanor Whaley is pure artifice, I assume.

Yeah. It seemed like it worked. That was another case where, by the time I was getting up into the '70s on that story, I was really sorry it was going to end, because I was loving those characters, and I was loving doing that story, which is how I ended up working on this story I'm working on now, which is basically a first-person reminiscence of Eleanor's aunt, a woman named Kate Whaley, that starts in the WWI era but goes down into the late 1970s.

Where does the bottle-cap-collecting come from? Did you collect bottle caps when you were a kid?

That comes from life, too. When we were kids, me and Simon went through a couple of years where we were huge on bottle-cap collecting, and the Holy Grail cap for us was that special, full-color, Girl in the Moon Miller High Life beer bottle cap. Our big years of bottle-cap collecting were approximately 1955, '56. That Girl in the Moon cap must have stopped being made in the early '50s or something, because we had one that got traded back and forth between us. That was a very elusive bottle-cap, that Girl on the Moon. I have a realistic rendition of it. I think it's on the back cover of *Deitch's Pictorama*. I did a prequel to the story that will be running in *Kramers Ergot*, which will be loaded with full-color bottle-caps both real and imagined.

Opposite: [©2008 Kim Deitch]

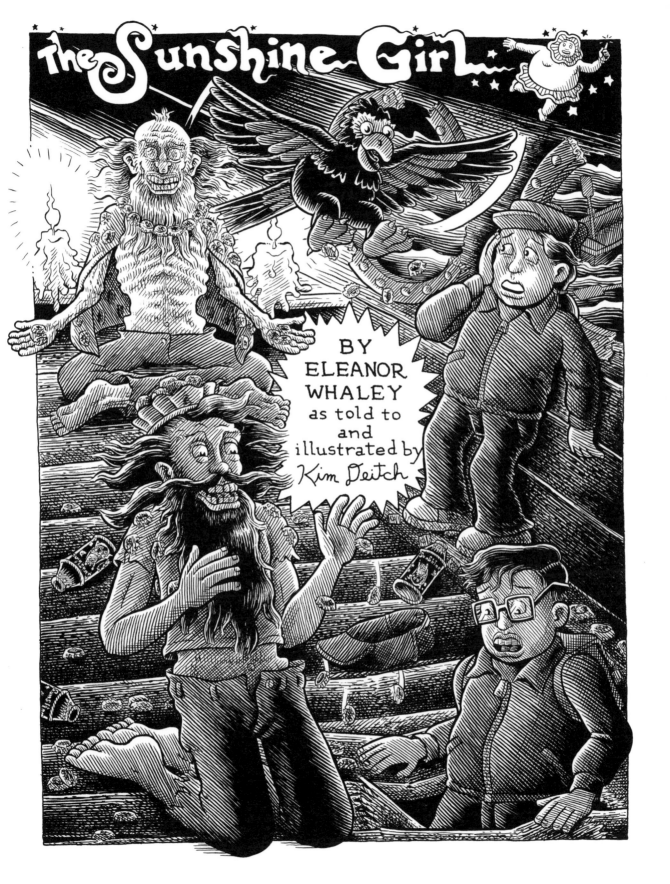

Anyway, this story isn't about old cartoons. It does take place in New York City but a lot later than 1932; 1968 to be exact, at which time I was a young man living on New York's Lower East side.

I was just getting my so-called career as a comic strip artist off the ground working for an underground newspaper called The East Village Other. The hippy era was in full cry,

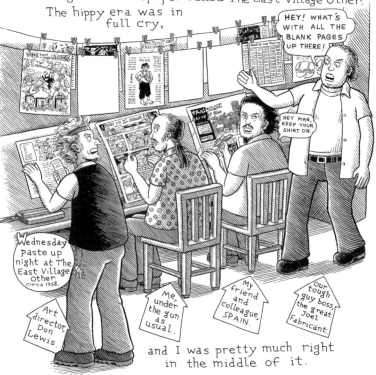

HEY! WHAT'S WITH ALL THE BLANK PAGES UP THERE!

HEY MAN, KEEP YOUR SHIRT ON.

Wednesday paste up night at The East Village Other circa 1968.

Art director, Don Lewis.

Me, under the gun as usual.

My friend and colleague, SPAIN.

Our tough guy boss, the great Joel Fabricant.

and I was pretty much right in the middle of it.

From "The Cop on the Beat, the Man in the Moon, and Me." [©2008 Kim Deitch]

"The Cop on the Beat" story purports to be an autobiographical story, but with you, I never know. So it is truly an autobiographical story?

No, it's a crock. *[Groth laughs.]* But there are parts of it that are true. I did know a rock group called The Group Image, who did big shows downtown, and they had a girl singer who looked something like that girl, whom I might have known vaguely, but it wasn't somebody I had a crush on. So, I used that atmosphere.

The most interesting part that's true is this: My buddy Al Dodge, who I modeled that Charlie character physically after, who played with the Cheap Suit Serenaders and is the leader of Dodge's Sun Dodgers, he's a record-collector buddy. He, with some record producer, put together a CD about — it must have been about 12 years

ago now — a singer named Charlie Palloy. Charlie Palloy was like a dime-store version of Bing Crosby or Russ Columbo, of the big-time crooners. You could tell by the records that he's playing his own guitar, and he's pretty good. But the interesting thing is that nobody knows who Charlie Palloy was. Nobody. It's a while ago, but you'd think ... Probably they'll figure out who he was, eventually. He's pretty good. He's not in the same class as Crosby, nor is he as good as Russ Columbo, but he ain't bad, and he plays really good guitar. If you get a hold of that CD, he did a really sharp version of "Stormy Weather" when "Stormy Weather" was a new song.

The last cut on there is that goofy song, "The Cop on the Beat, the Man on the Moon and Me." I just fell out of my chair when that came on, because I remembered it, from an old *Tom and Jerry* cartoon. Not when I saw it as a kid, but my brother Simon had a resurrected tape of it in the '80s, which looked exactly the way it looks in "The Cop on the Beat" comic strip. I had never heard that song before the cartoon; it wasn't a hit. It's a ditty. It's fun and funny, but it's just not a standard. But it's not bad in its own way, as a ditty, as a novelty tune. I've never heard anyone else's record of it but Charlie Palloy.

Even the name Charlie Palloy is probably made up. I mean, El Dodge speculates in the liner notes that they might be riffing on the term "hoi polloi." It's an interesting mystery, and when he gave me the copy of that CD, way back when, immediately, the seed in my head was planted. That would be interesting, to create a backstory about who was Charlie Palloy. More than 10 years ago, I had it in the back of my head that I'd like to do that, and then when this came along, *Deitch's Pictorama*, I thought, "Maybe this is a good time."

When I wrote the story, it was when I was writing a letter to Everett Rand at *Mineshaft*, for some reason I was hot that morning, and I basically worked out the plot right then and there while I was writing him a letter speculatively of what I might do for a story in this book with my two brothers. But it was good, and I made a Xerox of it, because I knew it was good. And then when the time came to do this thing, I fleshed it out a little more, but it's amazing how much of that story was full-blown right in

that letter I wrote the guy. It was also an interesting time to write a story about some music that maybe a lot of people aren't familiar with.

I mean, everybody's heard of Bing Crosby, but they mostly think, "Oh, he's just some old guy who sang 'White Christmas.'" You know, somebody your parents liked, but in actual fact, he was a pretty hip guy, based his singing style on Louis Armstrong, smoked dope, was basically a hipster of that period. What he became later, that's something else again, but his decline is interesting, because it started with the death of his best friend, Eddie Lang, who was the premier jazz guitarist of his day. And I thought, well, here's a lot of interesting musical history that is worth putting out there for people who never picked up on it before, and this might be an interesting place to do it.

Plus, just other interesting show-business stories, like the spectacular, untimely death of Russ Columbo is a wild yarn, and I always had it in my head, if I could figure out how to use that in a story. Well, suddenly, I got this way to use it. Then I thought, the other thing that would make this story really interesting was: You talk about the big ones, talk about some of the ones who never really made it who were interesting too, leading back to Charlie Palloy. So I threw in the story of this guy, Chick Bullock, who probably could have been a bigger star except he had this weird eye condition which meant that he was fine for radio, but he was never going to be in pictures. Also, what about the blacks? There was this Harlan Latimore, a really great singer who came out of the Don Redmond Band. They called him "The Black Crosby." I think what happened was, at one point, Crosby did a session with Don Redmond. They got a good record out of it, and after that, Redmond was going *[assumes a redneck voice]*: "Shit, man, I want mo' of that Bing Crosby," *[normal voice]* and so he made his own Bing Crosby: Harlan Latimore. The guy was great; the only problem he had was he was just a little bit before his time. It was a Nat King Cole situation about 10 years before the country was willing to accept that kind of a romantic singer being a black person. I'm sure a lot

of people who bought Harlan Latimore's records didn't realize he was black. He made records with Victor Young besides the ones with Don Redmond, his home band. So I figured, here's a lot of folklore about the popular-music business that's pretty interesting, and pretty un-discussed outside of the world of vintage-record collecting. It might make a good story. In fact, I thought that one would be a great one to do as a performance piece. I could even do a little singing in it myself, and I was going to do that.

Another reason why I'm glad I did "The Sunshine Girl" is I think that is a niche story that some people are going to appreciate, and a lot of other people are going to look at and just go, "Uh-huh." *[Groth laughs.]* I'm also covering my butt for myself by doing "The Sunshine Girl" and making a more accessible story. I'm supposed to do a thing for San Diego. I think I'm going to basically do

"I don't want to buy them…ah, never mind, just ring me up for this." I placed a sixteen-ounce bottle of JOLT Cola and a pre-packaged egg-salad sandwich on the counter. He just stared at me.

"Um, don't you want money?"

"You don't want to buy!"

"I want the sandwich and the soda, I just don't want rats."

"Yes, very good! No rats!" He started merrily punching keys on the register. I have no idea what he thought our conversation had been about.

The air was hot, humid and still that night. The dumpsters exuded a rich, cadaver breath flavored putrescence. The smoke from my cigarette hung in the air congealed, as if it feared dissipation, the way a human fears death.

From across the parking lot I heard a tortured yowl. The cat had bolted from beneath Crandall's dumpster

stopping every few feet to claw frantically at its face. As it came beneath one of the Sodium lights, I saw that its

furry mask was blood-streaked from a wounded eye. Beneath the dumpster were a dozen beady gloss-black reflections.

From "Unlikely Hours," written by Seth Kallen Deitch and illustrated by Kim Deitch. [©2008 Seth Kallen Deitch & Kim Deitch]

"The Sunshine Girl," a capsule version of that. I think what I'm going to do is tell the story — exactly what I've been telling informally here — of how *Deitch's Pictorama* came to be, but landing more solidly on demonstrating a good, big hunk of "The Sunshine Girl," and probably doing it with Pam doing all of the female first-person stuff. We tried a tabloid version of that at your store. I'm going to start fooling with that tomorrow.

***Pictorama*'s pretty much wrapped up. What's next on the Deitch agenda?**

I'm working on a new story. I feel like one of the things that started happening in *Pictorama* is, I seem to be reaching for doing a novel. I'd like to keep the illustrated-fiction format going a while longer, although it's becoming more morphed with comics, I want to do a novel. I've got about 112 pages of text so far, and about 70-odd pictures. I don't have a title yet, but it's a goofy story.

It's getting back into the Jesus Christ thing, and it's a story that has something to do with Jesus Christ, but it's not really a religious story, it's really dealing with Christianity more from the point of view of people who are known as Deists. During the 18th century in France, people like Voltaire and others in this country, Jefferson, got very involved in who was Jesus Christ, but they weren't necessarily religious. They started approaching it more from the point of view of ethical culture, if you will. Like Jefferson, for instance, decided to make his own bible. You can still get that now, it's called *The Jefferson Bible*, where he basically cut everything that was supernatural out of the four gospels, and then repieced it together as a story.

So, philosophically, that's the underpinning of this goofy story I wrote, which has to do with a new gospel of Jesus Christ being found, but the gimmick about this new gospel is, it's recorded sound like 2000 years before Edison came up with the talking machine, because really, in the original phonograph, there was no electricity involved. Somebody could have stumbled on how to record sound any time since the Greeks. It's weird that it didn't happen. Basically, what happens is, I've got a story where an Arab peddler is in the temple when Christ is throwing all the peddlers out of the temple, moneychangers. He's got this glazing process where he's making sacrificial urns to hold the ashes of sacrificial animals, and he's scoring etched lines on the outer sides of these things, by dripping acid through a horn, which looks suspiciously like the sort of horn that people used to shout in when they made acoustical records, and he accidentally records Christ's tirade when he's throwing the moneychangers out

of the temple.

After realizing what he's done later, he follows Jesus around with the other disciples and records a few more of these things, so part of the story is the quest for these strange records that were made of Jesus. So, you've basically got this lost gospel of Christ that's coming out of his own mouth. They're these weird acoustical records of Jesus. There's nothing particularly supernatural about it, this is all from a Deist's perspective, but all of his ethical talk about how we should live is there.

This is a story about a guy who has stumbled onto this secret, and all of the ramifications that go into that, and this weird, almost-romance that develops between him and Eleanor Whaley's great aunt. The story picks up at the end of "The Sunshine Girl," where we mentioned that Ellie has a husband that is serving with our soldiers in Iraq. Well, at the beginning of this story, this guy's been killed, and she's inherited this land in upstate New York from her great aunt. So she comes across this manuscript that this great aunt has left to her, because Eleanor and Sid, the two protagonists of "The Sunshine Girl," once visited her, circa 1978, when they're under 10 years old. This story spirals out of this book-length memoir, so again, I'm doing a story, first-person-singular, of a woman telling her story.

I think it's working. I don't know if it's something the public at large would find to be a raving success or not. Again, I'm getting into the world of silent-movie serials. Part of the thing that goes on in this story is the guy who found these etched urns with the voice of Jesus recorded on the sides of them wants to make a movie that will tell the world about this, but he wants to make it into an accessible form that people will get into, so he wants to make an exciting serial that tells everybody about it. But he goes one better than just making a serial, he wants to do a serial where the protagonist appears nude in the serial. If that sounds a little preposterous, well, I'm going to explore another facet of early-movie history that isn't that well known, which is: Nudity was taken fairly casually up to a certain point. There are a lot of movies in the teens that have nudity in them.

All the pre-Code stuff, right.

Yeah, but the real, pre-pre-Code stuff: the most fascinating one that's come to light recently is this one made by this woman director named Lois Weber called *Hypocrites* where basically, this totally naked woman, known as "The Naked Truth," is walking around buck-naked exposing the hypocrisy of various social situations. It's incredible. It's really a neat movie.

In a hidden nook of the great temple, FAZIL-Ah-RAHEEM, an exiled Arab artisan, is a witness to Christ's famed tirade against the money changers! While he continues to etch a surface of scored lines upon an urn for ashes of burnt offerings! Scored lines that Raheem is soon to discover exactly echo every nuance, in all of its vibrant fury, of the master's voice!

The Great Plot Weenie!

From Kim Deitch's work in progress. [©2008 Kim Deitch]

But there are others. There was Audrey Munson, who was a famous artists' model at the time, she made about three movies. Since she was an artist's model who posed nude, she's nude in all of her movies. I don't know if they're quite on the same high, moral level as the stuff that Lois Weber made, but … after a while, these nudie movies got cheesier and cheesier, and they cracked down. And that's what happens in my story, they make this serial and they've got a certain amount of nudity in it, but it never gets released. So those are some aspects of the story. There's a lot more to it than that.

I'm getting into the New York scene of the teens lately. I'm even going to get into the New York avant-garde scene of the teens a little bit. It's sad; things were really cooking in the teens, and then fucking WWI came along and set everything back.

Derailed things, yes.

Yeah. Movies and art, all over the place: people's lives.

I may stop and do some other stuff before finishing

that. I'm starting to think that, if *Deitch's Pictorama* has any legs at all, I might stop and do another issue of *Deitch's Pictorama*. Simon's got a story that I'm pretty strong for, that I might do the final art and have it inked this time on that.

I got an idea for a story I'm kicking around that would be like "The Cop on the Beat" except it would be a true story about this interesting singer that used to come over to my parents' house when I was a kid who was kind of a precursor to singers like Joni Mitchell and Sinead O'Connor. It's wasn't folk music. It wasn't jazz. It was fascinating songs she wrote herself. She completely disappeared at a certain point. She left a few notes around saying, "Please don't try to find me." And no one's seen her since. She never really made it. She was on national TV one time, which is a lost broadcast, except somebody took pictures of the screen. Just last week, my father was showing me the pictures of her and Walter Cronkite, who was the guy interviewing her on her one shot at fame.

I'm going to go pick up this old home recording my

Photograph of Kim Deitch by Seth Kushner.

father made of her that now is being set up for being reissued. If you saw, or downloaded, that show *Spinning on Air* that me and my father were on, the very last record he plays on that show is one of the cuts by this woman. I got to go see about several things to see whether or not I do this story. One is, first of all, the people who are promoting this, would they welcome me doing such a story? Second of all, when I listen to these songs again, will the lyrics of the song evoke enough to inspire the story? It's just a hunch, I'm not even mentioning this person's name right now.

Pictorama is a strange animal. I'm anxious to see what kind of reaction it gets.

Yeah, that's the thing. It could bomb. I'm thinking right now, I'm going to keep going on my novel, but see if I can come out with a much smaller *Pictorama*, call it like *Deitch's Pictorama Supplement* #1. *[Groth laughs.]* Have a spine but not be as fat or as long.

Yeah, this has got to be a couple hundred pages.

It is. It's a couple of hundred pages. Maybe we could do a *Pictorama* that's 90 pages with a spine, so we can get book distribution with it.

Well, the world is your oyster, I think.

I hope so. *[Groth laughs.]* Look, Gary, there's a lot more I'd like to do. I've got to the point where it's actually fun for me to do this. It's what I like to do. Naturally, I'd like to keep on doing it for a while. The medium of comics seems to be evolving and I too am evolving. Maybe people will appreciate this and maybe they won't, but I can't help that. Even if they don't take to it, I'm going to do this novel, even if I have to Xerox it and sell it on street-corners myself when I'm done.

You're hitting your creative peak when the medium is flourishing.

Well, I hope so. We're about to go into a recession here, but hey, on the other hand, listen, I've been through these before, and I tend to do my best work when they happen,

because I just get my back up about it. With me, I'm going to do the stories I want to do. That's my bottom line; if they can be successful too, great. But, the main thing with me is, I want to do the stories I want to do. I want to do them my way. The great covenant of doing comics as opposed to trying to make it in the movies or some other medium, is that, if you can afford some rent and a few art supplies, and if you're willing to throw a lot of hard work behind it, these things are essentially doable. You might have to tighten the belt: you might have to do this or that to bring the money in. I did "Smilin' Ed" by doing *Southern Fried Fugitives* for three years for *Nickelodeon* magazine. I'm starting to drift into doing more and more teaching. Maybe I'll end up doing more of that if times get tough, to get the story I'm doing now done. If I'm sounding downbeat, I always try to look at the worst-case scenario. And if things are better, great, but I think you should plan things out for the worst possible situation, so that you've got a good, solid plan that's going to get you through if things get tough. Look at the '30s: All kinds of great shit happened in the '30s and that was a tough, tough time.

Sometimes it can even be a catalyst …

Oh, for sure. I remember when underground comics went bust. A lot of people scrambled away, but those of us that were left, those tough years after '72 to '80, that was hard, hard times. But a lot of great work was done in that period.

[Laughs.] Made you stronger.

It did. You have to be tested. It's just part of the game.

I have to tell you, you have lived a life, my man.

I feel I have had a good life. I'm enjoying being alive, I'm a happy person. You know, I piss and moan with the best of them and the worst of them, but I feel pretty fulfilled, I've had a marvelous time.

You didn't just sit in a room and draw, you were all over the godamn place.

Yeah, that was useful. That's the thing: busting up with Sally forced me to grow up. But it also flushed me out of Berkeley and out into the world, and that was ultimately a good thing.

It makes for a great interview, so I'm glad you did it.

Good. *[Laughs.]* Wanna keep the continuity good.

[Laughs] Right, right. I'm interviewing your dad again Tuesday. I mean, I'm just up to my eyeballs in Deitches.

Oh, good, I'm glad you're weighing in there again. I mean that's the one thing I wanna be careful with. I was thinking about it after we talked last time and, basically what I'm doing is: It's a thin line, but basically let the chips fall, but I don't wanna trash anybody either.

Your dad was funny, because he was telling me he didn't think you drew that well early on but he absolutely loves your work and your storytelling today and he obviously admires your work and is very proud of you.

That makes me feel good, too, 'cause it wasn't always that way. The funny part about my old man is that I needed to get away from him to become my own person. And I did and that was a good thing, but now we're friends again. So that's good.

Look, I was extremely lucky to have gotten born into that particular situation. That was like pure gold, going out the gates. I honestly feel that in a way that I've had one of the luckiest, most fortunate lives that anybody could possibly have. The fact that I haven't been wildly successful has kept me more on my toes and made me strive harder. In a way, it's almost cosmic how well — knocking on wood here — things have worked out in terms of feeling rather fulfilled about it all. Living with him I learned a lot of things about what not to do and what I wasn't looking for. So that played into it. And meeting Crumb when I did, he reinforced everything along those lines with his stellar example.

Yeah, the guy's a fucking monument to integrity.

So in a way it's incredible how all these things dovetailed together the way they did. You know this sounds flaky, but sometimes I feel like there's a guardian angel watching over me. *[Groth laughs.]* It makes me wonder. It does make me wonder.

I think you may be right. I think there is a guardian angel looking over you.

Yeah, well, it seems like it to me. I really have this strong feeling of destiny about all of this. You know? And I'm not one of these people who thinks that life is just some kind of random mistake. I mean, I don't know what the meaning of life is, but I'm strongly convinced there is a meaning. You may not know what it is in this lifetime, but there's something going on. I'm not even trying to sell anybody on it, I'm just sorta telling you what my impressions are. 'Cause I don't really know.

Well, who the hell does? ∎

GARY GROTH:
Now, I'm not sure if you were born in '46 or '47.

SIMON DEITCH:
'47. 5/12/'47.

So that would make you —
Sixty-one this month.

And that would make you three years younger than Kim?
Right. And 10 years older than my other brother.

I understand that your relationship with Kim was pretty contentious from the beginning.
Yeah, when we were kids, we had problems. Kim didn't like me too much; he was the only kid for three years, and then I came along, stepping on his toes. What I always tell is, he would set me up, like if we were at a drug store, I'm looking for a comic book, something like *Captain Marvel, Superman* or something, and he sees *Frankenstein*. Kim says, "Ohhh, *Frankenstein,* why don't you get that? Dad likes that." Of course, I got in big trouble for bringing home a horror comic. My father tore it to pieces, and my brother was just in the background, [going], "Heh, heh, heh."

[Laughs.] I didn't know that about Kim.
Well, when we were younger, he was real vindictive and shit. But I liked him. He was my brother; I looked up to him.

But I assume you would say he changed over the years?
Yeah, yeah. Actually, in a lot of ways, we're just about best friends. I don't know how to put it, but we can have really good conversations. We know each other better than we know anybody else.

What was it like having a father who was an animator and a cartoonist? How did that affect you?
Actually, that was great. I must've picked it up a lot from him, I guess, because I became interested in drawing at a really early age. When he had his comic strip, I'd hang around his desk and watch him draw those things. I even gave him ideas. I came up with names of characters. He was always listening to us kids because he was trying to do a comic strip that was about kids.

Opposite: [©2005 Simon Deitch]

Kim and Simon Deitch in Hastings-on-Hudson in 1955: photo provided by Gene Deitch.

***Terr'ble Thompson,* right?**
Well, *Terr'ble Thompson*, and then when he went to Terrytoons [and created] *Tom Terrific*, which was pretty much the same thing, reformed.

How did you develop your interest in drawing, and how young were you?
Gosh, I was pretty young. I was interested in dinosaurs, and I started wanting to draw pictures of dinosaurs. My father would definitely point out things to me, showed me how to put the muscle structure in to make it look better and more real, so, it shouldn't have legs that looked like logs, and [things] like that. I really picked up a lot from him. I was always watching him and his cartoon characters and stuff. I'd always draw pictures of them the way he did it.

Did he take you into the animation studios that he worked at?
He sure did; that was always really great. I remember Terrytoons in particular was really fascinating. They had a vault room that had like every comic book ever printed, supposedly. But they probably had just a lot of Timelys and stuff since they were the first ones to do a Terrytoons comic. He gave us some 3-D comics when they first came out; of course, the first 3-D comic ever was *Mighty Mouse*. There was a lot of fascinating stuff; you go dig around the Terrytoons studio, and they let us take home cels and all kinds of great collectibles that are, of course, long gone.

I understand you bought comics, but that your parents

didn't approve of many of the comics you dragged home.

Yeah, well, the answer to that was like that story about the *Frankenstein* comic. The thing is, ECs for instance, were coming out, but the only EC, my mother begrudgingly approved was *Mad*, Kurtzman, stuff like that. But then I'd see *Tales from the Crypt* with all this great Jack Davis art and this and that, and it struck me as pretty much the same kind of thing, only a little different, but no, there was a *big* difference. I was not allowed to have anything like that. There was a tree house in the neighborhood where most of the kids from various families kept things like horror comics, and we'd go up in the tree house and read the horror comics. I'd definitely end up with nightmares.

They had that great forbidden-fruit quality.

Yeah, absolutely. My mother didn't really approve of even *Plastic Man*, because around that time, even they were getting into the kind of horror subject matter, only by Jack Cole — it was really weird, you know. And she said, "What are you reading these things for?"

Where do you think that attitude came from? Was it a devotion to higher art, or was it a middle-class attitude toward vulgarity, or what?

Well, I didn't really know what was going on at the time, but of course all of that Wertham stuff was going on, and I'm sure that had something to do with it. There were all these articles about terrible comic books and juvenile delinquency and all that crap. In fact, I even remember watching some of the hearings on television. Of course, my mother was watching that. It was mostly my mother. My mother encouraged my father to get in on it, too: "Gene, don't let them read this stuff." He'd get in on it from an art aspect. He'd go, "This is the lowest form of cartoon art there is, the bottom rung. People who draw these …" Etc., etc.

Especially someone like Basil Wolverton.

Well, that's strange. My dad, once he saw *Mad*, he went down to EC and met Harvey Kurtzman and got a whole pile of every issue printed and came home and gave them to Kim. But I looked at all of them. Wolverton was in *Mad*, and I guess my dad had a lot of respect for Kurtzman — interested in it, but I mean, not in the way that Kim and his friend Tony Eastman were, where they were actually making cartoons.

Were you involved in that at all?

Not really. I got involved in the monster movie we

Simon Deitch's back cover for *Get Stupid* #13. [©1984 Simon Deitch]

all made.

Dial M for Monster?

It was about two kids who find a mummy case, and then one thing leads to another, and I was one of the two kids who found the mummy case. I had a lot of fun making that: all kinds of stop-motion and all kinds of mask-making and make-up. We did everything that you could do in a monster movie.

Was there a point at which your interest in drawing became an obsession and you really wanted to devote yourself to it?

I suppose. You know, the thing is, almost everything that I was interested in had an art aspect to it. Like around, let's say, 1960, I was 13 [and] was interested in horror paperbacks and old *Weird Tales*, pulp magazines, and then of course I got interested in the various artists. There was a guy named Matt Fox who did the covers on *Weird Tales* in the late '40s, and I got obsessed with

him, and I started drawing like that, and then I discovered fanzines, and got a hold of a fanzine editor (George Zebrowski, later a science-fiction author) who put out a thing called *Epilogue*. It had like weird little illustrations in it, but they weren't very good. I knew I could do better ones. I'd been reading all the Arkham House books with various great cover artists, so I was interested in this stuff, and I got interested in weird drawings, so I guess I was the first one of us Deitch boys who got published — in a fanzine called *Epilogue*, and that was somewhere in the early '60s, '62 or something like that.

Your father said you were a difficult kid, a real hell-raiser, referred to you as a juvenile delinquent. And he said you gravitated toward the worst kind of people who got you deeper into trouble.

I know what he's saying. I don't exactly see it that way. Of course, I did get involved with guys who were sort of crazy, but I was sort of crazy, so I just gravitated toward people like that.

Minor league juvenile delinquency.

Yeah, right. I wasn't public enemy No. 1 or anything. *[Groth laughs.]* I was difficult, yeah. I'd steal money and stuff, but not a million dollars or anything, just money to go out to get some candy bars and comic books and stuff like that.

But more so than Kim would do.

Definitely. Kim was more straight-laced than me. He'd get involved with people who drew stuff and painted and whatnot.

Your dad left in 1960. What kind of an impact did that have on your life?

That was a rough thing. I outright told them that they didn't have permission to do that: "You're not allowed to do that."

I think your mother agreed with you.

Well, she told me there wasn't anything she could do about it. But I was pretty young, and I guess I was messing around. When they broke up, I guess I was around 11 years old.

Well, you would've been 13 in 1960. That's when he left for Prague.

All right, but it was shaken up before then. I can remember being a bit young, maybe 12, but for some reason, 11 sticks in my head as when the problems started.

And that hit you pretty hard.

Yeah, yeah. It did. My dad was the artist, he was the cartoonist, it was great having him around. He was very interesting; he was interested in all kinds of things. He was interested in monster movies, Universal stuff, *Frankenstein*, *King Kong*, stuff like that. He taught me about what stop-motion animation was after we saw *King Kong*; it was re-released in '54. And it was just great having him around; he was real interesting. And when they broke up, I couldn't understand it. It seemed like we were the greatest family in the world.

Did your dad sit down and explain to you what was going on as best he could?

Ehh, you know, if he did, I probably was ignoring him. I was just looking at my feet or something. He might've — if he says he did, he probably did. But I don't really remember him doing that.

I understand you dropped out of high school. Is that true?

Oh, you're getting up into '63, '64, and there were a lot of drugs around, and I got involved in that. You know, I just didn't have time for that. I dropped out of high school, and I moved to Greenwich Village.

Didn't you drop out after your junior year in high school?

Yeah, that's what it was. I was doing my junior year for a second time. I got left back and that was a real drag. It's just like they always say: Your friends move on a grade, and you're in grades with the younger guys, and they're all looking at you like, "Jesus, who's this?" A year's difference can be monumental when you're a kid. But anyway, it became very difficult for me, and I thought, "To hell with this."

Why were you left behind one year?

Because I wasn't doing anything; the only subjects I was paying attention to were art and science. It's funny about math: That was my absolute worst subject, but now, I have a real interest in math. I'm not bad at math at all. *[Laughs.]* All the things I was bad at in school, I've since picked up on my own: you know, history, and all this stuff.

It sounds like you were not good in an academic setting.

I wasn't too much. I guess I had some kind of a superior attitude or something. I just thought everything that I was doing myself was more interesting than what was

going on in school.

You dropped out and moved to Greenwich Village? About what year would that be?

Seventeen, I think I even had just become 18. And it was wild. We had a little rock group, so all of the people who were in this group moved down to the Village and we were going to try and get into something. But of course, all we were really doing was going down and taking lots of drugs. We tried out for a few things. We even cut a record, but it was all for naught.

What instrument did you play?

I was just playing blues harmonica.

And was this a rock band?

It was more or less a rock band, but it was like the rock bands that were coming out around that time, like the Rolling Stones. We were definitely into the Checker and Chess records and Muddy Waters and Bo Diddly and Howling Wolf, all that kind of stuff. We were doing somewhat rock versions of those kinds of things.

Kim told me that after you dropped out of high school and started living in the Village, he was in upstate New York working at the nuthouse. And he says that he would come down and you guys would hang out with pre-hippies around Washington Square Park.

Kim came down one day and just said that he was ready. He'd heard all about LSD; of course, I'd been taking that sort of thing for some time. But he was ready; I turned him on to that. And I remember, I couldn't find any LSD at the time, but I found some pharmaceutical mescaline, which was even better *[Groth laughs]*, and we just absolutely went to Mars on that stuff. And that was Kim's first trip. It had an immediate effect on his painting. He'd been doing painting, but now everything had a real psychedelic edge. If you ever look at his early comics, how there's all these little circles and little design motifs going around everything? Well, his paintings were like that at first, before he'd ever even thought about doing a comic strip. The first thing he was doing was these kind of weird, psychedelic paintings. Some of them still exist somewhere, and they're real interesting.

Kim told me it was that mescaline trip that reconciled you guys.

Yeah, I think so, pretty much. I remember him coming down to the Village previous to that time and just saying, "Man, come on, you gotta get your shit together.

What are you doing? Get back out." And I had various friends coming down, trying to drag me out of the Village. Everybody had it in their head that, "Oh, my God, he's gonna kill himself down there." Eh, maybe they were right, I don't know, but it was just something I was going through. I had a girlfriend down there, and it was all working out.

Now, you were still reading comics and still obsessed with comics?

Yeah, even Kim says that I stuck with comics longer than he did. He'd kind of given them up, but I discovered Marvel when it first came out, and before Marvel, I was reading all those cool monster books, Kirby and Ditko. I was reading the Charlton books, anything with Steve Ditko or Jack Kirby, before Marvel, I was really into. All of a sudden, they started doing these hero books, and I really liked *Spiderman* and *Fantastic Four* and stuff like that. They were really good comics at first. And before that, there was an interesting period in DC after they sued the Fawcett books out of existence. All the Fawcett guys came over — except for C.C. Beck — but all the writers like Otto Binder went over to DC. You started seeing these stories like *Jimmy Olsen* comics and *Lois Lane* comics. They might as well have been Captain Marvel stories; They had that flavor.

Did you want to draw these kinds of comics at some point?

I don't know about that.

I mean, you were an artist, and you were obsessed with comics.

Yeah, I know. You know, back in about '59, when the last Simon-and-Kirby thing, *The Fly* and *The Double Life of Private Strong*, those really impressed me. They were like Marvel before Marvel. I thought they had a really nice, strange feel to them. I remember drawing all kinds of illustrations, not copied straight, but stuff like that. Strange, strange stuff. And then, pretty soon after that, I started discovering Steve Ditko and like that. And yeah, I'd draw that kind of stuff, but, I didn't really feel like I wanted to become a comic-book artist, a superhero-comic-book artist or anything, *per se*. I liked the strange comics. The horror comics were run out of existence, but there were still weird comics, and there were guys like Ditko, like Kirby, who could do these kinds of books and do them within the structure of the Comics Code.

Not quite as grizzly, right?

From "Who's There?" in *The Many Ghosts of Dr. Graves* #38, June 1971, written by Joe Gill and drawn by Steve Ditko. [©1999 Steve Ditko]

Yeah, not quite as grizzly, but they had this weird style that gave them that same kind of forbidden-fruit quality.

Especially Ditko, yeah.

Oh, yeah, gosh, back in the early days when he's doing those kind of books, some of the inking he did, you know, really great stuff. It's a shame what happened with him, you know, when he had that disagreement with Stan Lee and left Spiderman. He was never the same. I mean, he did some nice things after that through Warren, those wash things he did for Warren; some of those were very nice.

Those were gorgeous.

But basically, any time he'd try to start up a new superhero or something, like for DC, you could tell his heart was not in it. And the further time went on, the less detail he was putting into anything.

Around '65, '66 you were in the Village. How were you making money and surviving there?

Well, various ways: I was a manager of this coffee-house sort of place for a little while, me and another guy, but some gangsters came in and got rid of us. *[Groth laughs.]*

It seems like you were always peripherally involved in the underground scene, and I'd like to nail that down a little bit more. Kim started working with *East Village*

***Other.* What was your involvement with that?**

He started doing this comic strip; there was one other guy before him, Bill Beckman, doing this thing called *Captain High*?

Which was not very good.

Yeah, right. But anyway, it showed Kim that there might be a market for something, so he started doing things. I don't think the first thing he did was *Sunshine Girl*, but things like that, you know? And it became *Sunshine Girl* really fast. And I took an interest in what he was doing. And he's smoking pot, and so was I. At first it just started with me making a suggestion here and there, and then we just did a few that were absolute collaborations, and they were signed *Deitch Brothers, Inc.*, that sort of thing. So from that point on, anytime I saw him working on a strip, whether it was an absolute collaboration or not, I always gave him some suggestions, or you know, I'd do him a little sketch, like, "Why don't you do this? Why don't you do that?" He liked what I had to say. He always thought I had a good sense of these kinds of things. But what happened then, you know, suddenly, it looked like things were happening in San Francisco, so he and Trina went out there to check on what was going on, and when he did, I just showed up on paste-up night with a piece of Bristol Board under my arm and a bunch of felt tips and whatnot. Joel Fabricant, who was the editor — great guy — he just said, "Hey, are you gonna have a strip? Are you gonna have a strip ready?"

And I said, "Absolutely." So I did my first solo strip right then and there. And then Kim was gone for a few weeks, so I guess I was working on the third one when he came back. So it was like two and a half weeks. But then, after that, it was just like, well, I'll do one, you do one, you know, and they were perfectly willing to pay me to do my own. And so I kept doing them. And again, I'm lazier than Kim — I probably didn't do one every week or anything, but like when *Gothic Blimp Works,* the comic paper they put out started, I did a couple things for that. Right around that point, I guess Kim up and went to San Francisco. I, of course, was having my problems with the drug culture. I had an outright heroin habit, you know. Finally, I knew I had to get the hell out of the town. If I didn't, I was going to destroy myself. So, I found a way to get out of town entirely cheap. I borrowed someone's ID card from New York University and got a student-rate ticket to San Francisco, and I just went out there; I showed up. And when I showed up on Kim's doorstep, of course he was terrified, you know.

Opposite: Simon Deitch flew solo on this strip for *Gothic Blimp Works* #2. [©1969 Simon Deitch]

[Laughs.] He wasn't thrilled to see you?

Not exactly. It actually worked out well. He took me down to Gary Arlington's, the San Francisco Comic Book Company, which was really one of the very first comic stores. I hear it said that it is the first one. I don't know if it's true or not, but it was certainly a very early one. And Gary let me live in the store, I got very much involved in the goings-on in the San Francisco Comic Book Company. You know, another guy who was down there was Rory Hayes. He also worked there.

Let me skip back just for a second and ask you a couple of questions about New York before we leave there. Enlighten me a little about the drug culture in Greenwich Village circa 1969. Was heroin so cheap you could become addicted to it?

If you wanted to go up to Harlem, you could get it for $2 a bag, and if you just bought it downtown, it was double that, $4 a bag, but still not very expensive. But it got expensive. If you started getting yourself a real habit, you're doing 10, 12 bags a day. In 1969 money, that could be a lot of money.

I see. So you were a low-level addict.

Yeah, right, you know, right.

Tell me a little about Joel Fabricant. What's your take on him? I have Kim's.

Well, Jesus. He was really something. He had his own attitude. I remember, though, a great quote from him was, "Never trust a nigger."

Was he serious?

Oh, definitely, yeah. Yeah, it had something to do with this guy Miccleunis who worked down there, one of the sub-editors, you know, getting ripped off big time by some black guy. "I told you, Miccleunis, never trust a nigger!" It was like that. He was like a gangster or something, you know? But he was a good guy.

Tell me how he was a good guy.

Well, if you needed something, he would see that you got it. If you didn't work that week, but you were busted, he'd throw me some money or something. I liked that. He definitely was like a father figure for all the crazy hippies who were working in the paper.

Did he ever haul you out of the offices by the scruff of your neck and throw you out?

Well, yeah, I guess that happened at one point.

But then he actually gave you some dough, too?

That was near the end. What happened was, things were getting pretty bad, and I knew it. And I got busted on, what was it, Dec. 31, 1969, and by the time I was booked, it was Jan. 1, 1970, and I remember, this cop literally beat the living shit out of me. You know, it was crazy. It was like assault. It was really nutso, tactical patrol cop. And I had to sit in the Tombs for 10 days or so — I guess it was actually 15 days — and then my case came up, and when I showed up, the cop didn't show up, so the judge said, "All right, we're going to reschedule this. In the meantime, you're released on your own recognizance." I got my shit together and got the hell out of New York.

What were you busted for? Drugs?

Yeah, possession. Heroin.

I understand, the Tombs is not a place you want to be.

No, it's not. I actually did OK there. You know, all this stuff about getting raped and all that shit in jail, I mean, if you're some kind of attractive, young thing, that's another thing, but if you're either a slimy-looking hippie type like I was or when you get older too, nobody wants to mess with you. It's like any other kind of sex. You gotta be somehow sexually attractive to the guy.

But you were young, you were probably sexually attractive.

Well, I don't know. I didn't see it that way. I don't think they saw it that way. *[Groth laughs.]* I mean, you gotta realize, these guys didn't like hippies, you know? These kind of guys, like big black guys, it wasn't their cup of tea. They thought we were fucking crazy. They pretty much stayed away from me. But actually, I got fairly friendly with some of the guys in there.

Who else did you get friendly with in terms of underground cartoonists in New York? Did you meet up with Crumb?

Yeah, I met Crumb in New York, and I met Art Spiegelman, and gosh, people would come through, like Jay Lynch. I got to where they all knew who I was, and I knew them. They all knew that I was Kim's troublesome brother.

Did you get to know any of them reasonably well?

Well, yeah. I mean, gosh — Roger Brand and all, we were good friends. Most of them liked me. I guess I was likeable in a certain way, so I really had no trouble. I usually got off with people well from the start. I can't say that there were any underground cartoonists who disliked me. It was nothing like that.

Although, I understand Spain might've beaten on you a little bit.

That was years later.

Oh, really? [Laughs.]

We were living together. When you live with people, you know … That was sometime in the early '70s.

In San Francisco.

Yeah, where I was just talking to Spain about, "Boy, it was a good thing I got out of New York when I did. I was just ripping off everybody," and I just made the mistake of saying to him, "I probably would've ripped you off, too, given the chance."

[©2004 Simon Deitch]

Uh-oh.

And right then he slammed into me and said, "You would *never* have done that!" I don't know; it was a crazy situation. I pissed him off. See, I have this cocksure thing that can, especially when I was younger, piss people off.

Seth used the same word to describe himself.

Maybe that's a Deitch trait.

Well, now, you moved to San Francisco, and from what you just said, you moved into Gary Arlington's store?

I did that. I lived there for a while.

Did you actually work there as well?

Yeah. I worked there and got involved with the publishing aspect, too. I helped him with that kind of stuff. I mean, it was a whole comic universe there. Right away, it was like the first few days I was in town, I was working on something for *Bogeyman* #3, you know, for Rory.

Tell me what he was like.

Well, Rory, he's a strange little guy. He'd always walk around, and he had this suede coat, a long suede jacket, and he had white socks and penny loafers, and he was real straight-looking and kind of strange. His eyes were a little off-kilter. He always looked like one of his eyes was looking off in some far direction. He was probably crazy also. We all were. He had this thing about the teddy bears: Him and his brothers had been doing storybooks initially about these toys they had when they were kids. There was teddy bears and there was an old lady rag doll named Granny, I think they named her Granny Crackbaggy. They did all these stories about them, and then they did 8-millimeter movies using the actual rag dolls. But then Rory, who was also interested in E.C. Comics, came up with this crazy thing of doing a horror comic starring teddy bears, which was *Bogeyman* #1, in that strange, primitive style of his.

You say you worked on *Bogeyman*. What did you do?

I remember, I did one about drugs. I did one about a mass murderer. I was into these weird comics and shit, you know? And in California at that time, the Charles Manson trial was kicking up, so the newspapers were like some kind of crime comics, you know — it wasn't like real news. It was like the *San Francisco Chronicle* turned into the *Enquirer* or something. They had all these stories about devil cults and this and that.

Not good PR for hippies.

No, it wasn't. I came up with the idea to do *Thrilling*

In a small backwoods village called **SAGORTHEM**, there exists, in a deep underground cave, a horrible **C**ult of **D**evil **W**orshipers. **O**nce a year, on a certain night when the moon is full, **F**orbidden rites are performed and a monstrous **D**emon from **H**ell itself is borne among us!

OPER FOZ

THE NEW NICKEL LIBRARY

R. HAYES THIS IS NUMBER 18 IN A SERIES OF 200 COLLECT EM ALL! SIMON DEITCH

This is signed Rory Hayes and Simon Deitch: courtesy of Simon Deitch.

Murder Comics.

You edited that comic, right?

Yeah, right, I edited it. I should've had a story in it, but me and Gary got into a terrible car accident, and I was in traction, so I had Bill Griffith do the story I should've done. I did the front cover and the back cover, and I put it together, and I came up with a gimmick: Blood-o-rama. Anytime that somebody got cut, it had the red color, so it had this special effect.

And apparently you got your younger brother in a lot of trouble by sending a copy to him.

Yeah, apparently, I did. Well, I was proud of it. I guess. I sent him a copy, and my mother sent it back. She apparently got it before he did, and she opened it and looked at it, and said, "I don't want you sending him these terrible books." This was right back to the '50s with horror comics. "Bad enough that you were doing these things —"

Did you feel socially comfortable in the underground-comics scene in San Francisco?

I had a good time. It was like this: I had a good time *being* an underground cartoonist, and I spent more time being an "underground cartoonist" than I did actually drawing underground comics.

Why was that? Why didn't that spur you to be more productive?

Well, for one reason or another — I wasn't doing drugs or nothing — but boy, when I got to San Francisco, it was like a real toddlin' town, you know. It was like everything sold liquor. Here in New York, we don't do that. There's a liquor store where you can buy liquor, but boy, you walk into a supermarket out there, they had a liquor aisle!

And you therefore found liquor irresistible?

Well, I guess I just fell into it. I started drinking mainly beer, but every day, you know? When you start going over my life story, this is gonna come up all the time. I was always doing something to get high. It was one of my stumbling blocks.

As opposed to drawing.

Exactly. That's the thing. You know, *Rolling Stone* would have a party. There was a party at Janice Joplin's house, and she had just been tattooed, and she had a tattooist there, and anybody who wanted to could get tattooed. So, I got tattooed there, and, oh God, that was wild. But you know, that's the thing, there were all these really wild parties, and so I'd be at all of them, and I'd get interviewed and stuff, you know, as though I were like Crumb or something. I was just me, having a good time.

[Laughs.] I understand you got fairly close to Wilson because he was a beer drinker as well.

Yeah, Wilson, well, he was like the Devil himself. He was always getting me into a bad situation somehow.

Such as?

Well, we were at his place, and there was some other guy there, and we were all drinking, having a good time, this and that, and ends up, "Oh, why don't you go home with this guy? You know, you're not gonna make it home on your own." I ended up going home with this guy who turned out to be gay and throwing a pass on me. Another time, he got me involved with some girl he didn't want to get involved with, and I ended up with her.

That doesn't sound too bad.

Ehh, well, I don't know. She was kind of like suicidal and shit. It was always some bad little thing to it as well,

in whatever situation I'd end up with with Wilson. But, you know, we both liked blues music, and he knew Charlie Musselwhite, and we went to some club there and saw him, and then Musselwhite came and sat with us. Boy, that was terrific. So yeah, there was an attraction. I liked to hang out with Wilson, but like I said, he was like the Devil himself.

And you drank more than you drew.
Definitely.

I understand you have a great story about flying to Las Angeles, posing as Gary Arlington and visiting Jerry Siegel.
Yeah, as a matter of fact I'm writing that up right now, an illustrated story about that. The way it goes down is, Gary, for some reason didn't want to leave the Bay Area. It was more a phobia, it seemed. Like an EC convention happened in New York and nobody liked these guys more than Gary. And it's probably the last time in any of their lifetimes all these guys got together again, they were all still alive. He just wouldn't go. I remember I went and Jack Jackson went, we all went and we had a good time. And this is connected to this other thing. You know, Gary thought he was the next Bill Gaines. Anyways, he thought he was going to start EC up all over again and the artists were gonna come from all over the world to meet at his comics store. And then sure enough, one day this letter shows up from Jerry Siegel, and he wants to write some comics for some of Gary's artists to illustrate. It's this real nice letter and he invites Gary out: "If you want to come out to Los Angeles, I'll have you over for dinner."

And Gary thought about it for a little while and he came to me and says, "Why don't you go. You could be me. They don't know what I look like. So you could be me." So I did. It was one of those so-crazy-it-just-might-work ideas. I ended up calling up Siegel and arranged a day and said, "Yeah, I'll come down and we'll talk about this." We put together a whole briefcase full of San Francisco comic-book goodies. We'd just printed Rick Griffin's book called *The Man from Utopia*, it had all the best paper and it was really a deluxe-looking book. We put a whole thing together, we tried to soft-peddle all the sexual stuff, We had all this stuff, so I could go and be Gary Arlington and hand these things out. I went out there and I met with Siegel and we talked. It was real interesting because we got to talk about the case. Of course, I'd heard about the DC lawsuit and all that, but I figured that whatever was going to happen with it had already happened and it was a done deal, but it was really anything but. All these years

A sample of Simon Deitch's underground-comics work: courtesy of Simon Deitch.

later, he's still working on it. Once he talked to me a little bit, he saw that I really knew my stuff about Golden Age comics. He dragged out these scrapbooks, which he'd put together. They had a panel from *Batman*, a panel from *Superman*, you could see that the *Batman* panel was swiped cold from the *Superman* stuff. He had whole volumes full of this stuff, things you wouldn't expect to see, things you wouldn't believe. In fact these scrapbooks he had were put together from thousands of dollars worth of Golden Age comics. I mean I'm sure they only cost him a dime apiece when he started putting these things together. But it was really fascinating to see.

And you got along well with him? He must have been about 30 years older than you.
Yeah he definitely looked like an old guy compared to me. He and I got along good, and we went through all his stuff. And he had all these scripts, the only real trouble was, they were just so lame. There's just no other way to

put it. He seemed to think he had a latch on what to do, and he really didn't. The only one I remember clearly was this one with some little girl who ended up stabbing the guy to death with a pair of scissors in the last panel. Which sounds like at least he had his heart in the right place. *[Groth laughs.]* Other than that, they just weren't very good. I know my brother was interested, and I ended up telling him, "You know these things are just not good; they're just lame."

You told Siegel this?

No, I told Kim this. I told Siegel that I'd do the best we could. I guess finally I just had to say, "Sorry." I explained it to him up front, that the way most of the people in the underground worked was they did the whole thing, and that we didn't really do scripts in the time-honored way that comics had been done for years and years. I tried to be nice about it.

It was weird though — years later I was at some convention in New York, I was just buying some Golden Age comics, which I still collect, and all of a sudden I hear from across the room: "Gary! Gary!" And I look over — it's Siegel and his wife.

[Laughs.] And you're still Gary Arlington?

Yeah, I mean I've got this big badge on that says I'm Simon Deitch and I was just got caught totally off guard and I wasn't really ready to take on the Arlington persona. I just didn't have it. So I go over, and I say, "Oh hi, great to see you, but listen, I'm not really Gary Arlington."

You told him this?

Yeah, and I do my best to explain how this all came to be: "I was working for Gary Arlington and this is what he had me do; I didn't mean to mislead you but this was my job." And dadadada. But by the time I summed it up, they were looking at me like I had to be the craziest person on the face of the Earth, maybe even dangerous. *[Groth laughs.]* You know, it was really an embarrassing situation, so I just said, "Well, good to see ya." And I shambled away.

It might have been better if you just told him you were using Simon Deitch's badge.

Yeah, it'd be better if I would have told him I was impersonating Simon Deitch. *[Laughter.]* I was just totally caught flatfooted. I didn't know what to do. And there they were and they wanted to talk to me right then and there. If I had known, when you go to this convention chances are pretty good you're gonna run into Jerry Siegel, I could have mulled it over. I could have come up with

something. It's just not the way life is sometimes.

Well now, you also befriended Roger Brand, and from what I understand you were both incredibly knowledgeable and interested in the history of mainstream comics and the artists in comics.

Yeah, right, and Roger was really interested almost in a whole other level than I was. He liked all these guys like Noel Sickles and guys who I didn't know much about. I was already more into strange artists like Bill Everett and Basil Wolverton and Jack Kirby and Steve Ditko … I always liked people who had some kind of style, where the artwork looked more like it was coming straight out of their brain onto the page. That's the kind of stuff that always did it for me. You know I wasn't really impressed if a guy could really draw people just the way they are. It had no real meaning for me; I wasn't a big Alex Raymond fan or anything like that.

Brand would have been Gil Kane's assistant when he was in New York.

Yeah, he was. Earlier than that, he was Wally Wood's assistant.

Did you ever meet Wood or Kane?

Oh yeah, both of them. Absolutely. I met a lot of those old pros, Bill Everett was another one. I got on pretty good with Bill Everett.

In what context would you have met Bill Everett?

Well, it was one of the very first New York conventions, and nobody really knew who he was. He just sort of showed up and saw me with some old *Marvel Mystery* comics and he kinda sidled up to me and sat down and started telling me, "I used to work on these books. You know I did that strip, *The Sub-Mariner*."

And I said, "Oh! You're Bill Everett!"

And he said, "Yes! Yes!" And he was of course impressed that I knew all about who he was and all the various things he'd done over the years. So I got to know him, and he never really forgot me. Any convention I went to after that and I'd see him, he'd always have fans around him once they got onto who he was. But I was one of the first guys to meet him at that stage.

And you liked him?

Yeah, and he had problems. Like later on when I was having problems again with the drugs.

He was a heavy drinker, wasn't he?

Yeah, he was an alcoholic. He was real understanding and sympathetic. I met him one time and I said, "Ahh, I'm not doing too good right now, Bill."

He understood and said, "You just gotta get it together," or something. He didn't look down on me for being a drug addict.

And how did you meet Wood?

Well, I met him at some party, and I had a butterfly knife. It's a knife that's got a split handle and the handles wrap around the blade. You can flip it around in a real impressive manner and open it up, like a switch blade only a little more interesting. I remember I had one of those and he saw it and he wanted to know about it. 'Cause he was a real weapons nut himself.

So you bonded over the butterfly knife?

Yeah, we got along pretty good. I did a little horror comic strip for the *East Village Other*. It was one of these things about these people at an old age home, but when they were 84, the guy who ran the place would go dump them in an incinerator pit. Wood got a look at that and thought it was really pretty good. It wasn't all that good, but he liked it, I guess he liked the twistedness of the story, and that was a really good feeling, him being one of the all-time greats and all.

And how did you meet Gil Kane?

That was just a matter of going up to see Roger when he was working. He'd invite me: "I'll be working at Gil's this week. Why don't you come up? He's got great stories." And he was right, 'cause Gil went all the way back to the golden age.

So you guys would just sit around and shoot the shit.

Pretty much. Also he had a closet full of artwork, and he said, "Ahh, go through this, if there's something in there you want."

His own artwork?

No, it was all kinds of people's. I got a nice Russ Heath page out of there. Yeah, he was real nice that way.

So getting back to San Francisco, how did that evolve and what happened? I mean underground comics sort of evaporated in the mid '70s, '74-'76.

Oh yeah, when they started saying that local communities could take you to court over it. Some guy down in the middle of Podunk could bring you before the bar, you know? 'Cause maybe their standards didn't match with what you were doing. It was really a terrible ruling.

And there was a crackdown on head shops.

Yeah, yeah it was a whole thing across the board.

So what did you do? What was your next port of call after undergrounds were on the wane? What was going on in your life in the mid '70s?

I was still having my problems with various things. I went back to New York and I didn't really do a whole lot for a while. Well, I had a 15-year marriage, but the only thing about that is that I didn't do a single piece of professional artwork throughout my whole marriage. But then when I finally broke up, I got into animation, which I knew from growing up around it and everything. I worked for Nickelodeon.

Now that would have been approximately when?

I guess around '92, something like that.

Well there's a good 20 years there where we have to figure out what you did.

Yeah, right, well, I'm pretty much telling you I didn't do nothing.

[Laughs] Well, you got married, and I guess you got divorced. What year did you get married?

Oh boy, I don't know, I guess it was around 1976.

How did you earn a living when you were married?

Actually I did things in and around town, like I was a manager of a store in New York called Super Snipe.

Oh yeah, sure, the famous comics store. But you weren't compelled to do creative work, comics or drawing?

No, you know it wasn't really coming up. I suppose I drew some stuff here and there but, nothing really.

So what did your wife do?

Ah, God, she was a boring person. *[Groth laughs,]* I know she worked for a Jaguar dealership and then a Cadillac dealership. She had these brothers who were really into cars, so she knew a lot about cars growing up. See, I knew her from school.

So you married your high-school sweetheart?

She wasn't my sweetheart at the time, but we were friends back then and we ran into each other later, yeah.

It doesn't sound like a match made in heaven

Nah, it wasn't. Hey now, actually, I've been married three times, and it was the most successful marriage I'd had. The rest of them were like what, five years, two years, you know? And this one was 15 years, so …

But 15 fairly uneventful years.

Yeah, very uneventful years.

So what was your life like? You had various jobs in retail stores, and your wife was working at the Jaguar dealership. How did you spend your free time.

Oh, I know what I was doing that was creative. I had a friend who was into filmmaking, and I knew a lot about makeup, monster makeup. You know, creating fake wounds and gore and whatnot. So I worked on, jeez, a few movies. Maybe even a couple of them came out on tape and what not.

Your father said you missed your true calling as a Hol-

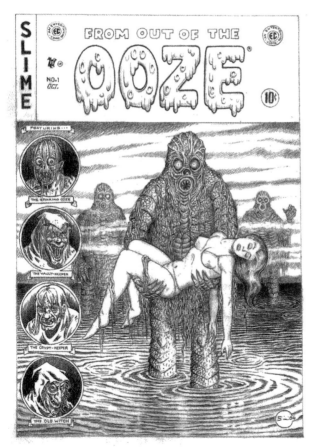

Courtesy of Simon Deitch.

lywood makeup guy.

Well, I was doing it for a while. Almost anything I've ever been interested in, I've done for a living at one time or another.

There was one film called *The Astrologer*, it was a strange cult sci-fi pastiche. And then I worked on a movie called *Igor and the Lunatic*, and you know, the thing is I'd have to go down to like, 42nd street to see these movies in a theater. They'd be in dive theaters, but it was something I was doing. There are some photos of some of my stuff in *Fangoria* #19.

You said in the early '90s you started working for Nickelodeon? Tell me how that came about and what you actually did.

All right, I was going through a divorce. My wife moved out of the house, so Kim moved in and he was talking with Tony, and Tony brought up the fact that they were looking for people at Nickelodeon. There was a little company called Jumbo Pictures down on Spring Street in New York, and he just told me the kind of samples I should put together. They asked me to come in and bring my portfolio, and I did, and I told them I had an animation background in my family, and they put me to work. I stayed in that for a while. It was the very beginning of what they call "Nicktoons" nowadays. One of the very first ones was called *Doug* and I was a designer on it, and a layout guy. Then I went from job to job. That's the way the animation thing was, you know. They'd start up a different company every time there was a new project. They'd start up a company to make a commercial.

But it was still the same umbrella company? They would just start different …

Yes and no. There were different places. There was a place called Curious Pictures. I worked there for a while on a couple of different things. There was some kind of series we were doing for ESPN; it was like a sports cartoon. And then a Captain Crunch commercial, at Curious Pictures. Then I was working for a guy, J.J. Sedelmayer who opened a studio in White Plains, and what we did was the first season of *Beavis and Butthead*.

And that would have been the mid to late '90s?

Yeah, about the mid '90s. And then at the same studio I worked on the revival of *Schoolhouse Rock*, and a lot of animation stuff. Sometimes I'd be working on animation, I'd actually be doing in-betweening, and

another place I'd be doing design work.

Where were you living at the time?

Westchester. That's when I got married, that's where we were and we were buying a house from the girl's parents.

I see, so you must have divorced sometime in the early '90s?

Yeah. About '92.

And then you burned your way through two more marriages.

No, no no, they were previous.

Good heavens.

Yeah, the first marriage, I was young, 19, 20 years old, and the second one was in San Francisco. That only lasted a couple years. *[pause]* It was exciting, you know?

Right, but it was the boring one that lasted 15 years.

That was the last one. You know, I sort of lost interest since then.

I was gonna say, you're now available again.

Yeah, but not really. I'm just not interested. I'm not out lookin' or anything.

Seth tells me you returned home for a few years when he was around 16 or so.

Yeah, that's when I first came back from San Francisco. I had to nest somewhere.

What was that like? You must have just been getting to know your younger brother at that point.

Yeah, actually we had a pretty good time together. We had fun together, but there was a lot of smoking marijuana and stuff, you know. So of course my mother was not all that happy about it.

Seth says he learned a lot from you, and I assume he means more than smoking marijuana.

Yeah, yeah, I'm sure he does. But I'm not sure what he means. Did he say what he learned from me?

Well, in terms of introducing him to a variety of comics, and you taught him a little about sculpture.

That's right, he was interested in that. Yeah, he got into working in micro-crystaline wax. He did some interesting things, and I taught him some stuff about old cartoons. He didn't have the advantage of growing up around my father. But you know, we'd smoke grass, and we'd watch cartoons together, and I'd tell him all about this stuff and that stuff or stop-motion movies.

What was your mother doing?

She was working at a place called Secon Metals. They dealt with gold wire and all kinds of thing. She'd actually had several careers in bookstores, being a bookstore person. She ran the book department in Macy's for several years. My mother's really pretty smart, you know. I mighta got into cartoons and stuff like that, and comic strips from my father, but my mother is the one that got me into pulps, like science fiction. Mother was a real science-fiction fanatic, I remember as a kid going down in the basement and there'd be all these cardboard boxes, and I started opening them and, God, it was full of *Thrilling Wonder Stories* and *Avon Fantasy Reader*s and *Startling Stories*. All kinds of great things with terrific lurid covers. And even some of the very first fanzines, she had copies. So she really knew about that stuff.

Did you become a reader because of her?

Oh, among other things, yeah. She started me on science fiction. I told her I was interested and she gave me a book of seven famous novels by H.G. Wells. She had me read *War of the Worlds*. I went from there into modern sci-fi.

It sounds like you had a great combination between the two parents. One was the written word, and one was the image.

Yeah. I think I got along with my mother better than Kim did. I don't think he ever really got into sci-fi or anything like that 'cause he didn't really spend a lot of time going over stuff like that with her. He got interested in it later. He interviewed my mother several times. But he's doing it more in [the context of] the history of the Deitch family, trying to get it all together.

When you were in New York, and when you moved to San Francisco, and you were involved in the underground scene, what was your relationship with your father like?

Well …

Did you have one?

It was weird. I think, for instance, when I was in New York, I'd get to see him here and there but the most memorable time of course, you gotta remember, is I got busted for drugs, and then all of a sudden, my dad's in town and,

boom, he's at the visitor window. And I'm going, "Oh *God.*"

[Laughs.] Was this when you were in the Tombs?

Yeah, when I was in the Tombs, my father suddenly shows up, and I'm going like "Oh *Christ*," you know.

Did you not assume he was going to get you out?

Well that's the thing, he wouldn't. It was like "Oh well, uh, Marie told me not to bail you out. You gotta learn your lesson," or something.

I was going, "Dad *please*, you gotta get me outta here," I mean I wasn't interested in talking to him if he wasn't going to get me outta there, you know?

In that case, why did he drop by?

Yeah, I know, really. I think he just wanted to check on me, make sure I was all right. "I'm *not* all right!" You know? "Get me outta here!"

Like you were saying initially how he was talking about how I was a bad seed and all that. Yeah, he's got a lot of that in his head. Actually we do get along quite good. Now and then. There was a point, I guess about two years ago, where I was really staying in touch with him, writing him all the time. He was getting on me 'cause I didn't have a computer. He likes this e-mail thing. Therefore it's my duty to get a computer. I said I really didn't want to, but I kinda took him up on the fact that we just don't talk much, so I started writing him a lot. And we had a good series of letters. And now, every time I see him, it's definitely very friendly, positive.

I'm not sure what year it was, but maybe' 97, you created, or co-created with Kim, "Southern Fried Fugitives." Can you give me your side of how that came about?

It was basically another thing with Nickelodeon, and they had a section in their magazine called "The Comic Book" and they were taking ideas. We came up with about four or five good ideas, and *Southern Fried Fugitives* was just another one we threw in. It was definitely not the best idea we had. But sure enough, that's the one they picked out of the whole pile of ideas. Kim was upset about that; he didn't really wanna do *Southern Fried Fugitives*. So it got down to: If I was willing to write it and draw it, he'd put that Deitch sheen on it, and that's what we did. And I started writing it. And it worked out pretty well for about a year or something. Then of course I got into some kind of trouble, and he took it over. He continued it for a while.

I just noticed, I found a few back issues of Nickelodeon, and for some reason, he did it for longer than he had let on to me that he was still doing it. You know, I thought he had quit it years earlier than apparantly he did. For some reason, he didn't keep me straight on that particular project. But he didn't like working for them. I'd already told him the various problems you run into working with these guys. You know, they would censor you for what seemed like ridiculous reasons.

It was a pretty good strip. As a matter of fact, just recently, they paid us to re-run the origin story in their *Best of Nickelodeon Comics* magazine that they put out. The fact that they started with the first episode has me thinking that maybe they've got in mind to run some more, so who knows. We'll see.

It seems like you do your creative work desultorily. Why haven't you had a more consistent commitment to doing this kind of work?

I'm not exactly sure how to answer that. I just did that Golem story, that was my story, and Seth wrote it up. I gave him a synopsis and exactly what was going to happen, and he went from there. And now I'm working on this other story about Jerry Siegel. I'll try to keep working for a while. Now and then, I'll go into a slump where I'm not doing anything. I gotta work my way out of it, right now.

Your work hearkens more back to mainstream comics, and almost '40s and '50s comics than it does underground comix with the latter's emphasis on the irreducibility of word and image together. Your work is

primarily drawing, not writing and drawing together, and your drawing is closer to the draftsmanship of the best mainstream artists rather than the more idiosyncratic underground artists.

I had some problems with underground cartoons. Like, I didn't like to do any of the stuff that was particularly pornographic. That didn't really appeal to me much. I love what Crumb did; that was hilarious. But as far as me doing it, no, it didn't really work for me.

With the Golem story that appears in *Deitch's Pictorama*, you did the drawings for that first, as I understand it, and gave the drawings to Seth, who wrote a story around the drawings; can you tell me a little about how you collaborated with Seth on that?

Yeah, but it was my story. It was Kim that suggested it to me. I was sending Kim the drawings on it, and I had the synopsises of various parts of it, and he said, "Why don't you give these synopses to Seth and maybe he could write it up, and I thought, you know, that's probably a good idea, so I did.

Kim and Simon Deitch in 1994: photo courtesy of Kim Deitch.

Are you happy with the way the *Deitch's Pictorama* is turning out?

I saw a picture of the cover, but I just haven't really seen that much.

Kim was just telling me that, if there was any way to darken up some of my illustrations, it would be better.

Because there was a certain delicacy to the pencil work.

Yeah, that's the thing. He was bugging me like crazy to get the original, so let the guy fool around with it, but my experience with pencil drawings and printers is most of them don't understand how you want it to look. I find that you do better to make Xeroxes and once they look about how you want it to look, then let them print from the Xeroxes. But Kim was bugging me and saying, "Well, you know, these guys want to see the originals," and now, here we are, it's on the verge of coming out and I'm hearing that, ah, they're looking too light.

I don't think that's true, I think that you'll be happy with the reproduction. I think they look very, very good.

Well that's good.

Kim's kind of a worrier.

Yeah, he is. He said, "This is my biggest concern as we go to press, but I'm worried, so I guess you should be too." *[Laughter.]* "I may be going overboard here, but at this stage, that is part of my function."

Well, he's right, but if I were you, I would not worry. ∎

From "The Golem," Simon Deitch's contribution to *Deitch's Pictorama*.
[©2008 Simon Deitch & Seth Kallen Deitch]

The Seth Deitch Interview

Conducted by Gary Groth

Seth, Simon and Marie in 1957: photo courtesy of Seth Deitch.

GARY GROTH:
You were born in '56, so: Kim was already, by the time you were born, 12 years old, and Simon —

SETH DEITCH:
They were respectively 13 and 10 years older than me.

And your dad left when you were either 3 or 4.

Yeah, around there. I was raised as an only child by a single mom.

Tell me what your childhood was like. You basically grew up without your dad being present.

It's true. I've gotten to know my father as an adult, and it's been a wonderful experience. I've got nothing bad to say about the man at all, but I didn't really know him as a kid, it's true.

How well did you know your brothers insofar as they were considerably older than you?

You know, I can say that I've gotten to know Kim quite well, also as an adult. Simon came back from San Francisco when I was still in high school, so I spent a lot of time with Simon. He taught me a lot of interesting stuff. It was good that I had that experience, although that was not necessarily the best time in his life. But it was a chance for me to get to know him, definitely.

My sense of Simon, without having spoken to him, is that he can be a dominating personality; that's he's very, very knowledgeable, and his passions are infectious.

Previous page: "It's Fun" from *De Septem Orbis Spectaculis*. [©2008 Seth Deitch]

Well, Simon *is* very knowledgeable, and his passions can be infectious, yes. Simon's an odd one, what can I tell you? He's got quite a head on his shoulders. He's very, very, very sharp. And he remembers almost everything you're ever gonna tell him.

You really couldn't have known Kim growing up, when you were a kid.

Not that well. I knew Kim, but there was not really any sort of intimacy or day-to-day contact with Kim at a time when I could have appreciated it.

I grew up knowing Simon pretty well; he was actually responsible for turning me on to a lot of important things.

Such as?

Well, you know, comic books. *[Laughs.]* I can say that some of the very first comic books I saw were ones that he had bought. The one that really sticks in my mind is *Fantastic Four #6*, because it's the first comic book I remember reading when he got it new. And I wasn't that good at reading at the time it came out, either, I'm not that old. *[Laughs.]*

What was it like being raised exclusively by your mother?

Well, my mom is a fantastic lady. She's a voracious reader, and she definitely got me into the habit of reading any book I could lay my hands on. And the thing is I must have had a little learning disability or something. I was a slow reader, actually. But she read to me, even well beyond the age that you'd normally read to a child. It really helped me a lot; it gave me an appreciation for books. I did really poorly in school, but the fact that I had become such a reader allowed me to take control of my own education, which is a damn good thing.

I gather that the Deitches are predominately autodidactic.

That is absolutely true, I would say. So far as I know, the only one of us that's had any college at all is Kim.

At one point, you realized that your dad wasn't there. What was that like?

Well, I had a concept of what had gone down. I think even as a young child I understood that adults were adults, shit happens. *[Groth laughs.]* If I hadn't learned it by then, I've certainly learned it by now through bitter personal experience *[laughs]*. But, I understood yeah, he wasn't here any more. Not only was he not here, he was *very* far away.

About as far as you could get.

Yeah, exactly. He was not on the same continent. I missed having a dad around, but I cannot say that it was a huge factor in my psychology. I mean, obviously I knew that other kids had different family situations than mine, but I thought that mine was satisfactory, and me and my mother were close. We got along. I enjoyed spending time with her. I guess I shouldn't say that I don't feel like I missed much, because both of my brothers got a tremendous art education from being around my father, which I did not get. But he did leave a whole pile of great old 78 rpm records, which I listened to voraciously. *[Groth laughs.]*

As a result, interestingly, when we finally started being in communication a lot, we discovered that one of the great things we had in common was the love of that particular kind of music.

And that would have been old jazz from the '20s and '30s?

That would have been old jazz, definitely, yeah.

Both your brothers became artists, and I don't think you did. You became a writer.

Well, I've had a number of different disciplines. I am not that handy with a pencil, but I painted for quite some time. For years and years I did collage, and I produced this magazine called *Get Stupid* that was a showcase for my collage.

Right. And you did a book called *De Septem Orbis Spectaculis*. And that was also a collage kind of comic, fumetti.

Yeah, exactly. And some of my collage actually got into this narrative comic-like thing. And I did that for quite some time. I don't know what happened. I just ran out of steam, I think; I just started getting other interests.

But you didn't become the draftsmen that Simon and Kim did.

Well, certainly not the type Simon is. As a draftsman, there are few people that can equal him. No, I never got the education of that sort or that particular discipline I never absorbed.

Do you think that's because your father was a presence in their lives in a way he wasn't in yours?

I think that's definitely a factor, sure. I didn't have him looking over my shoulder when I was trying to draw. So yeah, that's absolutely true.

Of course *[laughs]*, he wasn't able to discourage Kim, so…

Well, Kim is — you look at Kim's stuff, and you think, "Well, gosh, this guy is a primitive." But man, he has got this unmistakable style, and he is such a great storyteller. Any deficiencies that there may or may not be in his art — I'm not sure his art actually has what you would call deficiencies, it has a profound individuality. *[Laughs.]* And that ain't bad. Ain't bad at all. He is where he is through an absolute iron discipline. *[Laughs.]*

And his stories wouldn't be as potent as they are without his unique stylization.

Exactly, exactly. He is who he is. I gotta say, Kim is a real hero to me, because he has stuck to his guns about doing what he does. He's saying, "I am a comic-book maker, and that's what I do." And he's never been distracted. He's never been one to worry about day jobs or stuff like that: he does what he does and keeps on plugging. And he did it, you know? I certainly can't say that.

As you were growing up, what were the biggest influences that you experienced? You cultivated a love of reading, but not a love of academia.

I don't fare well in institutional environments.

Another Deitch trait.

Yeah, yeah. I think that probably actually is a Deitch trait. *[Groth laughs.]* I did not do well in school, but it's not because I have a low IQ, it's not because I don't have a love of learning; it's because I don't have a love of school. *[Laughs.]*

I've always been one to forge my own direction, for better or worse, and oftentimes it *is* for worse. I could have benefited quite a bit from school had I been a little bit more accepting of various of my peculiarities. I'm sure there are things I could have benefited from a great deal.

What kind of a kid were you? I understand that Kim seemed to be a bit on the shy side, and Simon was apparently a hell-raiser, according to both Kim and his father.

I was a loud-mouth, know-it-all pain in the ass.

[Laughs.] Rounding it out.

I'm *sure* you've seen the type. I was positive I knew the answer to everything. I made sure that everybody else knew it. I was pretty sure that I was surrounded by idiots. I'm not absolutely, totally disabused of that notion, even at this point in my life. *[Groth laughs.]* I know that I was

From *Get Stupid* #7. [©1988 Graphic Fishmonger Studios]

obnoxious, I was loud. I was positive that I was always, always, always right. Nobody could tell me anything. You know. I was just one of those.

Did this cocksure attitude come from reading a lot? Feeling you were more educated and knowledgeable?

I'm certain that was a contributing factor. I just think that I have this Type A personality, too. It all goes to that. For the good of all, these days I avoid most contact with humans.

[Laughs.] When did your creative impulses start to manifest themselves, and how?

As a child, I was an accomplished liar, of course, and that's creative.

More so than other children?

Nah, probably not. But when I got into high school I started getting into art. I started with sculpture. I found that I had a certain amount of talent with that, and actually Simon helped me quite a bit with that, because by that time Simon was back at my mother's house, and he

showed me a lot of tricks with sculpture. I did that for quite some time. And then, after that, that's when I started doing painting and other things.

Were these representational paintings?

Yeah. I don't think I ever became a terribly good painter, but I was a terribly enthusiastic painter. Especially with my second go-around, when I decided I was going to paint nudes, and that was just a great excuse to bring naked women into my house.

Did women fall for that?

Oh yeah. I'll tell you one thing that I learned from painting nudes is that practically every college girl in the world wants to pose nude for an artist.

I wish I had known that.

Yeah. I felt like it was this big secret that nobody told me, but I never had any problems getting models, ever. I mean, most of the time, they wanted to pose and that's it, unfortunately. *[Laughter.]* But I just think it's this fantasy that every young girl just going out on her own for the first time has: that she wants to pose nude for a bohemian artist.

Your dad told me that you actually created homemade rockets and that you and your friends would go into a field and shoot them off. Your dad didn't tell me how old you were when you did this, but can you tell me the circumstances surrounding this: Why, when and how you did it?

When I was a younger teen, like junior-high-school age, I flew little Estes model rockets. It was a lot of fun and appealed to my general scientific bent. It sort of went by the wayside as I became more interested in girls. Years later, in my late 30s, I started thinking about rockets again and started flying them. First the little models I used to fly and then much larger, higher-power things. All of those large ones I designed myself and flew them from a big field in Amesbury, Mass. with the rocket club. The club was a local of the NAR, the National Association of Rocketry (not to be confused with the NRA!). The club was made up of younger kids and lots of guys over 30, with guys in their late teens and 20s almost completely unrepresented. Lots of guys come back to rocketry as adults having done it as kid. They call it being a born-again Rocketeer. Anyway, I had to drop it again. The rockets were just getting bigger and more expensive to build and fly and taking up more and more of my time and I was also trying to be a writer which also took up a lot of time, so I just sold off

all my parts and rockets and motors for cheap just so I could focus.

Get Stupid — was that published between '86 and '91?

It was between '83 and '91, actually. I studiously avoided sending the early issues [to you] because they are not something I'd like to be remembered for. *[Laughs.]* I started doing it in '83, which is right around the time that I separated from my wife. I was at loose ends and I was finding that I wasn't feeling inspired for painting at all. I started just doing collage. I've always really liked Max Ernst and Joseph Cornell, those guys. I really liked Max Ernst's idea of telling stories through collage. And that influenced me a great deal. The thing about collage is that you're working with chance, it's very interactive. You put something on the page: it suggests something else back to you, it feels like you're doing some interaction with the artwork itself. And that pleased me a great deal, and I did that for a long time.

You would have been 26 when you started Get Stupid and when you divorced from your first wife. What did you do between high school and that? You did not go to college.

No, I did not. I hitchhiked around the country. I hung out and took drugs with my hippy friends. I did music. I completely forgot about the fact that I did music for a long time with my friend Scott Rasmussen. We had this little band together, where we were doing acoustic music. We did that all during the '70s, really, to absolutely no success whatsoever.

[Laughs.] What kind of music? Rock?

[Scoffs.] No. No no no. It was very individual acoustic music. I mostly played plectrum dulcimer, some ukulele; he mostly played guitar. But we built a lot of instruments. We were doing lots of very experimental stuff. At that point in time, I was listening to lots and lots of progressive jazz, but I was also listening to people like Harry Partch and Terry Reilly and The Residents and all kinds of strange influences.

Pretty experimental stuff.

Yeah, exactly. So we were getting into some pretty evolved stuff that was just not working for the audience. *[Groth laughs.]* I loved the stuff. I still pull out the tapes and play them once and awhile. I was making exactly the sort of music I wanted to hear, I'll say that much.

Well, Harry Partch is pretty far out there, musically.

He is, very far out there, but very, very disciplined and organized. It's not like these free jazz pie-fight kind of deals. Something real is going on there. He was trying to do something so ambitious that it was ridiculous, which is he was trying to completely reinvent Western music.

He was Virgil Partch's uncle.

Is that true, the cartoonist?!

Yeah.

No kiddin', I did not know that. I did not know that. That's interesting. Yes, the guy that drew too many fingers on everything. *[Laughs.]* That's quite interesting.

VIP. Small world.

Yes. Small world, indeed. You know, people frequently compare my father's Cat cartoons to Virgil Partch.

I can see that. I guess you were banging around and to use the well-worn cliché, trying to find yourself?

Oh yeah. Well, I mean, I haven't stopped doing that. *[Groth laughs.]* I think that's one of the things that may possibly be one of my great weaknesses and one of my

Art by Ruggles Smadbeck. [©1989 Ruggles Smadbeck]

great strengths: that I'm relentlessly immature. I still think about what I want to be when I grow up. I'm 51 years old *[laughter]*.

Your father would come back to the States, I think, two or three times a year, maybe?

Not even necessarily that often. I would see him from time to time. I gotta say, my interactions with my father when I was a kid — And I really understand how this is as a father myself, as a father who has not grown up with his daughter next to him, which is exactly my situation. I know exactly what it was: that there were these semi-comfortable meetings where we would do things and play our little roles, and nothing I had to say was that damned interesting to him, and nothing he had to say was that damned interesting to me. And that is not a problem. Really, I understand it, because I've had similar interactions with my daughter. But as an adult, my relationship with my father was completely different. I just wasn't that interesting to him as a kid. And that's OK. That's not saying anything awful about him. I understand that.

So he wasn't, when you were growing up, able to com-

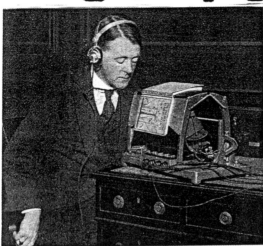

᭍᭍ ᭍᭍ ᭍᭍᭍᭍ ᭍ ᭍ ᭍᭍᭍ ᭍᭍᭍᭍ ᭍᭍᭍ ᭍᭍ ᭍ ᭍᭍ ᭍᭍᭍ ᭍᭍᭍ ᭍᭍᭍ ᭍ ᭍᭍᭍ ᭍᭍᭍ ᭍ ᭍᭍᭍ ᭍

By "Ahmed Fishmonger" (one of Seth Deitch's pseudonyms) in *Get Stupid* #10. [©1988 Fishmonger Graphix Studios]

municate any great principles to you that you adopted, or —

No. But I gotta say, whenever he showed up, he gave me access to things that most kids didn't likely have. He'd take me to Pete Seeger's place in Beacon, N.Y., and I'd hang out there for a week or so. And see that whole marvelous thing. Or he'd take me out to the Weston Woods Studios, in Connecticut, and I'd get to see firsthand how everything worked down there. This was important stuff. This is not meaningless stuff, but it *was* bringing me into environments where he could do his thing and I could do mine.

Did you remarry?

I only married once — to a lovely lady named Kathy Kallen, who I still consider a very good friend. I liked the name so much I wouldn't let her take my last name for her last name. Instead, we took each other's last name for a middle name, and I still use Seth Kallen Deitch to write under. But we were just not that suited to spend our lives together, that's all.

How old were you when you married?

I was 23.

Well, that's pretty damn young.

Yeah, yeah, yeah: I learned.

Did you get closer to your brothers as an adult?

I think I'm definitely closer to both of them as an adult, yes. Even when I was a teenager, Simon was not necessarily going through the best stage of his life, and everything that he had to deal with people about, there was always some kind of angle. He's not like that any more. So, our relationship is much, much better now. My relationship with Kim is much better, just because I'm not a kid any more.

How do you mean that he always had to have an angle?

Simon was a great schemer when he was young. That was one of his things. That's not where he's at now. I'm sure he'll have some amusing things to say to you about that when you talk to *him*.

Did you have a daughter by your wife?

No, by a girlfriend I met during my period of initial separation.

So, you separated when you were 26, that would have

been '83 —

Yeah. And that's when my daughter was born, in '83, so I think she's 25 now.

How did that shake out? It sounds like you were apart from her for quite a long time throughout her life?

Yeah, and I'm not proud to say this. I have not seen my daughter in two years or so. She's an adult now: She's not depending on me for anything in particular. She was born out of a fairly short relationship I had with a gal way back when, a nice gal, nothing bad to say about her at all. I've seen her from time to time, she's a good kid. She's a smart kid, but I do not know her that well.

What were the circumstances that she was raised under?

She was raised by her mother, and later, by her mother and her mother's current husband.

Was this because you did not want to participate, or because you were not allowed to, or … ?

I'd rather not go into any great detail about this, but I was cut out of the equation, and leave it at that. It did not work out at all.

Kim had a similar situation, as you probably know.

Yeah, yeah. He's in touch with his daughter, although I don't know if he's ever met his granddaughter yet. I gotta say, this is not something I've talked with Kim at great length about. I mean, I understand that everybody's got issues in their personal life, and it's something that I know is a sensitive spot for him. I know from my own experiences, I got a clue of how he probably feels.

You never remarried.

Nope! Nope!

To what do you ascribe your bachelorhood?

Oh, I don't know … [musing] … women find me repellent. *[Groth laughs.]* I don't think it's that. For one thing, I have just not, in recent years, felt like putting the energy into cultivating relationships with women.

And you're instead putting this energy into your creative work?

Oh, wouldn't it be nice if that was true.

[Laughs.] I'm trying to put as romantic a gloss on it as I can.

I think it's really more laziness. I will go out and have little casual things from time to time. … You know what it is? I'm selfish. I'm just really fucking selfish. I just don't want to share that much of myself with anybody at this point in my life. It's as simple as that. You get to a point in your life, and it happened to me, actually, earlier in life than a lot of people, I'd say in my 40s, where I started saying, "I just don't need the aggravation." I'm not saying that something couldn't come along at some point and turn my whole head around about this; by all means, girls, come on, give it a shot, I'm willing, but *[laughs]*. I'm a difficult personality. I am definitely strong coffee.

[Laughs.] So someone has to be able to put up with a certain amount of …?

Exactly, I am not easy. I understand that. I'm clear on that. It doesn't bother me, and I'm not offended when people say it.

***Get Stupid* basically seems like a fanzine. How many copies did you print?**

"Fanzine." My friend Donna Kossy, who published some of the best of them once asked, "If this is a *fanzine*, then what am I a *fan* of?" So many so-called *fanzines* were independent visions and not all that fannish. In early issues, I only printed like 50, but later issues I was printing 500.

One of the cartoonists who's most predominant in here is a cartoonist named "Fitz," whom we've actually published in the past. Was he a local?

Oh, Fitz, yeah, God. Tony Fitzgerald, what a guy. I worked with him at one of the reprographics companies I worked for. He is, I think, one of the funniest human beings around, absolutely. It was an absolute privilege to publish his stuff. He actually did a book for Fantagraphics: *Test Dirt*. Good book.

Previously you had been a dishwasher. How did you make the transition to the graphic-arts field?

Well, I actually moved from being a dishwasher to being a cook to being a manager at this restaurant. They ended up closing the restaurant. It was part of a chain, and I could have gone and worked in another one, but they were all far enough from my home that it was a pain in the butt. I ended up letting them lay me off so I was able to go a summer without working and thought about what my future was going to be. I had started producing *Get Stupid*, and I said, "Well, how serious am I about this?" I consciously said, "I'm going to go and get me a job at a Xerox shop," which I did. That was actually where I

met Tony. I'm still in the reprographics business. I mostly sit at a computer now, rather than run a Xerox machine, but that's still what I do.

I see. Now, is this to you, simply a job, or is it something you find some real fulfillment in doing?

Well, I don't know. I can't say that I have any deep feelings of caring about the job and the industry in particular, but I've been in it long enough that I've gotten quite good at what I do. I take pride in the fact I'm good at what I do. Do I think that what I do *matters*? Mmm, I don't know. *[Laughter.]* It's not what I devote my best mental energy to; most of that is devoted to writing.

How did the Church of the SubGenius enter into where your life was?

Well, OK, there was that issue of *Weirdo* #1 that published the pamphlet. And me and my friends read it with great amusement. And my friend Bill Kates was working at that time for WBCN and so he was able to just call people on the phone and interview them, and he decided to call Doug Smith, "Reverend Ivan Stang," on he phone, and forge a relationship with him. We ended up going to a SubGenius convention and I met all those guys, and we ended up getting along *real* well, becoming friends. I collaborated on various things for the SubGenius publications, and I brought a SubGenius sensibility into the magazine.

How would you characterize that?

Wow. How would I characterize the SubGenius sensibility? The thing about the Church of the SubGenius is that it is possibly the greatest participatory piece of performance art ever mounted. *[Laughs.]* But the flavor of it is anti-intellectual-authoritarian. That facts are not necessarily facts just because someone tells you so, that everything we know is not only likely wrong, but the things that we discovered that are wrong about them are probably also themselves wrong. Exactly. *[Laughs.]* It reminds me a lot of the early surrealists and dadaists too. It's the same sort of attitude toward intellectual truth that really, really appealed to me.

An absurdist perspective.

Exactly, yeah. And it just meshed very well with what was already going on in my brain.

At this point, you're in your 20s, you're heading into your 30s, but did you feel like you didn't quite fit in?

Well, with good reason, yes. *[Laughs.]* I didn't feel like I

The Church of SubGenius ad in *Weirdo* #1.
[©1980 The SubGenius Foundation]

fit in because I didn't fit in.

And how did you not fit in?

I didn't. I don't think I've ever had the same drives and ambitions as most people in the world.

Which is basically to get ahead and make money and —?

Well, I wouldn't mind any of those things, but it was just never anything I felt like devoting a huge amount of energy to.

Not as a specific goal, yeah.

Exactly, yeah. I just didn't *care* about owning a house or having a car or wanting to be better than the guy in the cubicle next door or any of that jazz. Just none of it appealed to me. I don't blame that on anything in particular, and I don't think I'd have it any other way. But I've got to say, that my whole attitude toward life, and I didn't realize it 'til a girlfriend of mine pointed it out to me once — she said to me, "You know, you live your life as if you thought you were going to never die."

And I said, "That's true, that's absolutely true." *[Laughter.]* I do live my life as if I'm never going to die. I have all the time in the world to do any little idea that occurs to me.

Is that still true today, do you think?

I think it is, yeah. I honestly think it is. I think I am relentlessly immature.

You say that as if it were a virtue as well.

I'm very accepting of that part of my personality *[Groth laughs]*, that's as far as I'll go. I'm not going to come right out and say I think it's a virtue, but I accept it.

Certainly, it seems as if Kim — because I know Kim

pretty well — shared that perspective, the sense that he did not share the priorities of most people.

Except — one thing that I will say about Kim that makes him very different is that he decided early on exactly what it was he did want to do with his life, in spite of the fact that it was something that society had almost no room for. He went out and he *did* it.

But he didn't give a shit that society didn't have room for it.

Exactly, exactly. Like I say: He's my hero. He's my absolute hero. He went out and did something. He was one of those people who basically created something that never existed before; he was one of the people who created underground comics. He went out and did something that didn't exist, and made a living out of it. And *I* can't say that.

You mentioned *Weirdo* #1, with the SubGenius manifesto. Were you paying attention to underground comics previous to that?

Oh, I've always been a huge fan of the underground comics, always. As early as I was allowed to look at them — which was earlier than I should have been.

I was going to say, you probably missed the heyday a bit, because you were a little bit too young.

I saw them. I definitely saw them. My mother was very willing to expose me to adult stuff. I was well-read, educated, and I was able to handle it in her opinion. She was more or less right.

If she allowed you to read underground comics, her attitude must have changed a bit from the time she did not want Kim and Simon to look at *Mad*.

Yeah, I guess so. But I wasn't around then. Actually, Kim and Simon *were* allowed to look at *Mad*. They weren't allowed to look at EC horror books. This is something that both of them are more than willing to tell me time and time again, that the only EC stuff they were allowed to look at were *Mad* and *Panic*. But the EC horror books were right out. And really, who could blame any parent? They are great, great books, I don't want to take anything away from them, but only an idiot would let their kids read that crap. *[Laughter.]* I remember — my brother Simon, had a book called *Thrilling Murder*: A great, great underground comic: one of the absolute classics.

He edited this?

As far as I know, yeah, he's the editor on that. He did

the cover for it, he did some pieces in it, and he came up with this whole thing of the "bloodorama" coloring, where, the whole book was in black and white, except whenever somebody was stabbed they'd bleed red. When he was finished editing the book, he sent me a copy of it, because he was proud of it, and my mother opened it before I got it, and what he always says is that he got it back the day before he sent it *[laughs]*. That was a book that he had to sneak me a copy of later. *[Groth laughs.]* My mother *absolutely* would not give it to me. I think I was maybe 14 at the time it came out, maybe 13.

First she had to protect Simon and Kim from EC and then she had to protect you from Simon.

[Laughs.] Well, yeah. Again, you look at that book and you'd say, "Well, any responsible parent wouldn't let that thing near their kid." I think of myself as a special case, but …

What underground comics did you particularly like, and how did they affect your view of things, or your view of possibilities?

I've always loved Bob Crumb. Not only is he a spectacular artist, he tells really entertaining stories. I've gotta say I'm a big fan of Kim's. Some of the things I really liked were based on the EC horror stuff.

Skull Comix and …

Yeah, exactly, stuff like that. I really liked *Death Rattle*. I loved *Wonder Warthog* and the Freak Brothers. Gilbert Shelton, I'm a big fan. God, who else? Who else did I really look at a lot.

Spain, S. Clay Wilson?

You know, Wilson I didn't like that much when I was younger; I like him very much now. When I was younger, I don't think I really understood his stuff that much and I found it a little hard to look at. I thought Spain's stuff was good — of course, at the time I was growing up, his stuff was stridently communistic *[laughs]*. That didn't appeal to me too much at that time. I dig it now. But I've always loved the way he draws. Robert Williams, I really got into his comic work. I wish he continued to do more comic work rather than painting as much as he does these days. I thought his comics were marvelously intricate. Of course, I wasn't only reading undergrounds. I was reading lots and lots of … I'm a huge, huge Superman fan. I think Superman informed my morality more than anything else in my life.

How early did you read _Superman_?

Oh, God. Probably before I could read, I think.

I would assume early '60s?

Oh yeah, yeah yeah yeah. It's weird. Simon was only into Marvels, really. But I'd always read _Superman_ when I went to the barber shop. That's what I associate my early _Superman_ reading with: sitting in the barber chair, reading _Superman_.]

Now, did you pay attention to the alternatives in the '80s? To _Weirdo_ and _Raw_ and ... ?

Oh, absolutely, yeah, yeah. I have a complete collection of _Weirdo_ and _Raw_. I love them to death. I actually tried to submit something to _Raw_, and even with various connections I had, Spiegelman just wasn't going for it. It's that thing in _De Septum Orbus De Spectaculus_ called "Testing 1-2-3," that was concocted specifically to go in _Raw_ when it was the large format. I got Simon to show it to Spiegelman, and then I wrote him a nice letter about it. And didn't hear, didn't hear, and finally I said, "What's up with that?" And he said, "Oh, it's out." That's all I ever heard: "It's out." _[Laughter.]_

From _De Septem Orbis Spectaculis_. [©2008 Seth Deitch]

Which indicates it was ever in, which it probably wasn't.

No, it was never in. I'm sure. I've met Spiegelman, but I've never asked him about it. I just assumed that he looked at it and decided it just wasn't for him.

Was there a point at which you saw your ambition as being a writer?

In 1993, when I completed my first novel, I realized that this is something I wanted to do. And that's it. It's interesting: it was a total attempt to write something just like Edgar Rice Burroughs. It's on my website, it's called _Bromfkidor_. It's not that great, but it really was such a great, fun thing to do. I was totally hooked; I realized that this was something that made me feel good to do. A lot of it had to do with technology. I don't write that well with a pen and paper. But as computers started coming along, writing became easier for me.

You started writing seriously when you were in your mid-30s.

Late 30s, I was 38 years old.

And prior to that, you were just feeling your way. You were doing _Get Stupid_, and …

I gotta say this, when I was doing _Get Stupid_, I didn't feel like I was feeling my way. I felt like this was what I was doing.

But you must have known it didn't have a chance to become a paying vocation.

I wish I had known that. _[Groth laughs.]_ I thought that this was something that, one of these days, people were going to wise up and this was going to catch on. I honestly did think that. I really did think it was possible. I don't make any apologies for that. I know it was not the most realistic concept I ever held _[laughter]_. I thought that, sooner or later, somebody was going to look at this and go, "Wait a minute. This is the next thing!"

OK: So a little delusional.

Yeah.

What prompted you to really take writing seriously, and start writing short stories?

It's the only time in my life where I ever said, "I really want to hone my abilities in this and do this." I sat down, I wrote a book: I read it back. I wrote _another_ one and read it back, and I was going, "I can see that this is not the greatest finished product in the world, but this really

feels like this is what I ought to be doing." And I wrote a few stories, and I showed them off to people, and people were agreeing with me, and said, "Yes, this is what you ought to be doing." I just really started concentrating and teaching myself how to do this, and wrote stuff that was both good and bad, I learned how to tell the difference between what was good and what was bad.

Now, when you say you taught yourself, how did you go about doing that systematically? Did you study other writers?

I did study other writers, yes.

Who would they have been, that you were most taken with? Obviously, you like Burroughs, because you did one called "ERB: the Urban Legend," but I assume you graduated beyond Burroughs …

I'll tell you what it was. I was really reading pulp writers a lot, because I really liked the idea of these guys able to write a novel every month. I'm going, "How did they do that? How did they ever do that?" I didn't realize that a lot of these guys were several guys *[laughs]*. I did figure that out ultimately. But some of these people actually did write a novel every month.

Yeah, yeah. Many of them were machines, they just cranked it out. How did you become attracted to pulp writers?

I just like — how do you put it — not necessarily very intellectually demanding but exciting stuff.

***The Laugh at Midnight* would have been an homage to, specifically, The Shadow, but pulp in general.**

It was an homage to a number of different characters, but The Shadow certainly looms large among them. At the time I wrote that, I had not read a Shadow story in over 20 years. I have since read very, very many. What I wanted to do there was I was saying, "OK, I want to do a character who is not necessarily defending the Christian American way." I just decided to do it as a pulp detective.

Most of the stories I've read by you have a pulp or science-fiction touch to it, or at least scaffolding.

I like genre fiction. I do very much.

Now, the three stories that appear in *Pictorama* are all

"… the golem reached out with a single great stone hand and enclosed his entire head."

Some of Simon Deitch's art from "The Golem," which was written by Seth Deitch based on Simon's story. [©2008 Simon Deitch & Seth Kallen Deitch]

quite different from one another.

Yes.

"The Golem" seems to be the most uncharacteristic of your stories, because it involves Jewish folklore and biblical references.

The reason for that is it's Simon's story. Simon came up with that story, I wrote it, I wrote every word of that story, but Simon came up with the illustrations, he had an idea, he had characters, it's just that he didn't — When the story appears in the book, I think it's going to say "by Seth and Simon Deitch."

I think that's correct, it does.

It is *Simon's* story.

I didn't quite know what that meant. So how did you guys collaborate on that particular story?

He made a pile of drawings. I actually made a couple of false starts. I started doing it as a comic story, originally,

but he said, "No, no, no, we're not doing it as a comic book, we're going to be doing it as an illustrated story." Fine, so I went back and I started again and I basically wrote a version of the whole thing, and sent it to him to criticize, and he called me back and we were on the phone for six hours, going over point-by-point the various criticisms he had for it, and I fixed them all.

Were they sharply observed criticisms, do you think?

I went into doing this project with the idea that this is *Simon's* story. So I wanted the story to be the story Simon wanted to tell. And so the criticisms were the criticisms that were going to make the story the story Simon wanted to tell. I've never written a story like that, but we managed to do it, and we did "The Golem" with my writing the story, him doing the drawings and a few phone conversations.

"Son of a bitch!," I burbled through my mouth full of blood.

We heard the tiny blades scratch the finish of my car and the cruiser as they zoomed past. The rat Zeppelin was directly overhead. I looked up to see that there were at least fifty of them, each and every one too smart for its own good. It was clear that the gas envelope was separate from the section that contained the "crew." I wondered where they got the helium. Did it *use* helium?

A smoking Diet Dr. Pepper can dropped from the sky and rolled under the cruiser.

"Run!" I hollered.

From "Unlikely Hours:" written by Seth Kallen Deitch with illustrations by Kim Deitch.

[©2008 Seth Kallen Deitch & Kim Detich]

It did seem like the kind of story that was slightly outside your bailiwick.

I wasn't uncomfortable putting it together, though. I didn't feel like I was out of my element writing it. It's a fantasy story. It had resonance for me. I'm very happy with the story and I find it entertaining. But yeah, it is definitely not the sort of thing that I would conceive from the beginning. But I thought it works very well.

And "The Children of Aruf" is like a fable, I think.

I can tell you exactly where that story comes from. I am very interested in the kind of SF about alternative history. And there is an Internet group about that, which I participate in from time to time. One time I remember, me or somebody threw out the idea, "Well, what if dogs could talk?" It seems absurd, but you think about the personalities of dogs, and we're not going to say they're super-intelligent dogs — they're regular dogs, not any smarter than dogs are. They have to be able to talk. Well, what are the tendencies of dogs?

I was thinking, "Well, God, I think dogs would be more religious than human beings were." *[Laughs.]* They have this pack mentality; they're very, very sensitive to the concept of leadership, the great omniscient God would appeal to them. I went with that. It would be a fable if it had some sort of moral, but it doesn't really have a moral, it's more like a slice of life in an alternate world where this can happen. But you don't really *learn* anything from the story.

That's right, that's right. It's got a nice resonance at the end, not a moral, per se. It's a beautifully tight story.

Yeah. That's the thing, it's only about 4,000 words, I'm very proud of that fact. Boy, writing a short short story, it ain't easy.

"Unlikely Hours" is a cracking good yarn with a lot of action.

I love that story. I really do. I had to convince Kim that this was the one he wanted to illustrate. He went for it, but it did take a little bit of convincing.

[Laughs.] Is that right?

Yeah, it did. But he says he actually really likes the story, now: Had to get used to it. It's got a different kind of pacing than he's used to …

I could see where it would be his kind of story, though, because Kim's such a page-turner …

I'm exceptionally happy with that. I'm definitely happy with the whole collaboration with him, I think we can go on and do much more together. Things went very smoothly with us.

In a collaboration like that, to what extent do you guys confer? In other words, you write the story, and then give it to Kim, presumably.

With "Unlikely Hours," there was a lot of back and forth with me and Kim.

What kind of back and forth?

He did a pile — I mean, really a large pile — of preliminary sketches for "Unlikely Hours." I got immediate feedback from him in terms of artwork — he sent me five or six pages of sketches for it, which then I went over and I go, "more like this, less like this, don't do that, do this instead," etc., etc. and sent it back to him, and he'd do different things. Which is the exact opposite of the thing with me and Simon, where he was working with my story, but he was very easy to work with at that. I don't really have any complaints: It worked out very, very well. He was very good about understanding my vision for how the story was supposed to be. He's a good illustrator for a writer.

And you enjoyed these? These were really good, comfortable collaborations?

Well, there were difficulties on "The Golem" story *[Groth laughs]*, that mostly had to do with the amount of time that Simon was taking. But he got the job done.

Your father and your brothers — how has your relationships evolved over your adult life? They have to have shifted and changed over time.

We've had our ups and downs, but I will say that right now, me and Kim probably have the closest relationship we've ever had. Me and Simon are definitely in a good place. But yeah, it hasn't always been the same, that's for sure.

You're writing every day, or almost every day?

Let's not say that I am perfectly satisfied with everything at my life in this point, but yes, I am comfortable with how things are going at this point. Obviously, a little bit more

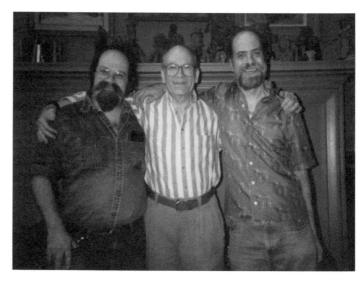

Seth, Gene and Kim Deitch in 1994: photo courtesy of Gene Deitch.

success with the writing would be more comfortable.

Clearly, writing is a very important component of your life.

Oh, yeah. it's the important component of my life. It is *the* important component. It is the one without which all the others would not feel like they were worthwhile at all.

Did you ever flirt with doing what Kim does?

In *Get Stupid*, I certainly approached comics. But, I know my limitations. I don't think I have enough talent in that direction that I could satisfy myself with what I did. If I satisfied myself, and everybody else still thought it sucked, I might still do it. But I don't think I could get to a point where I could satisfy myself doing that.

Well, that seems very non-delusional.

Well, I'm *trying* to be more realistic as I get older.

[Groth laughs.] Well, age tends to force you to do that.

Yes. It definitely does, it definitely does. There have been things that have made me say, "Yeah, right. Can't do that any more." *[Laughs.]*

Those moments come fast and furious.

Yes, they certainly do. But I'm happy with what I'm doing, and I want to keep doing it. I want to define myself as a writer. ∎

Laika

Nick Abadzis
First Second
205 pp., $17.95
Color, Softcover
ISBN: 9781596431010

Review by Rich Kreiner

Most comics that are so steeped in fatalism tend to be set aside as curiosities, either laughed off as indulgent claptrap or skirted as a genuine downer. Nick Abadzis' *Laika* deserves better than a summary judgement for its authority as historical chronicle and its admirable artistic resolve.

This is a cartoon biography of Laika, the Russian dog who was the world's first space traveler. Scarcely one month after the Soviet Union's astonishing triumph of Sputnik, Laika was sealed atop a rocket and sent into planetary orbit on Nov. 3, 1957. The date was anything but coincidental. The launch was rushed in order to coincide with the 40th anniversary of the Russian Revolution, thereby amplifying the in-your-face propaganda value over earthbound Americans and offering further proof of Soviet superiority in science and technology. If that right there doesn't give you a bad feeling in the pit of your stomach, then have I got a book-length lesson on history and human nature for you.

Because, in spite of the title, it is humans, and their nature, that effectively commandeer center stage. In practical terms, Laika's narrative role is that of a lens, focusing the actions of a small band of select Russian military men and bureaucrats as they carry out the duties required for their mission. In this light, however much individual cast members differ from one another otherwise, they are portrayed — to switch from optics to mechanics — as functioning cogs within a greater machine. Take Oleg Gazenko, who comes to stand for a Soviet Everyman, an upper-level functionary awkwardly pulled in disparate and unequal directions: cog. Or Sergei Korolev, "a man of destiny," victim of a Stalinist purge, former gulag prisoner, and now Chief Designer of Russia's budding space program: bigger cog than most. Or Yelena Dubrovsky, dog trainer and handler, eager if conflicted team member and principal figure in the book's final two-thirds: female cog.

The tale does a fine job of presenting Cold War mentality as an amorphous, pervasive despoiler. Today it may be hard to imagine how that mentality spurred the furious competition for achievements and firsts in the early space race, but Abadzis effectively brings readers up to speed, particularly in showing how personal motivations were swept aside for organizational objectives. Given that human conviction can be so pragmatically subsumed for the good of The People, how much hope can be held out for an abandoned pooch in service of The State?

As historian, Abadzis relates these annals with the pessimism they deserve. As artist, he must contend with the formidable dramatic challenges of staging, pace and editing that Laika's tale presents.

The first and foremost challenge is that in her capacity, Laika is largely passive, and never more so than when in the company of humans governing her fate. There is no suggestion of her fortune being deserved. Introduced to the Chief Designer during a moment of atypical behavior, she is given her "official" name, meaning "barker"; this outburst is her greatest contribution to her future, itself more happenstance than demonstration of merit or suitability. She is at the mercy of her mortal gods, which is to say all but powerless. There is no sense of tragedy, only waste, inhumanity, futility and the hubris of others.

In the comic, Laika gains liberty in fiction. With a second chapter of some 40 pages, Abadzis provides Laika a backstory. He imagines a life with two separate families prior to her days running wild in the streets. Abadzis is, in effect, attempting to attach certain aspects of Laika's documented existence to invented foreshadowing incidents. Such an introduction intends to broaden and deepen the reader's emotional connection. The thematic links are critical in generating a more profound sympathy for what essentially is — however otherwise dependent, anxious to please and lovable — a canine cipher.

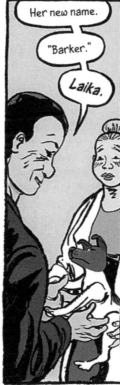

[©2008 Nick Abadzis]

Laika's "origin" also serves to widen the social purview of the story, bringing in wider glimpses of Russian domestic life than are to be found within secret military laboratories. Using Laika as a diffusing lens, empathy is generalized across species, even to her human overlords, constricted in their own way as thoroughly as she. See? Everybody's day-to-day existence is tough. Stray dogs just happen to be at the very end of the stick.

However obvious the narrative value, this grafting of Laika's fiction to documented fact feels calculated and artificial. In a volume that takes a while to get going, one that incorporates some jarring timeline shifts at its beginning, the fabrication is intrusive. The imagined beats of hardship, cruelty, affection and longing feel gratuitous and heavy-handed, especially in comparison to the more fluidly delivered hammer blows that follow in later segments.

Laika exhibits far greater freedoms through other such purposeful fictions as fantasies, hallucinations or drunken delusions. Again, her expanded latitudes and privileged interludes make storytelling sense but the variance of yarn and truth — of flying, talking and dreaming dogs on one hand and of cold, hard political and scientific realities on the other — is not easily reconciled. The attribution of special abilities to Laika and her fellow test subjects will prove to be as unpalatable for some readers as it would have been for Soviet commanders depicted in these pages.

As noted, humans — apart from remaining alive through book's end — fare little better than the title character, their own various, rigorously maintained hierarchies not so physically binding but every bit as ruthless. Their emotional range is stunted. In part, this stems from a stultifying contraction of pre-Revolutionary civility based on class consciousness and the post-Revolutionary formality of classless equality where all are designated as comrades. While characters are easy to understand — we can see how cogs work — it's difficult to warm to any of them. Most are unable to act upon (or can hardly bear to admit) their heartfelt desires. Benefactors are bereft, would-be protectors largely ineffectual. In the end there is not much evidence that the death of one dog changes much of anything. As if it could.

And that, to return to the book's strength, is a function of Abadzis' conduct as steadfast chronicler. This is a

sad tale of a bad time precisely because it *is* an unhappy episode in an era plagued with them.

A chronological coincidence makes a superficial comparison unavoidable. James Vining's *First in Space*, also published last year, tells of the American catch-up effort to put an animal into space ... making its title something of a misnomer from the get go. Comic and campaign culminate with the non-orbital launch and recovery of a chimp named Ham in early 1961. Vining's material is geared to "Youth Age 7+" which accounts for his straightforward, bare-boned, cartoon gloss. For our purposes, it exemplifies an easier course, as informational diversion for young readers, that *Laika* is not interested in pursuing, however much it remains age-conscious and accessible.

Laika intends to be better history than amusement, and not just because of the subject matter. Abadzis has committed his story more to exploring the implications of the former than to exploiting the license of the latter, making better choices accordingly. This is particularly smart in that staunch fidelity in effect sets up opportunistic artistry, making the narrative that much more memorable. The two long concluding chapters of Laika's training and eventual flight are propelled by a number of fine, fused moments, passages that carry emotional heft irrespective of one's stance toward PETA. A most prominent case in point is the extended, dead-of-night excursion whereby the condemned is provided her last laps of water before entombment.

Against steady-state hardships and a growing sense of misgivings, an emotional chorus is offered as bulwark. Refrains are wrung directly from and framed completely by the language of the long-suffering. At bottom, they are oppressed peasant mantras of enduring and coping: "Don't look back." "We will remember you." "Don't worry."

How did such last-ditch bromides for loss and resignation become so pitch-perfect for this time and place? Why do they not comfort? Implicit answers have been consistent, but the crystallization for me lies with the book's pivotal reckoning, a reflection made vivid within the spiritual limbo between sentence and execution. In the darkness, a drunken Yelena looks out from her room across the vast launching complex constructed on the desolate steppes of Khazakstan. The dogs give voice to collective complaints of the stinking, freezing turn of events. Everyone wonders how they arrived at such an alien, foreboding place and what their business there truly is, to which Yelena can only observe that "This place... is a place where **we** do what we do best...Where we don't let dogs be dogs ... or even people be people ... This place ... this place

... this place is a *monument* to man's ambitions.

[©2008 Nick Abadzis]

is a **monument** to man's ambition." It's a monument to which all contribute, and will keep on contributing, with immediate future sacrifices going explicitly unspoken.

Abadzis tells a big story, of expansive historical movements and small, telling details (the timing surrounding the proclamations of Laika's "success "and subsequent spin management is particularly chilling). His solution to working it all in is many panels and art writ small, a strategy that carries its own compromises. Very much on the positive side is that players — people and pups — appear constantly hemmed in by the margins of their world, be they cages, rooms, circumstances or frame borders. Claustrophobia is inculcated.

Many drawings mean many different potential patterns of panels which Abadzis shuffles to advantage. Scale is exploited. Larger panels invariably pack special oomph: A nondescript governmental building squats massively, an official letter scrolls down imperiously, the plains of Khazakstan sprawl wide. Full-page drawings are sensational, as with the first, to-scale vision of rocket and gantry that precedes Laika's last drink. Expanded dimensions permit fantastic cartooning to achieve its most seductive effects, as when Laika soars under her own power around a gloriously full moon high above a Moscow revealed in fisheye. And when those rare emotional outbursts between humans do occur, they are granted special resonance by their increased size.

The trade off is that the default settings for Abadzis' art are reduced, subdued and tamped down. Bodies are small; this may reinforce the impression of constraint but the possibility of the slight, revealing gesture is also surrendered. Faces are small — this is not the environment for broad emotional expression — but the chance of a subtle, voluble look is also conceded.

All this may suggest that nuance in figure drawing is not a forte for Abadzis and there's unfortunate corroborating evidence exhibited in his titular subject. Renderings of Laika are fine as far as they go in terms of cartoon shorthand, but they never lift the hound too far beyond graphic cypherdom. The inclusion of her photograph at book's end, however, is savagely eloquent. It effectively supplants her drawn representation in suggesting the weight and woe of her story. *Here* is the sacrifice, the spanner in the works. *This* is the face of the dog that captured hearts, weakened resolve, threatened self-interest. Now we see more clearly. Now we know the snout, the muzzle, the ears, the eyes of the creature that was, in essence, subject to the most expensive and premeditated execution of an animal that the world has ever known.

There's no consolation, no compensation. Abadzis du-

[©2008 Nick Abadzis]

tifully mentions the publicity hit the Soviets take from the West, but if the backlash did anything tangible to lessen future stupidity, it goes unrecorded in this book. Instead the epilogue belongs to Gazenko who, 41 years after the fact, offers for the record, "We did not learn enough from the mission to justify the death of the dog."

Laika intimates that whatever the significance of the Earth's first space voyager, it likely lies in the less tangible repositories of heart, mind and, most susceptible, memory. In the private moment that irrevocably seals Laika's fate and rushes this story down its steepening slope, the Chief Designer makes a confession to his caged charge, ending with a pledge: "I will honor you. Everyone will know your name, Laika ... *I* am a man of destiny. And **you** will be the most famous dog in **history**." How loudly that name has resounded to this very day, eh? Still, better to know than doomed to repeat. ∎

The Best of Mutts

Patrick McDonnell
Andrews McMeel Publishing
256 pp., $24.95
Color, Hardcover
ISBN: 9780740768446

Review by Chris Mautner

You don't have to be an animal lover to appreciate *Mutts*, but it helps.

In fact, it can be hard at times to imagine anyone who's not the most fervent of pet people and PETA supporters to be able to fully immerse themselves in the oh-so-cutesy-wootsiness that *Mutts* frequently indulges in.

Unless, of course, you happen to be a comics lover. That's the only other group of people I can see tolerating Patrick McDonnell's constant forays into utter adorableness and "gosh, isn't nature just grand"-isms.

Fact is, there's a darned good reason for that tolerance, namely that McDonnell is an inventive, accomplished and versatile cartoonist. His strip regularly contains a number of visual and verbal references not just to comics but to a wide variety of classic art and literature motifs. What's more, it frequently displays a level of formal play that is rarely seen on the daily-newspaper comic-strip page. It is frequently elegant, and yes, more often than not, rather funny.

When the strip made its debut way back in 1994, it was those elements that won it such huge acclaim and awards from critics, fans and the general public. Sure, it was another Funny Animal strip — co-starring a lazy, gluttonous cat no less — but it had a self-conscious artfulness about it that made a lot of the cute stuff go down easier. At any rate, it wasn't as insufferably nauseating as, say, *Rose is Rose*.

As *The Best of Mutts*, a handsome, hardcover, 10-year retrospective of the strip, shows, McDonnell hasn't altered the formula very much in the ensuing years. That's not terribly surprising — why mess with what works? But at the same time his adherence to a by now well-worn groove highlights the strip's flaws as much as it does its strengths.

First, the strengths. As you might expect, or at least

From *The Best of Mutts: 1994-2004*. [©2007 Patrick McDonnell]

hope, with a book that has the word "Best" in the title, *Best of Mutts* does a good job panning for gold. Most of the strips included here are worth at least a chuckle or two if not an outright guffaw. McDonnell gets a lot of mileage out of contrasting Mooch and Earl's behavior — as well as the other assorted animals they come across — with that of the human world. And in Mooch the cat he's found a real gem of a character, a comic-strip cat who embodies all the stereotypical characteristics that have made comic-strip fans come to hate "pet strips" but nevertheless manages to be not only funny but rather endearing (the lisp probably has something to do with that).

So yes, *Mutts* is a funny, charming strip. It can also, however, be a cloyingly sentimental one, dripping with forced whimsy and the sort of cuteness that would provoke more cynical readers to gag. McDonnell even has the audacity to indulge in "I hate Mondays" gags, with a straight face no less. That is just as much on display in this book as the good humor.

One of the main thrusts of McDonnell's strip is that less leads to more, and he will frequently tease out a joke or story well past the point of breaking. Strips that are charming or funny the first time around quickly become insufferable by the fifth or sixth. Declaring Monday to be "Mudday" (complete with Mooch jumping into a mud puddle) is fine, but then extending the joke to "Twosday," "Wetsday," "Turnsday," "Flyday" and "Splatterday" with every strip being a near exact variation on the mud-puddle jumping bit is really testing the reader's patience.

I know, I know. It's all deliberate and part of McDonnell's "zen" approach to cartooning. I don't care — it's also

tiresome and one is tempted to accuse McDonnell more than once of coasting. I'm well aware that coming up with ideas for a daily strip is hard work but *Mutts* dilutes its gags so frequently that the strip at times resembles thin gruel.

I should probably also mention the "animal shelter" stories since they're also a bit of a sticking point for me. I know McDonnell sees them as an essential part of the strip and the opportunity for him to raise awareness about an important issue and possibly even inspire a reader or two to take action and adopt a pet. And good for them if they do; I wholeheartedly support such behavior. But the fact remains that these are some of my least favorite strips in the book. Designed to make you feel as guilty as possible, these panels of various cats and dogs literally pleading with you to adopt them is as artless and grating as your average anti-drug TV commercial.

Honestly, I don't really read *Mutts* for the gags, at least not enough to warrant my seeking it out in the newspaper as often as I do. The truth is, I, and, I suspect, many others, read the strip and books like *The Best of Mutts*, simply to marvel at McDonnell's impressive design and general cartooning chops. To delight in say, his stellar adaptation of an old nursery-rhyme book or the way he draws the looping, spiraling leash that holds Mooch to his master. Or even just to enjoy the way Mooch's ears go up when he's surprised or alarmed. For me, that's enough to get fulfillment out of the book. Will it work for you? Depends. Do you also like animals? ∎

Chris Mautner writes a weekly column on comics for *The Patriot-News*. newspaper in Harrisburg, Pa.

Little Sammy Sneeze

Winsor McCay
Sunday Press
96 pp., $55
Color, Hardcover
ISBN: 9780976888543

Review by Noah Berlatsky

If you were a Freudian, you'd have to wonder when Winsor McCay was weaned. Indeed, his work is so obsessively and predictably orally fixated that you almost wonder if maybe he wasn't. In each episode, his longest running strip, *The Dream of the Rarebit Fiend*, featured a nightmare brought about by culinary overindulgence. And *Little Sammy Sneeze* stars a taciturn little boy with multicolored neckerchiefs whose mouth yawns open to the size of his entire head before it emits an "ah-choo!" powerful enough to knock down small buildings.

Psychologically, an oral fixation indicates arrested development — an inability to take on adult responsibilities and characteristics. Whatever McCay's own psychological profile, he certainly used the idea of oral obsessions to justify a world in which characters don't, in fact, learn or change or, indeed, even exist in anything but the most notional way. In none of the strips in Peter Maresca's new collection of all the Sunday *Little Sammy Sneeze* strips does the title character ever make an articulate noise. Instead, each strip follows the same pattern. In the first panel, Sammy says, "um," with his mouth closed. In the second, he says, "Eee Aaa," with his mouth slightly open.

In the third, he says, "Aah Aww," with his mouth open wide. In the fourth, he says "Kah" with his mouth gaping like some sort of bloated underwater fish. In the fifth, he says "Chow," and the force of his sneeze causes disaster and mayhem — either he hopelessly scatters the chits in a poker game, or startles the lions in a circus act, or sends Thanksgiving dinner flying into his grandfather's beard. And in the sixth and last panel, he wears a blank expression as he is removed, often with a kick in the pants, from the scene of destruction.

The adults who surround Sammy are barely more sentient than he is. It's true that they talk — but so repetitively that their words seem little more meaningful than Sammy's grunts. In one paradigmatic sequence, two Italian immigrants talk in a nearly impenetrable patois, reiterating again and again how great America is and how "Da Italio man maka no troub he maka no troub for no one. Every ahbody say Italio man maka great excite in dese countries. I don see. I don see it." The racism doesn't extend to WASP characters, of course, but the aphasiac repetition does; if a McCay character says in the first panel that she's afraid of falling on the ice, then you can

From the Sept. 25, 1904 strip. [©2007 Pete Maresca and Sunday Press Books]

be sure she'll say the same thing in the second. And the third. And the fourth. Really, Sammy's adults might as well be in a *Peanuts* TV special — "waah waah waah waah waah, waah waah waah waah waah."

These strips are, in other words, little more than the same slapstick cliché, endlessly repeated. Next to this, even *Beetle Bailey* starts to look positively inventive. At least Mort Walker had three or four gags. No wonder that, in the introduction to the volume, Thierry Smolderen suggests, rather nervously, that McCay is putting us on, that it's a "parody," which "chuckles at the absurdity of ... doing the same thing ad nauseum." McCay's strip, you see, isn't mindlessly repetitive; it's making fun of mindless repetitiveness! Thank goodness! He's a jaded intellectual, just like us.

McCay probably did enjoy doing the same thing over and over. Whether that enjoyment is adequately characterized by a distancing concept like "parody," though, is another question entirely. Instead, the pleasure of McCay's work seems more like that of a small child, who wants his parent to make that face again for the millionth time. It's excessive and infantile, linked, not to a sense of irony, but a sense of wonder.

This *Sammy Sneeze* strip was collected in *Winsor McCay: Early Works*. [©2003 Checker Publishing]

As G. K. Chesterton says in *Orthodoxy*: "Children have abounding vitality, because they are in spirit fierce and free, therefore they want things repeated and unchanged. They always say, 'Do it again'; and the grown-up person does it again until he is nearly dead. For grown-up people are not strong enough to exult in monotony. But perhaps God is strong enough ... It is possible that God says every morning, 'Do it again,' to the sun; and every evening, 'Do it again,' to the moon. It may not be automatic necessity that makes all daisies alike: It may be that God makes every daisy separately, but has never got tired of making them. It may be that He has the eternal appetite of infancy; for we have sinned and grown old, and our Father is younger than we."

There is certainly something godlike about McCay's artwork. *Sammy Sneeze* doesn't try for the sumptuous fantasy of *Little Nemo*; still, the level of detail when McCay renders for example, a grocery store interior, is jaw-dropping. In the first panel, towers of individual cans and products are shown with a flawless clarity that makes the scene seem more real than life. It's a *tour de force* in itself — and then McCay repeats it in the second panel, with everything the same except the positions of the customers. And then he repeats it again ... and again ... and then, with the explosive sneeze, throws everything into a chaos so crisply rendered it still somehow looks like order.

McCay is obviously one of a kind, but his particular take on cartooning is also a product of his era. The *Little Sammy Sneeze* panels, drawn in 1904-1905, look very much like cels for animation — and, of course, McCay

would create his own animated shorts a few years later. Sammy also harks backward to some of the early experiments in film, especially Edison's 1894 Kinetoscope five-second film *Fred Ott's Sneeze*, which, like the title says, shows one of Edison's assistants, Fred Ott, taking snuff and sneezing. (A still from this film is reproduced in this volume's introduction, though the caption erroneously identifies Fred Ott as "Ed Ott.")

This collection generously allows us to see how McCay compared to some of his print peers, as well. The book includes examples of two contemporary strips, *The Woozlebeasts* by John Prentiss Benson and *The Upside-Downs* by Gustave Verbeck. Visually, neither of these is much like *Sammy Sneeze*. In place of McCay's vivid detail and art nouveau sense of still composition, Benson's and Verbeck draw more on a tradition of cartoonish caricature. Benson's drawings of fantastic beasts, in particular, hark back to Tenniel's *Alice* illustrations. Verbeck is also influenced by children's illustration. His drawings are deceptively simple; they look sketchy and rough ... until you turn them over and realize that upside-down, they show a completely different picture.

Despite these differences, all three illustrators do have something in common. Their visual orientation is essentially infantile, in the Freudian sense. They're pre-Oedipal, the pleasures they offer have little, if anything to do with the symbolic system ... which is to say, they don't much care about narrative or character. In *Sammy Sneeze* the fun is in watching how each elegantly complicated panel differs from the last, and in the comforting repeti-

From the Feb. 19, 1905 strip. [©2007 Pete Maresca and Sunday Press Books]

tion. In *The Upside-Downs*, it's in the ingeniousness of the illustration; in *The Woozlebeasts*, it's the delight of the nonsense creatures, who are described in fairly rudimentary limericks. The stories that are provided are simple and subordinate — in the *Upside-Downs*, in particular, you get the feeling that Verbeck doodled first and then built the story around whatever random thing he decided he could turn on its head. In none of these is there development, either of story or joke. Instead, the strips provide a kind of optical orality. They're eye candy.

"Fred Ott's Sneeze" used to be eye candy too; when the film process was just beginning, anything moving on the screen was a source of wonder. Now, of course, what interest it has is historical. Neither can comics these days survive solely on visual wonder; for the most part, you really do need to make some concessions to plot and genre if you want people to look at your work. Nonetheless, some elements of comics' infancy survive. Linda Williams, in *Hard Core*, points out that both "Fred Ott's Sneeze" and porn share a common focus on biological ejaculations. Similarly, I think that the emphasis on surface pleasures in McCay and his contemporaries has a later analog in the cheesecake-inspired drawings of Los Bros Hernandez, and even in the fetish art of R. Crumb or Michael Manning. McCay's eye-candy approach also has an echo in *shoujo* and *yaoi* (where narrative coherence can take a distant second to flowery compositional bliss), and in Fort Thunder.

Of course, the comics faction that has most embraced McCay is not *shoujo* or Paper Rad or porn, but art comics. Which is a bit strange, because, as far as I can tell, the aesthetic goals of McCay couldn't be more different than those of, say, Art Spiegelman. It's true that Chris Ware has (brilliantly) borrowed a lot of McCay's style, but this only emphasizes how completely different they are as artists. For Ware, visual repetition is not a source of delight, but of existential monotony — effortless creativity is transformed into labored wasteland.

I don't blame Ware for the cannibalization of McCay's corpse — artists take bits and pieces of whatever they can from wherever they can, and they certainly don't have any obligation to remain true to someone else's vision. Still, it's too bad that (to return to Oedipus) the success of the son has so thoroughly obliterated the memory of the father. Which is to say that critics writing about Winsor McCay seem indecently eager to turn him into Chris Ware.

In this regard, the worst sinner in the volume is Jeet Heer. Heer provides an introduction for McCay's *Hungry Henrietta*, a black-and-white strip produced at the same time as *Little Sammy Sneeze* (many of the *Henrietta* strips

From the Oct. 23, 1904 strip. [©2007 Pete Maresca and Sunday Press Books]

are reproduced here on the reverse side of the *Sammy* strips which ran on the same day.)

The early *Henrietta* strips start out with her as a baby, being fussed over by grotesquely cavorting adults — at the end of each episode, she is offered a bottle, which she drinks with a single tear trickling from her eye. Over the course of later strips, Henrietta ages, and her appetite develops apace — each episode now focuses on her consuming vast quantities of some foodstuff or other, with the last panel generally featuring her fast asleep in peaceful and bloated contentment. Heer's interpretation of this is: "... while overzealous adults are eager to assuage Henrietta's anxiety, they themselves are the cause of her worries. ... By being overprotective, they turn her into a nervous nelly, always whimpering and needing cookies to calm her nerves. ... Eventually, Henrietta becomes a slave to her stomach."

So for Heer, *Hungry Henrietta* is about the tragedy of eating disorder; it's a kind of after-school special. If this argument is to make any sense, you have to assume that (A) McCay has some passing interest in psychological realism, and that (B) McCay believes that being a slave to your stomach is a bad thing. I don't think that there is any evidence that either of these things is true. On the contrary, the whole point of *Henrietta*, it seems to me, is not that she experiences some sort of vaguely Oedipal narrative development, but that she doesn't. She gets older, but the joke is she stays exactly the same. In those early strips, she isn't driven to eat by the insensitive adults around her; the adults are insensitive and grotesque, from her perspective — *because they won't let her eat*. She isn't sad in those last panels where the tear slides down her face. She's crying, yes, but she's calming down — the tear is the last sign of her fading discontent. Anxiety doesn't make her eat; on the contrary, it's the fact that she's hungry which makes her anxious (until she fills up, of course!)

In other words, McCay simply didn't do literary psychodrama, no matter how much Heer and other arts comics scholars might wish that he did. Rather, Henrietta eats the way that McCay draws; with a simple and tireless delight. ■

Noah Berlatsky is the editor of *The Gay Utopia*, an online forum with contributions from Dame Darcy, Johnny Ryan, Ariel Schrag, Michael Manning, Matt Thorn and Edie Fake, among others. http://gayutopia. blogspot.com/

A Dangerous Woman:
The Graphic Biography of Emma Goldman

Sharon Rudahl
New Press
128 pp., $17.95
B&W, Softcover
ISBN: 9781595580641

Review by Leonard Rifas

To a remarkable extent, *A Dangerous Woman: the Graphic Biography of Emma Goldman* conveys its message by manipulating the shapes of its panels. Fully unleashing a style that had characterized her stories in underground comix (including her 1980 solo comic *Crystal Night*), Sharon Rudahl has composed pages in which the balloons burst out in all directions to knit the pages together, exceeding outlines that already pulse with lightning energy or wriggle sinuously or do both at once, panels that stand up, that rest in ovals, and that finally disappear entirely, leaving us on the last page with the famous anarchist Emma Goldman entirely unframed after a life lived beyond ordinary limits.

The liveliness of *A Dangerous Woman*'s panel boundaries creates a Brechtian *Verfremdungseffekt*, with the unusual shapes forcing the reader into a critical frame of mind, unable to enter completely or for long into the world imagined on the page. This makes a virtue of necessity, since compressing the details of Goldman's full and fully documented life from 1869 to 1940 into 112 pages of comics requires frequent jumps from one event to another, often bridged by dense blasts of historical commentary. The morphing panels, unlike ordinary rows of cell-like boxes, serve as constant reminders that this story does not hold a mirror to reality, but an ornate picture frame.

The most dramatic episode in Goldman's life was to conspire with her lover and fellow anarchist-commune member Sasha Berkman to create an "attentat," a bold deed that would terrorize the factory owners and inspire the workers with the knowledge that the crimes against them would be avenged. On pages 30-31 of her book, Rudahl has plenty of dramatic material to work with, tinged with sex and heavy with violence. (If you prefer

[©2007 Sharon Rudahl]

to learn of those events by reading *A Dangerous Woman*, consider this your Spoiler Warning.) On the top of page 30, Emma Goldman is attempting to raise money to buy a gun for Sasha by offering herself to the cause as a streetwalking prostitute, but she lacks the "knack" to attract business. Nevertheless, she does succeed in raising enough money for him to buy a dagger and a gun, and on July 22, 1892, Sasha Berkman carries these weapons into the private office of Henry Clay Frick, manager of the Homestead Steel Plant. The previous month, striking Homestead steel workers had taken over the plant, and Frick had sent Pinkerton detectives against them, resulting in a deadly gun battle. In Frick's office, Berkman fires three shots in an attempt to assassinate him. Carpenters hear the shots and knock Berkman to the floor with a hammer, but Berkman manages to crawl over and stab Frick in the leg. At the police station, Berkman struggles to swallow the nitroglycerin suicide capsule he had prepared, and the police nearly break his jaw while prying it loose from him. The public rises up to demand that the police crack down on the anarchists.

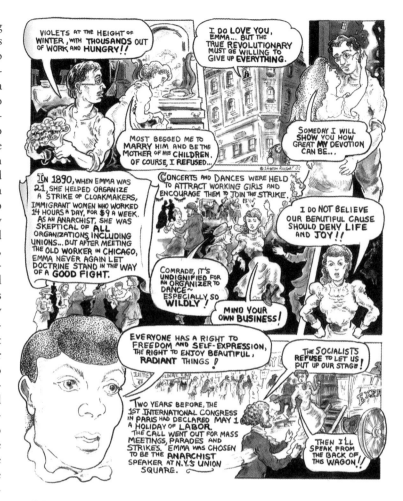

[©2007 Sharon Rudahl]

While newspapers demand her arrest, detectives ransack the flat Goldman and Berkman had shared, and she goes into hiding. She does, though, attend a political meeting where she publicly horse-whips a celebrity anarchist theorist, the former mentor of Berkman and herself — Johann Most — because Most was insinuating that Berkman was in league with the bosses for attempting this counterproductive stunt.

Rudahl's drawings on these pages do not carry the story. Without the captions, it would be easy to miss that Goldman was dressed as a streetwalker, that Berkman was aiming his gun at Frick, that Berkman was clubbed with a hammer, that Berkman stabbed Frick or that the police almost broke Berkman's jaw. Even with the graphic novel's text, the reader does not learn that Berkman hit Frick with the three bullets. The highly agitated panel

boundaries create a visual excitement, but the level of excitement these tricks produce remains at a near constant pitch throughout the book, overpowering the drawings in this part, but pepping up those parts of the story where Goldman merely makes a speech or has a conversation or reads a newspaper.

Berkman spent 14 years of a 22-year sentence behind bars for his attack on Frick. Goldman did not admit her complicity until her autobiography was published in 1931. Rudahl emphasizes the central importance of Goldman's relationship with Berkman to Emma Goldman's life story with several full-page illustrations of the two of them, including one especially effective one in which Emma looks in a mirror and sees as her reflection the imprisoned Sasha.

Goldman's main claim to fame rests on her power as

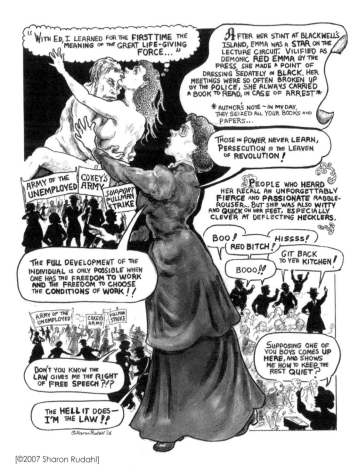

[©2007 Sharon Rudahl]

an inspiring orator. As this graphic novel notes, the art of oratory has been "lost in our age of electronic media." In a unique break from the drawings, Rudahl conveys this with a panel illustrating the spirit of Emma Goldman with her arm raised standing behind a *photograph* of Martin Luther King delivering his "I Have a Dream" speech 44 years ago. (None of the photographs of Emma Goldman appear in this book.) The most famous testimonial to the power of Emma Goldman's speechmaking came when Leon Czolgosz, who had heard her speak in May 1901, claimed when he confessed to assassinating President McKinley a few months later that "Emma Goldman set me on fire!!" When Rudahl portrays Emma Goldman delivering speeches, Goldman does not look like an enrapturing, wide-mouthed orator, but has the appearance of a woman raising her hand for permission to ask a question.

Besides the power of oratory, the power of sex also seems flattened in the book's pictures. In drawings scattered through the book, Goldman — famous for her

advocacy of love and sex without marriage — is first shown on the bottom, discovering how brutal intercourse can be, then rising at the side of her impotent husband, riding on top of Sasha Berkman, and almost vertical with Ed Brady and then Ben Reitman and then Frank Heiner, paralleling her rise as a sexual being toward egalitarian relations. (By interrupting this upward progression with a different position, the drawing of sex with the "strange and exotic" Hippolyte Havel seems slightly more charged.)

One exciting aspect of this project is that Goldman's highly readable, very long autobiography *Living My Life*, from which this story has been taken, is Web-posted. Without much trouble, a reader can compare Goldman's stories in her own words to Rudahl's adaptation, while at the same time seeing how severely the story had to be compressed. (The story of the attempt on Frick's life appears as chapters 8 and 9 of *Living My Life*.) In addition to this autobiography, Rudahl used essays and speeches of Goldman and her friends, and had free run of the scholarship of Goldman's biographer Dr. Alice Wexler, who contributed the foreword.

Today, Emma Goldman is perhaps best known for a quotation that she did not actually say: "If I can't dance, I don't want to be in your revolution." Rudahl depicts the incident that gave rise to this slogan more accurately, having Goldman answer the boy who thought her dancing too wild for someone representing the anarchist movement with "Mind your own business!"

Sharon Rudahl, with her background as a political activist and as a creator of anarchist, feminist and Jewish comic-book stories in the underground-comix movement, was the ideal person for this job. This book represents her best comics artwork yet. Rather than simply outlining her figures, she brings out their dimensions with more use of middle tones. Her deeply felt illustrations evoke a bygone age. The idealized images of physical beauty commonly found in Rudahl's earlier work are missing, replaced with more realistic-looking caricatures. Instead of idealizing Goldman's surface appearance, Rudahl uses her drawings to idealize Goldman herself, as a sensitive, fundamentally gentle spirit (even when she

draws the young Goldman biting her father's leg, yanking her teacher's beard or throttling an old lady.)

Longtime comix radical Paul Buhle instigated and co-edited this project. *A Dangerous Woman* has a table of contents, but no index or chronological summary.

Rudahl claims as a goal for the book that it encourage us to be bolder, especially as we get older. An indifference to the personal consequences of our protests makes us powerful people, dangerous to oppressors. In Goldman's case, that indifference meant spending several years as a political prisoner. In 1893, she was sentenced to a one-year term for "inciting to riot," when her audience broke bakery windows to grab unaffordable loaves of bread. She was jailed for half a month in 1916 for the crime of distributing information about birth control. The following year, she received a two-year sentence for urging draft resistance during World War I, after which the United States deported her at age 50 to the country she had fled as a teenager.

Goldman fought against patriarchy, capitalism, communism and fascism to advance the arrival of a world without kings, gods, hunger, greed or war. In the particulars of her struggles, the reader may glimpse a renewed sense of radical possibility as the artificiality of the assumptions that box us in and the categories that separate and enclose us becomes visible, just as the freely intermingling panels on Rudahl's pages shatter their frames. On the other hand, *A Dangerous Woman* provides ample material for understanding why people tended to find Emma Goldman's anarchist message more threatening than convincing.

In most comics, simply outlined, clearly divided panels continue to provide panes through which we can see into and imaginatively enter other worlds. They offer both possibilities for undemanding, reassuringly predictable aesthetic pleasures, and familiar frameworks through which new ideas can be communicated with clarity, efficiency and artistic power. We live increasingly through neatly boxed stories presented on rectangular movie, television, computer-monitor and cell-phone screens and within mostly rectangular comics panels. The long-reverberating intensity of Emma Goldman's willingness to tear through restrictive margins, crash through the screens and defy all limits on freedom remains both rare and scary. ∎

Leonard Rifas teaches a course on sequential art, comic books and graphic novels at Seattle Central Community College. As a comic-book editor, he included Sharon Rudahl's work in Corporate Crime Comics #1 *and 2 and* Energy Comics *many years ago.*

Azumanga Daioh

Kiyohiko Azuma
ADV Manga
688 pp., $24.99
B&W, Softcover
ISBN: 9781413903645

Review by Bill Randall

With *Yotsuba&!*, Kiyohiko Azuma has won fans around the world. Its story of an irrepressible young girl and her put-upon father offers gentle absurdities close to life. Even those comics readers skeptical of the manga "genre" have tried it and been surprised at how funny it is. One expects his earlier work, *Azumanga Daioh*, newly collected in one big volume, to win even more fans.

Azuma should have funny in his blood. He was born in Hyogo Prefecture, a part of the Kansai region in western Japan. Everyone from the Kansai is a comedian, or so they say. If nothing else, most of Japan's *manzai* comedians come through Yoshimoto, an Osaka-based theater and entertainment group. Azuma knows the territory, having briefly studied filmmaking at the Osaka University of Arts. He later graduated from Kobe Design University, well after his first comic appeared in the anthologies. He tips his pen to his heritage with Ayumu, a character born in the Kansai. Her classmates rename her "Osaka" and expect her to crack wise at any moment, not that she ever does.

She appears early in *Azumanga Daioh*. Serialized in *Gekkan Comic Dengeki Daioh* from February 1999 to May 2002, its term of existence roughly equaled that of its subject, the three years of a Japanese high school. Its title sandwiches "manga" between the names of its author and the anthology, the latter title roughly translatable as "Weekly Comic! Electric Shock of the Great King."

Some things are best left untranslated. *Azumanga* retained its original title when ADV Manga first published it in English in four volumes. Its team of translators also included some additional notes to explain certain references, though they don't reformat the page numbers. The translation is light and readable, if one can only say the latter about the new omnibus. It is truly a brick, taking up more shelf space than my copy of *War and Peace*, for pity's sake. I do, however, applaud publishers who collect longer works into fewer volumes, especially in this case, when four volumes would cost almost twice the price.

Azuma follows a group of friends from start to finish of high school matriculation, which resembles real school environments more closely than is normally seen in manga representations. Nothing explodes, no dimensional portals open, and the fantasies stay close to the earth. Cute girls rule the day. That is no surprise: *Electric Shock of the Great King* (ahem) has an audience of mostly hetero boys, and they will always like to look at girls. To suit all tastes, Azuma draws some girls tall, some short; some busty, some lithe, and one with glasses. There's one 10-year-old for the lolicons, who are parodied — not viciously enough — in the form of a male teacher. Azuma even throws in a couple of hot teachers for those highschoolers just discovering Van Halen.

Not to say *Azumanga* panders. Its eye candy does not damage the stories, which appeal to both male and female. It has a gentle humor appropriate for almost all ages (including preteens who say "damn," "ass" and "hell"). Furthermore, it hits the high notes familiar to all Japanese high-school graduates: the sports and culture festivals, the school trip. The characters' lives are dominated by these events in the same way that American high-school students are affected by their own proms and nigh-endless standardized tests. The grounds on which high-school manga have endured, they give timelessly familiar shape to the endless flow of classes. Artists return to this subject again and again, because its audience knows the terrain, but also because it offers a seemingly inexhaustable fount of stories. Azuma knows its theme and variation well, having drawn a parody of the venerable *Urusei Yatsura* while himself in high school.

Azumanga's form, however, differs from virtually all the high-school manga yet translated. *Azumanga* is a *yonkoma*, or "four-panel," the Japanese version of the comic

strip. Its strips run top-to-bottom, two to a page. He includes a few short installments of full-page manga here and there, but they merely bracket the four-panel strips. Hundreds of these form the bulk of the book. Some tell longer stories, but every one has a joke.

The form has deeper roots than full-page manga. The oldest date to the 1920s, but the first important one is *Fuku-chan*, by Ryuichi Yokoyama (not Picturebox's Yuuichi, mind). Spun off an earlier work, it first appeared in the *Asahi* newspaper's national edition in 1936. It continued in one form or another until 1971, an unprecedented run, and remains well regarded to this day. Yokoyama's light-hearted gags focus on the rambunctious boy of the title, while his crisp line-work sets a standard followed by gag cartoonists ever since. His influence can be seen in Ichirou Tominaga and Sanpei Satou, among others, and the strict format has its own rewards. It had a particular flowering in the 1980s and '90s. In 1994, Yokoyama became the first cartoonist designated a Person of Cultural Merit by the government. Osamu Tezuka never received the award, despite all the attention he has received in Japan and out.

Nonetheless, *yon-koma* have been a hard sell for the translation market. This in spite of seminal works (*Sazae-san,* the "Japanese *Blondie*") and mad masterpieces (Enomoto's *Golden Lucky*, covered in the April 2006 *Comics Journal*). The conventional wisdom holds that the form is too pun-y and culturally specific for foreigners. Perhaps more to the point, *yon-koma* usually lack the animation and merchandising tie-ins aimed at the prized youth audience.

Azumanga had a television series, so it also has an English edition. Unlike some of its Japanese and American cousins, its art does not suffer from terminal minimalism. Azuma is quite accomplished in the idiom of boys' manga. *Azumanga* is also a story strip, an innovation on neither shore, but refreshing considering that the gag-a-day format rules even online. Most of the gags have roots in Azuma's clearly defined characters. For example, Sakaki likes cats. She is beautiful and intimidating, so her affection is odd, the formula for hilarity. In a typical strip, repeated a half-dozen times in the first volume, she sees a cat. She reaches to pet it. Slowly. Wait for it — it bites her hand. Hilarious!

Perhaps. Unfortunately, I find most of the characters too flat to enjoy the jokes. Each has a key characteristic: Tomo is competitive, Osaka kind of dumb, and Kagura I don't recall, but she gets really tan at one point. Chiyo is

The teacher turns on the pupil in this *Azumanga Daioh* strip. [©2002 Kiyohiko Azuma, English text ©2002 A.D. Vision, Inc.]

An iteration of the Sakaki cat-bite gag. [©2002 Kiyohiko Azuma, English text ©2002 A.D. Vision, Inc.]

the child prodigy, too short but rich. That's about it. Azuma even sends up their thinness in a strip where Tomo makes fun of Chiyo: "I'm so smart! I'm so rich!" Chiyo gets mad, but Tomo's parody is not just spot-on, it is exhaustive. It was also the first time I laughed out loud.

That gag came on page 370, by which point I enjoyed the book more. The reason, aside from Azuma's incremental improvement, is that 300 pages of anything will grow on you. By then the thin characters and I have some history. Even better, the simplest variations on certain gags have played out, so Azuma has to put more invention into the strip. This development happens often enough in strips — people value the 1960s run of *Peanuts* more than the 1950s for reasons beyond nostalgia. In *Azumanga*, the best sequence happens after a couple of years. The girls build a cat-themed coffee shop. It offers one penguin costume, the culmination of a long, bizarre *Nekojiru* riff, and lots of slapstick. I only wish the lead-up had offered more laughs.

Even though Azuma creates little heat and no fire, *Azumanga* offers a pleasant enough place to visit. I suspect I would enjoy it more as a daily glance rather than a long slog through 600+ pages in a few sittings. Just as listening to music does not improve on record, the reading of comic strips often does not benefit from attractive collections. In this case, the omnibus robs *Azumanga* of its best tool: time. Some kind of serialization would allow its readers to experience time moving along with the characters. Then the pace of reading reflects that of living, and attachments grow. In a collection read in large chunks, our own investment decreases. Had Schulz drawn for 30 rather than 50 years, his achievement would be no less, but our esteem for it would have been.

Yet *Azumanga Daioh* does not, in its own way, ask to be so read. It arcs through three years of high school and then, like its characters, disappears. Everyone's high-school experience is ultimately memorable, if only to them. And everyone's has its own discoveries and entertainments. Some persist, like *Urusei Yatsura*, for their invention and influence, if fewer and fewer read them. Some matter only to their generation. I expect today's high-schoolers might not experience the same electric shock of hearing Rush (ahem) for the first time. Their reaction may resemble mine to *Azumanga Daioh*, a pleasant feeling of being lulled to sleep. ■

MW

Osamu Tezuka
Vertical Inc.
582 pp., $24.95
B&W, Hardcover
ISBN: 9781932234831

Review by Simon Abrams

Diligently released Stateside by Vertical Inc., Osamu Tezuka's manga can be put in two simple categories: white or black. On the one hand is his Harvey Award-winning *Buddha* series, a lavish rendering of the moralistic saga of Siddhartha Gautama and his ascent to Godhood. On the other is *Ode to Kirihito*, Tezuka's sweat-drenched, paranoid "medical thriller," centered on a metaphysical disease that turns men into beasts.

I categorize them simply because they're both works of predominantly simple morals. The corporeal manifestations of evil in *Kirihito*, for example, may seem more abstract, but they're no more nuanced than the kind that Siddhartha confronts. While Siddhartha is beset by the human evils of greedy tin tyrants, thoughtless thugs and callous bystanders, *Kirihito* reveals the worst in people through a pervasive, supernatural threat that turns men into dogs and one of the few women who help Kirihito into a traitor, and "a bitch in heat" to boot.

That being said, *Kirihito* had some small amount of gray in the nightmarish, flesh-turning affliction that afflicts its protagonists, antiheroes and villains. Both people that aid and harm Kirihito can be infected. *MW*, Tezuka's follow-up, boasts no such complexity in its villain's motivations. Yuki is motivated by naked ambition. An androgynous and scheming social climber who seduces his way to an Agent Orange-type chemical weapon, he's just a cartoon man without a conscience, whose outlandish plans to hump and then pump full of bullets anyone who gets in his way are more hammy than evil.

Worse, Yuki is a Punch-and-Judy aggressor with more bark than bite. Just because he sleeps with everyone in Tokyo and then laughs maniacally about how doomed they'll be after he gets his hands on MW, doesn't mean that he's, as one of the chapters calls him, "The Devil Incarnate."

Nevertheless, removing *MW* from its historical context takes away most of its impact. To an American reader to-

[©2007 Tezuka Productions, English text ©2007 Camellia Nieh and Vertical, Inc.]

day, it's the subject of jaded tsk-tsks and passé jokes. But when *MW* was originally published in 1976, in a serial format in *Big Comic* magazine a few years after *Ode to Kirihito* made a well-deserved splash, its content was shocking.

At the time, the hypocrisy of moral figures like Father Garai, a Catholic priest whose coupling with Yuki ethically

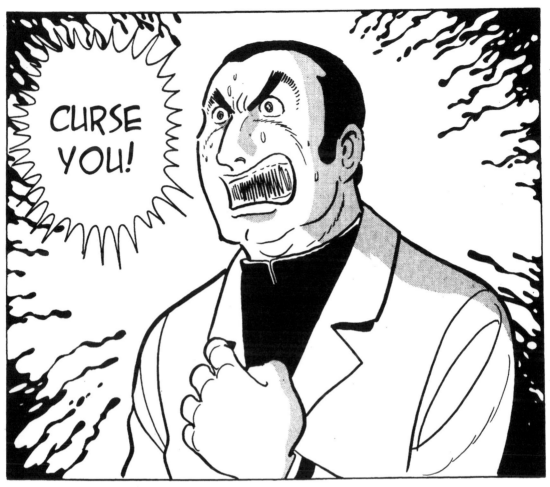

drags him down with the flamboyant flimflam man, was astounding. Likewise, news of the horrors of American chemical weapons was appalling then, even if they're nothing that we haven't processed and willfully forgotten now.

However, while both instances did jolt, it's unlikely that Tezuka wanted to do anything more than needle his readers by giving an otherwise preposterous villain real-world relevance. The story's melodrama intentionally undercuts its real-world implications. Garai's impotent wide-mouthed cries of outrage at discovering Yuki's manipulative schemes are absurd, especially when he's reduced to bellowing, "Curse you!" at no one in particular.

The only redeeming grace of *MW* is that while Tezuka may sometimes write pat beginnings, he never writes pat endings where evil is punished simply because it is evil. Left to their own devices, Tezuka's men sink or swim by their own merits. "The devil" doesn't go away in the end

either; he just vanishes out of sight, leaving only figure-heads to suffer.

But, ultimately, *MW* fails because it wants to have its cake and eat it too. Tezuka wants relevance, so he uses a serious problem. But he also wants to shock, so he makes the problem melodramatic. In doing so, he weakens both, making the shock value hollow and the relevance cheap.

Similarly, Yuki's escape seems like a half-hearted attempt at ambivalence. Tezuka takes Yuki, a serious problem, and has him run amok and finally slip away, but stops short of letting him triumph. It is Garai, a lesser evil and Yuki's only conscience-afflicted accomplice, who is sacrificed as a gesture of evil being punished. While *MW* may be superficially dark, its not-so-snarled black heart substitutes moral cop-outs for answers and short-changes the reader of a good story. ∎

Palestine: The Special Edition

Joe Sacco
Fantagraphics Books
320 pp., $29.95
B&W + Color, Hardcover
ISBN: 9781560978442

Review by Rich Kreiner

You'd hope that at this point the actual comics of *Palestine* would need no further introduction (otherwise, long-form admiration can be found in *TCJ* #204). They remain as vital, dynamic and galvanizing as when Sacco created them after his cartoon tour of duty in the waning days of the first Intifada. Given Sacco's talent and journalistic integrity, the enduring power of the comics shouldn't surprise. Nor is it news to anyone reading a decent newspaper these days that their insights continue to be all too timely and pertinent.

No, the quantum advance in readerly riches in this *Special Edition* is the volume's wealth of supporting material. Scholar Edward Said's "Homage to Joe Sacco" certainly deserves the reprinting, but the most revealing add-ons are internal, coming from the cartoonist himself. First is an essay dated 2007, reviewing the origins of the project and Sacco's current thoughts on the comics. Better are journal excerpts from his travels keyed to individual scenes and passages. Best are the excerpts coupled with photographs that were to become the raw ingredients of panels and pages. Included too are "outtakes" and redrawn segments.

For other cartoonists I imagine this edition would be a particularly fascinating and instructive examination of an extended and complex creative process. I imagine this because, for a non-cartoonist, these extra features are very much like the explanation of a really good, really complicated magic trick: They reveal how an astonishing feat was accomplished, offering in the place of an intractable mystery an enhanced esteem for rigorous problem-solving, human ingenuity and riveting execution.

Sacco's next book promises a return to the region to update conditions within the politically divided Palestine along with, no doubt, the evolving methods of steely mass-strangulation and sudden, indiscriminate death-from-above. Until then, this *Special Edition* relates a history doomed to be repeated. ∎

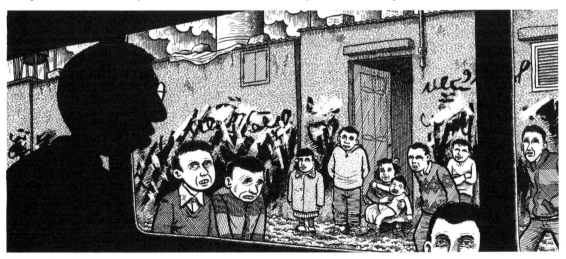

[©2007 Joe Sacco]

The Loud Silence of F. M. Howarth's Early Comic Strips

by Jared Gardner

Franklin Morris Howarth lived a very quiet life — so quiet, in fact, that few details of his 44 years are available to us today, which is no doubt precisely as he would have wanted it. Although he achieved fame as a cartoonist publishing in the preeminent New York illustrated magazines of his day, especially *Life* and *Puck*, he continued to live in Philadelphia, where he had been born in 1864. Howarth's father, William, had emigrated from England a few years earlier, finding work in the city as a pattern-maker, constructing molds for the emerging factory system — a skill set that Howarth would inherit in his own meticulous attention to line and design. Franklin was the eldest of four children and, by age 15, he was already done with school and working full-time as a clerk to help support the family. At age 16, Howarth began submitting illustrations and cartoons to the *Philadelphia Weekly Call* and other local papers, and by the early 1880s he had achieved sufficient success to pursue the career full-time.

It was perfect timing, as this was a golden age for periodical comics. The most influential of the illustrated comic weeklies, *Puck,* had launched in 1877, and by 1883 the energetic young cartoonist could also turn to *Life*, *Judge* and *Truth*, as well as a series of monthlies that had only recently discovered the appeal of comics. It was an exciting time to be starting out as a cartoonist, and Howarth clearly was inspired to experiment with both form and style. From the start, his comics looked different from most of his contemporaries, demonstrating an uncharacteristically clean line and sharp detail and deploying a striking amount of black. But in terms of his influence on the young art of the illustrated magazine, the most significant characteristic of his early work was his bold experimentation with sequential comics, as opposed to the single-panel comic still favored by most of the leading lights of the day.

These early experiments, mostly at the first *Life* maga-

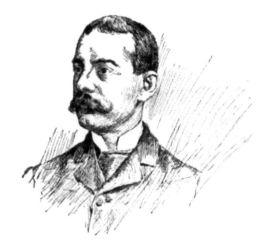

Portrait of the cartoonist as a young man.

zine, serve as one of the important foundations for the development of sequential graphic narrative in the coming century. While it is certainly too much to say, as his obituary would suggest in 1908, that he was "the first to run a series of drawings in periodicals," it is the case that he was as, Ian Gordon puts it, "the leading American proponent of multipaneled comic stories." Further, Howarth brought to sequential comics the focus on urban themes, types and mobility that would be the thematic bread-and-butter of the early comic strip in the works of Outcault, Opper, Swinnerton and others.

Growing up in the Philadelphia area, with its large German-speaking population and cosmopolitan literary community, Howarth had early and frequent contact with the sequential comics coming out of Europe, especially the comics work inspired by Wilhelm Busch in German and French magazines. Many of Howarth's early comics explicitly played off the naughty-boys routine Busch had perfected in *Max und Moritz* and which would provide a foundation

of the newspaper comic strip for years to come, beginning with *The Katzenjammer Kids*). And like Steinlen in France, he found animal acrobatics a source of fascinating fun.

But early on, there were aspects of Howarth's work that showed his determination not only to learn from European innovations, but to adapt them to an American urban context. Howarth's comics, for example, demonstrate a particularly dark comic twist that was unique to his work during this period, often focusing on urban crime. Howarth would alternate between openly winking at the thieves and tramps who operated in the shadows of the sprawling new metropolis and cheering their targets who came up with innovative ways of surviving the urban jungle.

There is a strong connection between the rise of sequential comic strips in the U.S. and Europe and the rise of the modern city, especially its most distinctive architectural feature: the apartment building. While tenements had been a fact of working-class life since the 1840s, urbanization in the 1880s brought about the rapid spread of apartment life to the middle-class. By the end of the 1890s, more than half of the city's population lived in apartment buildings. Suddenly the term "neighbor" began to shift in meaning, increasingly suggesting strangers and even adversaries rather than the tight-knit, organic community of earlier years. Social theorists at the time were quick to point out the potentially negative consequences of such a transformation, predicting dire consequences for the mental and ethical life of modern man as a result. As one respected journal of the period put it, "Local interests are destroyed, the homestead ceases to be a reality, old friends are forgotten, new acquaintances are made with less and less freedom, and seldom ripen into strong attachments."

The young Howarth, however, clearly relished the visual and narrative possibilities of this ominous apartment building, whose multiple stories and windows visually echoed the sequential comics form he was experimenting with at the time. In fact, more than any of his contemporaries, Howarth used the unique architecture of the multi-story building as a central device in his comics. And at first glance, his comics seem to echo the concerns of those who saw the breakdown of civilization in this mode of "cooperative living." For example, in "The Fifth Floor Lodger and his Elevator" (1890), the cruel humor lies less in the trivial theft of the oranges than in the fact that the apartment building's cohabitants are so estranged from one another as to take gleeful pleasure in their criminality. The amorality and nihilism of modern city life is the favorite joke of Howarth's early sequential comics — often played out to grisly effect. In "An Interrupted Elopement" (1891), for example, a valiant suitor from a more romantic era plummets to his death from a pulley "elevator" very similar to that devised by the "Fifth-Floor Lodger," as robbers appear at just the wrong moment (as they seemingly always do). Criminals are forever intruding in Howarth's apartment buildings, usually triumphing over their more respectable victims. For example, in "A Nocturne in Black and White" (1889), robbers break into a house and then watch, delighted, as the frightened tenant leaps from the second story window onto the police below. Howarth's city is one in which robbers are at every window, and the police cannot tell victim from thief. So crowded is the space of these early cartoon cities, that someone or something is forever being crushed or squeezed out an upper-story window.

In addition to apartment buildings, Howarth also explored the anarchic possibilities of the tramp, the outcast of urban "progress" and the lord and master of that other phenomenon of the late-19th century city: the urban park (Central Park was completed just a few years earlier). For example, in "The Reward of Enterprise" (1890), Howarth describes the way a tramp secures a crowded park bench for his private enjoyment. In the previous decade, a cartoonist would have handled the subject in a single panel, the tramp luxuriating on the empty bench as its former occupants retreat in disgust. And by the end of

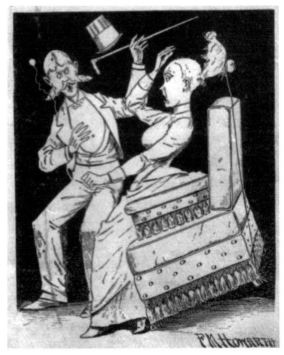

Detail from Howarth 1889 comic.

Detail from *E.Z. Mark* (1906).

Reward of Virtue" (1891), for example, the tramp takes advantage of a mother's inattention to push a baby carriage into the pond, enabling him to stage a "rescue" and claim his reward. The butt of the joke, here as elsewhere, is not on the tramp's machinations, but the inattention of the baby's caretakers, so easily distracted by all the sights, sounds and crowds of the new city.

Of course, like so many of his contemporaries, Howarth's more modern and urbane comics existed side-by-side with many strips that indulged in the lowest form of racial and ethnic stereotyping, too often the escape valve for Anglo-Americans confronting a growing city and a changing citizenry. And unlike Howarth's contemporary, Frederick Burr Opper, whose use of stereotyping ways displayed an abiding respect for his subjects, Howarth's racial Others were, at best, minstrel entertainment. Indeed, when put side by side with his single-panel work, which often displayed a coarse humor and decidedly unliterary sensibility, or alongside the starched nostalgia of Howarth's later newspaper strips, the strips collected in the gallery here seem almost to be the exceptions in a career that otherwise produced little truly remarkable work. And yet, this work *is* remarkable and needs to be appreciated as such in its own terms, even if Howarth himself seems to have abandoned what was truly exciting and revolutionary in his earlier career.

Once Howarth joined *Puck* as a member of the stable of cartoonists, he began to achieve his greatest fame, ironically coinciding with a marked drop-off in his innovativeness as a cartoonist. But of course, the coincidence should probably not surprise us: As Howarth looked to "brand" himself for *Puck*'s considerable audience, he could not help but notice that he had gained more attention and applause for his stylistic innovations than for his more radical experiments with wordless urban comic strips. And the silent strip did not fit in well with *Puck*'s very text-heavy political and social satire. And so, Howarth largely abandoned the silent sequential comic,

the decade, Howarth himself, having lost confidence in his earlier pantomime strips, would have annotated this sequence with conversation or description. But here, at the height of his powers, Howarth is content to let the study in urban types play itself out silently. Except for his slow movement from left to right across the frame, the tramp's body and expression never change, and no words are exchanged as each of his neighbors retreats in disgust. If film, as we know it, had existed at this time (it was but a glimmer in 1890), we might well describe this and other early Howarth comics as "cinematic."

The tramp figure, which, in the next generation, Charlie Chaplin will develop as the repository of romantic virtue in the unreal city of modernity, is Howarth's deeply amoral trickster figure, able to take advantage of his own marginal relation to this crowded city, turning random events to his advantage or amusement. In "The

Detail from *Old Opie Dilldock's Stories* (1908).

increasingly focusing on text-heavy strips emphasizing what emerged as his defining stylistic innovation: oversize bodies on tiny legs.

While the style would indeed prove extremely influential on the emergence of the first comic-strip characters in the early 1900s on through *Peanuts*, Howarth's discovery of this style came at the cost of all that made his earlier strips so dynamic and exciting. No longer were bodies in motion, caroming like pinballs around the modern city. Howarth's strips instead became static vignettes, heavily captioned and increasingly nostalgic for a Victorian sensibility that his own earlier work had helped make obsolete. But in terms of his career, Howarth had a steady job as a full-time cartoonist at *Puck*, still the most influential illustrated magazine of its day, and in 1899, *Puck* authorized the publication of a book of Howarth's comics, *Funny Folks*, arguably an important milestone in the development of the modern comic-book format. It was this book that surely caught the eye of William Randolph Hearst, who hired him a couple of years later to join Opper in pioneering the new Sunday supplement and the newspaper comic strip.

Unlike Opper, however, who would fully explore the possibilities of comic strips with *Happy Hooligan*, reinventing himself as an artist and a graphic storyteller in his middle years, Howarth was most decidedly not up for the job, seeming to retreat from the very possibilities his earlier work had opened up. His two most important strips of the 1900s were *E. Z. Mark* and *Lulu and Leander*, both attempts to translate successful work for *Puck* in the late 1890s to the newspaper comic. *E. Z. Mark* at least displays some signs of the old Howarth in its interest in urban themes. Telling the repeated adventures of a constitutional dupe of every conman and scam that the city can throw at him, each week's strip would end with E. Z. shaking his fists impotently at the heavens, realizing he had once again been taken for all he was worth. It was *Lulu and Leander*, however, that Howarth would focus on for his remaining years, and a century later, there is little aside from Howarth's craftsmanship to recommend the strip. It tells tiresome tales of Leander's continued defeat by his rivals for the attentions of the lovely Lulu, and the whole thing feels very much like a stiff throwback, a strip that proclaims its almost belligerent old-fashionedness in the Victorian dress and stuffy names of its protagonists. The strip dragged on for several years, finally dropped with no apparent protest from readers in 1907.

In the last year of his life, he had attempted to salvage his faltering career with a new strip, *Old Opie Dilldock* for the Chicago Tribune syndicate. The strip demonstrated little evidence that Howarth had recovered his

Self-portrait.

earlier faith in the power of the image to tell stories on its own, and he retains his growing fondness for characters that look more like Victorian paper-doll cutouts than dynamic characters. But *Opie* does display a new joy and energy in the story itself, taking its protagonist on new adventures each week to lands as wondrous and strange as any Little Nemo would explore in the coming years. As the newspaper comic strip began to truly open toward the end of the first decade of the 20th century, one cannot help but wonder whether Howarth would have found new inspiration in the work of men like Winsor McCay or George Herriman. Unfortunately, as was all-too common in those days before antibiotics, Howarth died in 1908 from pneumonia at the age of 44.

No doubt because his own career seemed to take him backwards, away from the vistas he opened up for narrative comics, Howarth's role in the history of the form is not well known today. Hopefully, this gallery of some of his exciting early comics will remind us how much we owe to his efforts. ∎

A NOCTURNE IN BLACK AND WHITE.

AN INTERRUPTED ELOPEMENT.

THE BEAM IN YOUR OWN EYE.

A GOOD JOKE.

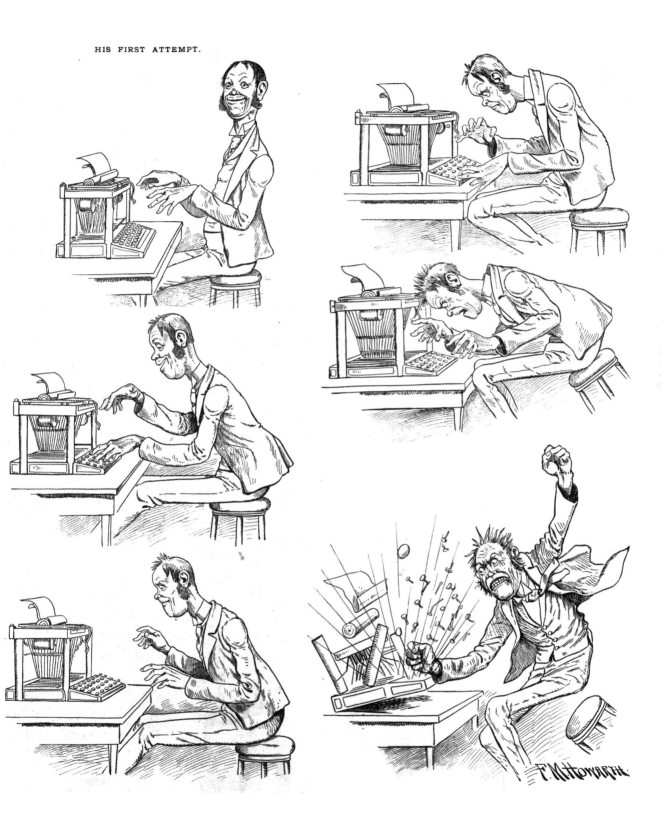

ONE TURN TOO. MANY.

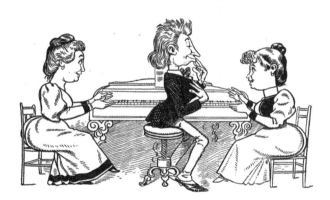

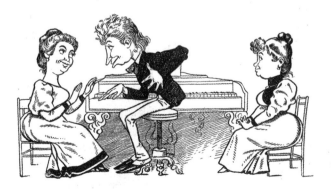

THE FIFTH-FLOOR LODGER AND HIS ELEVATOR.

A LESSON IN SUBTRACTION.

A STOLEN REPAST.

THE REWARD OF ENTERPRISE.

The Bilious Eye of George Price

by Donald Phelps

"The Professor here tells me that this goddamned thing is the Ubangi symbol of fertility." — *Caption of a* New Yorker *cartoon by George Price*

George Price helped introduce *The New Yorker*'s readers to a comic tone of saturnine deadpan: sandpaper rough, tinctured with petty-bourgeois crassness, unlike the urbanities of Whitney Darrow, Peter Taylor or others of *The New Yorker*'s tone-setters. Price emphasized his middle- to low-income characters' capacity for accepting, even engendering nonsense (the idle rich were included, but more rarely). He favored tenement dwellers, both white-collar and flannel-shirted working stiffs, definitely including the speaker quoted above.

Heavily mustached, in short-sleeved undershirt, his eyes vertical streaks of bleary misgiving, he holds aloft the symbol of his procreative misfortune. Beside him is the Professor, in spectacles and Van Dyke beard, still wearing (fresh returned from his digs?) pith helmet and jodhpurs. And thronging them, to the tenement room's very plaster are the handiwork of the Ubangi *objets d'art*: children, ranging from toddling 2 to tapering teens. Price's masterstroke, the image itself — poised in the hand of the protesting paterfamilias — is a tiny figurine, barely distinguishable from a captive water bug.

The diversity of visual detail would do justice to Theodore Dreiser. Most notably, the Professor's presence is suavely integrated into the swarming variety of presences — the dense interplay of angles and curves underscored by the fine discretion of Price's shading. Price's best cartoons observe a crisp urgency in the interplay of lines. A distinct energy is transmitted even by his motionless figures. He can transmit the fetid entanglements of second-hand clothing, the defiant inanity of musical instruments, in a Third Avenue junkshop from "anytime" — while, in the foreground, the dealer vaults over

"Boy, did I have an afternoon! The census man was here."

A 1940 George Price *New Yorker* gag cartoon. [©2004 The New Yorker]

the counter, dramatically plugging the accuracy of some secondhand binoculars. Visual verisimilitude is always on hand, like a mercenary army, in Price's drawings: Ready to support absurdity itself against the stark background of a judge's bench, a frenzied, posturing prosecutor hurls pantomimed denunciation/exhortation at the "witness," a parrot, perched on the witness chair. From far above, the judge's only comment is a pair of mildly elevated eyebrows.

Price handled the outright fantastic and surreal on occasion with the matter of fact-ness familiar during the popularity of "fantasy fiction" that marked the Depression '30s, in the fantasy fiction of Michael Fessier, Nelson Bond and their like in the pages of *The Saturday Evening Post* and *Esquire*, always with the amiably crass wink. Price's low-income personae receive with weatherworn aplomb the visitations of fabulous wealth or its symbols. "Notice anything new, dear?" asks an ancient dowager, a lorgnette in hand, as her mate hangs up his coat in their crumbling single room. Very obviously, he has not. Against one unpapered wall, next to a gash of missing plaster, there stands erect a liveried chauffeur. A young husband, in similar straits, undertakes to explain to his pretty wife his towering, fez-adorned, scowling companion. "Remember that raffle, we thought would win us a turkey?" Such visitations suggest the 1930s comedies of Frank Capra or Preston Sturges' chronicles of preposterous social fluctuations: *The Palm Beach Story, Christmas in July, Sullivan's Travels*. But Price's graphic dexterity and humane skepticism bypass both Sturges' romanticism and Capra's sentimentality. He was an outstanding documentarian of old age: neither cutesy quaint, nor — like Kliban's "Madame" cartoons in *Playboy* — a cruel caricaturist. Even certain mordant flights radiate a wry plausibility. Consider the reverie sequence of an old lady in a rocking chair, dozing cat in her lap, as she recalls her early marriage and its progress: Dream chronicle, or wish-fantasy? Either way, it retains its mordant lilt. He realized a refinement of stylized realism that, with his subtle and dexterous command of tone, guarantees George Price's place of respectful recognition in 20th-century American cartooning. And perhaps a creative heir or two. George Booth, a longtime *New Yorker* contributor, has evolved his own microcosm of comic squalor, usually involving a moribund couple, a dog with the face of a senile lecher and a rudimentary table-chairs set. Already more hopeful, an accomplished heir of George Price's jaundiced vision. ∎

French Quarter Becomes Habitat for Reuben Winners

by R.C. Harvey

If your newspaper runs Wiley Miller's *Non Sequitur* on Sundays, you may have guessed, if you are inclined to leap at conclusions, who won the NCS Reuben as "cartoonist of the year." Miller, who drew the strip six or seven weeks ago — making it a high flying performance of audacious daring or colossal cynicism (or, perhaps, cynical daring) — effectively predicted which one of the three nominees would win by congratulating Al Jaffee, the 87-year-old cartoonist famed for "fold-ins" on the last page of *Mad* magazine. And just to make sure we all knew who he was talking about, Miller devoted the Sunday strip to a fold-in made by his perspicacious young heroine, Danae. Miller was not alone in commemorating the New Orleans meeting of the National Cartoonists Society over Memorial Day Weekend, May 23-25. Greg Evans in *Luann* also dedicated his Sunday May 25 strip to his brethren in the inky-fingered fraternity. But Miller, by then, had already gone Evans one better, devoting the previous Sunday to NCS and other New Orleans disasters. Bil and Jeff Keane at *Family Circus* also noted the convergence in New Orleans of the nation's 'tooners. And three days later, the *Washington Post's* political cartoonist, Tom Toles, did a fold-in cartoon; he didn't mention Jaffee, but he undoubtedly knew Jaffee was up for the Reuben and was probably cheering him on.

Miller's daring in predicting the Reuben winner this year is not quite as stupendously audacious as it seems. In recent years, NCS arranges, every once in a while, for one of the Reuben nominees to be a heroic figure in the history of cartooning — Will Eisner in 1998, Jack Davis in 2000 — and whenever that gesture of recognition is made, the colossus inevitably wins over the two other nominees, whose accomplishments are contemporary rather than historic, mundane, comparatively speaking, rather than epochal. This year, Jaffee was running against *Speed Bump's* Dave Coverly and *Bizarro's* Dan Piraro,

both of whom had been nominated before but hadn't run against one of the profession's legends; this time, they did, and, predictably — as Miller has amply demonstrated — the legend won.

Incidentally, Miller claims no special insight in predicting Jaffee's win: "Really, it was a no-brainer," he told me. "When I saw he was a nominee, I got to thinking, who was NOT going to vote for such a beloved icon as Al Jaffee? He's 87 years old and everyone loves him! He might have even gotten Dan Piraro's and Dave Coverly's vote! It's not a matter of bias on the part of the NCS; it's simply human nature. And as cartoonists, we're supposed to be observers of human nature ... and I know the membership of this organization all too well. So this was really a one-time deal. Ordinarily, you can't really tell how the voting will go for the Reuben or any of the division awards. I had several people ask me if I had some 'inside information' on the Reuben winner. It just made me laugh. They do hold that information very tight, as they should. I sent Jeff Keane [NCS President] a copy of the strip several weeks ago, just to give him a head's up, and I got no hint from him one way or the other on the accuracy of the cartoon."

Before *Mad*, Jaffee did humorous comic-book characters (*Inferior Man, Ziggy Pig and Silly Seal, Squat Car Squad*, not to mention *Patsy Walker* and *Super Rabbit*) and a syndicated feature called *Tall Tales*, a vertical pantomime cartoon (1958-65). Ron Goulart in his *Encyclopedia of American Comics* quotes Jaffee's response to a question asked by one of his NCS colleagues who wanted to know Jaffee's goal in life: "To become a vital force reshaping the social intellectual, and political destiny of mankind with a view toward bringing peace, prosperity, and a higher degree of understanding between people regardless of race, color, or creed throughout the world and elsewhere." It was probably an election year when he said that. Jaffee's

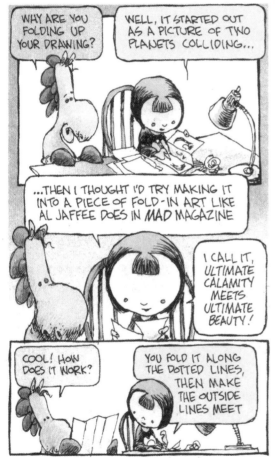

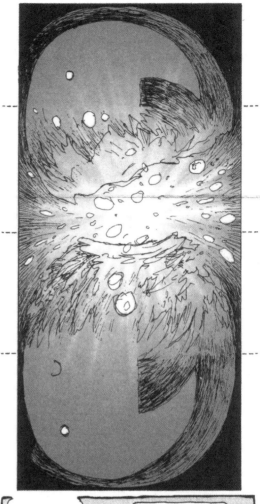

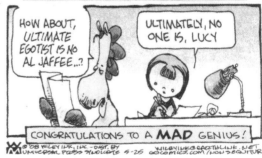

Tall Tales is being reprinted with an introduction by Stephen Colbert; due out soon.

The evening after the awards banquet, wearing a crown and seated in a horse-drawn carriage with another *Mad* legend, Jack Davis, Reuben winner Jaffee led a parade of cartoonists through the streets of the French Quarter, a typical New Orleans jazz band preceding the ensemble, to the dining finale of the weekend at Broussard's Restaurant, where everyone lined up for a lavish New Orleans buffet.

Al Jaffee and his wife Joyce: courtesy of R.C. Harvey.

At the Reuben banquet on Saturday, Sandra Boynton, greeting-card entrepreneur, Grammy-nominated songwriter and comical illustrator, received the Milton Caniff Lifetime Achievement Award. She also won the Reuben division award for book illustration. Attorney Stuart Rees was awarded the Silver T-Square for his tireless work on behalf of cartoonists and the society, and NCS presented the first Jay Kennedy Award, named for the late highly regarded editor-in-chief of King Features, to Juana Medina, who moved to the U.S. from her native Bogota, Colombia, in 1998 to continue her studies in art and design at the Corcoran College of Art and Design in Washington, D.C., and then at the Rhode Island School of Design, where she now regularly contributes cartoons to the weekly campus magazine, *College Hill Independent,* produced by students at nearby Brown University and RISD. The Kennedy Award is accompanied by a $5,000 scholarship from the NCS Foundation, which, this year,

received more than 200 applications.

Winners of the Reuben "division awards" were also announced at the Saturday banquet. Since being nominated is as distinct an honor as winning, I'm listing here all the nominees, with an asterisk next to the winner in each division: Comic Books — Nick Abadzis (*Laika*), Bryan Lee O'Malley (*Scott Pilgrim Gets It Together*), *Shaun Tan (*The Arrival,* a graphic novel, not, strictly speaking, a comic book; Tan was not present to receive his award); Newspaper Comic Strips — Paul Gilligan (*Pooch Café*), *Jim Meddick (*Monty;* Meddick was not present to receive his award), Richard Thompson (*Cul de Sac*); Newspaper Panel Cartoons — *Chad Carpenter (*Tundra*), Glenn and Gary McCoy (*The Flying McCoys*), Kieran Meehan (*Meehan*), a Scot who also does the comic strip *A Lawyer, A Doctor & A Cop;* Newspaper Illustration — Drew Friedman, *Sean Kelly, Ed Murawinksi; Magazine Gag Cartoons — Benita Epstein, *Mort Gerberg, Glenn McCoy; Editorial Cartoons — Gary Brookins, Michael Ramirez, *Bill Schorr; Greeting Cards — Gary McCoy, Glenn McCoy, *Dave Mowder; Magazine Feature Illustration — *Daryll Collins, John Klossner, Tom Richmond; Book Illustration — Nancy Beiman (*Prepare to Board*), *Sandra Boynton (*Blue Moo*), Jay Stephens (*Robots*); Television Animation — Sandra Equiha and Jorge Gutierrez (*El Tigre: The Adventures of Manny Rivers*), *Stephen Silver (*Kim Possible*), Richard Webber (*Purple and Brown*); Feature Animation — Brad Bird (*Ratatouille*), Sylvain Deboissy (*Surf's Up*), *David Silverman (*The Simpsons Movie*); Advertising Illustration — Jack Pittman, *Tom Ricmond, Tom Stiglich.

Mike Peters, editoonist and creator of *Mother Goose and Grimm,* was Master of Ceremonies for the Reuben Banquet, taking the podium vacated after last year by Dan Piraro. Peters' performance included ripping off his tear-away tuxedo to reveal, beneath, the Superman suit he always wears under his street clothes, and a riff on Patrick McDonnell's *Mutts,* to which Peters could not help but compare his own strip, which also features a dog and a cat but, alas, has never won accolades for animal activism like *Mutts* has. Peters began by saying how wonderful *Mutts* is, then he recalled that every time he opens *Editor & Publisher,* he sees yet another article extolling the public-spirited virtues of "the goddamn *Mutts*" for spotlighting the good work of yet another animal shelter. Peters announced his decision to try for similar commendations by devoting future *Grimm* installments to representing an underrepresented and abused species — bugs, say, tape

worms in particular. His remarks were illustrated by pictures of Grimm with a tape worm partially protruding from the dog's, er, anus, saying, "It's really dark in here." Hilarious, but you probably had to be there.

The afternoon seminars on Friday and Saturday contemplated gag cartooning, cartoonist biography and comic-stripping. Mort Gerberg began a brief review of his career by noting that when he started out, he was told magazine gag cartooning was a dying craft. Twenty years later, he was told the same thing; and, years later, he's still hearing the mantra even today. He showed cartoons from a recent collection of gag cartoons he edited on death and dying and old age: *Last Laughs.* Nancy Goldstein talked about her research into the life and cartooning artistry of Jackie Ormes, recently published in *Jackie Ormes: The First Female African American Cartoonist.*

And then Mark Tatulli, who draws both *Heart of the City* and *Lio,* made a presentation that concentrated mostly on the protest mail he gets about *Lio*'s corrupt morality. "All I ever wanted was to do a comic strip," Tatulli began, "and now, with two daily strips, all I ever do is comic strips." Tatulli, erstwhile art director in film and

TV, did at least two comic strips before hitting on *Heart of the City,* his first strip to last. *Mr. Fipps,* focused on a junior high teacher, was his debut strip; then *Bent Halos,* about a couple of ne'er-do-well angels. *Heart of the City,* featuring a little fun-loving city girl and her single mom, began Nov. 23, 1998, and is now in 80-100 papers, not enough to make a living for Tatulli, so he concocted *Lio,* which started May 16, 2006; and *Lio,* being about the perverted amusements of the young, is in 300 or more newspapers. It's a living. But Tatulli's daily life is fraught with letters from irate readers, mostly tightly wound religious enthusiasts who object to the Satanism they see lurking in every *Lio* panel, or "concerned citizens" who see Nazism or some other perversion in the strip.

Attendance at this year's Reuben weekend reached almost 350, including the spouses and families of cartoonists and syndicate representatives; of that number, about 180 were cartoonists, practicing and retired. Mort Walker was not present this year for the first time anyone can remember, due to illness in his immediate family; and Bil Keane, the legendary longtime emcee of the proceedings, was also absent: His wife was dying of Alzheimer's.

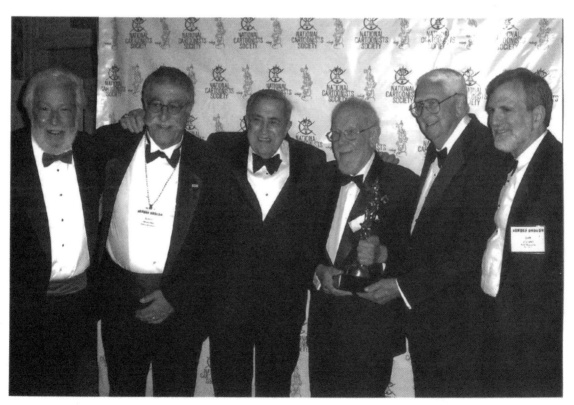

From left to right: Nick Meglin, Sergio Aragonés, Bill Gallo, Al Jaffee, Jack Davis and Sam Viviana: courtesy of R.C. Harvey.

The National Cartoonists Society 62nd Annual
REUBEN AWARDS
The Ritz-Carlton, New Orleans
Memorial Day Weekend
May 23-25, 2008

Tom Richmond art: Mike Peters in Superman costume, followed by Sandra Boyton, Mark Tatulli. To the right of Charlie Brown: Tom Batiuk. Bellow: Mort Gerberg. [©2008 Tom Richmond]

During the weekend, many cartoonists signed letters about the Orphan Works Act that NCS subsequently forwarded to the appropriate congressmen. The Orphan Works Act of 2008, if adopted, will modify copyright law. The letter explains cartoonists' objections: "Under the Orphan Works Act, any person or company desiring to use my work for *free* need only conduct a 'diligent search' for me. If the search fails, the image is deemed 'orphaned.' The key requirement of a diligent search will be to run the image through privately owned and managed databases. I (the artist) will be asked to pay to digitize every cartoon I've ever published, and then pay again to have it catalogued in the databases of private for-profit companies. The average cartoonist has thousands of images, so the cost of compliance will be exorbitant and most cartoonists simply will not be able to afford it. Furthermore, regardless of the type of third party use and regardless of my efforts to register my works with the Copyright Office and private databases, if I discover an infringing use, I will only be entitled to the amount paid on the open market between willing sellers and buyers in similar deals. Since there will no longer be penalties for infringement, the Orphan Works Act actually encourages, rather than deters, infringement. I strenuously object to commercial enterprises using my work for free in the pursuit of profit and then only having to pay me a modest amount if I somehow catch them in the act."

As a preamble to the weekend's festivities, on Friday, members of NCS helped Habitat for Humanity build houses in the desolated neighborhoods. Making a presentation during the Reuben Banquet, Arnold Roth commended his colleagues for their good work, adding that while they were out pounding nails in planks and building houses, he and a few others had been "down in the bar, building a habitat for drunks, which," he added, "is harder than it seems." ∎

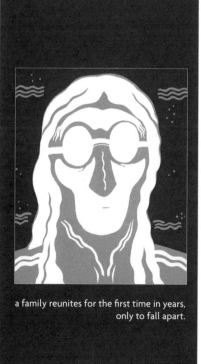

Cruel Story of Youth

by Bill Randall

Red Colored Elegy
By Seiichi Hayashi
Drawn & Quarterly
240 pp., $24.95
B&W, Hardcover
ISBN: 9781897299401

From "Red Dragonfly" in the Japanese edition. [© 2000 Seiichi Hayashi]

It's spring. Love is in the air. Sachiko and Ichiro are wandering among the cherry trees when she tells him about the wedding. In a flash, Prince Charming takes Snow White in his arms. It's no metaphor: Disney's famous couple intrudes. And the cherry blossoms fall, bitterly.

So goes *Red Colored Elegy*, Seiichi Hayashi's youthful masterpiece. He was just 24 when its first episode appeared in *Garo* in January 1970. The magazine itself was then only six years old, young like the idea of avant-garde comics. It had published Yoshiharu Tsuge's "Screw-Style" in 1968, heralding a new direction in the medium. Tsuge certainly influenced Hayashi. But so did Meiji-era illustrator Yumeji Takehisa, and the Western counterculture in the air. Hayashi made all these influences his own in an oblique, evocative work that still stuns almost 40 years later.

When it first appeared, *Red Colored Elegy* had a double shock. It married radical storytelling to a subject daring for the time. It centers on Ichiro and Sachiko, living together in Tokyo. Clothed as often as not, their unmarried state prefigured the early '70s "*Dousei Buumu*" (cohabitation boom). Back home in the countryside, Sachiko's hidebound father has no idea. He has been preoccupied with finding her a good match. He tells her to save the date in a letter. Ichiro's incredulous, not at the marriage but Sachiko's insistence that it concerns him too. So the Disney cameo intrudes and mocks. Cartoon love looks garish next to real life.

Regardless, Ichiro's life mixes the two. He works as an animator. Hardly upstanding, his profession invites ridicule on a page drawn as a storyboard. A later sequence shows him walking with a cartoon character. This companion, headless, ink splashing out of its turtleneck, nags Ichiro to quit his job. Annoyed, he stabs it, leaving its Mickey Mouse glove hanging on a barbed-wire fence. Such bizarre intrusions punctuate his life. These fantasies

— an image of James Dean, Katsuichi Nagai's surrealist office, even a bullet to his own head — counterpoint his emotions. Despite these flights of fancy, his least realistic dream is to create art. When a fellow artist says you can't eat a painting, Ichiro declares, "I want to make comics!"

Sachiko doesn't share his dreams, even though she encourages him. At one point she poses nude for his art. She reminds him, "What if you become a famous artist? I'll be known as your eternal muse …" She's hoping for stability in their relationship. After all, her animation job is hardly stable. The studios are shady. Her peers are quitting to get married. The ones who don't are consumed by union activism. Sachiko just wants a hotplate so she can cook at home with Ichiro. But the couple doesn't communicate well. When they first appear together, they're silent; in the next panel, Sachiko's alone, saying, "I don't understand him." As time passes, increasingly they fight and fail to communicate. Even sex, the first and last refuge of young love, goes sour.

Hayashi mirrors their relationship with disjointed storytelling. The action moves in fits and starts; few scenes go longer than a couple of pages. They sit in their rundown apartment for a page; they negotiate an embrace for two. Then she's at work, at home, out at night, at a coffee shop with her sister. Hayashi has a special feel for small, fleeting moments. Some, like the couple singing together or their day at the beach, feel like photos and letters found in a discarded album long after the relationship has ended.

To anchor his storytelling, Hayashi employs tightly controlled page layouts. He typically uses a three- or four-panel page. The full-width panels run top to bottom, recalling a storyboard. They foreground character and movement, often on white ground. One telling page shows Ichiro at his light table, animating. Instead of a background, beside him floats the image he is drawing: a burning building. Because the layouts communicate simply and directly, Hayashi can take more risks with his story and images.

Like the storytelling, his art is simple but fragmented. He usually draws with an animator's unadorned line and relies heavily on silhouette and broken framing. Often, action is implied. This simplicity belies his skills as an illustrator. Pages are crisply designed, with balanced blacks. When he needs it, he provides lavish detail, drawing weather-beaten buildings or sweeping natural vistas. A scene of Ichiro running past a field at dusk especially stands out. Occasionally, images stand alone, as if above the narrative. In one, Sachiko sits in profile, as though modeling for a painting. Later, three pages of clouds

From *Red Colored Elegy*. [©2008 Seiichi Hayashi]

swell over the ocean. Each builds the atmosphere of the work, at once romantic and hermetic. Soon enough, the romance erodes.

Even though *Garo*'s circulation had peaked in the early '70s, it never passed 80,000, a relatively small audience. Nonetheless, this story of free love resonated outside the cognoscenti. Freedom was in the air, and in the imported counterculture. *Red Colored Elegy* tapped into the prevailing currents, a rare convergence of artistic flowering and eager audience. It inspired a hit song and outright imitations. Nonetheless, Hayashi's best-known work is the design of a girl in advertisements for Lotte, a candy company.

Now a respectable commercial artist, he has made just a few other comics. None but *Red Colored Elegy* has transcended a small audience of connoisseurs.

A few of his early works, however, offer a fuller understanding of his masterpiece. He produced a num-

ber of short stories after his debut in November 1967. They reveal a searching beginner. The first two are not memorable, with sophomoric ideas and unpolished art. However, he matured quickly. By May 1968 his story "The Giant Fish" ("*Kyojinna Sakana*") showed a leap in his art, and more visceral emotions: Something personal was at stake.

In June, he made a breakthrough. "Red Dragonfly" ("*Akatonbo*") marks him as a talent. It centers on a boy whose single mother has been forced by circumstance into discreet prostitution. The spare pages balance wispy lines and heavy blacks. The boy plays at war, even though it's clear why his father is no longer around. Like many war stories, the setup borders on cliché, but here the emotions are earned. After all, Hayashi's own father had died in occupied Manchuria in 1945, the year his son was born. Hayashi spent much of childhood, not with his single mother, but alone in movie theaters.

Three months after "Red Dragonfly," a completely different story appeared, his first to win acclaim. "Mountain Witch Lullaby" ("*Yamauba Komoriuta*") appropriates Western counterculture with confidence. The story retells the Kintaro legend of a boy possessed of great strength. The story, however, matters little before its vista of pop-culture flotsam. It looks like the work of another hand, such as Tadanori Yokoo or a toking Hokusai. It shows a newly confident illustrator, a label that fits few of Hayashi's *Garo* peers.

While both stories inform *Red Colored Elegy*, only the latter explains its popularity. The '60s had just peaked. The news from abroad spoke of free love and a youth revolution led by the popular arts. They found an eager audience in young Japanese. In a 2000 essay for the Shogakukan edition of *Red Colored Elegy*, singer-songwriter Morio Agata recalls how Japanese artists found inspiration abroad. The Group Sounds bands took The Beatles as a model; filmmakers Nagisa Oshima and Masahiro Shinoda borrowed from the *Nouvelle Vague*. "Mountain Witch Lullaby" recalls Peter Max and *Yellow Submarine*, and *Red Colored Elegy* shows the social changes many young Japanese desired, in homegrown works they could call their own.

Nonetheless, many of the similarities are superficial: Any cultural export, from Hollywood to democracy, gets reinterpreted by the recipient. In America, "Make Love Not War" focused mostly on the love; yet Tokyo 1968 looked more like Paris than Woodstock. May in both countries saw nationwide strikes by student Marxists. A key issue in Japan was the Anpo Treaty, the security agreement that allows the American military presence on Japa-

> DID YOU READ MY LETTER?

> I'M GETTING MARRIED...

> IT CONCERNS YOU TOO, YOU KNOW.

This spread: *From Red Colored Elegy.* [©2008 Seiichi Hayashi]

nese soil. Because of the Vietnam War and Japan's peace constitution, the treaty's renewal invited dissent. Photos from 1968 show oceans of protesters crowding the Diet building. The '70s saw further protests, but weaker ones, as the counterculture began to die. The Left's failure, at least, transcended national boundaries.

These young activists, and the ones just along for the ride, found rallying points in their own youth culture. In comics, they had *Kamui-Den*, the most popular of *Garo*'s serials. In film, *The Grand Adventure of Horus, Prince of the Sun* ("*Taiyou no Ouji Horusu no Daibouken*") barely concealed its Marxism as an adventure tale. Easier and more pleasurable than Marx, they offered vital rallying points.

Horus in particular offers a case study of the day's politics. Like many of the great '60s films, its story reflected its production. The unionized staff fought the studio Toei Douga for better pay and artistic freedom, even as they went wildly over budget. The staff was young, eager to revolutionize Japanese animation. Its credits read like a roll call of that generation's great talents. Yasuji Mori, Youichi Kotabe and Reiko Okuyama did some of their best work for director Isao Takahata. Of course, he would later form Studio Ghibli with the fiercely talented young animator who drew the original art for *Horus*: Hayao Miyazaki. Eventually the pair would make Japan's most vital contemporary films, such as *My Neighbor Totoro* and *Pom Poko*. At the time, they were content to reinvent anima-

tion, organize labor against management and occasionally strike.

Fresh out of design school, Hayashi found himself in the mix. He responded to a newspaper ad and joined Toei's staff in 1964. While working for Sadao Tsukioka on a television series, he met Takahata. Hayashi joined his staff when production began on *Horus*. Most notably, Hayashi assisted Miyazaki and Kotabe on the design of the character "Gruenwald." During a labor stoppage in 1965, though, Hayashi quit. He appears not to have shared their revolutionary fervor, preferring to join Tsukioka's start-up studio, Knack.

Red Colored Elegy captures this world, just as *The Dreamer* captures the comic book's birth in New York. Perhaps because Hayashi's portrait was five years removed, not 50, it lacks Will Eisner's sentimentality. The studios never seem stable, and the work always seems desperate and exhausting. The politics, too, are sketchy. When the union appears, Sachiko keeps it at arm's length. She laughs at herself for wearing a union headband home, and keeps quiet when an activist derides their peers for abandoning the struggle for "the emancipation of female laborers." Uninvited to the Grand Struggle, Sachiko and Ichiro focus on the day-to-day. For them, the personal is not political.

Despite Hayashi's personal connection to its world, *Red Colored Elegy* should not be read as an autobiography. He was a design school graduate, and held positions of authority. By contrast, Ichiro does outsourcing work at home, and only graduated from middle school, the end of Japan's compulsory schooling. One can imagine dozens of Ichiros hanging around the studios, flattering themselves with artistic dreams. As in "Red Dragonfly," Hayashi uses elements of his own life only as a starting point.

Having left that world for more stable, commercial work, Hayashi also left comics for a while. He produced two more short stories in 1971, then nothing until 1986. Meanwhile, the countercultural movements ground to a halt. Even though it broke new ground, *Red Colored Elegy* mourns more than just a dead relationship.

In the year after *Red Colored Elegy* finished, two things happened to prevent it from fading into history. First, and most importantly, Morio Agata made his debut with a love song of the same title. It sold half a million singles and remains popular. Second, Kazuo Kamimura wrote and drew his own *gekiga* masterpiece, *Dousei Jidai* (The Age of Cohabitation"), which I will review in a future column. In it, a young couple in Tokyo live together unmarried as they pursue careers in illustration. It's terribly romantic and melodramatic. You can practically

hear Kamimura's publisher urging him to make a more marketable version of *Red Colored Elegy*. Nevertheless, he is a formidable artist, and *Dousei Jidai* offers its own pleasures. Not least among them are its 2,000 pages of unhinged layouts and gorgeous art. Apart from the plot summary, the two comics resemble each other little. Besides, *Dousei Jidai* inspired a hit 1973 movie, not a song. Agata's film version of *Red Colored Elegy* had to wait another year.

Though they used different words, the Marxist student movement and the hippy counterculture both promised the same thing. Freedom (emancipation to the comrades) had a particular ring in Japan. It was not just a chance for the young to enjoy free love and long hair, but to shed the

oppressive web of obligations that makes up the fabric of daily life. None binds more tightly than family obligations. As "Red Dragonfly" had already shown, Hayashi had a hard-won understanding of how persistent those bonds were.

In *Red Colored Elegy*, Sachiko and Ichiro may live free in Tokyo, but they still cannot escape their parents. No sooner have we met them than her father has arranged her marriage. Probably because her refusal has shamed the family, he kills himself with a razorblade. Later, Ichiro deals with his own father's death by cancer. Considering they have already defied their families, they might welcome these deaths as one less hassle. Initially, they do. Sachiko is relieved that her father is gone, as he had already attempted suicide three times. Ichiro doesn't even go to his father's funeral. His sister visits to ask why, and he lies, saying he couldn't afford it. When Sachiko says she would have helped him, he barks, "Stop acting like you're my wife!" It seems only absolute freedom will do.

Nevertheless, both characters discover how illusory such freedom proves. They may have moved to Tokyo, but they are still their parents' children. Nothing can change that. Ichiro doubles over sobbing when he learns of his father's death. Likewise, Sachiko's early relief later fades as she sits naked, terrified, begging to be held. Their young love can't erase their profound attachment to their parents. Nor can it save their relationship. At the book's end, both are free from family and each other. It is awful. In a striking final image, Ichiro again finds himself doubled over sobbing, a mere shadow of the brash loner who kept Sachiko at arm's length for so long.

From the short story "Mountain Witch Lullaby" in the Japanese edition.
[©2000 Seiichi Hayashi]

This perspective, approaching wisdom, makes *Red Colored Elegy* more than just an avant-garde breakup story. It also lifts it out of the counterculture, which so often proved adolescent. Much of the work of the period has aged badly. Another comic, from the same year but a different country, makes for an interesting comparison. After all, both borrow from Disney.

Air Pirates Funnies caused a stir when it appeared. Its two issues introduced Mickey Mouse to sex and drugs. Disney's lawyers took exception. The story fascinates, especially as told by Bob Levin, the lawyer and critic who recounted it in this journal. It touches on free speech and parody; individual expression versus corporate Philistinism; and a lone artist, passionately ruin-

ing himself before the court. It also supersedes the comics, which display fine craft but little of enduring interest. There are no ideas past the infantile prank. These comics also raise the question: If one creates to destroy, what to do when the goal's achieved?

In *Red Colored Elegy*, Hayashi appropriates Disney, as well, if just for a panel. He uses it, however, to completely different ends, speaking to his medium's history and the gulf between art and life. Best of all, his work still has relevance beyond the counterculture that birthed it. Time has not diminished its energies at all.

From *Red Colored Elegy*. [©2008 Seiichi Hayashi]

To appreciate Hayashi's achievement in comics fully, a brief closing history should suffice. The idea of comics for adults first appeared in several anthologies at roughly the same time. *Garo* appeared in 1964; Osamu Tezuka answered with *COM* in 1967. In the United States, *Zap* appeared in 1968, after *The East Village Other* began running underground comics in 1965.

The American undergrounds fostered many creative talents and a few unequivocal masterpieces. The best, like *Binky Brown Meets the Holy Virgin Mary* (1972), should still be read in a hundred years. Unfortunately, most of the rest confused "adult" with "perverted adolescent." As the freedoms won had no particular purpose, the movement faltered. It would be another 15 years before a new generation of artists would take those freedoms and use them to produce aesthetically mature work consistently.

The Japanese scene likewise had its share of dreck, but from the beginning, produced work of far greater value. For instance, one of *COM*'s contributions in 1970 was Tezuka's *Karma*, a masterpiece by any measure. What's more, because no separate system of distribution ghettoized the counterculture, the mainstream absorbed its influence much more quickly. The perverse humor of Go Nagai and Tatsuhiko Yamagami appeared in major magazines for huge audiences, an innovation ironically fostered by strict censorship. Casual entertainments suddenly became masterpieces: *Barefoot Gen* (1973) in *Shonen Jump* and *The Heart of Thomas* (1974) in *Shoujo Comic*. The scene overall was one of great innovation and lasting artistry.

Meanwhile, the same year *Red Colored Elegy* appeared, superheroes in America discovered they could feign social relevance through heroin. Funny animals foreshadowed a change in course with Art Spiegelman's first three-page *Maus* strip. Yet to appear were these art-comics milestones: *American Splendor* (1976), *A Contract With God* (1978) and *Arcade* (1974), and in France, *Les Frustrés* (1975), *The Airtight Garage* (1976), and the first *Adèle Blanc-Sec* album (1976), just to name the first that come to mind.

Red Colored Elegy prefigured all these. In fact, I can think of no work outside Japan it truly resembles, even now. Taken on its own, it should stun and excite. When taken along with these contemporaries, it should change the way the cognoscenti outside Japan read both comics and their history.

Finally, a note on Drawn & Quarterly's English edition, translated by Taro Nettleton. The dialogue has the right feel for the milieu, without sounding dated. The book reads left-to-right, but is only half-flipped. The panels are rearranged, not mirrored. Most pages flow top-to-bottom rather than left-to-right, and so are unchanged. All translations are compromises; This is better than asking readers to relearn how to read, though I realize I am now in the reviled minority among manga fans in so thinking. Rich Tomasso's font design matches the art well. My only quibbles: the sound-effects font I like less, and a couple of the sound effects have been awkwardly rendered. As a whole, the package shows D&Q's continued high standards. Its translation marks a considerable milestone for manga in English. Of course, much work remains to be done. Nonetheless, I now hope we'll soon see Hayashi's *pH 4.5 The Guppy Doesn't Die* in an equally fine package, along with many others. ∎

September, 2008 – October, 2008

ALTERNATIVES

Rutu Modan follows up the acclaimed *Exit Wounds* with *Jamilti and Other Stories*, a collection of shorts, from Drawn & Quarterly in September ($19.95, 120 pp.). In Nate Powell's *Swallow Me Whole* from Top Shelf, two stepsiblings cope (September, $19.95, 216 pp.). Two Gabrielle Bell projects from Drawn & Quarterly this fall: *Cecil and Jordan in New York: Stories by Gabrielle Bell* ($19.95, 112 pp.), which includes the titular short story adapted by Michel Gondry into an upcoming film, and *Kuruma Tohrimasu*, a collection of production drawings and photographs ($12.95, 64 pp.). John Pham deconstructs the dwellers of 221 Sycamore St. in *Sub Life* #1 (Fantagraphics, September,$8.99, 64 pp.). The second volume of *An Anthology of Graphic Fiction, Cartoons, and True Stories*, edited by Ivan Brunetti, is slated for 9/15 (Yale University Press, $28.00, 400 pp.).On Sept. 30, Pantheon releases David Heatley's comics memoir *My Brain is Hanging Upside Down* ($24.95, 128 pp.). Dark Horse publishes two more Web-comics collections: Chris Onstad's *Achewood: The Great Outdoor Fight*, which collects the most popular story arc from the strip (9/10, $14.95, 96 pp.), and Nicholas Gurewitch's *The Perry Bible Fellowship Almanack* (10/29, $24.95, 272 pp.), which collects the rest of the strips plus bonus material. In time for Halloween, Fantagraphics puts out Lilli Carré's *The Lagoon*, about a family and a Creature ($14.99, 80 pp.). Cartoon animals with human heads run amuck in John Kerschbaum's *Petey & Pussey* (Fantagraphics, October, $19.95, 128 pp.).

CLASSIC STRIPS/COMIC BOOKS

Hermes Press releases the first volume of Philip Francis Nowlan and Richard Calkins's seminal sci-fi strip *Buck Rogers In The 25th Century* in September ($39.99, 336 pp.). Marvel repackages *Tomb Of Dracula* — by Conway, Goodwin, Wolfman, Claremont Colan, Ploog, et al. — into an omnibus series. Volume 1 is slated for October ($99.99, 768 pp.).

INTERNATIONAL

The first volume of the basketball manga *Slam Dunk* — "one of the most read of all time" — by Takehiko Inoue, is slated from Viz in September $7.99, 208 pp.). Vertical, Inc. releases the first volume of Osamu Tezuka's *Black Jack*, which is about a renegade surgeon, on Sept.23 ($16.95, 300 pp.). Inio Asano's slice-of-life tale about a young couple, *Solanin*, is coming out from Viz Oct. 21 ($17.99, 432 pp.). *Tamara Drewe* is Posy Simmonds' retelling of Thomas Hardy's *Far from the Madding Crowd*. It appears Stateside Oct. 8 (Mariner Books, $16.95, 136 pp.). First Second puts out Emmanuel Guibert's *Alan's War: The Memories of G.I. Alan Cope* Oct. 28 ($24.00, 336 pp.).

MAINSTREAMY

It's not a complete set, but with *Dilbert 2.0* Andrews McMeel is giving the deluxe slipcover treatment, with extras, to Scott Adams' strip (September, $85.00, 576 pp.). Also from Andrews McMeel, *The New Yorker Cartoon Caption Contest* gets its own collection in September: edited by Robert Mankoff ($29.99, 240 pp.). *The Alcoholic* is drawn by Dean Haspiel and written by novelist Jonathan Ames, who is also the fictionalized protagonist of the graphic novel (DC/Vertigo, 9/17, $19.99, 136 pp.). Joss Whedon, Gerard Way, Mike Mignolia, Gabriel Ba and Fábio Moon all have work in the anthology *MySpace Dark Horse Presents* Vol. 1 (9/17, $19.95, 176 pp.). *Jack and the Box* is Art Spiegelman's contribution to his and Françoise Mouly's Toon Books line for children (October, $12.95. 32 pp.). Mariko Tamaki wrote *Emiko Superstar*, drawn by Steve Rolston, for DC's Minx line ($9.99, 176 pp.), in which a girl finds her artistic side. From Marvel in October comes writer Chris Claremont and artist David Nakayama's *Big Hero Six* #1 (9/10, $3.99, 48 pp), about "Japan's top heroes," and *Omega: The Unknown Premiere HC* by bestselling novelist Jonathan Lethem, Farel Dalrymple, Gary Panter, Paul Hornschemeier, et al.

ABOUT COMICS

Fables: Covers by James Jean collects the artist's work with extras, including a forward by Bill Willingham (DC, 10/29, $39.99, 208 pp.). Titan Books publishes *Watching the Watchmen*, a companion to Alan Moore's graphic novel (10/21, $39.95, 208 pp.). Artist Dave Gibbons heavily contributed to this project, providing his take on the work as well as supplementary materials; designed by Chip Kidd. ■

Have you recently discovered a new favorite cartoonist and want to read an in-depth interview with him or her? Are you doing research for a book or a paper, or do you just want to catch up with the comic industry's magazine of record? Below is a sampling of *TCJ* back issues available from our warehouse for your perusal. For the full backlist of in-print issues, please visit www.tcj.com.

40: JIM SHOOTER interviewed, Spiegelman's BREAK-DOWNS reviewed. ($3.50)

48: A 140-page partial-color Special, featuring interviews with JOHN BUSCEMA, SAMUEL R. DELANY, KENNETH SMITH AND LEN WEIN! ($6)

72: NEAL ADAMS interview. ($3.50)

74: CHRIS CLAREMONT speaks; plus RAW with SPIEGELMAN and MOULY. ($3.50)

89: WILL EISNER interview; EISNER interviews CHRIS CLAREMONT, FRANK MILLER & WENDY PINI! ($3.50)

124: JULES FEIFFER interviewed; BERKE BREATHED defends his Pulitzer. ($5)

127: BILL WATTERSON interviewed! Limited Quantity! ($10)

131: RALPH STEADMAN interviewed! ($5)

142: ARNOLD ROTH and CAROL TYLER. ($5)

152: GARY GROTH interviews TODD McFARLANE! ($6)

154: DANIEL CLOWES interviewed; HUNT EMERSON sketchbook. ($6)

156: GAHAN WILSON! ($6)

157: BILL GRIFFITH; special KURTZMAN tribute. ($6)

158: ED SOREL; R. CRUMB discusses life and politics. ($6)

162: Autobiographical cartoonists galore! PEKAR, EICHHORN, NOOMIN, BROWN, MATT, SETH! ($6)

169: NEIL GAIMAN and SOL HARRISON interviewed. ($6)

172: JOE KUBERT interview. ($5)

180: ART SPIEGELMAN; R. CRUMB. ($7)

187: GILBERT SHELTON; GIL KANE. ($6)

206: PETER BAGGE and MILLIGAN, SPAIN II, TED RALL interviewed, JACK KATZ profiled. ($7)

209: FRANK MILLER, SAM HENDERSON! ($6)

213: CAROL LAY interview, Kitchen Sink autopsy! ($6)

215: JOHN SEVERIN part I, TONY MILLIONAIRE. ($6)

216: KURT BUSIEK, MEGAN KELSO, SEVERIN II. ($8)

225: MAD issue. JAFFEE, DAVIS and FELDSTEIN! ($6)

227: CARL BARKS tribute, C.C. Beck's *Fat Head* pt. 2 ($6)

231: GENE COLAN, MICHAEL CHABON, ALAN MOORE interviewed; Moore's ABC line of comics reviewed! ($6)

241: JOHN PORCELLINO, JOHN NEY RIEBER! ($6)

242: GIL KANE chats with NOEL SICKLES! ($6)

244: JILL THOMPSON, MIKE KUPPERMAN! ($6)

247: Our 9/11 issue: RALL, RUBEN BOLLING interviews! ($7)

248: STEVE RUDE ! ANDI WATSON interviewed! ($7)

250: 272-page blowout! HERGÉ, PANTER, CLOWES and RAYMOND BRIGGS interviewed! CARL BARKS and JOHN STANLEY chat! NEIL GAIMAN vs. TODD McFARLANE trial transcripts! Brilliant manga short story NEJI-SHIKI translated! Essays on 2002-In-Review, EC, racial caricature, post-9/11 political cartooning, Team Comics, etc. and a rare essay by the late CHARLES SCHULZ on comic strips! ($14)

251: JAMES STURM! Underground comix panel! ($7)

252: JOHN ROMITA SR., RON REGÉ interviewed. ($7)

253: ERIC DROOKER, JOHN CULLEN MURPHY, JASON! ($7)

254: WILL ELDER, Kazuo Umezu interviews! ($7)

256: KEIJI NAKAZAWA; FORT THUNDER! ($7)

257: A suite of four never-before-published interviews with the late, great comix artist RICK GRIFFIN! Hard-workin' writer JOE CASEY interviewed! ($7)

258: A comprehensive look at the work of STEVE DITKO, and a conversation with GILBERT HERNANDEZ and CRAIG THOMPSON! ($7)

259: 2003 Year in Review: Comics and Artists of the Year! Youthquake: A new generation emerges! ($7)

260: DUPUY and BERBERIAN! JEAN-CLAUDE MÈZIÉRES! They're foreign! ($7)

261: PHOEBE GLOECKNER! JAY HOSLER! ($7)

262: NEWFORMAT! ALEX TOTH profiled, with a generous color selection of his 1950s crime comics, plus an interview with STEVE BRODNER! ($10)

263: ED BRUBAKER interviewed! CEREBUS examined! George Carlson's JINGLE JANGLE TALES in color! ($10)

264: IVAN BRUNETTI interviewed, Underground Publishers, Harold Gray's LITTLE JOE in color! ($10)

265: Essays on WILLIAM STEIG, ERIC SHANOWER interviewed, Harry Anderson's Crime Comics in color! ($10)

268: CRAIG THOMPSON! BOB BURDEN! TINTIN AT SEA! WALT KELLY'S "OUR GANG" in color! ($10)

269: SHOUJO MANGA ISSUE! MOTO HAGIO interviewed and her short story "HANSHIN" in english! ($10)

270: JESSICA ABEL interviewed! MARK BODÉ and LALO ALCARAZ! NELL BRINKLEY comics in color! ($10)

271: JERRY ROBINSON interviewed! RENÉE FRENCH! 50 pages of pre-Popeye THIMBLE THEATRE! ($10)

273: EDDIE CAMPBELL interviewed! JUNKO MIZUNO interviewed! ART YOUNG goes to HELL! ($10)

274: MIKE PLOOG interviewed! SOPHIE CRUMB! Early HARVEY KURTZMAN comics in COLOR! ($10)

275: 2005 YEAR IN REVIEW! DAVID B. interviewed! BOODY ROGERS comics in COLOR! ($10)

276: TERRY MOORE interviewed! BOB HANEY pt. 1! Early B. KRIGSTEIN comics in COLOR! ($10)

277: 30 YEARS OF THE COMICS JOURNAL! THE STATE OF THE INDUSTRY! IT RHYMES WITH LUST! ($13)

278: BILL WILLINGHAM interviewed! BOB HANEY pt. 2! ORESTES CALPINI comics! JAXON tribute! ($10)

279: JOOST SWARTE interviewed! JOHNNY RYAN! LILY RENÉE comics! ($10)

280: FRANK THORNE interviewed! CARLA SPEED McNEIL! CRIME DOES NOT PAY comics! ($10)

281: THE BEST COMICS OF 2006! YOSHIHIRO TATSUMI and MELINDA GEBBIE interviewed! ($10)

282: ALISON BECHDEL! FRED GUARDINEER! Andru & Esposito's GET LOST comics! ($10)

283: LEWIS TRONDHEIM! DAVID SANDLIN! THE 39 STEPS comic adaptation! ($10)

284: ROGER LANGRIDGE! GENE YANG! Frederick Burr Opper's HAPPY HOOLIGAN in color! ($10)

285: DARWYN COOKE! ERNIE COLÓN! KEITH KNIGHT! John Buscema WANTED comics in color! ($10)

286: POSY SIMMONDS! GAIL SIMONE! Otto Soglow's THE AMBASSADOR in color! ($10)

287: JEFFREY BROWN! GREG RUCKA! Non-Krazy Kat comics of GEORGE HERRIMAN! ($12)

288: NEW FORMAT! THE BEST COMICS OF 2007! Tarpé Mills MISS FURY in color! ($12)

289: ROBERT KIRKMAN! SHAUN TAN! A gallery of MINUTE MOVIES strips! ($12)

290: SCHULZ AND PEANUTS ROUNDTABLE! MATT MADDEN! A gallery of '50s horror comics by BOB POWELL! ($12)

291: TIM SALE! JOSH SIMMONS! A gallery of DAN GORDON comics! ($12)

Libraries and Specials:

TCJ SPECIAL I: WINTER 2002: JOE SACCO interviewed! ($24)

TCJ LIBRARY VOL. I: JACK KIRBY: All of The King's Journal interviews! ($23)

TCJ SPECIAL II: SUMMER 2002: JIM WOODRING interviewed! ($27)

TCJ SPECIAL III: WINTER 2003: BILL STOUT interviewed! ($27)

TCJ LIBRARY VOL. II: Frank Miller: All of FM's Journal interviews and more! ($23)

TCJ LIBRARY VOL. III: R. CRUMB: All of Crumbs Journal interviews! ($23)

TCJ SPECIAL IV: WINTER 2004: Profiles of and interviews with four generations of cartoonists — AL HIRSCHFELD, JULES FEIFFER, ART SPIEGELMAN and CHRIS WARE! ($23)

TCJ LIBRARY VOL. IV: DRAWING THE LINE: Lavishly illustrated interviews with JULES FEIFFER, DAVID LEVINE, EDWARD SOREL and RALPH STEADMAN! ($23)

TCJ SPECIAL V: WINTER 2005: Almost half of this volume is devoted to MANGA! Also features Vaughn Bodé, Milt Gross, and a comics section! ($25)

TCJ LIBRARY VOL. V: CLASSIC COMICS ILLUSTRATORS: A full-color celebration of the work of FRANK FRAZETTA, RUSS HEATH, BURNE HOGARTH, RUSS MANNING, and MARK SCHULTZ! ($23)

TCJ LIBRARY VOL. VI: THE WRITERS: Interviews with ALAN MOORE, CHRIS CLAREMONT, STEVE GERBER and more! ($20)

TCJ LIBRARY VOL. VII: KURTZMAN: Interviews with HARVEY KURTZMAN! ($23)

The *Utne* Independent Press Award Winner for Arts & Literature coverage just keeps getting better. Subscribe now to get these issues:

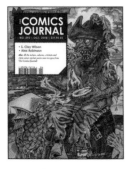

THE COMICS JOURNAL #293

The *Journal* interviews *Zap* artist S. Clay Wilson, best known for his panoramas of sex and violence involving lesbian bikers, zombie pirates and a Checkered Demon. The Harvey-and-Eisner-winning Alex Robinson will discuss *Box Office Poison*, *Tricked* and *Too Cool to Be Forgotten*. And a special back-to-school section will feature a gallery of undiscovered potential comics masterpieces by students from the Center for Cartoon Studies.

THE COMICS JOURNAL #293

Art speaks louder than words when the *Journal* interviews two cartoonists who have found success in "silence": Norwegian Jason, who populates comics such as *I Killed Adolf Hitler* with deadpan anthropomorphic animals, and Mark Tatulli, whose pantomime boy-and-ghoul strip, *Lio*, features some of the most innovative and entertaining cartooning to be found on today's Funny Pages. Plus a color comics gallery of Billy De-Beck's *Snuffy Smith* precursor, *Take Barney Google, F'rinstance* from 1919-22.

"Still the best and most insightful magazine of comics criticism that exists."
— **Alan Moore**

"You ignore it at your peril."
— **Neil Gaiman**

"The good is always in conflict with the better. *The Comics Journal* attempts to explain the difference."
— **Gil Kane**

"All in all, *The Comics Journal* is a stand-out inspiration to me."
— **Kim Deitch**

Read *The Comics Journal* the way the professionals do:
by SUBSCRIPTION.
